Art and the Human Experience

ART

A Global Pursuit

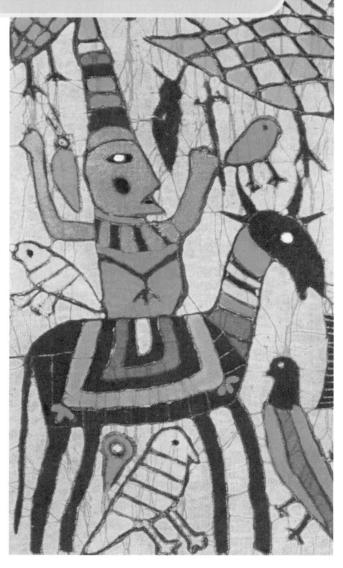

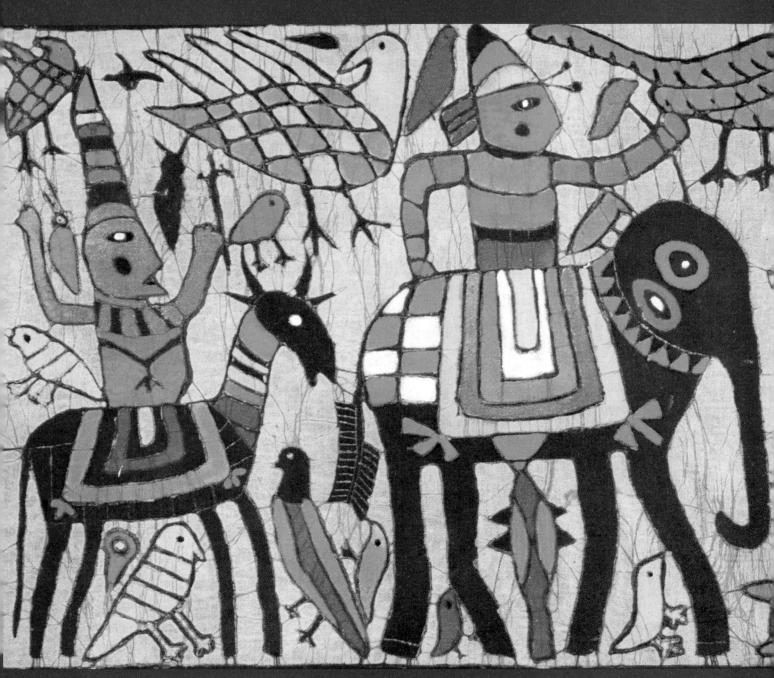

Cover, and above: Yunan Province, China, Wall Hanging, 20th century. Batik on cloth, 20" x 32" (50.8×81.2 cm). Private Collection.

Art and the Human Experience

A Global Pursuit

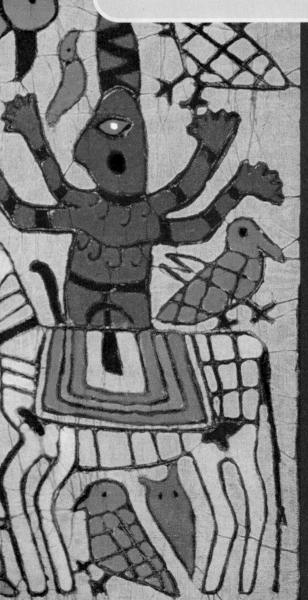

Eldon Katter Marilyn G. Stewart

Davis Publications, Inc. Worcester, Massachusetts

Foundations What Is Art?

Foundation 1

- 2 The Whys and Hows of Art
- 4 The Functions of Art
- 6 Subjects and Themes for Artworks
- 10 Styles of Art
- 14 Connect to...
- 17 Chapter Review

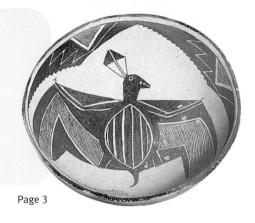

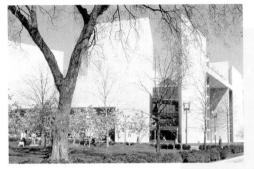

Page 24

Foundation 2

- 8 Forms and Media
- 20 Two-dimensional Artworks
- 24 Three-dimensional Media
- 28 Connect to...
- 31 Chapter Review

Foundation 3

- 32 Elements and Principles of Design
- 34 Elements of Design
- 42 Principles of Design
- 48 Connect to...
- 51 Chapter Review

Page 56

Foundation 4

- 52 Approaches to Art
- 54 Art History
- 56 Art Criticism
- 58 Art Production
- 60 Aesthetics
- 62 Connect to...
- 65 Chapter Review

Themes Art Is a Global Pursuit

Page 73

T	l.	em	-	4
- 1	n	αm	63	- 1

- 68 Messages
- 70 Core Lesson Messages in Art
- 76 1.1 Art of the Ancient World
- 80 1.2 Line and Pattern
- 82 1.3 Messages of African Kingdoms
- 86 1.4 Making a Bas-Relief
- 90 Connect to...
- 93 Chapter Review

Theme 2

- 94 Identity and Ideals
- 96 Core Lesson The Art of Special Groups
- 102 2.1 The Art of Three Empires
- 106 2.2 Texture and Rhythm
- 108 2.3 Native North American Art
- 112 2.4 Drawing Architectural Forms
- 116 Connect to...
- 119 Chapter Review

Page 96

Theme 3

- 120 Lessons
- 122 Core Lesson Understanding Art's Lessons
- 128 3.1 Art of the Medieval World
- 132 3.2 Shape and Balance
- 134 3.3 The Art of India
- 138 3.4 Creating a Folded Box of Lessons
- 142 Connect to...
- 145 Chapter Review

Page 131

Printed in U.S.A. ISBN: 0-87192-489-7 LC No.: 00-130409 10 9 8 7 6 5 4 WPC 05 04

© 2001 Davis Publications, Inc. Worcester, Massachusetts, U.S.A. All rights reserved. No part of this publication may be reproduced or transmitted in any form or by any means, electronic or mechanical, including photocopying, recording, or any storage and retrieval system now known or to be invented, except by a reviewer who wishes to quote brief passages in connection with a review written for inclusion in a magazine, newspaper, or broadcast. Every effort has been made to trace the copyright holders. Davis Publications, Inc. apologizes for any unintentional omissions and would be pleased in such cases, to add an acknowledgment in future editions.

Page 156

	Theme 4
146	Order and Organizatio
148	Core Lesson Organizing Artwork
154	4.1 The Art of the Renaissance
158	4.2 Unity and Variety
160	4.3 The Art of China and Korea
164	4.4 Drawing in Perspective
168	Connect to
171	Chapter Review

	Theme 5
172	Daily Life
174	Core Lesson Art and Daily Life
180	5.1 European Art: 1600-1750
184	5.2 Light, Value, and Contras
186	5.3 The Art of Latin America
190	5.4 Decorating a Container
194	Connect to
197	Chapter Review

Page 187

Page 202

198	Place
200	Core Lesson Telling About Places
206	6.1 European Art: 1750-1875
210	6.2 Space and Emphasis
212	6.3 Isolated in Place: Oceanic Art
216	6.4 Stitching an Artwork
220	Connect to
223	Chapter Review

Theme 6

Page 241

	T	h	e	m	e	1

224 Nature

- 226 Core Lesson Art Connects with Nature
- 232 7.1 European Art:1875-1900
- 236 7.2 Color
- 238 7.3 The Art of Japan
- 242 7.4 Making a Paper Relief Sculpture
- 246 Connect to...
- 249 Chapter Review

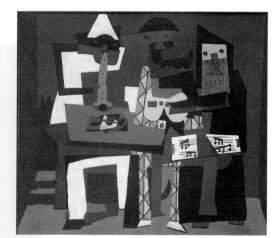

Page 260

Theme 8

Continuity and Change 250

- Core Lesson Continuity and Change in the Art World 252
- 258 8.1 European Art: 1900-1950
- 262 8.2 Shape and Form
- 264 8.3 The Art of Southeast Asia
- 268 8.4 Creating a Montage
- 272 Connect to...
- 275 **Chapter Review**

Page 288

Theme 9

276

Possibilities

- 278 Core Lesson Expanding the Possibilities of Art
- 284 9.1 Art Since 1950
- 288 9.2 Proportion and Scale
- 9.3 Global Possibilities 290
- 294 9.4 Making a Book
- 298 Connect to...
- 301 **Chapter Review**

Resources

- **Acknowledgments** 302 **Bibliography** 309 303 **Artist Guide** 312 Glossary **World Map** 306 **Spanish Glossary** 315
- Color Wheel 308 319 Index

While all artists possess and express a unique perspective, art from across the globe reflects certain shared ideas or themes. Art: A Global Pursuit dedicates a chapter to each of art's universal themes.

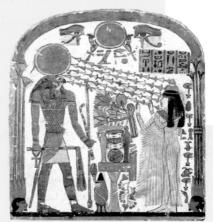

From cave painting to music videos, artists use signs and symbols to communicate Messages

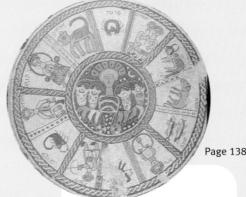

Page 138

Background, foreground, perspective and line provide

Order & Organization

to our visual lives

Page 110

Tapestries, temples, statues, and stained glass teach

Lessons about art and life

Logos and totems, monuments and masks reflect a culture's

Identity & Ideals

Page 146

Whether it's soup tureens or computer screens, quilts or clocks, artists record and shape

Daily Life

A Global Pursuit

Page 203

Through landscape paintings, plazas, and parks, artists celebrate the magic and wonder of **Place**

Artists are inspired by and respond to the forms, patterns, power, and moods of **Nature**

By breaking, borrowing, and building on tradition the arts embrace

Continuity & Change

Through new materials, techniques, subjects, and styles artists push boundaries and explore

Possibilities

Page 286

Foundations in Art

This text opens with an exploration of the fundamental **hows and whys of art.**

- Why do people make art?
- Does art serve a function?
- How do artists choose their subjects?
- Are there different styles of art?
- What is a 2-D art form?
- Why are the elements of design important?
- How are art historians and critics different?

In answering these questions, these introductory lessons provide a foundation on which to build your understanding of art.

Make the most of each chapter!
A unique CORE PLUS 4 chapter organization provides a structured exploration of art with the flexibility to zoom in on topics that interest you.

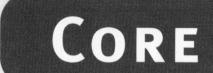

Sample pages from Chapter 5

Each theme opens with a Core Lesson that provides a comprehensive overview of the topic.

This theme examines how artists record and shape daily life.

Each theme concludes with a studio activity that challenges you to apply what you have learned in a hands-on art project.

This studio exercise creates a still-life painting using objects from daily life.

PLUS 4

4 regular follow-up lessons reinforce and extend the Core Lesson.

The first lesson examines the theme from the perspective of **art history**. This lesson studies how Europeans used an ornate style of art to decorate and chronicle daily life during the 1700s.

The second lesson explores the theme using the **elements and principles of design**. This lesson examines how artists use value and contrast to make common objects look real.

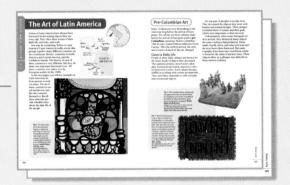

The third lesson looks at the theme from a global or multicultural viewpoint. This lesson considers how ancient and contemporary artists have used a range of art forms to chronicle daily life in Latin America.

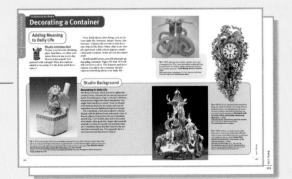

The fourth lesson studies the theme through a **studio activity**. In this project you design and decorate a container that is useful to and expressive of your daily life.

At the end of each chapter the themes

Connect to...

- Careers
- Technology
- Other Subjects
- Other Arts
- Your World

Make the most of each lesson!

There are a number of carefullycrafted features that will help you read, understand, and apply the information in each lesson.

Connecting

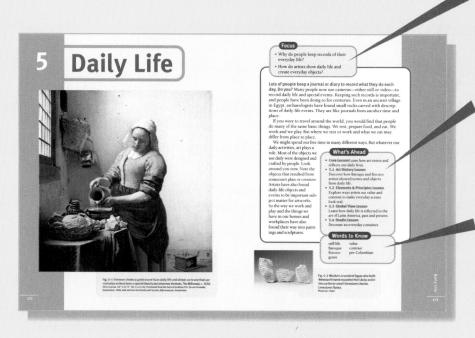

Read with purpose and direction.

Thinking about these Focus questions will help you read with greater understanding.

Prepare for What's Ahead! See how all the lessons are related? Like a map, this will help you plan where you want to go.

Build your vocabulary.

The first time these terms are used they are highlighted in bold type and defined. These terms are also defined in the Glossary.

Organize your thoughts.

By dividing the lesson into manageable sections, these headings will help you organize the key concepts in each lesson.

"Read" the visuals with the text.

Note how the visuals are referenced in the text. Following these connections will help you understand the topic.

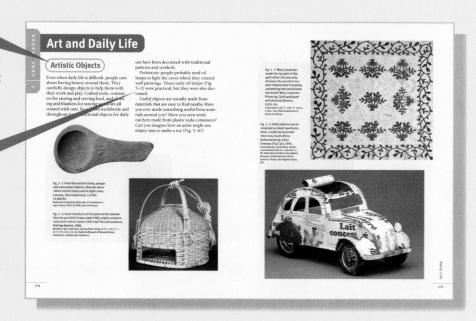

Images and Ideas

Who made this? When was it made? What is it made of?

These and other important questions are answered by the credits that accompany each visual. This information will help you appreciate the art more fully.

Check Your Understanding! In addition to helping you monitor your reading comprehension, these questions highlight the significant ideas in each lesson.

Don't Miss

Timelines

Each **Art History** lesson is supported by a timeline that locates the lesson in history. As you read this timeline consider how the art reflects the historic events that surround it.

Locator Maps

Each **Global View** lesson is supported by a map that highlights the lesson's location in the world. As you read this map, consider how the art reflects the geography and culture of the place.

Work with Your Mind

Make the most of each studio opportunity!

Core Studio

An expansive studio assignment concludes and summarizes each Core Lesson.

Studio Lesson

A comprehensive studio lesson caps off each chapter by tying the theme's key concepts together.

Sketchbook **Connections**

Quick processoriented activities

help you hone your technical and observations skills.

Studio Connections

Practical realworld studio projects explore concepts

through hands-on activities.

Computer Options

An alternative to traditional art materials, the computer can be

used to do all or part of the lesson.

Decorating a Container

Adding Meaning to Daily Life

Studio Introduction Picture your favorite drinking glass, lunchbox, or other container that you use every day. How is it decorated? Is it painted with a design? Were decorations added to its surface? Is the form itself deco-

Now think about other things you see in Now think about other things you see in your daily life furniture, lamps, linens, din-nerware. Cultures all over the world deco-rate objects like these. Many objects are sim-ply patterned, while others appear compli-cated and overdone. Some are not decorated at all. In this studio lesson, you will decorate an

everyday container. Pages 192 and 193 will tell you how to do it. The features and deco-rations you add to the container should express something about your daily life.

Studio Background

Decorating for Daily Life

Build background knowledge

Artists regularly draw from the lessons of history. This background information chronicles how artists from the past approached similar artistic endeavors.

Learn from your peers.

An example of student artwork allows you to see how others responded to these hands-on exercises.

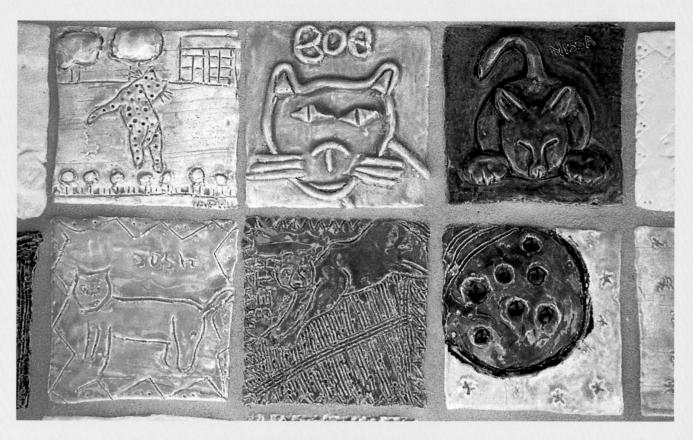

Page 87 Panther tiles. Ceramic, $8' \times 8'$ (2.45 \times 2.45 m). Students of Plymouth Middle School, Maple Grove, Minnesota.

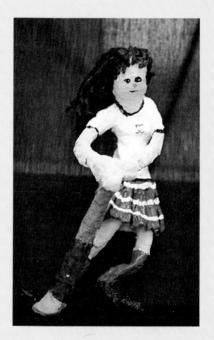

Page 101 Kelly O'Connor, Field Hockey Girl #10, 1999.
Plaster gauze, over a wire and newspaper armature, and acrylic paint. 12" (30.5 cm) high.
Pocono Mountain Intermediate School South, Swiftwater, Pennsylvania.

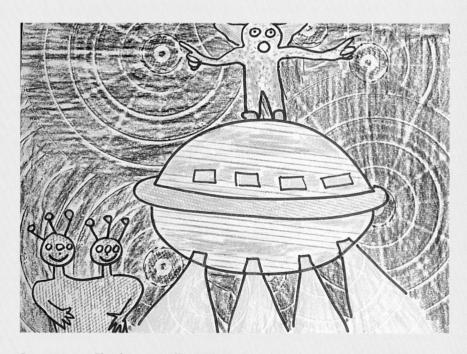

Page 53 Jenna Skophammer, *Alien UFO*, 1998. Crayon, 8 ½" x 11" (21 x 28 cm). Manson Northwest Webster, Barnum, Iowa.

Student Gallery

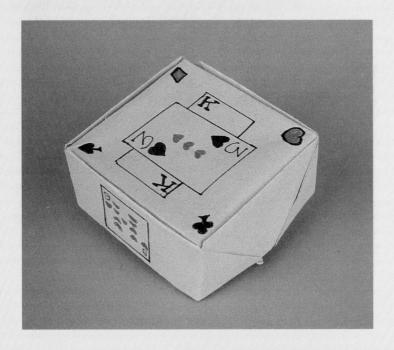

Page 139 Abby Reid, Untitled, 1999. Paper, markers, $3^{1}/4$ " x $3^{1}/4$ " x $1^{5}/8$ " (8 x 8 x 4 cm). Shrewsbury Middle School, Shrewsbury, Massachusetts.

Page 153 Amanda Sacy, Strings of Life, 1999. Mixed media, 22" x 14" x 6" (56 x 36 x 15 cm). Avery Coonley School, Downers Grove, Illinois.

Page 191 Claire Whang, *Rococo Container*, 1999.
Papier-mâché, acrylic, found objects, 7" x 9" x 9" (18 x 23 x 23 cm).
Plum Grove Junior High School, Rolling Meadows, Illinois.

Think with Your Hands

Try This!

These directions and illustrations guide you stepby-step through the studio experience.

Check Your Work

One way to evaluate your art is through constructive group critiques. These strategies help you organize peer reviews.

Decorating Your Container

- sketch paper
- container cardboard
- * newspaper
- · paints * brushes
- found objects

Try This

1. Discuss the artworks shown in 1. Discuss the artworks shown in this lesson. How do the decorations on the clock, centerpiece, and stirrup vessel reflect the ideas or interests of each culture? Which decorative style appeals to you more? Why? How might you use features from that style to decorate your own every-day container. day container?

2. Look at your container. What kinds of decorative features and decorations can you add that will express something about your life? Sketch your ideas.

3. Using the contain as your base, build which you will apply which you will app papier-maché. Tape features made from cutout cardboard o wads of newspaper securely to the con-

5. Paint your container. Choose a color scheme that best fits your daily life. When the paint is dry, decorate the container with buttons, sequins, beads, ribbons, foil, tissu papers, or other found objects.

Identify the best features of your work. What do your decorations say about your culture or your daily life? Why is the decorative style you chose appropriate for your container? Is this a container you could use every day? Why or why not?

Sketchbook Connection

This book will take you on a journey around the world and through time. In your travels you will explore the universal language of art and learn why the joy of making and perceiving art is a global pursuit.

Student Gallery

As you become fluent in the universal language of art, a wealth of studio opportunities will help you find your own voice. The artworks on these four pages show how students just like you express their own unique insights and concerns.

Page 21 Travis Driggers, *Torn*, 1997. Montage, 17" x 12" (43 x 30 cm). Johnakin Middle School, Marion, South Carolina.

Page 5 Tyler Goff, Clay Coil Pot with Line Design, 1999. Clay, glazes, 7" (18 cm). Verona Area Middle School, Verona, Wisconsin.

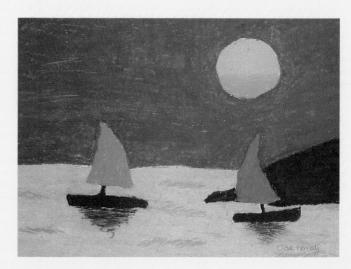

Page 33 Clare Kennedy, Sunset Sailing, 1999. Oil pastels, 9" x 12" (23 x 30 cm). Avery Coonley School, Downers Grove, Illinois.

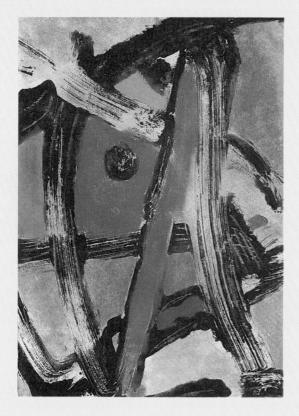

Page 274 **Dustin Bennett**, *Untitled*, **1997**. Ink, pastel, 17" x 23" (43 x 58 cm). Sweetwater Middle School, Sweetwater, Texas.

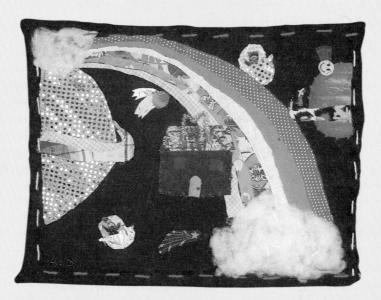

Page 283 Nick Hampton, Rebakah Mitchell, Alexander Moyers Marcon, Earthquake, 1999. Tempera, 33" \times 52" (84 \times 132 cm). Mount Nittany Middle School, State College, Pennsylvania.

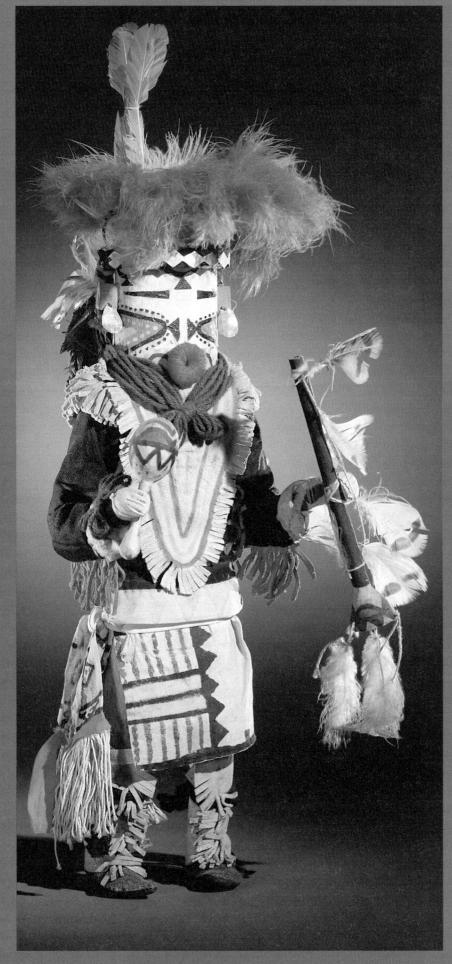

Page 4

Foundations

What Is Art?

If you ask three friends what art is, they probably won't give the same answer. Throughout history, art has meant different things to different people. And that remains true today.

Many art museums display beautiful objects from different cultures. Even though we call these objects works of art, the people who made them may not have thought of them as art. In fact, some cultures have no word for art. Yet they take great care in making beautiful pottery, jewelry, and masks.

Whether or not it is intended as art, an object made by a person shows that individual's creativity and skill. The artist, designer, or craftsperson must have thought about why he or she was making the object. Something he or she saw or imagined must have provided inspiration. Once the object is made, other people may see it as a work of art, or they may not. How they see and appreciate the object depends on their sensitivity and their own ideas about what art is.

Look carefully at some of the objects pictured in this book. Write down the names of the ones that interest you, including their page numbers. Which objects do you consider works of art? Why? Why do you feel that other objects are not art? Write down your answers. When you are finished with Part 1 of this book, look at the objects again. How have your opinions changed?

The Whys and Hows of Art

Focus

- Why do people all over the world create works of art?
- How do artists make their work unique?

Do you remember the first time you painted a picture?

You might have painted an animal or a scene from nature. Or perhaps you just painted swirling lines and shapes because you liked the way the colors looked together. No matter what the subject of the painting, there are many questions we can ask about how your first painting came to be. For example, what made you want to create it? How did you use paint to express your ideas? Why did you decide to paint the picture instead of draw it with crayons or a pencil? How was your painting similar to others you had seen?

These are questions we can ask about any work of art, whether it be your creation or someone else's. When artists work, they might not always think about these questions, but the answers

are there. And while the answers might differ from one artist to the next, the whys and hows of art can lead us to a world of wonder.

What's Ahead

- F1.1 The Functions of Art Learn about the many roles that art plays in peoples' lives.
- F1.2 Subjects and Themes for Artworks Recognize that objects, ideas, and feelings inspire people to create art.
- F1.3 Styles of Art Understand why there can be similarities among certain artworks, even though every work of art is different.

Words to Know

subject theme style

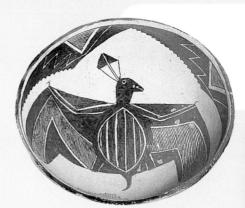

Fig. F1–1 The inside of this bowl shows a bat with outstretched wings. In Pueblo and Mesoamerican cultures, bats can suggest death and the underworld. What might a bowl like this be used for? Mimbres people, New Mexico. *Bowl*, 1200–1300 AD.

Earthenware, pigment, height: 4" (10.2 cm), diameter: 9" (22.9 cm). Purchase 113:1944. St. Louis Art Museum.

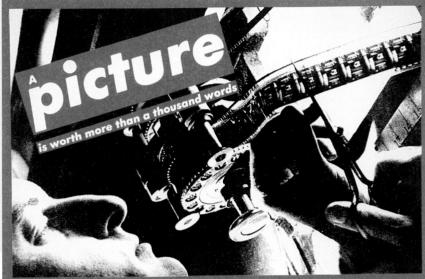

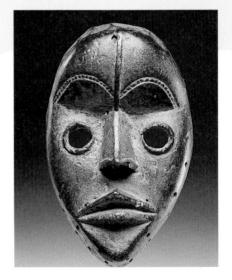

Fig. F1–2 Barbara Kruger's art combines photographs and words. Through her artworks, she often expresses her opinions about the ideas and issues that a culture cares about. Barbara Kruger, Untitled (A Picture Is Worth More than a Thousand Words), 1992. Photographic silkscreen and vinyl, 82" x 123" (208 x 312.4 cm). Collection of New Line Cinema, New York. Courtesy Mary Boone Gallery, New York.

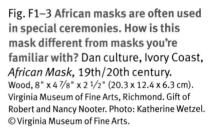

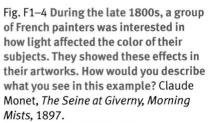

Oil on canvas, 35" x 36" (89 x 91.4 cm). North Carolina Museum of Art, Raleigh, Purchased with funds from Sarah Graham Kenan Foundation and the North Carolina Art Society (Robert F. Phifer Bequest).

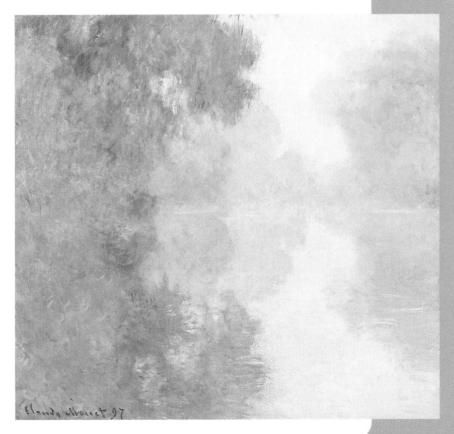

The Functions of Art

Although people create art for many reasons, most artworks belong to one of three broad categories: practical, cultural, or personal. These categories describe the function, or role, of an artwork.

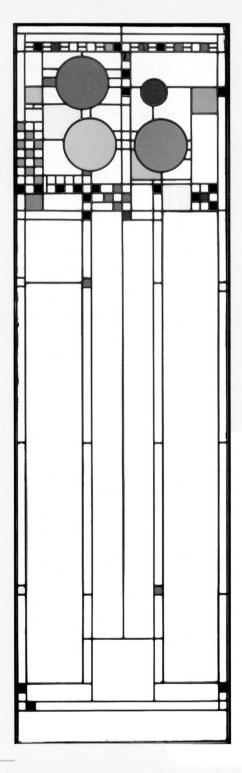

Practical Functions

Much of the world's art has been created to help people meet their daily needs. For example, architecture came from the need for shelter. People also needed clothing, furniture, tools, and containers for food. For thousands of years, artists and craftspeople carefully made these practical objects by hand. Today, almost all everyday objects that are designed by artists are mass-produced by machines.

Think about the clothes you wear and the items in your home and school. How do they compare to similar objects from earlier times or from other cultures? Which do you think are beautiful or interesting to look at? Why?

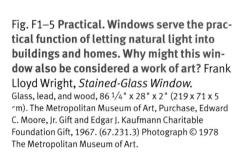

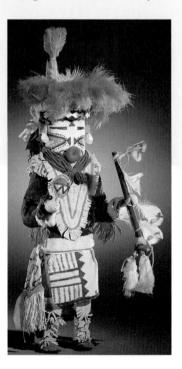

Fig. F1–6 Cultural. The Pueblo people of the American Southwest make Katsina dolls to represent important spirits. The dolls are given to young girls as a blessing and to teach them about the spirits. Zuni, New Mexico, *Katsina Doll*. Wood, pigments, wool, hide, feathers, cotton, tin, 9" x 22 ½" (23 x 57 cm). Brooklyn Museum of Art, Museum Expedition 1903, Museum Collection Fund. 03.325.4631. ©Justin Kerr.

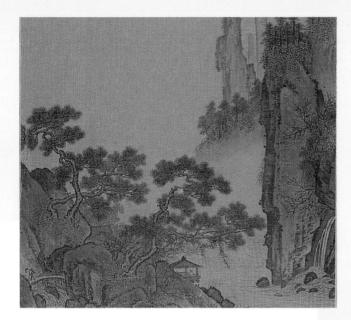

Fig. F1–7 Personal. This Chinese landscape painting is an expression of the artist's deep respect for nature. Notice how tiny the human figure appears to be in the larger natural world. Southern Sung Dynasty, China (1127–1279), Gazing at a Waterfall, late 12th century. Album leaf, ink and color on silk, 9 3/8" x 9 7/8" (23.8 x 25.2 cm). The Nelson-Atkins Museum of Art, Kansas City, Missouri (Gift of Mr. Robert H. Ellsworth). © 1999 The Nelson Gallery Foundation. All Reproduction Rights Reserved.

Cultural Functions

We can learn a lot about different cultures by studying their art. People have created architecture, paintings, sculpture, and other objects for a variety of reasons. Some buildings and artworks were made to honor leaders and heroes. Other works help teach religious and cultural beliefs. Sometimes art commemorates important historical events or identifies an important person or group.

Many artists continue to create artworks for cultural reasons. What examples can you think of in your community or state that serve a social, political, religious, or historical purpose? How are these examples of art different from artworks that have a practical function?

most difficult part was to make the coils the same thickness." Tyler Goff, Clay Coil Pot with Line Design, 1999. Clay, glazes, 7" (18 cm). Verona Area Middle School, Verona, Wisconsin.

Fig. F1-8 "The

Personal Functions

An artist often creates a work of art to express his or her thoughts and feelings. The materials an artist chooses and the way he or she makes the artwork reflect the artist's personal style. The work might communicate an idea or an opinion that the artist has about the subject matter. Or it might simply record something that the artist finds particularly beautiful. Such personal works are created in many forms, including drawing, painting, sculpture, cartooning, and photography. What artworks do you know about that were created for personal expression or sheer beauty?

Try This

Create a drawing, painting, or sculpture that fulfills one of the three functions explained in this lesson. Describe how your artwork fits its function.

Foundation Lesson 1.1

Check Your Understanding

- **1.** Describe at least four reasons why people create art. (These reasons may be from any of the function categories.)
- **2.** Find a piece of art in this section created for a practical function, one for a cultural function, and one for a personal function. Explain how one of these works might fulfill two of these functions.

Subjects and Themes for Artworks

Artists are observers. They find subjects and themes for their work in almost everything they see and do. The **subject** of an artwork is what you see in the work. For example, the subject of a group portrait is the people shown in the portrait. Other familiar subjects for artworks include living and nonliving things, elements of a fantasy, historical events, places, and everyday activities.

You can usually recognize the subject of an artwork. Sometimes, however, an artist creates a work that shows only line, shape, color, or form. The artwork might suggest a mood or feeling, but there is no recognizable subject. This kind of artwork is called nonobjective.

Fig. F1–9 Artworks that show natural scenery, such as mountains, trees, and rivers, are called *landscapes*. Those that show buildings, streets, and bridges are called *cityscapes*. Would you call this image a landscape or a cityscape? Why? Vincent van Gogh, *Starry Night*, 1889.

Oil on canvas, 29" x 36 ½" (73.7 x 92.1 cm). The Museum of Modern Art, New York. Acquired through the Lillie P. Bliss Bequest. Photograph ©2000 The Museum of Modern Art, New York.

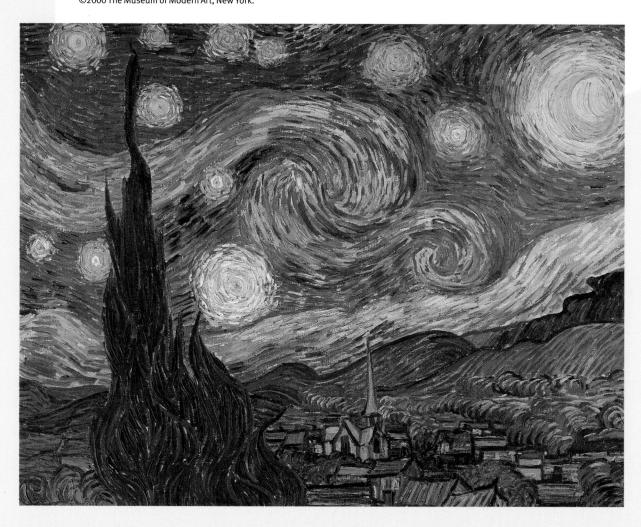

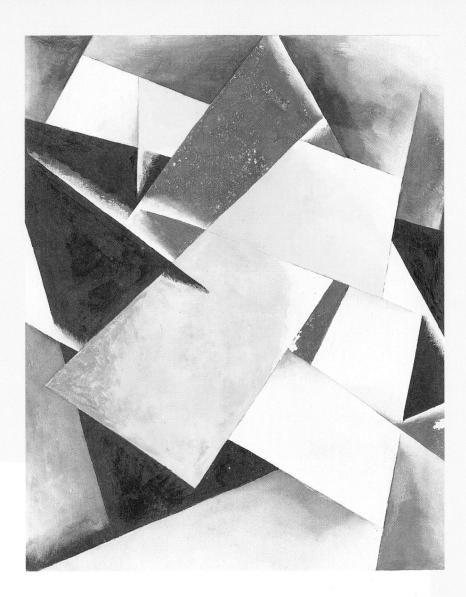

Fig. F1–10 As you can see, this painting shows only shapes and colors. How does this painting make you feel? Why? Liubov Popova. *Painterly Architectonics*, 1918. Gonache and watercolor with touches of varnish, 11 9/16" x 9 1/4" (29.3 x 23.5 cm). Yale University Art Gallery, Gift from the Estate of Katherine S. Dreier.

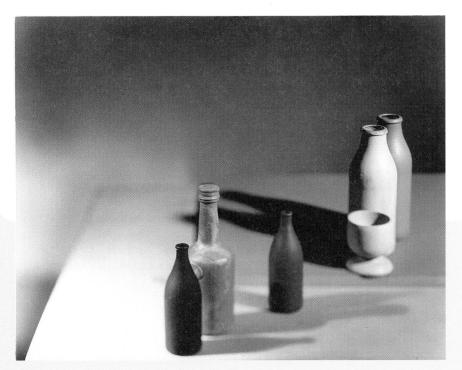

Fig. F1-11 A still life is an arrangement of objects, such as flowers, fruit, or tableware, that are not alive or cannot move.

Still-life arrangements are popular subjects in art. How is the still life you see here different from the one by Chardin on page 184?

Jan Groover, Untitled, 1987.

Print, 30" x 40" (76 x 101.6 cm). Janet Borden, Inc.

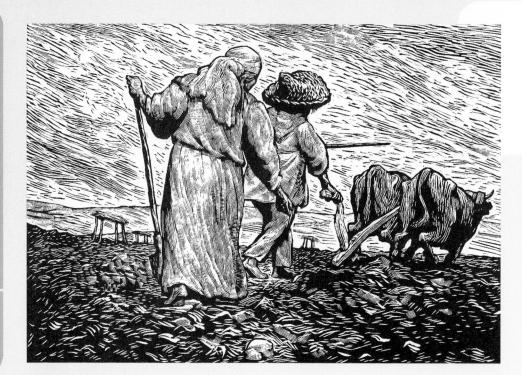

Fig. F1–12 What activity is taking place in this scene? What theme does it suggest? Leopoldo Méndez, Arando, c. 1943.
Linoleum cut. Collection of McNay Art Museum, Museum purchase from the Margaret Pace Fund.

The **theme** of an artwork is the topic or idea that the artist expresses through his or her subject. For example, the theme of the group portrait might be family togetherness or community support. Themes in art can be related to work, play, religion, nature, or just life in general. They can also be based on feelings, such as sadness, love, anger, and peace.

Artworks all over the world can reflect the same theme, but will still look entirely different. Why? Because the subjects used to express the theme probably won't be the same. For example, imagine that an artist in Australia and an artist in Canada each create a painting about natural beauty. Would the Canadian artist show a kangaroo? Probably not.

Look at the artworks in this lesson. What subjects do you see? What themes are suggested?

Try This

Look around you. What do you think would make a good subject for an artwork? An object? An animal? A particular view of your schoolyard? What kinds of themes come to mind that are related to the subject? Choose a subject and theme and create a drawing.

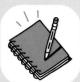

Sketchbook Connection

Choose a small object that interests you. Spend some time looking at it carefully. Turn it over in your hands and

observe how it feels to the touch. Notice the object's shape, color, and detail. When you are familiar with the object, sketch it from at least three different angles. How are the three sketches different from one another?

Foundation Lesson 1.2

Check Your Understanding

- 1. Look through other chapters of this book. Select an artwork that interests you and write about it. Describe the image. What subject is depicted? What seems to be the theme of the artwork? Why do you think so?
- **2.** What is a landscape? Identify a landscape in this book.

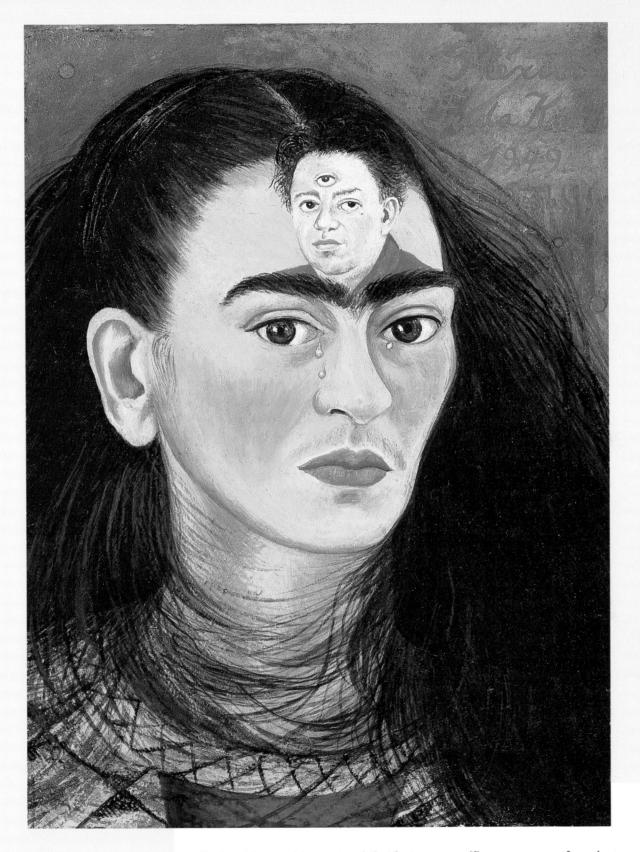

Fig. F1–13 A portrait is an artwork that features a specific person, group of people, or animal. This artist has created a portrait of her husband within a self-portrait—a portrait of herself. What feeling does this image suggest? Frida Kahlo, Diego y yo, 1949. Oil on masonite, $11\,^5/8$ " x $8\,^{13}/16$ " (30 x 22 cm). Courtesy Mary Ann Martin/Fine Art, New York.

Styles of Art

A **style** is a similarity you can see in a group of artworks. The artworks might represent the style of one artist or an entire culture. Or they may reflect a style that was popular during a particular period in history.

You can recognize an artist's *individual* style in the way he or she uses art materials, such as paint or clay. An artist can adopt certain elements of design and expression that create a similar look in a group of his or her works. Sometimes an artist uses the same kind of subject matter again and again.

Artworks that reflect *cultural* and *historical* styles have features that come from a certain place or time. For example, Japanese

painters often depict scenes from nature with simple brushstrokes. From an historical perspective, the columns used in ancient Greek architecture have characteristics that are immediately recognizable. As explained in the following sections, there are also four *general* style categories that art experts use to describe artworks from very different times and cultures.

Expressionism

In an expressionist artwork, the mood or feeling the artist evokes in the viewer is more important than creating an accurate picture of a subject. The artist might use unexpected colors, bold lines, and unusual shapes to create the image. Expressionist artists sometimes leave out important details or exaggerate them. When you look at an expressionist work of art, you get a definite feeling about its subject or theme.

Fig. F1–14 In this expressionist portrait, the artist captured the musician's performance, instead of a true likeness of the man. What features of expressionist art do you see here? Eugène Delacroix, *Paganini*, 1831.
Oil on cardboard on wood panel, 17 5/8" x 11 7/8" (44.8 x 30 cm). The Phillips Collection, Washington, DC.

Realism

Some artists want to show real life in fresh and memorable ways. They choose their subjects from everyday objects, people, places, and events. Then they choose details and colors that make the subjects look real.

Sometimes a particular mood is suggested in the artwork. Artists who work in this style often make ordinary things appear extraordinary. Some of their paintings and drawings look like photographs.

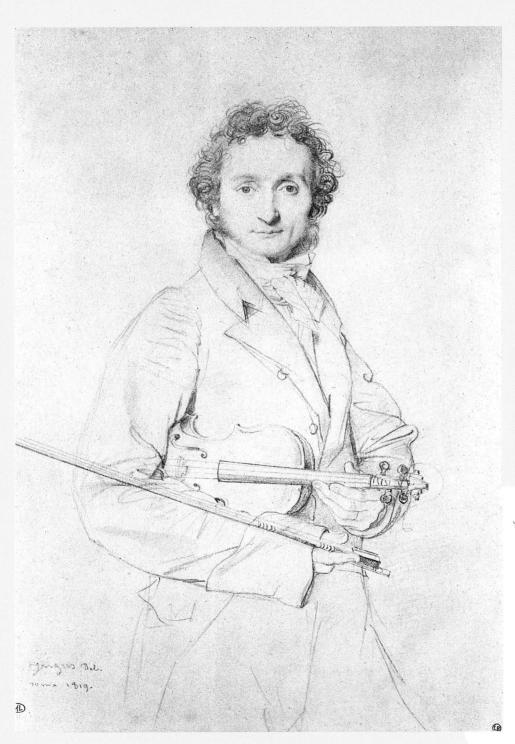

Fig. F1-15 This artist shows us a realistic likeness of the violinist Paganini. Notice how the face, hands, and instrument are drawn in detail, while the clothing appears to be sketched. Why might the artist have drawn the portrait this way? Jean-Auguste-Dominique Ingres, Paganini, 1819. Black chalk drawing, 12" x 8 1/2" (30.5 x 21.6 cm). Louvre, Paris. Giraudon/Art Resource, NY.

Abstraction

Artists who work in an abstract style arrange colors, lines, and shapes in fascinating ways. They find new ways to show common objects or ideas. Their artworks appeal to the mind and senses. For example, most

people see and feel flowing curved lines as graceful. Jagged lines remind people of sharp objects or sudden, unexpected events, such as lightning. Nonobjective artworks usually fall into this style category.

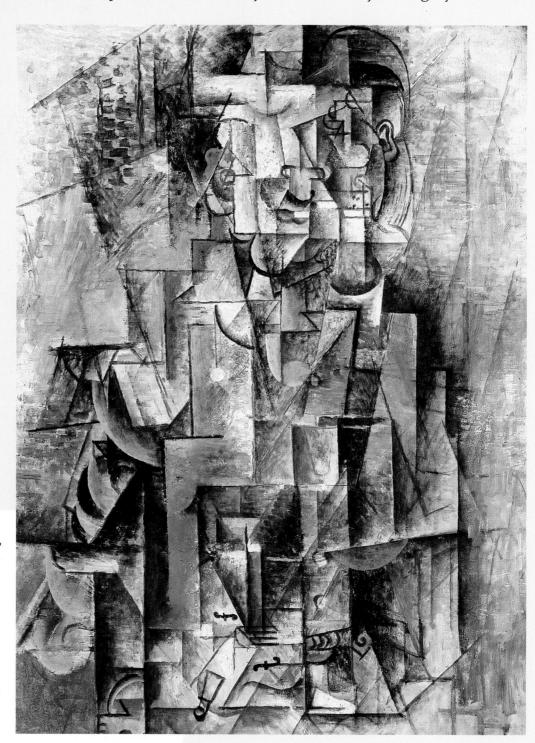

Fig. F1–16 In this painting, Pablo Picasso shows his subject from many different angles at once. His use of lines and angles creates an abstract kaleidoscope effect. Pablo Picasso, Man with Violin, 1911–12.

Oil on canvas, 39 3/8" x 29 7/8" (100 x 76 cm). Philadelphia Museum of Art: Louise and Walter Arensberg Collection. © 2000 Estate of Pablo Picasso/Artists Rights Society (ARS), New York.

Fantasy

The images you see in fantasy art often look like they came from a dream. When fantasy artists put subjects and scenes together, they create images that appear unreal. While the subject might be familiar, the details in the artwork might not seem to make sense. You won't find scenes from real life in fantasy artworks!

Try This

Choose the style category that interests you the most. Make a color drawing of your shoe in that style. Include details that suggest where the shoe is. Be as imaginative as you can. Compare your finished drawing to those by other members of your class. Discuss the differences you see in personal and general styles.

Foundation Lesson 1.3

Check Your Understanding

- **1.** What is the difference between abstract art and expressionist art?
- **2.** Choose an image from this lesson. How might it look different if it were recreated in one of the other styles?

Computer Option

In a painting program, draw a shoe or a hat. Keep your drawing simple. Save the file. Now create three different versions,

in these three styles: Expressionist, Realist, and Fantasy. Add colors, backgrounds, and details to each version to achieve the desired styles. Without discussing your work with your classmates, print out your finished work. Have classmates take turns identifying the styles of your work.

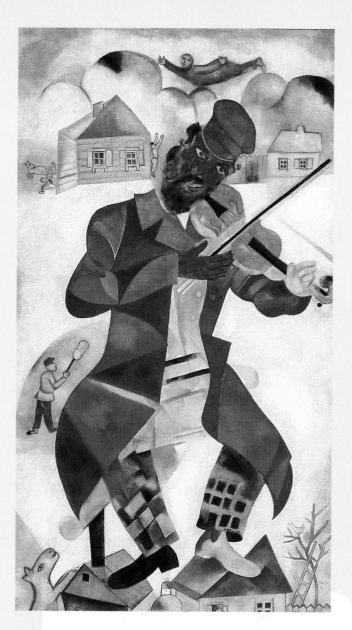

Fig. F1–17 What details of this painting are things you might see in real life? What features make the scene look unreal? Marc Chagall, *The Green Violinist*, 1923–24.

Oil on canvas, 78" x 42 3 /4" (198 x 108.6 cm). Solomon R. Guggenheim Museum, New York. Gift, Solomon R. Guggenheim, 1937. Photograph by David Heald ©The Solomon R. Guggenheim Foundation, New York. (FN 37.446). © 2000 Artists Rights Society (ARS), New York.

Connect to...

Careers

When you question ideas about art in thoughtful and deliberate ways, you are thinking like a philosopher. Philosophers since the time of the ancient Greeks have discussed the nature of art, sharing an age-old search for understanding. The philosophy of art is known as aesthetics, a word that, in the 1700s, came to mean "the science of the beautiful."

Historically, aestheticians have had quite rigid ideas about what artists should create and what people should like. Present-day aestheticians—most of whom teach college-level philosophy—are concerned with the way we think about art, especially art's "big" questions.

F1-18 "I challenge people to think about what makes something a work of art, by showing them this cake pan. Is it a work of art when it sits in my cupboard at home? Suppose you came across it in a museum and saw that it was titled Women's Destiny. Would you think it was a work of art in this context?" - Marcia Muelder Eaton, professor of philosophy, University of Minnesota

Other Arts

Theater

Like art, theater is part of our lives. At a very basic level, we have theater when one person communicates an idea physically and/or verbally to another person. So, theater can be the telling of a story to a friend or the playing of charades at a party.

Would a two-way conversation be theater? Why or why not? If a third person listened to the conversation, would this be theater? Why or why not?

Write a list of everyday theatrical events that you participated in last week—as actor or audience. Circle the three most dramatic events. What characteristics do these three events share?

F1-19 In this photograph, we see a teacher working with her class. Could the act of teaching be considered theater? Why or why not? Photo courtesy of Kathy Burke, Lusher Alternative Elementary, New Orleans, Louisiana.

Other Subjects

Social Studies

Look through your social studies or history textbook, and count the number of artworks in it. Surprised? The **works of art** you found most likely were created to **serve a cultural**

function—perhaps to commemorate an event or to provide a portrait of an important person. Why do you think these images are important to us? We have learned much of what we know of past cultures and peoples from their art. Do you think that will still be the case when the people of the future look back at us?

Science

Artists have long used subjects and themes from the life sciences in their work. In land-scapes, they might portray the violent forces of nature, or show scenes of breathtaking natural beauty. They might depict animals in real or imagined settings; they might paint still lifes of flowers and fruits. Some artists' works depict life cycles and ecosystems, and might even serve as warnings of damage to the environment.

F1–20 Can you imagine finding this photograph in your social studies textbook? Why or why not? What purpose might this artwork serve? Diego Rivera, *Tropical Resources*, 1923–28.

Education Ministry, Court of Labor, Mexico City. Courtesy of Davis Art Slides.

The generally accepted domains, or areas, of science are life science, physical science, and earth and space science. Can you identify an artwork for each domain?

Daily Life

You encounter the work of artists and designers daily, probably more than you realize. Start with this morning—with the clothes you put on, the words and pictures on your cereal box, and the TV you may have watched while you were eating. If you came to school in a vehicle, it was designed and promoted through the efforts of transportation, graphic, and computer designers. On your way, you may have passed public artworks made by sculptors or muralists. Even your school was designed by an architect, and a landscape designer may have planned its grounds.

These examples of purposeful design serve different functions, but each was skillfully developed. What are some more examples of the role that art plays in your life?

Internet Connection

For more activities related to this chapter, go to the

Davis website at www.davis-art.com.

Portfolio

F1-21 Priyanka Patel, *Storm Night at Sea*, 1998. Oil pastel, 9" x 12" (23 x 30 cm). Avery Coonley School, Downers Grove, Illinois.

F1–22 Brad Baxley, *Fountain Boys*, 1999. Pencil, 12" x 18" (30 x 46 cm). Johnakin Middle School, Marion, South Carolina.

"We got the idea for these buildings from foods we know. The cheese is a mall, the french fries building is a restaurant. A tube connects them together and cars can go through the tubes." Kristine Chan / Lindsay Weisberg

F1–23 Kristine Chan and Lindsay Weisberg, *Future City*, 1999.

Watercolor, 11" x 30" (30 x 76 cm). Plymouth Middle School, Plymouth, Minnesota.

CD-ROM Connection

To see more student art, check out the Global Pursuit Student Gallery.

The Hows and Whys of Art

Foundation 1 Review

Recall

List three functions and at least three different styles of art.

Understand

Explain the possible functions of a stained-glass window. (example at right)

Apply

Design a work that has artistic qualities and a practical function. Consider what style and theme you will use and how these will relate to the piece's function. Write an explanatory label describing why your work is art and also a functional object.

Page 4

Analyze

Examine pictures of musicians on pages 10–13. Compare and contrast them in terms of style, theme, and function.

Synthesize

Write two poems, one based on a realistic artwork and the other based on an artwork that is very abstract. How will your words and images correspond to the visual compositions and communicate something about their style?

Evaluate

Imagine being an art critic for your local newspaper, and write a review of an exhibition consisting of Figs. F1–1, F1–2, and F1–3. Create arguments to convince readers that these objects are artworks, making sure to address their function as well as style.

Keeping a Sketchbook

Your sketchbook is a place for you to develop ideas for projects, collect images that interest you, and write your

thoughts about art and your experiences. Think of your sketchbook as a place to plan the artworks that you may later put into your portfolio.

Keeping a Portfolio

A portfolio is a record of your growth in art. What you put into your portfolio can be such things as your completed art-

works; statements of what you think about art; and reports and research papers about artists, art styles, and art of a certain time or culture. You might even include a regular review of your progress in art.

For Your Portfolio

For your portfolio, set aside a page on which you will make an entry when you complete each chapter. In the entry,

you may tell how you think your ideas about art are progressing. You may also write a few sentences that compare what you once thought about a certain area of art and what you think now.

Forms and Media Focus

When you tell someone that you just created a painting or a sculpture, you are naming the

• What are the differences between two-dimensional art forms and three-dimensional art forms?

 What materials do artists use to create two-dimensional and threedimensional artworks?

art form you used to express yourself. Art forms can be two-dimensional, as in painting, drawing, printmaking, and collage. Or they can be three-dimensional, as in sculpture, architecture, and even furniture.

When artists plan a work of art, they decide which art form will best express their idea. Then they work in that art form. For example, an artist who wants to express an opinion about nature might create a painting or a drawing. An artist who wants to honor an important person might create a sculpture.

The differences you see between artworks of any one form are vast. This is because artists use a wide variety of materials, or **art media**, to create their artworks. For example, a painter might choose to use oil paints or watercolor. He or she might paint on paper, canvas, or even glass. Similarly, a sculptor might work with clay, stone, or any object that best expresses his or her idea. Imagine seeing a sculpture made from a beach umbrella or a car!

The lessons in this chapter explore art forms and the media most commonly used by artists.

What's Ahead

- **F2.1 Two-dimensional Artworks**Explore a variety of two-dimensional art forms and the media artists use to create them.
- **F2.2 Three-dimensional Artworks**Explore a variety of three-dimensional art forms and the media artists use to create them.

Words to Know

art form mobile
art media relief sculpture
fresco ceramics
montage mosaic

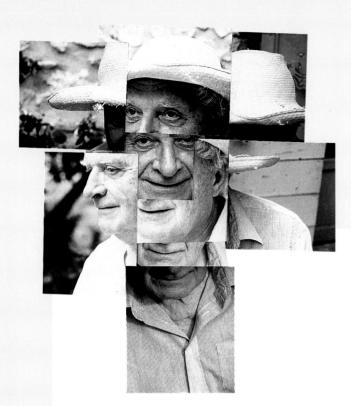

Fig. F2-1 This artist has combined "instant" photographs into a collage. What idea might he be trying to express about the man in the image? David Hockney, Stephen Spender, Mas St. Jerome II, 1985.

Photographic collage, 20 $^1\!/_2$ " x 19 $^3\!/_4$ " (52 x 50 cm). © David Hockney.

Fig. F2–2 Basket weaving is a popular art form in Native-American cultures. Baskets are made from grass, cornhusks, reeds, strands of willow, and other natural materials. Their decorative designs and symbols often have special meaning. Native-American baskets are used as ceremonial objects, hats, cooking and storage vessels, and carrying vessels. Filepe Yepa, *Unfinished Basket*. Coiled plant fibers, dyes, height: 1 ½" (3.8 cm), diameter: 5" (12.7 cm). Brooklyn Museum of Art, Museum Expedition 1907, Museum Collection Fund. 07.467.8229. ©Justin Kerr.

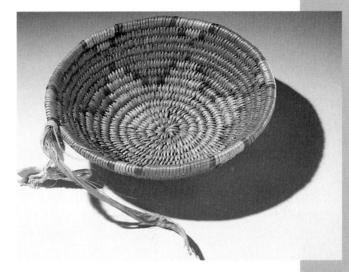

Fig. F2–3 In this artwork, a student expressed her appreciation of "the life we use every day." If you made a drawing like this, how would it look different? Why? April J. Brown, Fruit and Veggie Delight, 1999. Pastel chalk, colored construction paper, 16" x 20" (40.5 x 51 cm). Johnakin Middle School, Marion, South Carolina.

Two-dimensional Artworks

Drawing, painting, and other two-dimensional (2-D) art forms have height and width but no depth. To create 2-D artworks, such as those you see in this lesson, artists work with different types of art media.

Drawing and Painting

The most common media for drawing are pencil, pen and ink, crayon, charcoal, chalk, pastel, and computer software programs. Artists who draw choose from a wide range of papers on which to create their images. Although many artists use drawing media to plan other artworks, drawings can also be finished works of art.

Fig. F2-4 Frescoes are painted directly on a wet plaster wall. Why might some people choose this method of wall decoration over framed paintings? Why might other people prefer framed paintings on their walls? Pre-Columbian, Tulum (Maya) Mexico, *Temple of Frescoes*, interior, after 1450.

Courtesy of Davis Art Slides.

Oils, tempera, watercolor, and acrylics are common media used to create paintings. An artist might apply paint to a variety of surfaces, including paper, cardboard, wood, canvas, tile, and plaster. A **fresco**, for example, is a tempera painting applied onto a wet plaster surface.

Collage

To create a collage, an artist pastes flat materials, such as pieces of fabric and paper, onto a background. Some artists combine collage with drawing and painting. Others use unexpected materials, such as cellophane, foil, or bread wrappers. Look back at Fig. F2–1, the collage created by David Hockney, on page 19. A collage made from photographs is called a **montage**. How does Hockney's montage compare with the montage in Fig. F2–5?

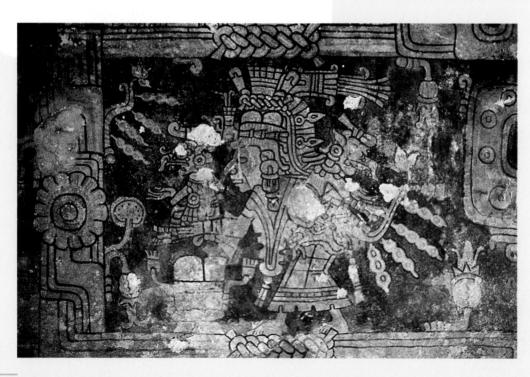

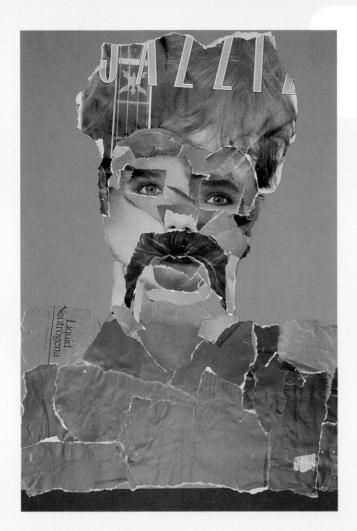

Printmaking

This form of art can be broken down into several different kinds of processes. The main idea is the same for all: transferring an inked design from one surface to another. The design itself might be carved into wood or cut out of paper before it is inked. Then it is pressed by hand onto paper, fabric, or some other surface.

The most common printmaking processes are gadget, stencil, relief, and monoprint. Other more complex processes include lithography, etching, and silkscreen. An artist can print a single image many times using any printmaking process, except monoprinting; as the "mono" in its name suggests, an image can only be printed once.

Fig. F2–5 Through thoughtful choice of imagery and color, this young artist created an expressive, though imaginary, portrait. Travis Driggers, *Torn*, 1997. Montage, 17" x 12" (43 x 30 cm). Johnakin Middle School, Marion, South Carolina.

Try This

Many contemporary artists combine materials from two art forms to create mixed-media artworks. Choose two forms of 2-D art to combine in your own mixed-media work. Some possibilities are mixing pen and ink with watercolor, computer art with collage, and photography with drawing or painting. Experiment with a few combinations to find one that works for you.

Computer Option

Create a simple scene and, separately, a character (person or animal) in a painting program. Draw the scene using

just one tool, such as the paintbrush. Save the file. Draw the character using a different tool, perhaps the pencil or the pen. Save the file. Import the scene and character into an animation program. How might your character move—will it run or fly? Will you add sound? When you are satisfied with your animated artwork, consider how it might change if you created the scene and the character using different tools.

Sketchbook Connection

Landscape artists often sketch scenes outdoors before they create paintings or drawings of them. Find a scene that you

like and make a sketch of it in color. Which elements of the scene appeal to you most? Include as many or as few of the elements as you like. Take your sketch home or to class and make a finished painting or drawing from it.

Graphic Design

Graphic designers create original designs, but unlike printmakers, they do not print their designs by hand. They combine type and pictures to create posters, signs, corporate logos or symbols, advertisements, magazines, and books. Most graphic designs are mass-produced on high-speed printing presses. Look around you. What examples of graphic design can you find in your classroom?

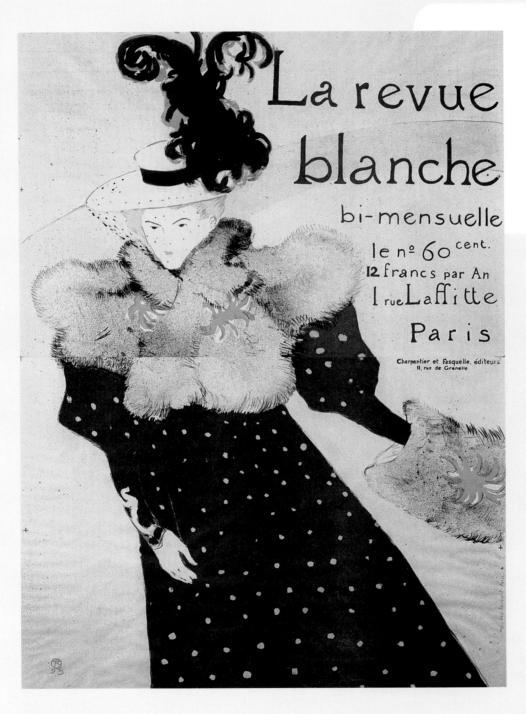

Fig. F2–6 This artist often portrayed dancers, circus people, and the nightlife of Paris. Notice how he has combined type and image in this artwork. Why might it be useful to combine type and image on a poster or in an advertisement? Henri de Toulouse-Lautrec, *La Revue Blanche Poster*, 1895.

Collection of the McNay Art Museum, Mary and Sylvan Lang Collection.

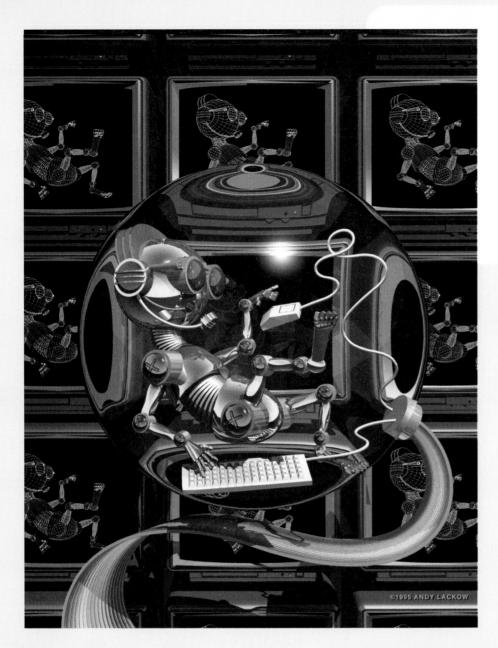

Fig. F2–7 Today, computers offer artists the same kinds of "tools" and "materials" that traditional artists have, only in electronic form. In addition to painting and drawing, software programs allow artists to blend and manipulate images. They also create special effects, and do many other things that traditional artists would find difficult or impossible. Andy Lackow, *Birth of a New Technology*, 1995.

Digital art, 3D modeling and rendering, 5" x 7" (12.7 x 17.5 cm). Courtesy of the artist.

Photography, Film, and Computer Art

These 2-D art forms are fairly new in the history of art. The camera was invented in the 1830s, followed by moving pictures about sixty years later. Since their invention, photography and film have become two of the most popular media. Today, video cameras and computers offer even more media for artists working in the film or TV industry.

Although individuals may use a single camera or computer to create art, feature films and television shows are usually created by a team of artists.

Foundation Lesson 2.1

Check Your Understanding

- **1.** What is the difference between art forms and media? What is one art form that you have worked with? What media did you use when you worked in this form?
- **2.** In your own words, describe the difference between printmaking and graphic design. Name an example of a graphic design.

Three-dimensional Artworks

Architecture, sculpture, and other three-dimensional (3-D) art forms have height, width, and depth. To create 3-D artworks, such as those you see in this lesson, artists work with different types of art media.

Architecture and Environmental Design

Architects design the buildings in which we live, work, and play. They think about what a building will be used for, how it will look, and the way it will relate to its surroundings.

Architects combine materials such as wood, steel, stone, glass, brick, and concrete to create the buildings they design. Then interior designers plan how spaces inside the buildings will look. They choose paint colors or wallpaper, carpeting, and upholstery fabrics. They also suggest how the furniture should be arranged.

Environmental and landscape designers plan parks, landscape streets, and design other outdoor spaces. They use trees, shrubs, flowers, grasses, lighting fixtures, and benches. They also use materials such as stone, brick, and concrete to create paths, sidewalks, and patios.

Fig. F2-8 Natural daylight provides the best light for viewing fine art. When an architect designs a museum, he or she often creates sources of natural light, such as windows and skylights. You might not know by looking at this view of the East Building that the museum is flooded with natural light. What other things might museum architects have to think about?

I. M. Pei. East Building of the National Gallery of Art, 1978.

Exterior view, Washington, DC. Photograph © Board of Trustees, National Gallery of Art, Washington, DC. Photo by Dennis Brack.

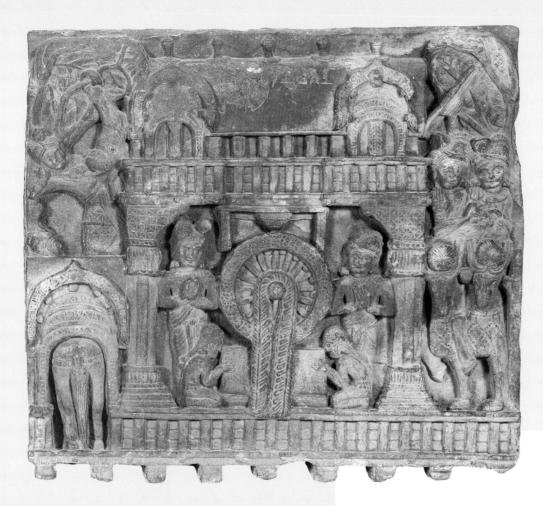

Fig. F2–9 Relief sculptures often show scenes. How might this sculpture look different if it were created to be seen from all sides? India, *King Prasenajit Visits the Buddha*. Detail of a relief from the Bharhut Stupa, early second century BC. Hard reddish sandstone, 19" x 20 3 /₄" x 3 1 /₂" (48 x 52.7 x 9 cm). Courtesy of the Freer Gallery of Art, Smithsonian Institution, Washington, DC.

Sculpture

Sculptures come in many forms. Most are designed to be viewed from all sides. You are probably most familiar with statues. A statue is a sculpture that stands alone, sometimes on a base. It can be life-size, as are the monuments you see in some parks. Or it can be small enough to place on a table or mantelpiece. A **mobile** is a hanging sculpture that has moving parts. The design on a **relief sculpture** is raised from a background surface and is intended to be viewed from only one side.

In addition to having many forms of sculpture to choose from, a sculptor can select from a great variety of media.

Traditional materials include wood, clay, various metals, and stone such as marble.

Sculptors also work with glass, plastic, wire, and even found objects.

Crafts

The term *crafts* applies to artworks made by hand that are both practical and beautiful. Among the many crafts are ceramics, fiber arts, mosaics, and jewelry making. **Ceramics** are objects that have been made from clay and then fired in a kiln. Fiber arts include objects that have been woven, stitched, or knotted from materials such as

wool, silk, cotton, and nylon. A mosaic is a design made of tiny pieces of colored glass, stone, or other materials. Artists who make crafts such as jewelry and other personal adornments might use gold, silver, wood, fabric, leather, and beads. Look at the clothing and jewelry your classmates are wearing. What materials are they made of?

Earthenware, grey-green celadon glaze with melt fissures and fire marks, $3\frac{5}{16}$ " x $7\frac{7}{16}$ " (8.28 x 8.9 cm). American Craft Museum, New York. Gift of Ann and Paul Sperry, 1991. Photo by Eva Heyd.

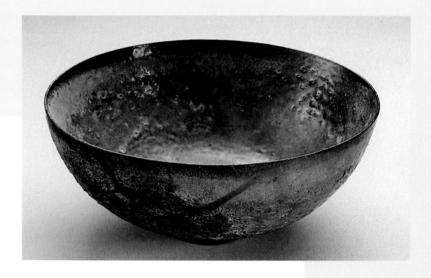

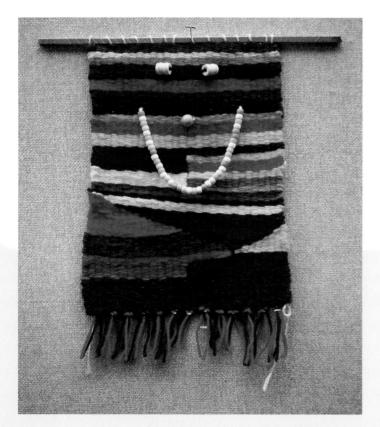

Fig. F2-11 Weaving is a popular craft in many cultures. The designs you see in some blankets, clothing, and wall hangings have special meaning. The designs you see in others are purely decorative. Would you consider this wall hanging meaningful or decorative? Why? Sabrina Cogburn, Untitled, 1999. Yarn, 11" x 13" (28 x 33 cm). Asheville Middle School, Asheville, North Carolina.

Industrial Design

Artists who design three-dimensional products for mass production are called industrial or product designers. They design everything from spoons and chairs to bicycles and cruise ships. Industrial designers pay great attention to a product's function and appear-

ance. They use materials such as metal, plastic, rubber, fabric, glass, wood, and ceramics. The next time you're in a grocery or department store, note the many examples of industrial design all around you.

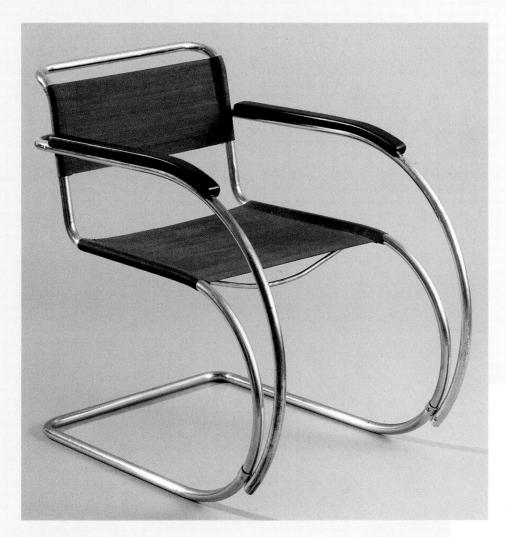

Fig. F2–12 How is this chair different from a chair you would find in a living room or in your school? Ludwig Mies van der Rohe, *Armchair*, designed 1927. Nickel-plated tubular steel, horsehair, ebonized wood, 30 ½" (77.4 cm) high. Purchase: Museum Shop Funds 53: 1987. St. Louis Art Museum.

Try This

Think of an interesting example of architecture, sculpture, and industrial design that you have seen. Describe each work. What makes each one interesting to look at? How does each one compare to the other works? Share your choices with the class.

Foundation Lesson 2.2

Check Your Understanding

- **1.** Explain why the East Building of the National Art Gallery is considered to be a three-dimensional art form.
- **2.** If someone asked you to create a craft of some sort, what would you make? What media would you use? Why?

Connect to...

Careers

When asked to name a type of art form, people often select an oil painting. Although **painters of recent centuries** worked primarily with oils on canvas or board, **painters today** might use acrylic paints, automobile paints, or any other pigments that will adhere to a surface.

Some painters begin their career upon completion of their

formal education. Many painters teach at the college level, and often paint and exhibit artworks in addition to their teaching duties. Others become graphic artists or work at non-art-related jobs while continuing to paint independently. Not all painters seek professional training: some are self-taught.

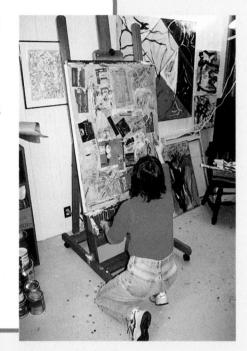

F2-13 Julia May Starr prepares a canvas in her Houston, Texas, studio. Starr soaks paper, cardboard, and other material in water and then uses acrylic gel medium to apply the items to the gessoed canvas. The collaged surface of the canvas, when dry, is ready to be painted with acrylic paint. Even covered with paint, the shapes are visible.

Photo by G. Young.

Other Arts

1 Park and the second of the s

Theater

Scene designers and scenic artists work in both two- and three-dimensional media as they create the set design for a theatrical performance. Examples of two-dimensional scene design are representational paintings, such as a backdrop that depicts a park; painted designs on wall flats to indicate wallpaper; and *trompe l'oeil*, the art of painting 3-D, photographic details, such as windows or doors, on a 2-D surface.

Three-dimensional scenic elements include working windows and doors, stairways, and furniture. When you next see a play, note the difference in how actors interact with the 2-D scenic elements and with the 3-D elements.

F2–14 Which scenic elements in this photograph are two-dimensional and which are three-dimensional? How would actors interact with each type of scenery? Scott Dunlap, set design, *The House at Pooh Corner*, 1998. Photo courtesy of The Chattanooga Theatre Center, Andrew D. Harris, director.

How many **art forms** and **media** do you think you encounter in one day? Find out by writing a list on paper. First, list art forms—painting, drawing, printmaking, collage, and so on. Then list art media—oil paints, watercolor, clay, stone, metal, and so on. For an entire day,

carry the list with you, and keep a tally of the art forms and media you come upon.

Do any of the results surprise you? Did you find that writing down the art forms and media made you more aware of art than usual? Did you see anything in a new or different way?

Other Subjects

Mathematics

You might be surprised to learn that art and mathematics share some concepts but have different vocabulary for them. For example, in art, shapes that have only height and width are called two-dimensional shapes. In math, the term for these same shapes is plane figures. In art, shapes that have height, width, and depth are termed three-dimensional forms. In math, they are called space figures or space solids.

Social Studies

Paper has played an important role across cultures and over time. Paper began with the ancient Egyptians in 3000 BC. By pressing together thin stems of papyrus reeds, they developed papyrus. In 100 AD, the Chinese invented paper made from mulberry and bamboo bark. In Europe and the Mediterranean, animal-skin parchment and vellum was developed as early as 200 BC. Sheepskins or calfskins were soaked, and then stretched on a frame and scraped. Rubbing with pumice smoothed the final surface.

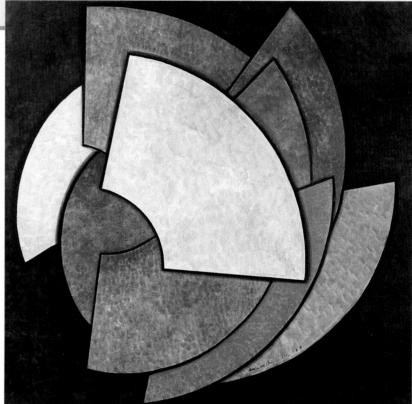

F2–15 Brazilian artist Sonia von Brusky focuses on mathematical concepts in her work. Sonia von Brusky, Fractalization of a Circle, 1997.

Tempera on canvas, 59" x 59" (150 x 150 cm). Courtesy of the artist.

Paper became popular in Europe during the thirteenth century. Though less durable than parchment, paper was cheaper and easier to make. Early paper was made from a pulp of water and rags. With a press, water was removed from the pulp and the fibers flattened.

Internet Connection

For more activities related to this chapter, go to the

Davis website at www.davis-art.com.

Portfolio

"For Space Kitty, I wanted to be creative and do a space theme. Normally you see cats doing the usual thing: sitting or playing with a ball. I did use the ball of yarn, but thought it would be neat with stars and planets and not colored polka dots." Kiera Hartnett

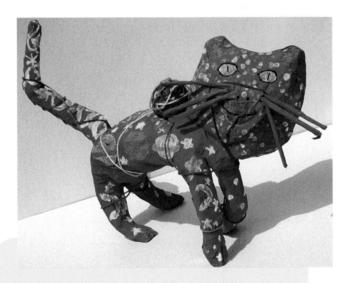

F2–17 Kiera Hartnett, Space Kitty, 1999. Papier-mâché, tempera paint, 20" x 16 $\frac{1}{2}$ " x 8" (51 x 42 x 20 cm). Copeland Middle School, Newton, New Jersey.

F2–18 Christina Marshburn, Ceramic Pin, 1999. Clay, 2" x 2" (5 x 5 cm). Colony Middle School, Palmer, Alaska.

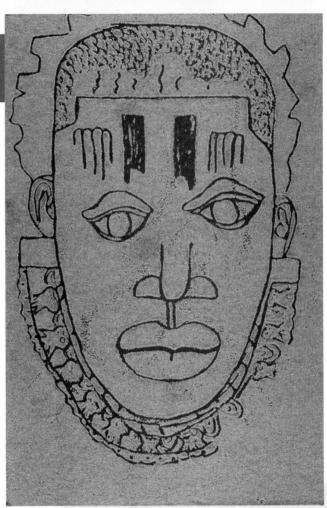

F2–16 Jenetta Tart, *Ancestor's Face*, 1997. Relief print, 9" x 6" (23 x 15 cm). Johnakin Middle School, Marion, South Carolina.

Forms and Media

Foundation 2 Review

Recall

Give three or more examples of both twodimensional and three-dimensional artworks.

Understand

List the different media that artists might use when creating three- and two-dimensional artwork

Apply

Select a reproduction of a two-dimensional artwork in this book (*example below*), and transform it into three dimensions. Consider what materials will work best as you translate a flat image into one with actual depth.

Analyze

Describe how a mosaic is both a two- and three-dimensional artwork. (See also page 122.)

Synthesize

Write explanatory labels for a two-dimensional artwork and a three-dimensional artwork, providing information about their materials and form. (You might select works from this book, from another book, or from an art display in your school.) How do the form and media work together to express the artist's intent? Interview a viewer to see if she or he understands your labels, and amend the labels if necessary.

Evaluate

Imagine shopping for a beautiful new desk for your home. In the showroom, you see a hand-carved wooden desk by a craftsperson and a sleek metal-and-leather desk by an industrial designer. Write a dialogue between you and the salesperson in which you explain your final choice of one desk over the other.

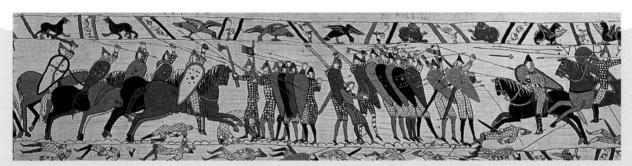

Page 124

For Your Sketchbook

Paste in your sketchbook some images of artworks made with different media. These might be from maga-

zines, printouts of web pages, or photocopies from books. For each image, write notes about features that interest you.

For Your Portfolio

Carefully select artworks for your portfolio. You may want to include work that shows how you have grown as an

artist. Or you may want to choose works that show your use of different media and techniques. With each portfolio artwork, include your name, the completion date, the purpose of the assignment, what you learned, and why you selected the work.

Elements and Principles of Design Focus

Artists use their imagination when they work. They experiment with ideas and art media, and invent new

ways to create artworks. But before they actually get down to making a work of art, they must have a plan, or design, in mind.

In art, the process of design is similar to putting a puzzle together. The basic pieces or components that an artist has to choose from are called the *elements of design*. Line, shape, form, color, value, space, and texture are the elements of design. The different ways that an artist can arrange the pieces to express his or her idea are called the *principles of design*. Balance, unity, variety, movement and rhythm, proportion, emphasis, and pattern are the principles of design. When an artist is happy with the arrangement, the design is complete.

As you learn about the elements and principles of design, think about how they can help you plan and create your own art. Soon you will see that they can also help you understand and appreciate the artworks of others.

- What are the elements and principles of design?
- How do artists use the elements and principles of design in their artworks?

What's Ahead

• F3.1 Elements of Design

Learn how artists can use the elements of design to create certain effects in their artworks.

• F3.2 Principles of Design

Learn ways that the principles of design can make an artwork exciting to look at.

Words to Know

Elements of Design Principles of Design value line balance proportion shape space unity pattern form texture variety movement color emphasis rhythm

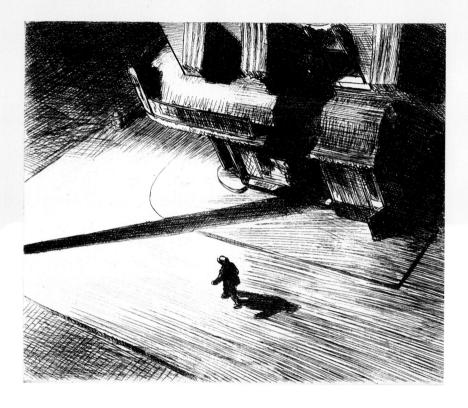

Fig. F3-1 This artist used a printmaking process called etching to create this image. Notice how the image is made from hundreds of tiny lines. How has the artist used line to create light and dark areas? Edward Hopper, Night Shadows, 1921.

Etching. Collection of the McNay Art Museum, Gift of the Friends of The McNay.

Fig. F3-2 You might find it hard to believe that this artwork is a sculpture. What elements and principles of design do you think you see here? Write down your answers. When you are finished with this chapter, see if you want to add more to the list. Jackie Winsor, *Double Bound Circle*, 1971. Hemp, 16" x 61" x 61" (40.6 x 154.9 x 154.9 cm). High Museum of Art, Atlanta, Georgia; Purchased with funds from the National Endowment for the Arts and the Members Guild, 1980.95.

Fig. F3–3 Artists can create a striking image with few colors. What makes this picture so exciting? Why do you think so? Clare Kennedy, *Sunset Sailing*, 1999. Oil pastels, 9" x 12" (23 x 30 cm). Avery Coonley School, Downers Grove, Illinois.

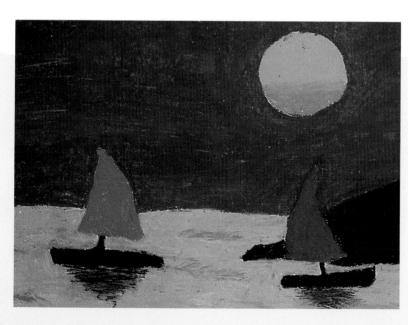

The Elements of Design

Line

Many people think of a **line** as the shortest distance between two points. To artists, a line is a mark that has length and direction. Lines can have many different qualities that help artists express their ideas. They can be thick or thin, wavy, straight, curly, or jagged. Artists use lines to outline shapes and forms or to suggest different kinds of movement. Sometimes artists use *implied* line. An

implied line is not actually drawn, but is suggested by parts of an image or sculpture, such as a row of trees or a path of footprints.

If you look closely, you can find examples of line in every work of art you see. Notice how they affect the mood of an artwork. For example, how might a drawing with thick, zigzag lines be different from one with light, curved lines?

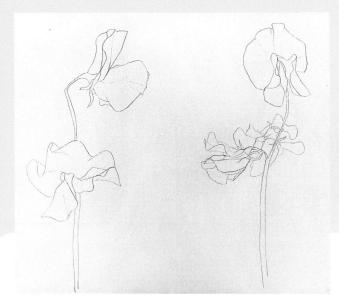

Fig. F3-4 Artists sometimes use *contour* lines to show the edges, ridges, or outlines of an object. What shapes do the lines in these drawings suggest? Are the shapes geometric or organic? Why do you think so? Ellsworth Kelly, *Sweet Pea*, 1960.

Graphite on white wove paper, 22 $^{1}/_{2}$ " x 28 $^{1}/_{2}$ " (57 x 72 cm). The Baltimore Museum of Art.

Fig. F3–5 This student used lines and shapes to create the look of action. How might this drawing be different if all the lines were horizontal and vertical? Michael Byrd, In Every Direction, 1997. Watercolor marker, 18" x 12" (46 x 30 cm). Johnakin Middle School, Marion, South Carolina.

Fig. F3-6 This artist used geometric shapes to build the forms of her sculpture. Notice how the corners of the squares create implied lines. Where do you see positive shapes? Where do you see negative shapes? Helen Escobedo, *Coatl (snake)*, 1982. Steel I-beams, 19' 6" x 48' 9" (6 x 15 m). National University of Mexico.

Shape and Form

A line that surrounds a space or color creates a **shape**. Shapes are flat, or two-dimensional. A circle and a square are both shapes. A **form** is three-dimensional: It has height, width, and depth. A sphere and a cube are examples of forms.

Shapes and forms may be organic or geometric. *Organic* shapes and forms—such as leaves, clouds, people, ponds, and other natural objects—are often curved or irregular. *Geometric* shapes and forms—such as circles, spheres, triangles, pyramids, and cylinders—are usually precise and regular.

Most two-dimensional and three-dimensional designs are made up of both *positive* shapes and *negative* shapes. The figure in a painted portrait is the painting's positive shape. The pieces of fruit in a still-life drawing are the positive shapes in the drawing. The background or areas surrounding these objects are the negative shapes. The dark, solid shape of a statue is a positive shape. The area around and inside the forms of the statue make the negative shapes. Artists often plan their work so that the viewer's eyes move back and forth between positive and negative shapes.

Color and Value

Without light, you cannot experience the wonderful world of **color**. The wavelengths of light that we can see are called the color spectrum. This spectrum occurs when white light, such as sunlight, shines through a prism and is split into bands of colors. These colors are red, orange, yellow, green, blue, and violet.

In art, the colors of the spectrum are recreated as dyes and paints. The three *primary hues* are red, yellow, and blue. *Primary* means "first" or "basic." *Hue* is another word for "color." You cannot create primary colors by mixing other colors. But you can use primary colors, along with black and white, to mix almost every other color imaginable.

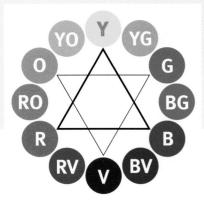

Fig. F3-7 A color wheel arranges the colors of the spectrum and related colors in a circle. It can help you remember some of the basic principles of color. Refer to a color wheel whenever you plan an artwork. (See page 308.)

Y=yellow V=violet G=green R=red B=blue O=orange

Fig. F3-8 Artists can mix colors of paint to create any color on the color wheel and many more. Look carefully at this painting. Where do you see primary colors? Secondary colors? Intermediate colors? Stanton MacDonald-Wright, Conception Synchromy, 1914.
Oil on canvas, 36" x 30 ½" (91.4 x 76.5 cm). Hirshhorn Museum and Sculpture Garden, Smithsonian Institution, Gift of Joseph H. Hirshorn, 1966. Photo: Lee Stalsworth.

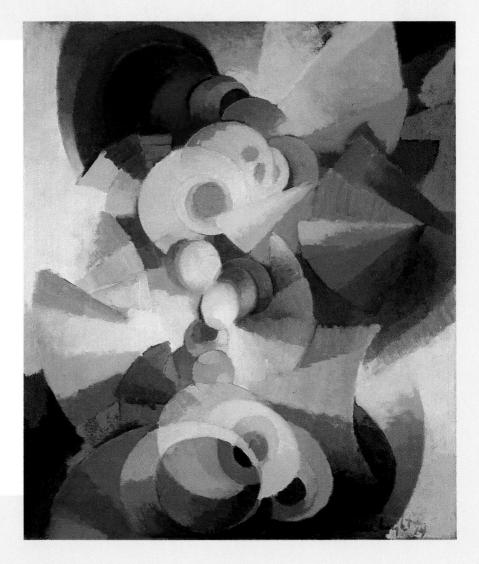

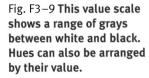

Fig. F3-10 Artists use shading to create a gradual change in value and a smooth transition between light and dark areas. How does shading make the fruit look realistic? Claudio Bravo, *Still Life*, 1980.

Pencil on paper, $14^{9/16}$ " x $20^{13/16}$ " (37 x 52.7 cm). Jack S. Blanton Museum of Art, The University of Texas at Austin, Barbara Duncan Fund, 1980. Photo: George Holmes. © Claudio Bravo/Licensed by VAGA, New York, NY/Marlborough Gallery, NY

The *secondary* hues are orange, green, and violet. You can create these by mixing two primary colors: red and yellow make orange; yellow and blue make green; red and blue make violet.

To create *intermediate* hues, you mix a primary color with a secondary color that is next to it on the color wheel. For example, mixing yellow and orange creates the intermediate color of yellow-orange.

Value refers to how light or dark a color is. A light value of a color is called a *tint*. A tint is made by adding white to a color. Pink, for example, is a tint made by adding white to red. Artworks made mostly with tints are usually seen as cheerful, bright, and sunny.

A dark value of a color is called a *shade*. A shade is made by adding black to a color. For example, navy blue is a shade made by adding black to blue. Artworks made mostly with dark values are usually thought of as mysterious or gloomy.

The intensity of a color refers to how bright or dull it is. Bright colors are similar to those in the spectrum. You can create dull colors by mixing complementary colors. *Complementary* colors are colors that are opposite each other on the color wheel. Blue and orange are complementary colors. If you mix a small amount of blue with orange, the orange looks duller. Many grays,

browns, and other muted colors can be mixed from complementary colors.

When artists plan an artwork, they often choose a *color scheme*—a specific group of colors—to work with. An artist might use a primary, secondary, intermediate, or complementary color scheme. Or the artist might choose any of the color schemes illustrated in the chart below.

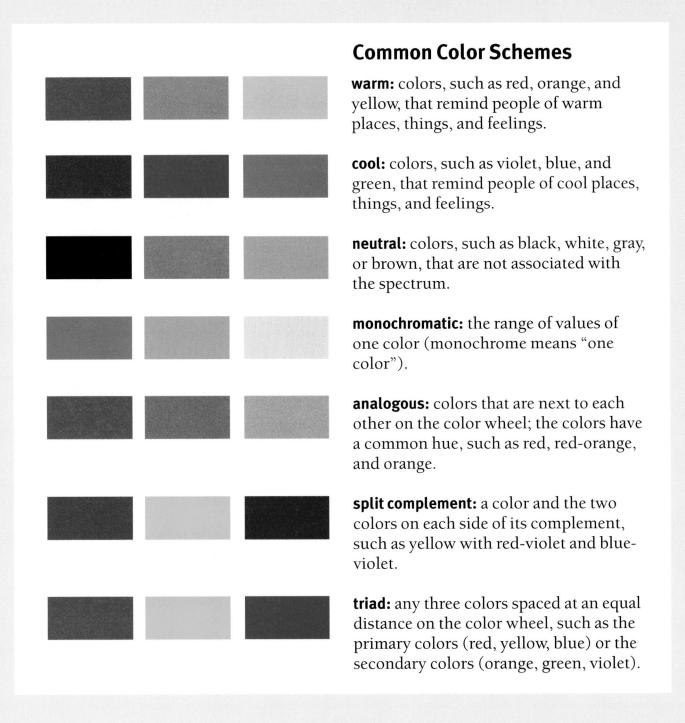

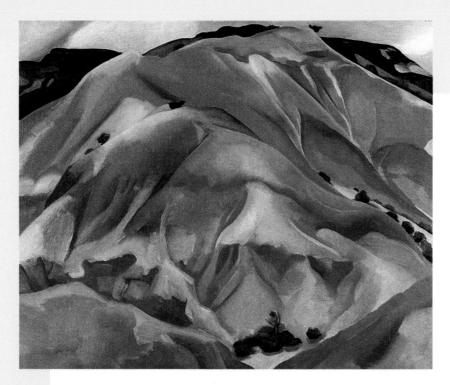

Fig. F3–11 Georgia O'Keeffe used a warm color scheme to create this painting of a mountain. Why might she have chosen a warm color scheme? How does the painting make you feel? Georgia O'Keeffe, *The Mountain, New Mexico*, 1931.
Oil on canvas, 30 ½" x 36 ½" (76.4 x 91.8 cm).
Collection of Whitney Museum of American Art, New York. Photo by Sheldon C. Collins. © 2000 The Georgia O'Keeffe Foundation/Artists Rights Society (ARS), New York.

Fig. F3-13 Howard Storm chose a cool color scheme to show a wintry land-scape. Why might someone also call this an analogous color scheme? Howard Storm, *Winter House*, 1980.
Oil on canvas, 26" x 26" (66 x 66 cm). Courtesy of the artist.

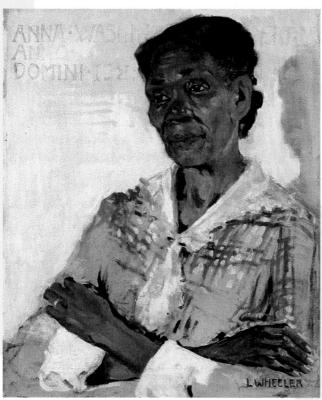

Fig. F3-12 The color scheme you see here includes neutral browns, tans, and whites. What feeling might the artist be expressing with this color scheme? Laura Wheeler Waring, *Anna Washington Derry*, 1927.

Oil on canvas, 20" x 16" (51 x 41 cm). ©National Museum of American Art, Smithsonian Institution, Washington, DC (Gift of the Harmon Foundation)/Art Resource, New York.

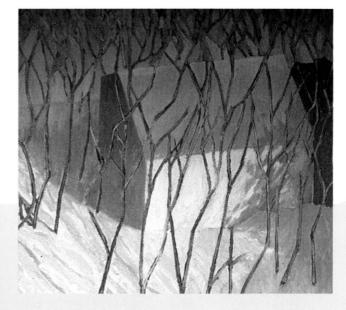

Sketchbook Connection

Use colored pencils to create a value scale in the color of your choice. Refer to Fig. F3–9 as needed. Next, diagram your

own example of each of these color schemes: complementary, split complement, analogous, and triad. Which color scheme interests you the most? Why?

Space

Sculptors and architects work with actual **space.** Their designs occupy three dimensions: height, width, and depth. *Positive* space is filled by the sculpture or building itself. *Negative* space is the space that surrounds the sculpture or building.

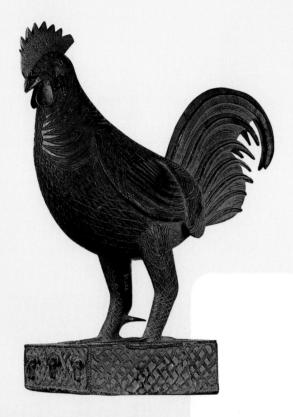

In two-dimensional (2-D) art forms, artists can only show an illusion of depth. They have simple ways of creating this illusion. For example, in a drawing of three similar houses along a street, the one closest to the viewer appears larger than the middle one. The house farthest away appears smaller than the middle one. Artists can also create the illusion of depth by overlapping objects or placing distant objects higher in the picture.

Artists working in two dimensions also use linear perspective, a special technique in which lines meet at a specific point in the picture, and thus create the illusion of depth.

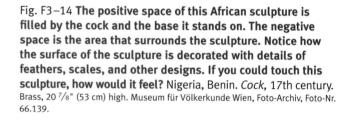

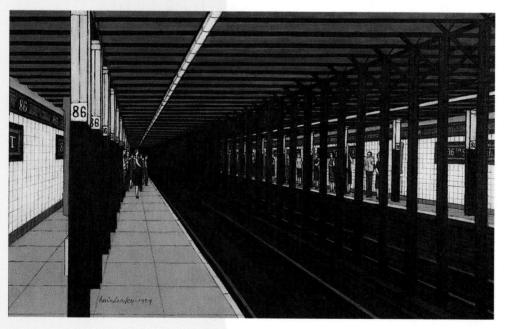

Fig. F3-15 Here is a clear example of linear perspective. Notice how the lines of the subway platform, tracks, and walls seem to meet behind the group of people on the left. How does the illusion of space that you see here compare to the illusion of space in Fig. 3-5 (page 124)? Jacques Hnizdovsky, New York Subway, 1960. Oil on canvas, 24" x 36" (61 x 91 cm). The Butler Institute of American Art, Youngstown, OH.

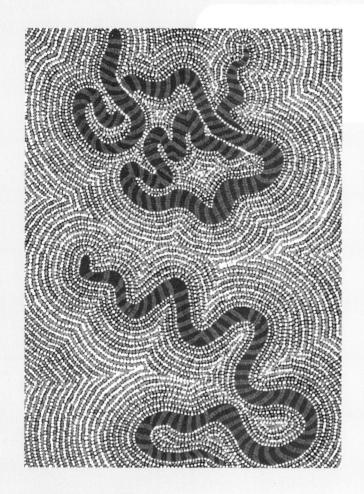

Fig. F3-16 How did this artist use line, shape, and color to create implied texture? If these were areas of real texture, how might they feel? Rene Robinson (Aboriginal), *Snake Dreaming*, 20th century.

Natural pigments on bark. Jennifer Steele/Art Resource.

Try This

Place a piece of paper over a textured surface and hold the paper down firmly. Rub the paper with the flat side of a crayon or piece of chalk to create a rubbing. Find other textures and create additional rubbings. Compare the results.

Computer Option

Explore the illusion of implied texture by using a paint program. With the pencil tool, create a simple still life draw-

ing. Fill the entire page. Select the various objects and fill with different texture effects. How did you choose your textures?

Texture

Texture is the way a surface feels or looks, such as rough, sticky, or prickly. Real textures are those you actually feel when you touch things. Sculptors, architects, and craftspeople use a variety of materials to produce textures in their designs. These textures can range from the gritty feel of sand to the smooth feel of satin.

Artists who work in two-dimensional art forms can create *implied* textures, or the illusion of texture. For example, when an artist paints a picture of a cat, he or she can create the look of soft fur by painting hundreds of tiny fine lines. What kinds of implied texture have you created in paintings or drawings of your own?

Foundation Lesson 3.1

Check Your Understanding

- **1.** What are the elements and principles of design? How are they related?
- **2.** How is an implied line unlike any other type of line?
- **3.** In your own words, explain the difference between positive and negative shapes. Choose an artwork from anywhere in this book as an example.
- **4.** Analyze the color in one of the paintings in this section. Tell what type of color scheme was used. What mood do these colors suggest?

Principles of Design

Balance

Artists use **balance** to give the parts of an artwork equal "visual weight" or interest. The three basic types of visual balance are symmetrical, asymmetrical, and radial. In symmetrical balance, the halves of a design are mirror images of each other. Symmetrical balance creates a look of stability and quiet in an artwork.

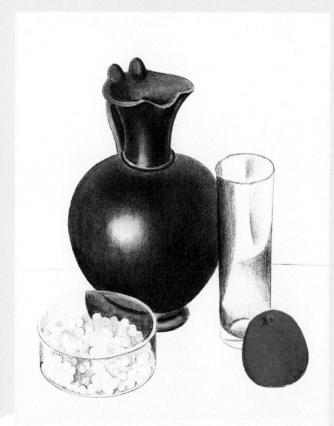

Fig. F3–17 The large, dark vase in this drawing is balanced by the small, bright apple. Why do you think the artist chose this group of objects? Charles Sheeler, Suspended Forms (Still Life), c. 1922. Charcoal, chalk, and watercolor, 19" x 15 ¹/₄" (48.2 x 38.7 cm). Bequest of Mrs. G. Gordon Hertslet 123:1972. St. Louis Art Museum.

In asymmetrical balance, the halves of a design do not look alike, but they are balanced like a seesaw. For example, a single large shape on the left might balance two smaller shapes on the right. The two sides of the design have the same visual weight, but unlike symmetrical balance, the artwork has a look of action, variety, and change.

In radial balance, the parts of a design seem to "radiate" from a central point. The petals of a flower are an example of radial balance. Designs that show radial balance are often symmetrical.

Try This

Choose one form of balance. Create a drawing or painting that illustrates your choice. Compare and contrast your artwork with those of your classmates. How are the artworks the same? In what ways are they different?

Computer Option

Explore balance using a drawing or painting program. First, create four geometric shapes. Fill the shapes with colors,

values, or patterns. Arrange the shapes on the left half of your document so they do not touch or overlap. Select your entire design. Create a symmetrical design by copying and flipping the selected area horizontally. Save your work. Next, create an asymmetrical design by rearranging the shapes on the right side. Do you need to resize some shapes to balance the new design?

Unity

Unity is the feeling that all parts of a design belong together or work as a team. There are several ways that visual artists can create unity in a design.

- repetition: the use of a shape, color, or other visual element over and over
- dominance: the use of a single shape, color, or other visual element as a major part of the design
- harmony: the combination of colors, textures, or materials that are similar or related

Artists use unity to make a design seem whole. But if an artist uses unity alone, the artwork might be visually boring.

Fig. F3-18 Repeated shapes help unify this design. Large and small shapes add variety. What kind of balance is shown? Lyna E. Lacayanga, *Kaleidoscope*, 1999.

Colored pencil, 14" x 14" (35 x 35 cm). T. R. Smedberg Middle School, Sacramento, California.

Variety

Variety adds visual interest to a work of art. Artists create variety by combining elements that contrast, or are different from one another. For example, a painter might draw varying sizes of circles and squares and then paint them in contrasting colors such as violet, yellow, and black. A sculptor might combine metal and feathers in an artwork or simply vary the texture of one material. Architects create variety when they use materials as different as stone, glass, and concrete to create the architectural forms of a building.

Fig. F3-19 This artist wove different textures to create variety in this wall hanging. In what ways has she created unity? Lori Kammeraad, *Llama Deux*, 1982. Tapestry, 72" x 42" (182.9 x 106.7 cm). Courtesy of the artist.

Emphasis

Look at *Endangered Hawksbill Turtle* (Fig. F3–20). What is the first thing you see? The answer is easy: You'll probably say you see the turtle first. Now see if you can explain why you noticed it first. Here are some clues.

When artists design an artwork, they use **emphasis** to call attention to the main subject. The size of the subject and where it is

Fig. F3-20 In this silkscreen print, the artist's use of pattern helps create emphasis. Notice the strong differences between the animal and background patterns. Are the patterns planned or random? Why do you think so? Christine Kidder, Endangered Hawksbill Turtle, 1990. Silkscreen, 25" x 25" (64 x 64 cm). Courtesy of Preston Graphics.

placed in the image are two key factors of emphasis. You probably noticed the turtle first because it is larger than the things that surround it. It's also placed in the middle of the image. Sometimes artists create emphasis by arranging other elements in a picture to lead the viewer's eyes to the subject. Or they group certain objects together in the design.

Pattern

An artist creates a **pattern** by repeating lines, shapes, or colors in a design. He or she uses patterns to organize the design and to create visual interest. You see patterns every day on wallpaper, fabric, and in many other kinds of art.

Patterns are either planned or random. In a *planned* pattern, the element repeats in a regular or expected way. A *random* pattern is one that happened by chance, such as in a sky filled with small puffy clouds or in the freckles on a person's face. Random patterns are usually more exciting or energetic than planned ones.

Fig. F3-21 Look carefully at this print. How many patterns do you see? Emily Carr, Dancing Parrots, 1997.

Watercolor, ink, 18 x 24" (46 x 61 cm). Turkey Hill Middle School, Lunenburg, Massachusetts.

Try This

Create a stencil or gadget print that shows emphasis and pattern. You might choose a specific subject for your print or create a print that is nonobjective. Think about how you will create emphasis and pattern. Experiment with color and design before you make your final print.

Proportion

Proportion is the relationship of size, location, or amount of one thing to another. In art, proportion is mainly associated with the human body. For example, even though your body might be larger, smaller, or shorter than your best friend's, you both share common proportions: Your hips are about halfway between the top of your head and your heels; your knees are halfway between your hips and your feet; and your elbows are about even with your waist.

Fig. F3–22 Artists often change the normal size, scale, or proportion of things to show their importance in artworks. What might the artists be saying about these objects? Claes Oldenburg and Coosje van Bruggen, *Spoonbridge and Cherry*, 1988. Aluminum painted with polyurethane enamel and stainless steel, 29'6" x 51'6" x 13'6" (9 x 15.7 x 4.1 m). Minneapolis Sculpture Garden, Walker Art Center, Minneapolis. Photograph by Attilio Maranzano. Courtesy of the artists.

Scale is the size of one object compared to the size of something else. An artist sometimes uses scale to exaggerate something in an artwork. Look at *Spoonbridge* and *Cherry* (Fig. F3–22). How do these artists' use of scale make ordinary objects look important?

Movement and Rhythm

Artists often create a sense of action, or **movement**, in their artworks. Artworks that actually move, such as mobiles, are called *kinetic* art. Other forms of art, such as photographs, paintings, and sculpture, may only record the movement of their subjects. Movement in an artwork creates excitement and energy. Artists use movement to communicate an idea or to set a particular mood, such as surprise or humor.

Rhythm is related to both movement and pattern. Artists create rhythm by repeating elements in a particular order. It may be simple and predictable, such as the lines in a sidewalk. Or it may be complex and unexpected, such as the rhythm shown in *Dynamism of a Dog on a Leash* (Fig. F3–23). Artists use rhythm, like pattern, to help organize a design or add visual interest.

Fig. F3–23 **How has this** artist captured the rhythmic movements of the dog and its owner? Giacomo Balla, *Dynamism of a Dog on a Leash*, 1912.
Oil on canvas, 35 ³/₈" x 43 ¹/₄" (89 x 110 cm). Albright-Knox Art Gallery, Buffalo, New York. Bequest of A. Conger Goodyear and Gift of George F. Goodyear, 1964. © 2000 The Artists Rights Society (ARS), New York/SIAE, Rome.

Sketchbook Connection

Choose a partner and spend some time observing each other's face. What shape is the face? Where are the eyes locat-

ed in relation to the top of the head and chin? Where are the nose, mouth, and ears located in relation to the eyes and the rest of the face? Sketch your partner's face in as accurate proportion as you can.

Foundation Lesson 3.2

Check Your Understanding

- **1.** Why might a totally unified design be visually boring?
- **2.** Describe some ways that an artist might create emphasis in a design.
- **3.** How does kinetic art differ from other works of art that depict movement?
- **4.** Select a piece of art from this chapter that appeals to you. Describe how the artist used at least two of the art principles in this design.

Connect to...

Careers

The **photography** profession requires expertise with the elements and principles of design: the success of a photograph depends on the photographer's composition of the image in the camera's viewfinder. For instance, the composition may have asymmetrical or symmetrical balance, and contrasting values, colors, lines, or shapes.

Career options in photography include commercial photography,

such as advertising and graphic design; fashion photography; wedding and portrait photography; sports photography; and medical photography. Photojournalism, fineart photography, videography, or filmmaking are other possibilities.

F3-24 Wildlife photographer Clayton Fogle combines his love for animals and the outdoors with his artistic profession.

Digital montage courtesy of the artist.

Other Arts

Music

What is music? Are sounds of nature—such as those made by birds, water, and animals —the same as music? How is singing different from speaking? Listen to some music, and make a list of what things about the sounds make them music. Discuss findings with classmates. Can you agree on what makes music?

Music, like art, has design: it is made to express something. If we compare their elements, we might say that a line in art is like a note in music. As a line moves in a certain direction, a note has a certain duration: it goes somewhere in time. Color in art is similar to tone color (or timbre) in music. Musical sounds have "color," which is how we can tell a guitar from a saxophone.

The principles of art can also apply to music. Music is made up of patterns of sound, but composers balance repetition and contrast to create music that has a sense of unity, so it all "hangs together."

Daily Life

F3–25 What kinds of lines do you see here? Franz Steiner, Sunset, 1999. Watercolor, brush and ink, 22" x 14" (55.8 x 35.6 cm). Central Tree Middle School, Rutland, Massachusetts.

You can easily find examples of the **princi**ples and elements of **design** in your daily environment. Try looking for the element of line. Vertical and horizontal lines outline windows, buildings, telephone and lamp poles, signs, and other human-made structures. The painted lines on both sides of a road appear diagonal when they seem to meet in the distance. Tree trunks are often vertical lines, and their branches may be diagonal or curvy lines.

To sharpen your observational skills, chose another element or a principle of design, and look for examples of it throughout a day. Make note of what you find.

Other Subjects

Mathematics

Both artists and mathematicians work with the principle of design known as **pattern.** Artists use combinations of lines, colors, and shapes to form repeating designs. Mathematicians are interested in analyzing the symmetry, or balanced proportion, of such patterns. Congruent shapes—shapes that are the same size and shape—make up basic mathematical symmetry.

Mathematicians use types of congruent shapes such as translations, rotations, and reflections to create tessellations—repeating symmetrical patterns without any gaps or overlaps. Can you name an artist who is well known for his expertise in designing tessellations?

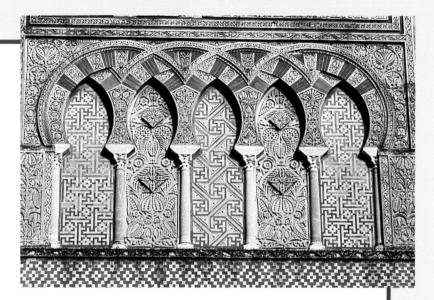

F3-26 The entire facade of this building is covered in patterns. Can you find some tessellations? Cordoba, Spain. *Grand Mosque*, 8th-11th century.

West Facade. Courtesy of Davis Art Slides.

Science

The primary colors (red, yellow, and blue) and the secondary colors (green, violet, and orange) appear on the **color wheel** (see page 308) familiar to you and used by artists. However, this color wheel applies only to dyes and pigments, such as paint or other applied color. The color

wheel used in photography is different, because **the human eye perceives light differently than it perceives pigment.** For example, a combination of red and green pigments produces brown; combining red and green light produces yellow.

In **optics**, the scientific study of light, the primary colors are red, blue, and green; and the secondary colors are yellow, cyan, and magenta. Who might most need to understand and use the color wheel for light?

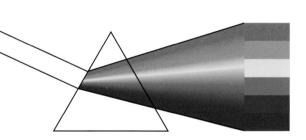

F3-27 When white light passes through a prism, the result is a band of colors called the spectrum.

Internet
Connection
For more activities related to this

chapter, go to the

Davis website at www.davis-art.com.

Portfolio

F3-28 Sarah Smalley, *Rowboat on the Shore*, 1999. Watercolor, 12" x 18" (30 x 46 cm). Samford Middle School, Auburn, Alabama.

"I got the idea because I like rabbits. The easy parts were the body and the hard part was the head." Spencer Heaton

F3-30 Spencer Heaton, *Sumi-e Rabbit*, 1998. Ink, 7" x 9" (18 x 23 cm). Fairhaven Middle School, Bellingham, Washington.

"I got the idea to paint this picture after I saw a picture of a rowboat in the water. I really liked the boat but it had people in it. I decided to put the boat on the shore, add trees and bushes, and take the people out of the boat. I had a lot of fun painting and adding things to the background." Sarah Smalley

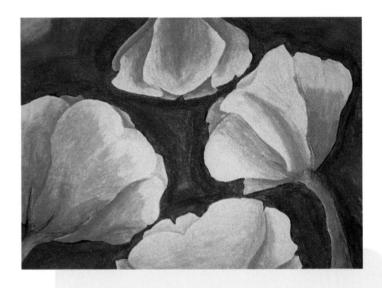

F3–29 Jessie Bergsma, *California Poppies*, 1997. Oil pastels, 18" x 24" (46 x 61 cm). Fairhaven Middle School, Bellingham, Washington.

"I've loved poppies ever since I was a little girl. Since I started painting, I've loved using opposite colors. I like contrast a lot and tried to use it in this picture as well as balance. It was one of the first times I've ever used pastels, so that was definitely the most difficult part." Jessie Bergsma

CD-ROM Connection

To see more student art, check out the Global Pursuit Student Gallery.

Elements and Principles of Design

Foundation 3 Review

Recall

List the elements and principles of design.

Understand

Describe the difference between the elements and the principles of design.

Apply

Examine Fig. F3–6 (Helen Escobedo, *Coatl [snake]* shown below and on page 35), and identify which elements and principles of design the artist used.

Analyze

From the theme chapters of this book, select reproductions of artworks that illustrate each of the elements and principles of design.

Synthesize

On separate note cards, write the name of each element of design, and put the cards into a hat or bag. Do likewise for the principles of design, but put them into another hat or bag. Without looking, pull out two cards from each hat. Use your four selections as the basis for a realistic or abstract artwork.

Evaluate

Examine one of your favorite artworks—your own or one by another artist. Write a persuasive argument as a song lyric or poem that explains how the artist mastered the elements and principles of design in this piece.

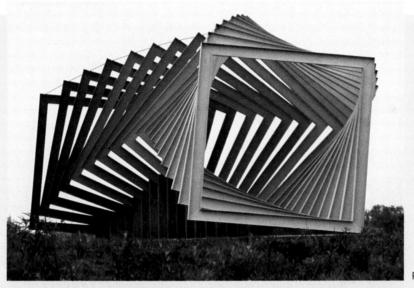

Page 35

For Your Portfolio

From artworks that you have created, choose one that you think shows your understanding of one or more of the ele-

ments and principles of design. On a separate sheet of paper, explain how you used the elements and principles to get certain results.

For Your Sketchbook

Study the sketchbook entries that you made during this chapter. Choose one idea, think about it, and develop it

in a different way.

Approaches to Art

Focus

- What do people want to know about art?
- What kinds of questions do people ask about art?

Imagine finding an object that's unlike any-

thing you've ever seen before. You turn the object over in your hands and ask yourself, "What is this? Who made it? How was it made?" Suppose something about the object suggests that it was made a long time ago. You might wonder why the object was important to the people who lived at that time. What did they use it for? How is it different from objects that you normally see or use?

For thousands of years, people have wondered where objects and artworks come from and why they were made. It's human nature to be curious. We can be as curious about the function of an artwork as we are about its meaning. Asking questions about the artwork helps us understand it. The information we learn about the artwork can also teach us something about the times and cultures of our world and where we fit in.

This chapter will introduce you to the kinds of questions peo-

ple ask about artworks. As you read the chapter, you will see that the questions fall into four categories: art history, art criticism, the making of art itself, and the philosophy of art.

What's Ahead

- F4.1 Art History
 - Learn how to find the story behind an artwork.
- F4.2 Art Criticism
 - Explore ways to find the meaning of a work of art.
- F4.3 Art Production
 - Learn more about yourself as an artist.
- F4.4 Aesthetics
 - Investigate the larger world of art.

Words to Know

art historian ar art critic ae

artist aesthetician

Fig. F4-1 Look carefully at this painting. Try to imagine how the artist painted it. Notice that the name of the artwork is Ladybug. What features of this artwork suggest the idea of a ladybug? Might the artwork actually be about something else? What functions do titles serve? Joan Mitchell, Ladybug, 1957.

Oil on canvas, 77 7/8" x 108" (197.9 x 274 cm). The Museum of Modern Art, New York. Purchase. Photograph ©2000 The Museum of Modern Art, New

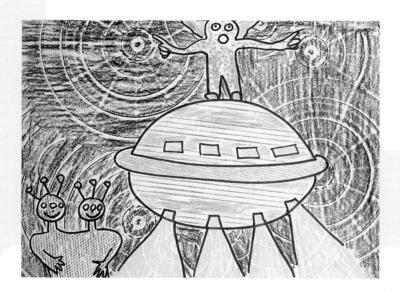

Fig. F4-3 This artist used crayon rubbings to make her artwork. What qualities do the rubbings add to the subject? Jenna Skophammer, Alien UFO, 1998. Crayon, 8 1/2" x 11" (21 x 28 cm). Manson Northwest Webster Community School, Barnum, Iowa.

Fig. F4-4 To make this artwork, the artist assembled electronic parts. How is this set of parts different from electronic parts you might find on the street? Is it any different? Howard Finster,

The Model of a Super Power Plant, 1979.

Assembled and painted electronical television parts, painted metal, 20" x 6 $^5/8$ " x 7 $^5/8$ " (50.8 x 16.9 x 19.4 cm). Gift of Herbert Waide Hemphill, Jr. and Museum purchase made by Ralph Cross Johnson. 1986.65.245. National Museum of American Art, Smithsonian Institution, Washington, DC/Art Resource, NY.

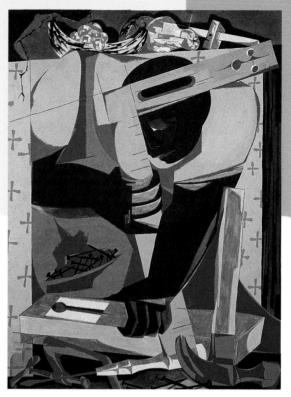

Fig. F4-2 Jacob Lawrence's artworks often show events from African-American history and working life. How could you use information about hammers and other carpentry tools to determine when this artwork was made? Hint: Do you think the look of carpentry tools has changed over time? Jacob Lawrence, Cabinet Maker, 1957.

Casein on paper, 30 $^{1}/_{2}$ " x 22 $^{1}/_{2}$ " (77.5 x 57 cm). Hirshhorn Museum and Sculpture Garden, Smithsonian Institution, Gift of Joseph H. Hirshhorn, 1966. Photo: Lee Stalsworth.

Art History

The Stories Behind Art

Art history is just what you'd expect: the history of art. **Art historians**—people who study the history of art—want to know where artworks began. They research the cultures from which artworks spring. They learn about the people, the politics, and the economic conditions at the time and place where artworks were made. They try to figure out why artists created artworks and how the artworks are different from others. And finally, when all of their research is done, they piece together the stories of art.

Do you ever wonder where artworks come from or what their story is? If you do, then you have begun investigating their history.

Looking at Art

There are certain basic questions that will get you started on the search for an artwork's story.

- **1.** What is the artwork? What is it about? What is its purpose?
- 2. When and where was it made?
- **3.** Has the artwork always looked like this? Or has it changed somehow over time?

Finding the Story

The next set of questions will help you find out what an artwork meant to the artist and to the people who lived at the time it was made. By asking these questions, you can learn how the artwork reflects the cultural traditions of the time. Your answers will also help place the artwork in history.

1. What was happening in the world when the artwork was made? How is the world different now?

Fig. F4–5 Dutch painter Pieter de Hooch painted this bedroom scene during his last years in the city of Delft. When you look at this painting, what can you learn about everyday life in mid-1600s Holland? Pieter de Hooch, *The Bedroom*, c. 1660. Oil on canvas, 20" x 23 ½" (50.8 x 59.7 cm). The National Gallery of Art, Washington, DC, Widener Collection.

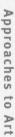

Fig. F4-6 Many artworks are influenced by family or cultural traditions—customs and beliefs passed down from generation to generation. If you wanted to learn about this traditional artwork, what questions could you ask?

Navajo, *Saddle Blanket*, late 19th century. Germantown yarn, 46 " x 37 $^{1}/_{2}$ " (116.8 x 95.3 cm). Smithsonian Institution, Washington, DC. National Muesum of the American Indian, Matthew M. Cushing Collection. Presented by Mrs. Nellie I.F. Cushing in his memory. Photo by Katherine Fogden.

- **2.** How do the customs and traditions of the artist's family or culture add to the meaning of the artwork?
- **3.** What other kinds of art did people make at that time?

Introducing the Artist

As the story of an artwork unfolds, questions about the artist begin to surface. Some art historians focus their investigations mainly on the life and work of a single artist. Imagine the challenge of discovering something new and interesting about an artist!

- 1. Who made this artwork?
- **2.** What role did artists play in the community in which this work was made?
- **3.** How does this artist's style compare to the style of other artists during that time?
- **4.** What decisions was the artist faced with as he or she created this artwork?

Fig. F4-7 Imagine that someone will find this artwork 100 years from now. What clues in the artwork will help the person learn about the artist who made it? Philip Brooks, Caged, 1997.

Found object assemblage, 36" x 30" x 30" (91.4 x 76 x 76 cm). Andrew G. Curtin Middle School, Williamsport, Pennsylvania.

You can ask any of these sample questions about a specific artwork or artist. You can also ask similar questions about an entire art period or about the value and use of artworks in general.

See if you can find out what art historians have said about artworks and artists that interest you. Try to learn more about when and where the artworks were created.

Try This

Choose one artwork in this chapter and see what answers to the sample questions you come up with. You don't have to answer all of them. Choose one from each category that interests you most. Do some research at the library or on the Internet. Then, present your findings to the class.

Foundation Lesson 4.1

- **1.** What general topics do art historians focus on in their investigations?
- **2.** How does the work of the art historian help you understand why an artwork looks the way it does?

Art Criticism

Searching for Meaning

Art critics want to know what artworks mean. They can help us learn about artworks by describing them and pointing out interesting things to look for. They judge the quality of artworks and suggest why they are valuable or important. Art critics often write about art in newspapers or magazines. Their views can influence the way we look at and think about artworks.

You have already asked questions like an art critic, perhaps without even realizing it. You may have looked at artworks in this book and wondered about their meaning. You have expressed your thoughts and opinions about objects and artworks around you. And you have compared them to other objects or artworks you're familiar with.

Your views may have affected the way your classmates or others think about artworks.

Finding Clues

As an art critic, you need to observe certain things about an artwork before you can begin to think about its possible meaning. Here are some questions that will help get you started.

- 1. What does the artwork look like?
- 2. How was it made?
- **3.** How are the parts of the artwork arranged?
- **4.** Does it seem to suggest a mood or feeling? An idea or theme?

Making Connections

Once you understand how the artwork is put together, you can focus more on its meaning and ask questions such as these:

- 1. What is the artwork about?
- **2.** What message does it send? How does it make me think, feel, or act when I see it?
- **3.** How is the artwork related to events in the artist's life? How is it related to events that happened at the time it was made?

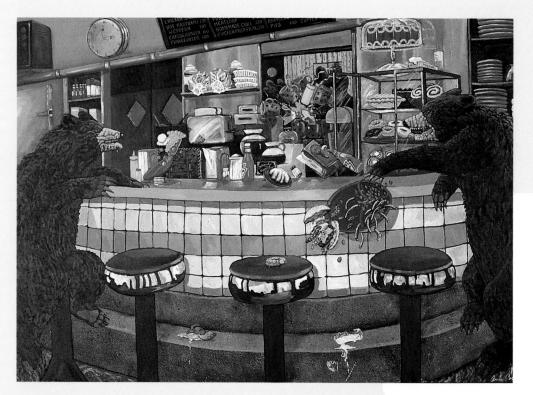

Fig. F4–8 Art critics have suggested that this artwork pokes fun at the human destruction of nature and animal habitats. What clues do you see in the painting that support this idea? Anne Coe, Counter Culture, 1990.

Acrylic on canvas, 50" x 70" (127 x 177.8 cm). Courtesy of the artist.

Fig. F4–9 Art critics say that this photograph is important because it makes us look carefully at natural forms. What do you think? Edward Weston, *Two Shells*, 1927. Gelatin silver print, $9^{1}/2^{n} \times 7^{1}/4^{n}$ (24 x 18.4 cm). J. Paul Getty Museum, Los Angeles.

Judging Importance

Suppose you have learned enough about the artwork to decide that it is important. Next, you need to support your judgment. Ask yourself:

- **1.** What aspects of the artwork—such as artist, culture, message, or function—make it important? Why?
- **2.** What sets this artwork apart from similar artworks?
- **3.** How is my response to this artwork different from my response to similar artworks?

You can see the kinds of things art critics say about art when you read a review of an art exhibit in your local newspaper. Try to visit the exhibit yourself. Do you agree with what the critic says about it? Why or why not?

Try This

Sometimes, the meaning of a group of artworks by one artist is easier to interpret than the meaning of a single artwork. Choose one artwork in this book that interests you. Then find two or three other artworks by the same artist in other books, magazines, on the Internet, or on CD-ROMs. Use questions from this lesson to find the meaning and importance of the group.

Foundation Lesson 4.2

- 1. What do art critics learn about artworks?
- 2. Why, do you think, are art critics important?

Fig. F4–10 **What elements of this image suggest a park?** Dylan Haynes, *Woman in the Park*, 1999. Magazine cut-outs, markers, 12" x 18" (30 x 46 cm). Asheville Middle School, Asheville, North Carolina.

Art Production

Making Art

Artists all over the world make artworks for decoration, to celebrate important events, and to communicate ideas or feelings. When artists plan a work of art, they think about its purpose and meaning. As they create the work, they explore their ideas and sometimes test the limits of the materials they use. In the end, they create a work that satisfies their personal and social needs, interests, values, or beliefs.

You think like an artist every time you explore the things you can do with pastels,

a lump of clay, or any other art material. You might have an idea when you start, or your exploration might lead you to one. When you are finished expressing your idea, you have a work of art that is all your own.

Reflecting on Your Art and Yourself

As you create art, you will begin to realize what art and making art mean to you. Asking questions about your art-making experience will help you uncover that meaning.

Fig. F4-11 Roy Lichtenstein is known for creating paintings that resemble comic strips. This artwork sends a message. If you were to create a painting like this, what subject would you choose? What message would you send? Why? Roy Lichtenstein, Forget It! Forget Me!, 1962.

Magna and oil on canvas, 80" x 68" (203 x 173 cm).
Rose Art Museum, Brandeis University, Waltham,
Massachusetts. Gevirtz-Munchin Purchase Fund.
©Estate of Roy Lichtenstein.

- **1.** What artworks are important to me? How do they affect the way I make art?
- 2. What feelings or ideas do I like to express in my artwork? What does my art say about me?

 3. What process do I go through when I

3. What process do I go through when I make art?

Considering Your Art and the World

When you have a better understanding of your own art, you can think about how it fits into the big picture. Ask yourself:

- **1.** What does my artwork tell others about the place and time in which I live? What special events, people, or things does it suggest?
- **2.** What do my choices of materials and techniques tell others about my world?
- **3.** How is my artwork similar to or different from art that was made in other times and places?

Fig. F4-12 Look carefully at this drawing. What feeling does it suggest? What feeling would you suggest in a drawing like this? Melissa Sung, *Tiger*, 1999.

Pastels, 17" x 23" (43 x 58 cm). Reading-Fleming Middle School, Flemington, New Jersey.

Comparing Your Art to Other Art

As an artist, you are probably aware of ideas and concerns that other artists have. When you compare your work to theirs, you might see a connection.

- **1.** How is my artwork similar to or different from artworks made by others? How has their work affected my work?
- **2.** If I could create an artwork with another artist, whom would I choose to work with? Why?
- **3.** What materials and techniques have other artists used that I would like to explore? Why?

The next time you create a work of art, ask yourself the questions in this lesson. See what answers you come up with. You'll probably learn something surprising about the artist in you!

Fig. F4–13 Marie Vigée-Lebrun shows herself as a painter of portraits. If you were going to paint a self-portrait, how would you show yourself? Marie Louise Elisabeth Vigée-Lebrun, Self-Portrait of Marie Louise Elisabeth Vigée-Lebrun, 1791.

Oil on canvas, 39" x 31 ⁷/₈" (99 x 81 cm). Ickworth, (The Bristol Collection)

National Trust Photo Library / Angelo Hornak.

Try This

Use the questions in this lesson to interview and write a report about a classmate's artmaking experiences. Create a portrait of your classmate to accompany the report. Use what you learn from this experience to interview an artist in your community.

Sketchbook Connection

Plan a work of art that uses materials and techniques you haven't tried before. Talk to people who have used the

materials and techniques. Sketch your ideas. When your plan is finished, create the work of art. Then write about your experience. Describe your process and how you feel about the artwork.

Foundation Lesson 4.3

- **1.** What are the main reasons artists make things?
- **2.** What three types of questions do artists typically explore?

Aesthetics

Investigating Art

Aesthetics is the philosophy, or investigation, of art. **Aestheticians** (*es-the-TISH-uns*) can be called art philosophers. They ask questions about why art is made and how it fits into society. They're interested in how artworks came to be.

Every time you wonder about art or beauty, you think like an aesthetician. The questions that come to your mind about art are probably like the questions that aestheticians ask. All you need is a curious mind and probing questions to be an art philosopher yourself.

Thinking About Artworks

At some time or another, you have probably wondered what artworks are. Like an aesthetician, you can ask certain questions that will help you think more carefully.

- 1. Are all artworks about something?
- **2.** In what ways are artworks special? What makes some artworks better than others?
- **3.** Do artworks have to be beautiful or pretty? Why or why not?
- **4.** What makes one kind of artwork different from another?

Thinking About Artists

As an aesthetician, you might wonder about the people who make art, why they make it, and why some people, but not all, are called artists. You might ask:

- **1.** What do artworks tell us about the people who made them? What do they tell us about the world in which they were made?
- **2.** What do people express through making art? Do artworks always mean what the artist intends them to mean?

Fig. F4–14 What does this artwork tell you about the artist who made it? Charles McQuillen, *Ritual III*, 1995.

Clay on tree. Courtesy of the artist.

3. Should there be rules that artists follow to make good artworks?

Thinking About Experiences with Art

When you talk about art, you probably discuss whether you like an artwork or not. And you probably talk about how an artwork makes you feel. These questions will help you dig deeper into your experience with an artwork.

- **1.** How do people know what an artwork means?
- **2.** Is it possible to dislike an artwork and still think it is good?

Approaches to Art

- **3.** How is the experience of looking at an artwork like the experience of looking at a beautiful sunset? Or are these experiences completely different?
- **4.** How do beliefs about art affect the way people look at and explore artworks?

The questions that aestheticians ask do not necessarily investigate a specific artwork. Instead, they investigate the larger world of art in general.

Try This

What makes one kind of art different from another? Break this question down into other questions, such as: What do all paintings have in common? What do all sculptures have in common? What do all photographs have in common? etc. Design and illustrate a book called *Asking Questions About Art*.

Computer Option

Begin with an imported photograph—a still life, landscape, or portrait. Use filters and other effects to trans-

form the photograph into a digital painting. Now find a painting on the Internet or a CD-ROM with a similar subject. Print out copies of each "painting" for discussion. How do computers affect our understanding of different kinds of art?

Foundation Lesson 4.4

- **1.** Why might it be important to have some understanding of art in general?
- 2. What do aestheticians do?

Fig. F4–15 a and b How are these images different from snapshot photos of people? What might the artist be saying here? Nancy Burson with Richard Carling and David Kramlich, First and Second Beauty Composites: a: Bette Davis, Audrey Hepburn, Grace Kelly, Sophia Loren, Marilyn Monroe, 1982. b: Jane Fonda, Jacqueline Bissett, Diane Keaton, Brooke Shields, Meryl Streep, 1982. Computer generated. Courtesy of the Jan Kesner Gallery and the artist.

Connect to...

Daily Life

In your day-to-day life, you probably do some of the same things that art critics, historians, aestheticians, and artists do. For instance, have you ever recommended that a friend see a movie that you have seen? **As a critic,** you probably gave your friend some reasons for your recommendation. Have you ever asked an older person to tell you about what life was like at an earlier time? Historians wonder about such things. You act **like a historian** whenever you try to figure out how an unfamiliar object was used when it was new.

Have you, **like an aesthetician**, looked at something that other people called art and wondered why they did so? Whenever you look at one of your own or a friend's artworks and wonder how you can know if it is good or not, you act like an aesthetician. You have probably made or decorated lots of things. Every time you make an artwork, wrap a gift, or make drawings on a notebook, you make decisions **like an artist** does. Try to keep track of the many times in your daily life that you think like an art critic, an art historian, an aesthetician, or an artist.

Other Subjects

F4-16 Sir Isaac Newton, 1642-1727. ©Bettman/Corbis

Science

The scientific method, an approach to scientific study first designed by Isaac Newton in 1687, is a standard way of conducting scientific experiments. It involves the observation of a phenomenon, or event, and the formation of a hypothesis, or theory, about the event. The next steps of the scientific method are experiments to prove the hypothesis, gathering the data, interpreting the results, and drawing conclusions.

Now consider the approach taken in art criticism: description, analysis, interpretation, and judgment. What are some similarities between the two approaches?

Language Arts

Think of some stories you learned in language arts. **Narrative artworks** also tell stories. Many artists consider themselves to be storytellers. They use visual rather than written or spoken language to tell their tales. Both kinds of narrative can entertain, inform, or teach the audience or viewer. Stories—whether written, oral, or visual—may have characters, events, action, plot, sequence, and purpose.

Discover these similarities yourself. Choose a narrative artwork from this chapter, and write a summary of the story that you think is told in the image.

Internet Connection For more activities related to this chapter, go to the

Davis website at www.davis-art.com.

F4–17 How do you think these instruments might sound? Can you imaginge a dance that is likely to be performed to their music? Turkey, Costumes of the Court and the City of Constantinople — musicians, 1720.
Bibliotheque Nationale de France, Paris. Giraudon/Art Resource, New York.

Other Arts

Music/Dance

When you listen to a new piece of music or see a new dance, you naturally compare it to music you have heard or dance you have seen. If it is similar to music or dance you know, you will probably understand it. The less it is like what you know, the more difficulty you will have. Questions to ask about any piece of music or dance are:

- What kind of work is this?
- What is its purpose?
- In what culture was it created?
- How does it reflect that culture?

You could answer some of these questions by listening or watching. For others, you might need to do research. **The questions that you ask about music or dance** might also be the questions that you ask—and answer—about art.

Try it out. Choose an artwork, a piece of music, and a dance video. For each work, write answers to the questions above.

Careers

Art critics may have different theories about art, but they all write persuasive arguments to convince us to look at the art ourselves. An art critic might be a newspaper reporter, a scholar who writes for professional journals or textbooks, or an artist who writes about other artists.

Journalistic art criticism, written for the general public, includes reviews of art exhibitions in galleries and museums. Journalistic criticism appears in newspapers and magazines, and on radio and TV. Scholarly art criticism is written for a more specialized art audience and appears in art journals and other texts. Scholarly criticism is usually written by professors or museum curators who have a particular knowledge about a style, period, medium, or artist.

F4–18 Arlene Raven is an art historian who has published seven books on contemporary art. She has written criticism for a variety of newspapers, magazines, exhibition catalogues, and scholarly journals. She has also taught art and curated exhibitions.

Photo: ©Robert MacDonald.

Portfolio

"I got this idea from an old calendar. I was going to draw just a flower, but I needed something that would grab on to the flower. I thought a butterfly would be perfect. The hard part of this artwork was making perfect dots so the lines on the butterfly will show up clearly." Joy Simongkhoun

F4–19 Joy Simongkhoun, *Butterfly/Pointillism*, 1999. Tempera, 9" x 12" (23 x 30 cm). Fairhaven Middle School, Bellingham, Washington.

"I was thinking about how disoriented I look and feel whenever I wake up late. I feel like my face isn't in one piece. This is why I put the ears on top of the mask. I named the mask's mouth 'plow-mouth' because when I wake up late, I just don't feel like talking much and the plow part of my plow-mouth just absorbs my breakfast (or plows it up)."

Nicole Peter

F4–21 Nicole Peter, Woke Up Late, 1999. Cardboard, plaster of paris, acrylic paint, 12" \times 8" (30 \times 20 cm). Copeland Middle School, Rockaway, New Jersey.

F4–20 Dana Edwards, *Sumi-e Painting*, 1999. Ink, brush, 12" x 18" (30 x 46 cm). Horace Mann Middle School, Franklin, Massachusetts.

CD-ROM Connection

To see more student art, check out the Global Pursuit Student Gallery.

Approaches to Art

Foundation 4 Review

Recall

Name the four categories for or approaches to examining art.

Understand

Explain the major differences in the work of an art historian, an art critic, an artist, and an aesthetician.

Apply

Give examples of questions an art historian might ask about Fig. F4–5 (Pieter de Hooch, *The Bedroom*, shown below and on page 54) and try answering them yourself by closely examining the work. Conduct additional research if necessary.

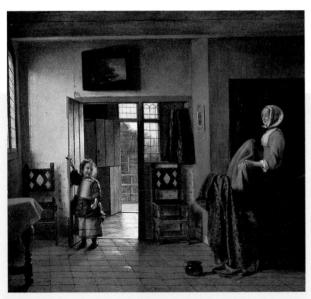

Page 54

For Your Sketchbook

Start a page in your sketchbook on which you write questions that you have about artworks, artists, how

to look at art, and how art is made. Add to this list throughout the year.

Analyze

Write a critical review of the images in Foundation 4.2. Then describe and support your selection of the single work you find most successful.

Synthesize

Write an imaginary diary entry as the artist Marie Vigée-Lebrun about what she might have wished to communicate to others in her self-portrait (Fig. F4–13), and the challenges she faced while working.

Evaluate

As an aesthetician, write an essay, based on Fig. F4–14, explaining whether all art has to be beautiful. Defend the use of Vermeer's *The Milkmaid* (Fig. 5–1) as an introduction to Chapter 5's theme of daily life.

For Your Portfolio

To show that you understand how to think like an art historian and like an art critic, choose one artwork from this

chapter. Then write a list of questions that an art historian would explore, and a list of questions that an art critic would explore. From each list, pick one question, and research and write the answer. Write the date on your report, and put it, along with the lists of questions, into your portfolio.

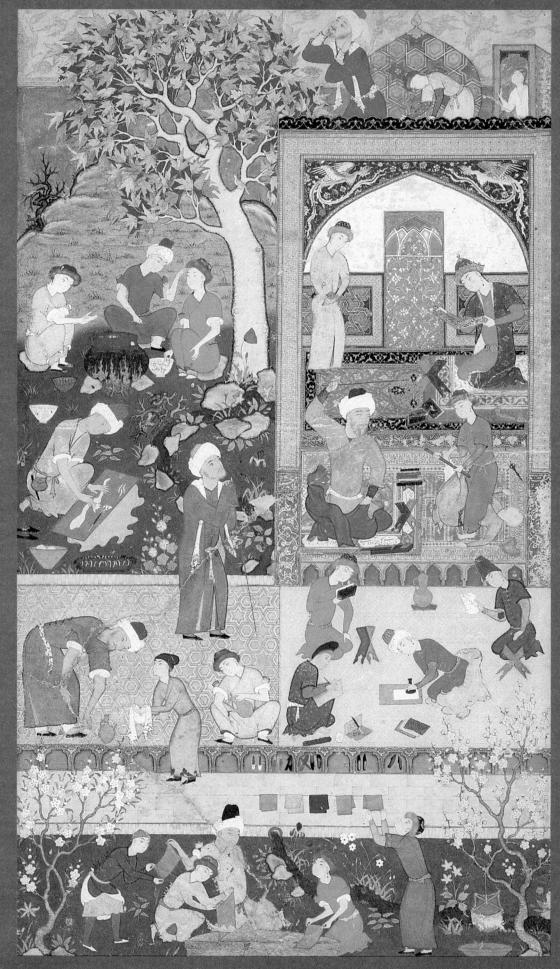

Page 149

Themes

Art is a Global Pursuit

What's a neighbor? Not very long ago, your neighbors were just the people who lived next door. Today, because of television and other kinds of communication, almost anyone could be called your neighbor. You can make friends with people who live on the other side of the globe. You can see and learn about ways of life that are nothing like your own. If you were to "travel" around the world via the Internet, videos, and satellite broadcasts, you'd learn about many different religions, holidays, types of food, and lifestyles. You'd see that many people have beliefs and customs that are strange to you. But you'd also begin to see that people have lots of things in common.

One important thing that people everywhere have in common is the desire to make art. Throughout history, people have decorated the things they use and the places where they live and work. They have used the materials around them to make things that beautify their lives. And if you look closely at art from around the globe, you'll see that no matter where they live, people care about similar things.

All over the world, people teach each other what they think it's important to know. They create ways to organize their lives. They gather together to remember and celebrate the past. They respond to nature. Themes like these have been part of people's lives throughout history.

In this part of this book, you'll explore some common themes in art. Look carefully at the artworks on these pages. Then look for these same themes in the artwork around you. Can you find them? Can you see how many "neighbors" you really have?

1 Messages

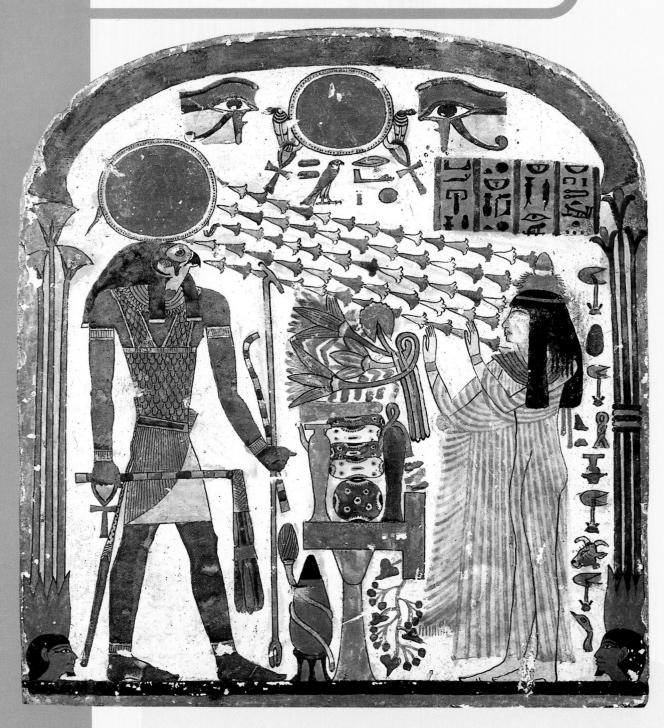

Fig. 1–1 Carved and painted stone slabs like this one, called a stele (STEE-lee), tell of a woman making offerings to the Egyptian sun god Re-Harakhte. The large disk above his head, along with other symbols, identify who he is. The lotus flowers—which represent rays of the sun—lead from Re-Harakhte, over a table filled with offerings, to the woman standing before him. Lower Egypt (Lybia), 22nd dynasty (950–730 BC.), Lady Taperet before Re-Harakhte. Painted stele, Louvre, Paris, France. Girauon/Art Resource, New York.

Focus

- How do we send messages to one another?
- How have people around the world and over time communicated with one another through art?

Like many people, you have probably had the experience of looking at an artwork and asking, "What does it mean?" "What is it about?" We tend to believe that all artworks are about something—that they have some kind of meaning. We assume that whoever made the artwork was trying to communicate something. In some cases, the meaning or message is obvious. At other times, for a variety of reasons, we cannot be sure what the message is.

Imagine how exciting it was to discover the Egyptian artwork shown in Fig. 1–1. When these images were carved and painted on the stone surface, the artist could not have known that thousands of years later, people would find the artwork and wonder about its meaning. The

message on this stone stele was not put there for us specifically, yet the painting still holds a message for us. These images—put on the walls of tombs to accompany the dead to an afterlife—tell about life in ancient Egypt. They also say to us, "We were here. This is what we believed. This is what we cared about when we were alive. You can see it in our artworks."

What's Ahead

- **Core Lesson** Examine some of the many ways that art is used to communicate.
- 1.1 Art History Lesson
 Discover how people in early times communicated through their art.
- 1.2 Elements & Principles Lesson
 See how ancient Egyptians used line and pattern to tell about their lives.
- 1.3 Global View Lesson
 Learn how people in Africa send
 messages through their art.
- 1.4 Studio Lesson
 Explore the use of clay to create your own message in relief.

Words to Know

stele line
symbol pattern
narrative cultural meaning
contour lines bas-relief
cuneiform

Messages in Art

Sending Messages

Groups of people who live together need to communicate. At a basic level, we communicate about topics important to our survival: obtaining food, building shelters, and protecting the community. But we humans communicate about much more than these basic needs. We tell stories. We share our

dreams for the future and our memories of the past. To communicate all this—to send messages—we use words, gestures, and symbols. A **symbol** is an image that stands for something else, such as the slash within a circle that means "not allowed," or the heart that can stand for love.

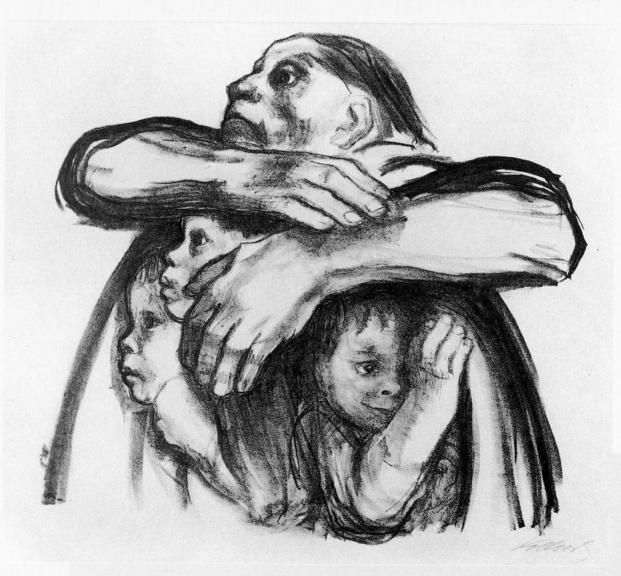

Fig. 1–2 In her artworks, Käthe Kollwitz tells about the dignity and strength of the poor, the beauty of the human spirit, and the horror of war. This was her last artwork, made following the death of her grandson in World War II. Käthe Kollwitz, Seed for Sowing Shall Not Be Ground, 1942. Lithograph on ivory paper. Private Collection, Courtesy Galerie St. Etienne, New York. © 2000 Artists Rights Society (ARS), New York/VG Bild-Kunst, Bonn.

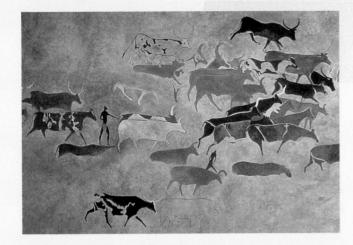

Receiving Messages

Artworks are like words and gestures: They convey meaning, and people use them to

communicate. We don't know what all words and gestures mean from the moment we're born. We learn their meanings gradually, as we grow up. How do we learn how to interpret messages in artworks?

Sometimes understanding what an artwork means is fairly easy. For instance, most viewers can see the compassion and love of a mother for her children in the artwork by Käthe Kollwitz shown in

Fig. 1–2. Do the words "guard" and "protect" come to mind as you study the image?

Fig. 1–3 What can this painting tell us about life in prehistoric times? Saharan rock painting of Jabbaren showing early

herders driving cattle, 5500 BC–2000 BC. Phototheque du Musee de l'Homme, Paris.

With other artworks, we might not be as sure about the message. For instance, we cannot fully understand messages left by prehistoric people—those who lived before the time of written records. They made drawings of animals and hunters on cave walls and other rock surfaces. These drawings give us clues about how prehistoric people lived. For example, some rock art tells us about their early hunting methods.

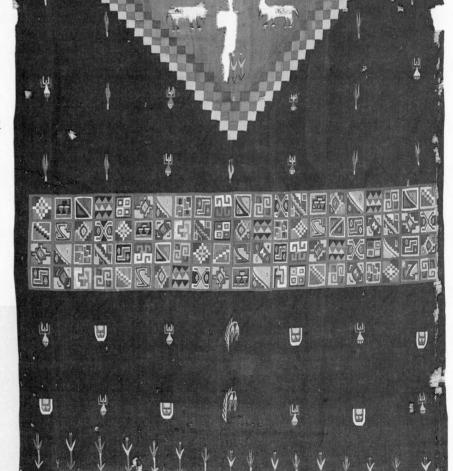

Fig. 1–4 Artworks that show symbols can be more difficult to understand than artworks that show objects we know. Look closely at the symbols in this tunic from Peru. What ideas do they suggest to you? Peru, South Coast, Inca, Early Colonial Period, Half-Tunic.

Interlocked tapestry: cotton warps and wool wefts, $37 \frac{1}{2}$ " x $28 \frac{1}{2}$ " (95.3 x 72.5 cm). ©The Cleveland Museum of Art, The Norweb Collection, 1951.393.

Messages About Our Lives

People make artworks to communicate ideas and goals. Through our art, we tell what is important, what we believe, and how we think people should live. Some art suggests ways to make the world a better place.

Fig. 1–5 A single image can sometimes tell a complicated story. What do you think this American artist tells? Jacob Lawrence, *Tombstones*, 1942. Gouache on paper, $28\sqrt[3]{4}$ x $20\sqrt[3]{2}$ (73 x 52.1 cm). Collection of Whitney Museum of American Art, New York. Purchase 43.14. Photo by Geoffrey Clements.

We often teach our values and beliefs through stories, legends, and myths. An artwork that suggests a story is called a **narrative** artwork. Not all narrative art is made to teach important lessons. Some narrative artworks tell stories to delight or amuse us. Others use images to report actual events. These artworks help document history and send messages to others about who we are and how we live.

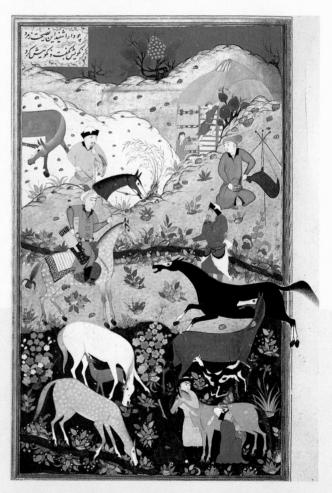

Fig. 1–6 You can "read" this lively Persian miniature painting much as you would read a written story. The scenes toward the bottom of the painting are closest; those at the top are in the distance. Notice the expressions on the faces of animals and people. What story is told here? Sa'di, Bustan (Garden of Perfume): Darius and the Herdsmen, mid-16th century. Ink, colors and gold on paper, 11 ½ " x 7 ¾ " (29 x 20 cm). The Metropolitan Museum of Art, Frederick C. Hewitt Fund, 1911. (11.134.2) Photograph © 1978 The Metropolitan Museum of Art.

Telling About Who We Are

People make artworks as a way to dream. We imagine other worlds, other creatures, other lives. Through artworks, we can communicate our visions and fantasies.

From early records of games and toys, we know that humans have always loved to play. Artworks can reveal this playful side of us. When we lightheartedly combine materials to make new forms, we show how we love to experiment.

People do more than experiment with materials. We also explore techniques and processes, such as using computers for new ways to make art. As artists experiment and play with materials and techniques, they seek new ways to send messages. They explore art's potential to communicate with others—both today and in the future. Whether carved into stone or digitized for cyberspace, art sends messages about our lives.

Fig. 1–7 Rand Schiltz playfully combined forms that, at first glance, seem lighthearted and even silly. Often, however, humorous artworks contain serious messages. What might the message be here?

Rand Schiltz, *Renovations*, *Out with* the Old, In with the New, 1991.

Vacuum cast bronze and lacquer, 14" x 11" x 4" (35.5 x 28 x 10.2 cm). Courtesy of the artist.

Photo by Jock McDonald

Fig. 1–8 What kind of fantasy do you see in this picture? If this were a painting instead of a computer-generated image, how might the message be different? Kenneth B. Haas, III, Crossroads, 1999.

Computer-generated image, 17.7" x 13.3" @ 72ppi. Bryce Software. Courtesy of the artist.

Drawing in the Studio

Creating Your Own Message

In this studio experience, you will use contour lines and pattern to communicate something about life in the twenty-first century.

Contour lines are lines that follow the edges of forms. *Pattern* can be created by repeating lines in a planned way. Imagine that people in the future will "receive" the message you create.

Think of some ways that early artists showed how people lived in the past. Use line and pattern to show people in a present-day scene. You might show an event important to many people, such as astronauts building a space station, or a more common event, such as someone selecting clothing at a mall, playing soccer, or cooking a meal.

Fig. 1–9 Notice the many different ways this artist used pattern. Rachel Freeman, *Katelyn's Softball Portrait*, 1999.

Marker, $12" \times 18"$ (30 x 46 cm). Hayfield Secondary School, Alexandria, Virginia.

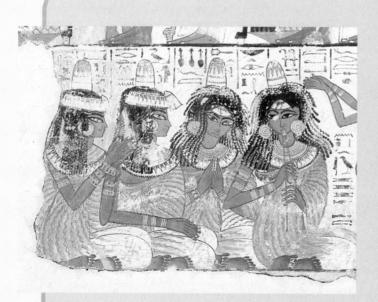

Fig. 1–10 Contour lines show the forms of these women. Line creates pattern in their robes, jewelry, and wigs. Egypt, Thebes, 18th Dynasty, *Banquet Scene*, (detail), about 1400 BC.
Wall painting. ©The British Museum.

Studio Background

Messages in Art

Art provides a glimpse of life from around the world and throughout history. It communicates messages from an earlier time.

Artworks that depict people often show them engaged in an activity. Examine the artworks on page 72. Notice how they send messages through the use of line. Notice how the lines in the images in Figs. 1–10 and 1–11 record the edges of forms: arms and legs, garments, musical instruments, and other objects. The artists followed these edges by moving a drawing tool. Look for differences between the length, weight, and thickness of the lines in the images.

Repeated lines can create pattern. Notice the pattern of the garments and jewelry in Fig. 1–10. Patterns can be simple, as in the earrings worn by the musicians, or more complex, as in the garment worn by the Assyrian soldier. Observe how pattern creates variety and interest in the overall composition.

You Will Need

- props
- sketch paper or newsprint
- pencil
- markers
- drawing paper

Try This

- **1.** Sketch classmates posing in different activities. Practice drawing just the edges of clothing, features, and props. Notice the ripples, creases, and other features of the edges you draw. Exact detail is not important.
- **2.** After you have made several practice drawings, choose an event or activity to show in a finished drawing. What visual message do you want the drawing to send about life in your time?

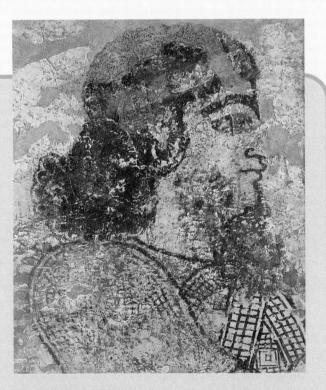

Fig. 1–11 This fresco was painted for Assyrian King Tiglathpileser II. Notice the way the artist used contour lines to show the soldier's shoulder, profile, and other detail. Line is repeated to create pattern. Neo-Assyrian, Head of Man with Beard, 8th century BC.

Fresco from the Palace of Tiglathpileser III at Tell Atimar (Til Barsip), Syria. Giraudon/Art Resource, NY.

- **3.** Plan your drawing on a sheet of sketch paper. How many people and poses will you include? What props will add meaning to your message?
- **4.** Try a variety of ways to create pattern with line.
- **5.** Use markers to make your final drawing.

Check Your Work

Share your drawing with a small group of classmates. Take turns describing the main features of each other's artwork. Pay attention to the way each of you used contour lines. Note where and how lines were repeated to create pattern. Discuss what messages about life today would be sent if the drawings are found a hundred years from now.

Sketchbook Connection

Fill several pages of your sketchbook with experiments in line and pattern. Repeat short diagonal lines. Make a

series of curved lines in several rows. How can you change each pattern by making bold or delicate lines? Create a very simple line pattern. Then try to make the pattern complicated. Use your patterns to make future drawings more interesting.

Core Lesson 1

- **1.** Use artworks as examples to explain the statement, "Art sends messages."
- **2.** What might an artwork tell about life in the past?
- 3. What do we mean by "narrative" art?
- **4.** How is a contour line different from an outline?

Art of the Ancient World

Marks with Messages

Have you ever used a stick to scratch lines or other marks into dirt or sand? Do you notice scuff marks made by people walking down a hallway? Humans make marks. Sometimes, we make marks unintentionally, but most of the time, we do so for a purpose.

We might doodle to help us think, or draw a map to show someone where we live. When early humans drew on rock surfaces, painted on tomb walls, or carved huge stones, they did so with a purpose—to communicate.

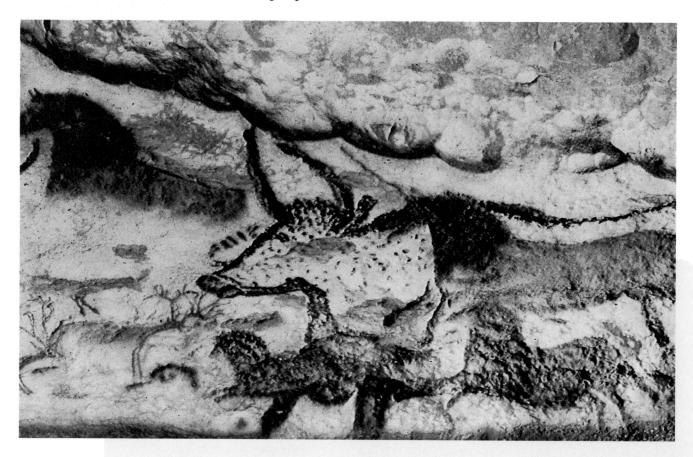

Fig. 1-12 These cave paintings may have been created to tell stories and to educate children. Lascaux, Hall of Bulls, detail, c. 15,000-13,000 BC, Dordogne, France. Color photo Hans Hinz.

Prehistoric Art: Our First Messages

Some of the oldest known images—more than 25,000 years old—are those painted on cave walls or carved into rock. These early messages have been found on every continent. The purpose of these images may have been to communicate hope for a successful hunt, to record events, or to educate children.

Most rock art shows three main subjects: humans, animals, and symbols. In rock painting, people often appear as stick figures with spears. Animals are shown mostly from the side and appear detailed and lifelike. Often, the images fit the surface or shape of the rock. Images sometimes overlap, which suggests that people worked on them at different times.

People used available materials—such as chalk, burned wood, and clay—to create these images. Some of these early artists mixed powdered minerals with animal fat to create colored pigments. They applied

these colors with their fingers, moss, or brushes made from fur, feathers, or chewed twigs. They also applied color by blowing it through tubes made of bone.

Art of the Near East: Records of Accomplishment

About 7000 years ago, people began to live in farming communities along fertile river valleys in Mesopotamia (present-day Iraq). Over time, these ancient people began to create art to tell about the power of their rulers. Magnificent palaces and royal tombs were filled with furniture and other artworks. The works were made of wood, gold, silver, gemstones, shells, stone, and clay. Some of these artworks show the rulers as animal gods. Some tell stories of hunts, battles, and ceremonies.

The Mesopotamians also developed a system of writing for keeping records. The earliest examples of writing date to about 3000 BC. This writing—called **cuneiform**—was made up of wedge-shaped symbols pressed into clay tablets.

Fig. 1-13 This is one of the two sides of a mosaic-like panel of shell and colored stones. This side tells a story of peace after a military battle; the other side depicts the battle. Notice that the figures are evenly spaced, and that the king is larger than the other figures he faces. Sumerian, Standard of Ur: Peace, about 2685-2645 BC. Mosaic panel of shell and colored stones, 19" (48 cm) long. Royal Cemetery at Ur. ©The British

Museum.

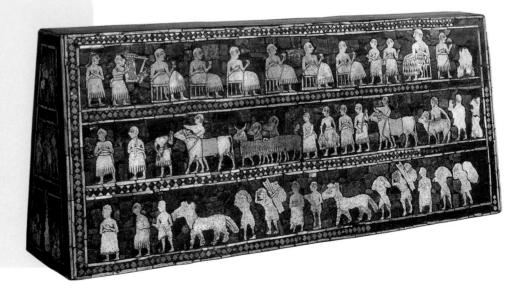

Art of Ancient Egypt: Lasting Messages

During a period spanning more than 3000 years, powerful kings called pharaohs ruled the vast kingdoms of ancient Egypt. This civilization grew up along the Nile River, in northeastern Africa. The Egyptian pharaohs built elaborate royal cities and commanded skilled artisans to create artworks. These artworks told important stories about the daily life of the pharaohs.

The earliest Egyptian stone structures, carved monuments, tomb paintings, hieroglyphics (an early form of picture writing), and artifacts of daily life are almost 5000 years old. The region's dry climate has helped preserve them. These objects give us a record of ancient Egyptian life and culture.

The Egyptians believed that their pharaohs were gods who would live after death. Many pharaohs had their tombs built in the form of pyramids. Tombs were filled with furniture, jewelry, and other items that the rulers would need in the afterlife. Wall paintings, relief sculptures, and small models in the tombs tell stories of servants bringing gifts, harvesting crops, and fishing.

For centuries, artists in Egyptian kingdoms used a single set of artistic rules. For example, drawings of people were carefully measured for correct proportions. The human figure was always outlined. Artists were valued for their ability to follow these rules. Being original or spontaneous was not part of an Egyptian artist's role.

Much of Egyptian art is considered timeless. Artists today use many of the same artistic principles that the ancient Egyptian artists used nearly 5000 years ago.

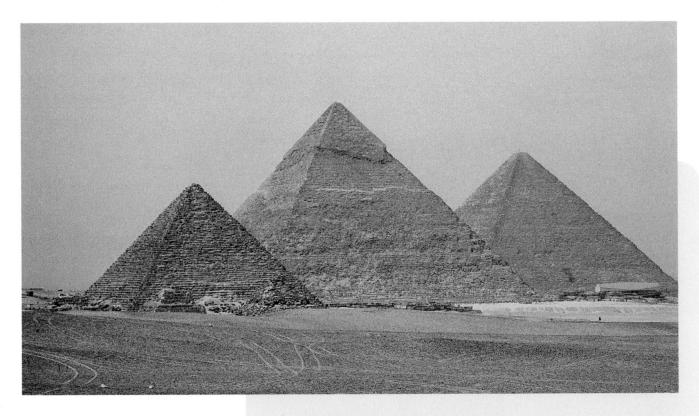

Fig 1-14 The great pyramids were once covered with smooth stone that reflected sunlight. What kind of message might that convey to someone looking at them from a distance? Giza, Egypt, *The Pyramids of Mycerinus, Chefren, and Cheops*, built between 2589 and 2350 BC.
Limestone. Erich Lessing/Art Resource, NY.

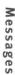

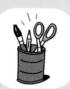

Studio Connection

As a contrast to the Egyptian style, try gesture drawing to record human figures in action. Gesture drawings are

made with quickly drawn lines that define the basic position and mass of a figure: quick, easy strokes that capture a pose or action. These drawings are not meant to be realistic, but they should communicate the action of the figure.

Draw your friends or classmates quickly as they "freeze" in different action poses for a few moments. Try to capture their essence with just a few lines. Compare your gesture drawings with the Egyptian and an Assyrian contour drawings shown in Figs. 1–10, 1–11, and 1–15. Which method sends more interesting messages?

Fig 1–15 This painted relief reflects the Egyptian artistic rules for showing people. The head, arms, and lower body are shown in profile. The eye and upper torso are shown in a front view. Egypt, *Ptahmoses*, *high-ranking official of Memphis receiving offerings from his children*, 19th dynasty.

Painted relief. Museo Archeologico, Florence, Italy. Scala/Art Resource.

1.1 Art History

- **1.** What is the main subject matter depicted in most ancient rock art around the world? What might have been some purposes of this art?
- **2.** What stories are told on many of the stone carvings of Mesopotamia?
- **3.** What stories are told on the walls of Egyptian tombs?
- **4.** Why did the Egyptian style of representing the human figure remain constant for thousands of years?

Line and Pattern

If you look carefully at artworks from the earliest times, you can see that line is the oldest and most direct form of communication. **Lines** are marks made by pushing, pulling, or dragging a tool across a surface. To tell about their lives, people from all cultures have used lines to decorate objects and mark surfaces. Sometimes the lines are combined with additional lines and shapes to form **patterns**.

Looking at Line

Drawn quickly or slowly, heavily or lightly, line can define space. It can create the illusion of volume and form. One simple line might suggest the belly of a horse, a muscle in a leg, or a fold of cloth. Artists make lines by using a variety of tools and methods. For instance, by using a light pencil line, an artist expresses a feeling different from that of a heavy, painted line.

The direction in which lines go and where they are placed can suggest various actions, moods, and space. You can describe a line by the way it looks—straight, curved, or broken, for example. You can also describe lines as being graceful, calm, energetic, and so forth.

Artists use lines to create shapes, textures, and patterns. Egyptian artists used line to divide space and define shapes. Before they applied color, their paintings probably looked like the outline drawings in a coloring book.

Looking at Pattern

Artists create patterns by repeating lines, colors, or shapes in an orderly or systematic way. Every pattern involves the repeated use of some basic element. This element can be a dot, a line, or a shape. Large patterned areas tend to hold an artwork together, whereas smaller patterns in only a few areas tend to add interest.

Fig. 1–16 The thrills of a desert hunt are captured in this scene. Where do you see line? Where do you see pattern? Egypt, Thebes, King Tutankhamen after the Hunt, c. 1352 BC.
Photo by Fred J. Maroon.

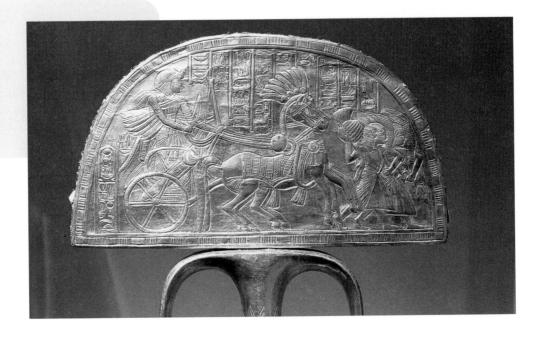

In Figs. 1–16 and 1–17, Egyptian artists used pattern in a variety of ways. What patterns do you see in these artworks? Identify both a pattern of repeated lines and a repeated flower shape.

Studio Connection

Design a book jacket for your favorite novel or a CD label for the soundtrack from your favorite movie. Use line and

pattern to help communicate the important message or theme of the story or movie. Select an element that is important to the plot and repeat it as a border or decorative element in the design. Use markers or colored pencils.

Sketchbook Connection

Fill several pages of your sketchbook with line experiments. Use a range of tools: twigs, feathers, and cardboard

edges dipped in ink, markers, brushes, crayons, charcoal, chalk, and pencils of different types. Change the way you work: Draw at arm's length, with two hands, with your eyes closed, and with your drawing tool taped to a yardstick. Think of other ways to experiment. Return to your sketchbook after a few days. Assign a name to each type of line you created.

1.2 Elements & Principles

Check Your Understanding

- **1.** What are some ways that artists create pattern?
- 2. How do lines function in artworks?

Fig. 1–17 The outer coffin is decorated with a representation of the chantress and figures of the gods of the underworld. The chantress sang hymns, much as a cantor does in today's churches or synagogues. Thebes (Egypt), Outer coffin of Henettawy, Chantress of Amun at Thebes, 1085–719 BC.

Wood, painted and gessoed, length $79^{7}/s$ " (203 cm). The Metropolitan Museum of Art, Rogers Fund, 1925. (25.3.182). Photograph © 1992 The Metropolitan Museum of Art.

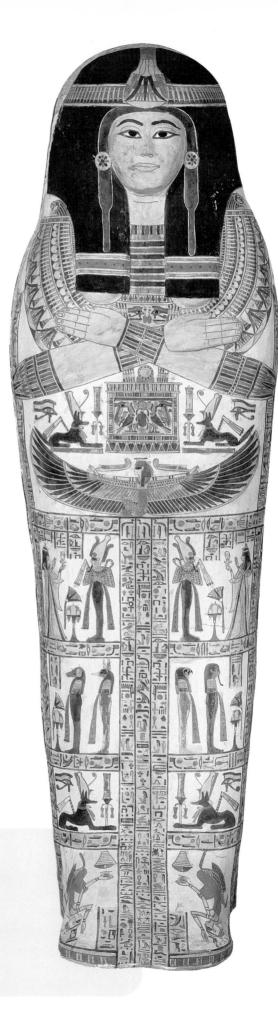

Messages of African Kingdoms

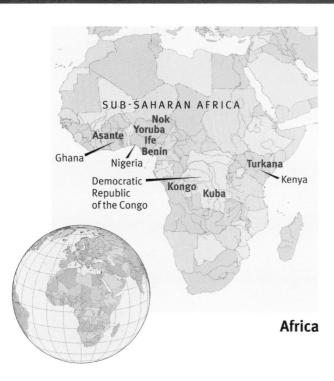

The arts of the ancient North African civilization of Egypt were an early influence on Western culture. Sadly, much of the early African artwork south of the equator was destroyed by hot, damp weather and woodeating insects. By looking at objects and traditions that remain, we can tell that much African art—both past and present—has been created to send messages to spirit worlds or community members.

Artworks from the widespread African kingdoms are made in many different materials and styles. They have many levels of meaning and a variety of uses. Household objects such as spoons and stools, sculptures of figures and animals, jewelry, and textiles are often used to send messages about power, status, hope, good health, and the like. Unless we have learned the **cultural meaning** (meaning that only members of a specific culture can understand) of symbols, and understand what the artwork is used for, we can't receive the messages the artwork sends.

Forms That Communicate

African peoples create art for special purposes, but we can't always tell what the artwork's purpose is just by looking at it. Some artworks are used in secret rituals and ceremonies. Others are used in public celebrations.

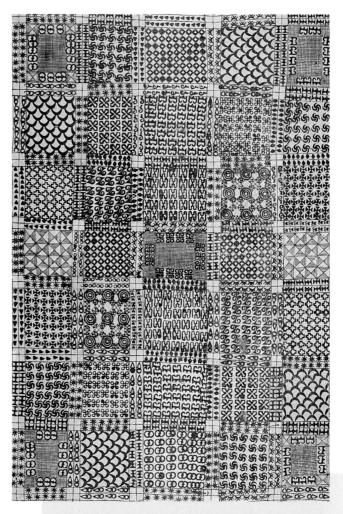

Fig. 1–18 The designs of African fabrics sometimes have special meaning. The message of this fabric is "good-bye." This hand-stamped cloth is worn at functions for departing guests and at funeral ceremonies. Asante people, Ghana, *Display Cloth*, late 19th century. Cotton cloth, natural dye, 82 ³/₄" x 118 ⁷/₈" (210 x 302 cm). Museum purchase, 83-3-8. Photograph by Franko Khoury. National Museum of African Art, Smithsonian Institution, Washington, DC.

Specially handcrafted objects and costumes might be used to communicate with powerful spirits. Ancestors are an important part of the spirit world.

In many ritual ceremonies, carved wood masks are used as part of a costume. African people might think of a costumed dancer as a messenger for the spirit world. Masks and costumes are used to mark the time when children move into adult life. They might also be used when judging a person accused of a crime. Each situation has its own special ritual. Each ritual makes use of certain types of masks, costumes, and other objects.

Fig. 1–19 This bronze relief sculpture once decorated the king's palace in Benin. Plaques like these tell about the achievements of great leaders. What does this plaque tell about royal life in Benin? Edo peoples, Benin Kingdom, Nigeria, *Plaque*, mid-16th–17th century. Cast copper alloy, 116.8" (46 cm). Purchased with funds provided by the Smithsonian Acquisition Program, 82-5-3. Photograph by Franko Khoury. National Museum of African Art. Smithsonian Institution, Washington, DC.

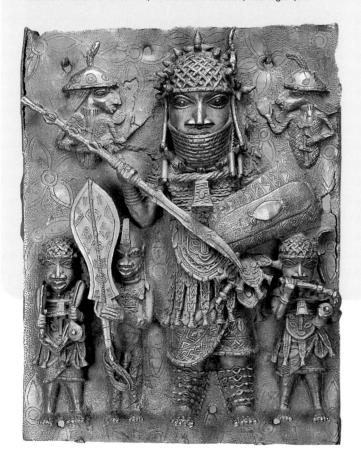

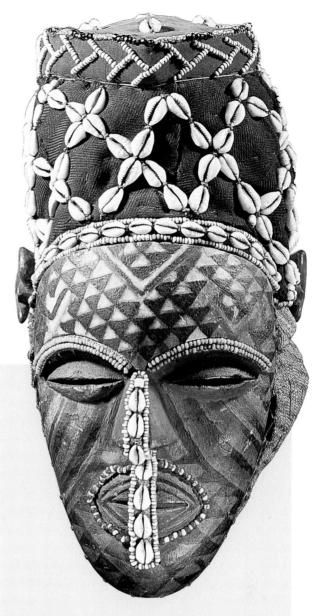

Fig. 1–20 When viewing masks in a museum, remember that they were part of a costume and were used in ceremonies that likely included chants, music, and dance. This mask communicates sorrow and was used in a performance that honored deceased members of the group. What do the parallel lines that run from the eyes suggest to you? Democratic Republic of the Congo; Kongo, Kuba, Female Mask (Ngady Mwaash), 19th century.

Wood, cowrie shells, glass beads, paint, raffia cloth, trade cloth, height: 13 $^3/8$ " (34 cm). ©Bildarchiv Preussischer Kulturbesitz, Berlin.

Meaning Over Time

Africa is a continent of diverse cultural and ethnic groups. Because of this, many creative traditions with long histories are represented in African art. About 500 BC, people of the Nok culture created clay sculptures of people and animals. During the 1400s and 1500s, artists of the kingdoms of Benin, in southern Nigeria, and Ife, west of Benin, mastered bronze casting. The bronze works are detailed, well-crafted, and tell us much about the Ife and Benin kingdoms.

Masks and other art forms from Africa were first displayed in Europe during the late 1800s. Beginning in the nineteenth century, African artisans began to produce art objects for trade. These objects were usually replicas of items used in ritual celebrations or other ceremonies. Ceremonial artworks like these influenced such Western artists as Pablo Picasso and Henri Matisse early in the twentieth century. Today, many museums have collections of African art.

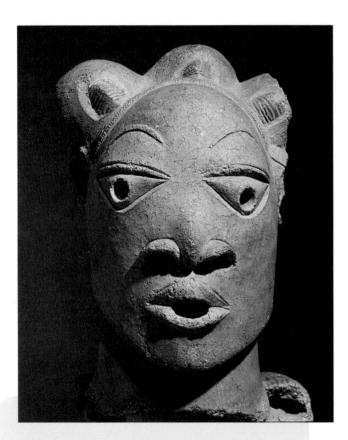

Fig. 1–21 The oldest sculptures discovered so far in sub-Saharan Africa are figures such as this one, which is about 2000 years old. The figures probably served a religious function, perhaps as personal offerings or as messengers to the dead. Nok culture, Nigeria. *Terra cotta head from Rafin Kura*, 500 BC – 200 AD.

Frontal View. National Museum, Lagos, Nigeria. Werner Forman/Art Resource, NY.

Studio Connection

Construct a sculpture of a human figure to celebrate a joyous occasion—a sports victory, birthday, special holi-

day, or even the beginning of summer vacation. Construct your sculpture to be free-standing, perhaps with a flat base. Select materials and use colors that will help to show the feeling that goes along with the event. Use details to create a festive effect. How can you simplify a human figure? How can you make it express happiness or joy? What shapes, color, and symbolic elements can you use to show what you mean?

1.3 Global View

- **1.** How do African artists use artworks to communicate?
- **2.** Why is knowledge about a culture important for understanding the meaning of its artworks?
- **3.** Where and when in Africa was bronze casting mastered?
- **4.** How was twentieth-century European art influenced by African art?

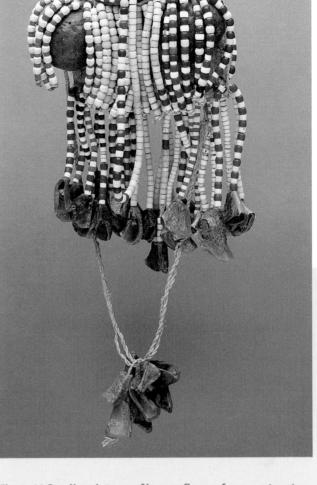

Wood, pigment, cloth, iron, metal, foil, mastic, height: 28 5 /16" (71.9 cm). Indianapolis Museum of Art, Gift of Mr. and Mrs. Harrison Eiteljorg.

Fig. 1–23 Small sculptures of human figures from most parts of Africa are commonly labeled as dolls in museum collections. Bead-decorated dolls like this one, made from a gourd, are more than playthings: They communicate a hope to bear children. Turkana (Kenya), *Doll*.

Gourd, beads, glass, fiber, leather, horn, $10 \text{ "} \times 2^{1}/2 \text{ "} (25.4 \times 6.3 \text{ cm})$. Seattle Art Museum, Gift of Katherine White and the Boeing Company. 81.17.1077. Photo by Paul Macapia.

Sculpture in the Studio

Making a Bas-Relief

Sending Your Own Message

Studio Introduction

Have you ever noticed public statues or monuments in your neighborhood or in a nearby town? Why were they made?

Who or what do they help you remember? The bas-relief sculptures of ancient kingdoms are similar to our public monuments. They, too, celebrate important events and individuals.

In this studio lesson, you will carve, model, and emboss clay to create your own bas-relief sculpture. Page 88 will tell you how to do it. *Carving* involves scooping out unwanted clay. You can *model* a clay slab by shaping it with your fingers or adding smaller pieces of clay to it. To *emboss* clay, press objects into its surface.

Use these techniques to tell about events in your life, a single event, or a sequence of daily activities. As you plan your sculpture, ask yourself: What will I show? What purpose will it serve? How will I display it?

Studio Background

Messages in Relief

The artworks shown in Figs. 1–24, 1–26, and 1–27 are **bas-relief** sculptures. In a bas-relief, some parts of the design stand out from the background. The people who created these sculptures were highly skilled artists: Their works are greatly detailed and show a feeling of depth, even though they are fairly flat.

Bas-reliefs were often created to help people remember a special accomplishment. They may have recorded a military victory, the opening of a new waterway, or the completion of a large building project. Their dramatic stories, high level of craftsmanship, and size were no doubt intended to impress the general public.

Fig. 1–24 This stele is a boulder of pink sandstone, six feet high. The natural shape has been altered only slightly. What kinds of lines do you see? What shapes are repeated? What can you see that suggests it commemorates victory in battle? Akkadian, The stele of Naram-Sin, c. 2300–2200 BC. Pink sandstone, 6' 6" (1.98 m) high. Louvre, Paris. Giraudon/Art Resource, New York.

Figs. 1–25 "Panther"
tiles, which feature the
school mascot, border
the main images of two
large murals made by
students at the Plymouth
Middle School, Maple
Grove, Minnesota. See
the full image on page 89.
Plymouth Middle School, Maple
Grove, Minnesota.

Fig. 1–26 This relief shows a soldier in battle. Notice the detail. How many different patterns do you see? What are they? How could you make these in clay? Assyrian, *Ashurbanipal in battle*, 7th century BC.

Fig. 1–27 A tribute is a gift or payment that one person gives to another. Notice the object that the man in this relief is holding. Notice the fragment of the person behind him holding a lamb. What story might his artwork tell? Persia (Persepolis), *Tribute Bearer*, 5th or 4th century BC. Limestone, 32 ½ x 19 ½ x 5 (82.5 x 49.5 x 12.7 cm). The Nelson-Atkins Museum of Art, Kansas City, Missouri (Purchase: Nelson Trust).

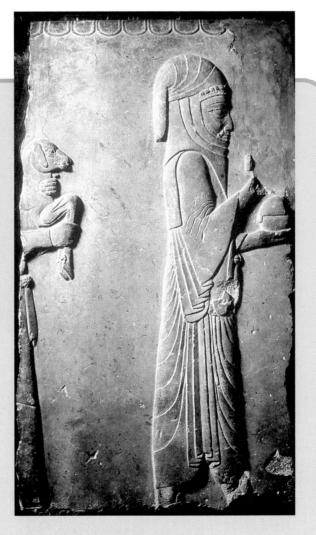

Sculpture in the Studio

Making Your Bas-Relief

You Will Need

- clay
- paper clip
- board covered with cloth
- rolling pin or dowel
- finishing materials
- wooden slats
- clay modeling tools or tongue depressor
- · found objects
- finishing materials

Try This

- **1.** Use a rolling pin or dowel to roll out clay into a slab about $\frac{1}{2}$ to 1-inch thick. Cut the slab into the shape you want with a paper clip.
- **2.** Combine carving, embossing, and modeling to create your relief sculpture. Reshape the surface of the slab with your hands and fingers. Apply coils, pellets, and ribbons of clay with slip. Create surface textures by embossing.

3. As your sculpture begins to take shape, ask yourself: How will the composition fill the space? Which techniques will best show the message? Think about how the high and low areas of the relief create areas of light and dark.

- **4.** When you are satisfied with your work, put it aside to dry evenly and slowly. Your teacher will supervise the kiln firing when the sculptures are dry.
- **5.** Finish your work in one of the following ways:
- Rub neutral pigments or moist dirt into the embossed areas. Before the dirt or pigment dries, wipe the raised surfaces with a moistened rag. Add a protective coat of liquid wax or clear gloss polymer.
- Paint your sculpture with acrylic paint. Use only one color. After the paint is dry, stain it with diluted black acrylic or shoe polish.

Check Your Work

What message did you try to communicate? Were you successful? Were you able to combine modeling, embossing, and carving in a visually pleasing way? Discuss your work with your classmates. As you worked on this project, did you gain any insights into the question of why we make art?

Computer Option

Consider how you might send a message using shapes or symbols only, no words. Using a draw or paint program,

design a shape-and-symbol plaque that sends a message. As you develop your design, you may wish to save several versions. Make a printout of the version you think works best. Using markers, add shading for a threedimensional effect.

Sketchbook Connection

Design a series of coins commemorating important events in your life. Work within a circular format. Consider images

for both sides of the coin.

Fig. 1–28 With the help of their art teacher, 150 students designed and made two large murals, composed of approximately 750 ceramic tiles, for the front entrance of their school. General themes include daily life, friendships, sticking together, equality, peace, connectedness to the world, and unity throughout the school. Images used to show these themes include school materials like the pencil, ruler, computer, books, piano keys, and violin. In addition to working with clay, students stated they had learned teamwork. "You have to do your own part. If you don't finish, it ruins the whole thing. What other people did affected us."

Ceramic, 8' x 8' (2.45 x 2.45 m). Plymouth Middle School, Maple Grove, Minnesota.

Connect to...

Daily Life

What do Adinkra stamps, Egyptian hiero-glyphs, and cuneiform writing have in common? Whether created on stone, wood, cloth, or clay, these symbols of language and ideas send messages. Although they were once understood by people from a particular culture, we often do not fully understand the meaning of such ancient symbols. For example, think how difficult it would be for someone from the ancient world to understand a pedestrian crossing sign, a red traffic light, or other signs and symbols that we see daily.

Look around your immediate environment for **messages from contemporary culture**. What product brands do you recognize and understand just from their symbol, needing no written language to help you? What messages can you find that are meant to be seen by many people?

Fig. 1–29 Coffin of Bakenmut, detail, Egypt, late 21st–22nd Dynasty. Gessoed and painted sycamore fig wood, 81 ⁷/s " x 172.7" (208 x 68 cm). ©The Cleveland Museum of Art, Gift of John Huntington Art and Polytechnic Trust, 1914.561.a-.b

TERNY GUST 6

Fig. 1–30 What music do you imagine playing during this scene? Harold Lloyd in *Safety Last* (1923 US). The Museum of Modern Art, Film Stills Archive, New York.

Other Arts

Music

Musicians play or sing music for various purposes, depending on the event (what is happening) and the audience (who is listening). Watch a scene from a movie or a TV show. Notice how the film score or the soundtrack communicates danger, fear, sadness, action, bravery, or love. How does the composer use musical elements—such as tempo (speed of the music), rhythm, melody, harmony, choice of instruments, and dynamics (loudness and softness)—to create mood? What messages does the music send? Is the **musical message** ever different from the visual message? What might that tell you?

Other Subjects

Mathematics

How do you think early artists created large paintings with **accurate proportions** on high walls? Like many contemporary muralists, they first created drawings in a size that they could easily handle. Then they added a lined grid on top of the image. Next, they drew a much larger grid on the wall, and then transferred and enlarged the image, block by block. Each block, for instance, might have been three times the size of the original drawing, so the ratio of the smaller to the larger drawing was 1:3. This method guaranteed the desired proportions in the completed wall painting.

Social Studies

Artworks and monuments have both **social** and historical significance. They might symbolize, or stand for, various ideas whose meaning depends on the viewer's social or cultural background. Some works are widely recognized and become part of general cultural knowledge. Artists may take advantage of this situation to "copy" and alter such works. For example, Stonehenge has been recreated in a variety of ways. Some artists have used objects other than monumental stones. Two such works are **Autohenge**, in Ontario, and **Fridgehenge**, in Santa Fe. What messages do the artists of these works send?

Fig. 1–31 What does this monument tell about the artist's culture?
William Lishman,
Autohenge, 1986.
Crushed, painted automobiles.
Blackstock, Ontario. Photo by W. M. Lishman.

Careers

How do we know how people in ancient cultures lived? The scientists who provide that information are **archaeologists**. But, along with their expertise in science, many archaeologists also have artistic skills, such as the ability to observe carefully, draw, or paint. Such scientists/artists must accurately depict and document historic finds and help interpret messages from the past. Usually specializing in a particular culture, an archaeologist goes on field studies and excavations to search for tools, buildings, weapons, and other evidence of a culture. Often using scientific dating methods, the archaeologist will then interpret the historic sites and artifacts, and thereby give us a picture of the past.

Internet ConnectionFor more activities

related to this chapter, go to the

Davis website at www.davis-art.com.

Portfolio

"I love rock 'n' roll music. If you have a problem and go listen to the music, your problem will go away, just for that moment."

Jessica Tejeda

Fig. 1–32 Artwork can communicate what the artist cares about. When asked to design a CD cover, this artist made a list of the things she liked: guitar, head phones, dogs, and pizza. Why do artists use line and pattern to create a frame around their work? Jessica Tejeda, Hard Rock, 1999. Colored pencils, 8 ½ " x 8 ½ " (22 x 22 cm). Central Middle School, Galveston, Texas.

Fig. 1–33 A student artist who has won awards for her poetry included a poem in her sculpture. Words are written on a strip of paper held between two hands she fashioned with plaster. Her message speaks of the conflict and isolation between people of different races. Natalie Araujo, *Black and White*, 1997.

Mixed media sculpture, 18" x 18" x 18" (46 x 46 x 46 cm).

Avery Coonley School, Downers Grove, Illinois.

Fig. 1–34 A successful gesture drawing will capture the feeling of action or movement. What do you think this figure is doing? (See Studio Connection on page 79.) William Lara, *Thinking of Someone*, 1992.
Oil stick, 18" x 12" (46 x 30 cm). Sweetwater Middle School, Sweetwater, Texas.

CD-ROM Connection

To see more student art, check out the Global Pursuit Student Gallery.

Chapter 1 Review

Recall

What is a symbol?

Understand

Explain how artworks send messages.

Apply

Design two dinner plates—one with little or no decoration, and the other with added lines and patterns. Consider the message sent by each, and give your dinnerware an appropriate name.

Analyze

Compare and contrast the use of symbols in two artworks reproduced in this chapter. Identify and describe the artworks and consider how they look, what they represent, and how easy or difficult it is to understand the message they send.

Synthesize

Design a poster that encourages people to appreciate how art has been used as a means of communication around the world and throughout time.

Page 83

Evaluate

Select an artwork from this chapter that you believe is a good example of an artist's use of line or pattern to communicate an important message. (One example is shown above.) Write a short essay in which you describe the artwork and give reasons to justify your selection.

Keeping a Portfolio

A portfolio provides a single place to put your work and keep it in good condition. You may use the work in your

portfolio as a reminder of your growth as a maker and viewer of art.

Keeping a Sketchbook

From themes—such as "messages" or "nature"—you might get ideas for artworks. Explore various themes—

and try out personal ideas—in your sketch-book.

For Your Portfolio

Choose an artwork that you made during this chapter. On a separate sheet of paper, write the media and tech-

niques you used; how the work sends a message; how you used elements and principles of design to send your message; and why you are or are not satisfied with the work. Include your name and the date, and put your report into your portfolio.

For Your Sketchbook

Keep one or two pages in your sketchbook on which to design symbols for human emotions. Instead of

using facial expressions for an emotion, you might, for instance, use line and pattern. Add more such designs to these pages throughout the year.

2

Identity and Ideals

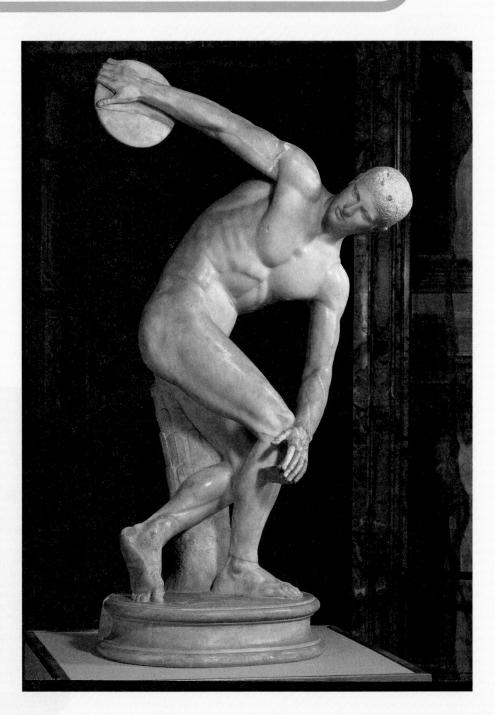

Fig. 2-1 By copying the original Greek Discus Thrower by the sculptor Myron, the Romans showed that they greatly admired the Greeks. The body of this athlete shows the strain of throwing a heavy discus, but the face seems calm. How do both the motion of the body and the calm expression reflect important ideals of the ancient Greeks? Myron of Athens, Discobolus (Discus Thrower). Roman copy of Greek original (c. 450 BC).

Museo Nazionale Romano delle Terme, Rome, Italy. Scala/Art Resource, New York.

Focus

- Why are identity and ideals important parts of life?
- What does art tell us about identity and ideals?

Add up the amount of time that you spend alone in a day. Do you find that most of your time is spent with other people? We tend to live, work, and play together. We live together in households. We pull together to get jobs done. We create games and play sports for fun.

Each of us has an individual **identity**—who we are as a person. When we are young, much of our identity comes from the people who take care of us. As we get older, the groups we belong to also help give us our identity. Groups may be small, like a science club, or large, like a political party. People usually gather in groups because they like to be with others who have similar goals or beliefs. Throughout history and around the world, people have created art that shows and celebrates these similarities.

Members of a group often share **ideals**—a view of what the world and the people in it would be like if they were perfect. What does per-

fection mean to you? Think of a group you belong to. What is the group trying to do? How does it show its ideals? The Discus Thrower (Fig. 2–1) reflects the ideals of people who lived together in ancient Greece. The Greeks believed that the ideal person—one who was perfect in every way learned to control both mind and body. The ideal mind was calm and not emotional. The ideal body was strong and flexible, with pleasing proportions.

What's Ahead

- **Core Lesson** Examine ways that art reflects identity and promotes ideals.
- 2.1 Art History Lesson
 Learn about three Mediterranean empires and how art helped each empire show its ideals and identity.
- 2.2 Elements & Principles Lesson
 Focus on ways that artists use texture
 and rhythm to unify their artworks.
- 2.3 Global View Lesson
 Learn how Native-American art
 promotes identity and helps keep
 people together in groups.
- 2.4 Studio Lesson
 Make drawings of architectural elements that reflect a group's identity.

Words to Know

identity	tesserae
ideals	crest
self-portrait	totem
rhythm	architectural
texture	floor plan
mosaic	elevation drawing

The Art of Special Groups

Art Reflects Identity

Imagine that you are watching an Independence Day parade. Think of groups that march in the parade. What do members of these groups have in common? How do they show that they are a group? Marching bands, war veterans, town clubs, and sports teams, for instance, might show their group identity by their uniforms, floats, or theme songs. Many such groups use symbols to help represent who they are and what they believe.

Artworks can show group identity, too. Some artworks are used in important ceremonies or rituals. Some cultures believe that wearing elaborate costumes or using special objects will help them achieve a goal. The carved wooden mask in Fig. 2–2 was made to be worn in a ceremonial dance held by the Native-American Kwakiutl (*kwah-key-OOT-ul*) of Vancouver Island. The mask was used to remind the group of significant beliefs.

The way artworks look can tell us something about what is important to a group. For example, the clay sculpture in Fig. 2–3 represents an important person in ancient

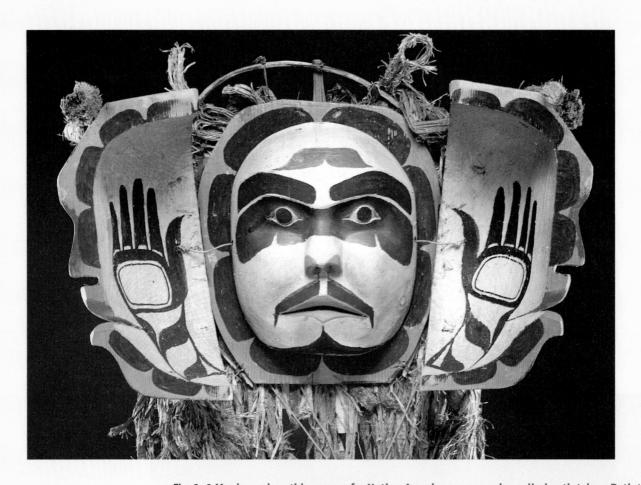

Fig. 2–2 Masks such as this one are for Native-American ceremonies called potlatches. Potlatches are held to distribute property and make marriages and other contracts official. How might this mask show that the wearer belongs to a group? Hopetown, *Mask of Born-to-Be-Head-of-the World*. Wood, reed and undyed cedar bark, rope, 24 ½ " x 29 5/8" x 9 1/8" (62 x 75 x 23 cm). No. 4577(2). Photo by Lynton Gardiner. Courtesy Department of Library Services, American Museum of Natural History.

Identity and Ideals

Mayan society. To show their status, Mayan kings, lords, and warriors wore fancy head-dresses. The more complex the headdress, the more important the wearer. Think about your own culture. How do people make themselves look important or powerful? How can you tell, for instance, the difference between an ordinary soldier and a general?

Artists can also challenge group members to question their beliefs. When Native-American artist Jack Malotte created *It's Hard to Be Traditional When You're All Plugged In* (Fig. 2–4), he wanted to challenge young people—especially Native Americans—to question the way they live their lives.

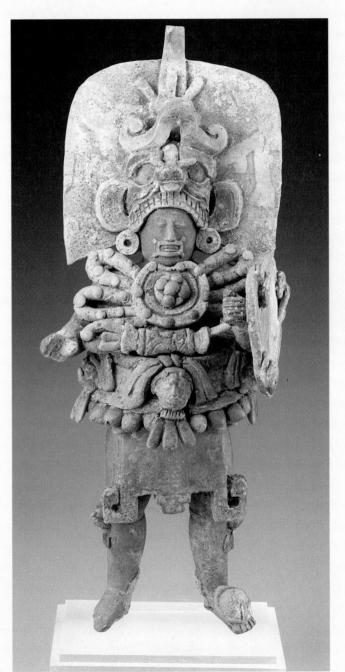

Fig. 2–3 The Mayan ruler represented in this sculpture wears a very complex headdress. What other details in this artwork might suggest this ruler's identity? Mayan, A Ruler Dressed as Chac-Xib-Chac and the Holmul Dancer, c. 600–800.

Ceramic with traces of paint, 9 3/8" (23.8 cm) high. Kimbell Art Museum, Fort Worth, TX. Photo by Michael Bodycomb.

Fig. 2–4 This artist points out how difficult it can be to hold onto ancient traditions in a modern world.

Jack Malotte, It's Hard to Be Traditional When You're All Plugged In, 1983.

Mixed media, 22" x 30" (55.9 x 76.2 cm). American Indian Contemporary Arts.

Art Promotes Ideals

People like to celebrate and display what they believe is important or ideal. Citizens of the United States understand that the red,

white, and blue flag with stars and stripes stands for their country. The flag also stands for democracy and the ideals of freedom, responsibility, and loyalty. When artists use this powerful symbol, they expect viewers to recognize a message about American ideals. Study Fig. 2–5, Whirligig Entitled "America." Why do you think artist Frank Memkus combined the playfulness of the whirligig with the seriousness represented by the flag?

Ideals are often presented through a culture's customs. Throughout history in China, for example, color, style, and fabric patterns all have special meaning. For official business, men wore a dragon robe like the one in Fig. 2–6, in which several dragons are shown. The dragon, a symbol of authority, is usually associated with the Chinese emperor. Patterns on the robe represent water, clouds, mountains, fire, and grain—all symbols of power and authority.

Fig. 2–5 Imagine you didn't know about United States symbols and ideals. Would you be able to name some American ideas represented by this painted wooden form? Frank Memkus, Whirligig Entitled "America," 1938/42. Wood and metal, 80 ³/4" x 29" x 40" (205 x 73.7 x 101.6 cm). Restricted gift of Marshall Field, Mr. and Mrs. Robert A. Kubiceck, Mr. James Raoul Simmons, Mrs. Esther Sparks, Mrs. Frank L. Sulzberger, and the Oak Park-River Forest Associates of the Woman's Board of The Institute of Chicago, 1980.166. Photo by Thomas Cinoman. Photograph copyright 1999, The Art Institute of Chicago, All Rights Reserved.

Most world religions use symbols to remind followers of shared ideals. The cross shown in Fig. 2–7, for example, suggests ideas, values, and goals that are important to Christians.

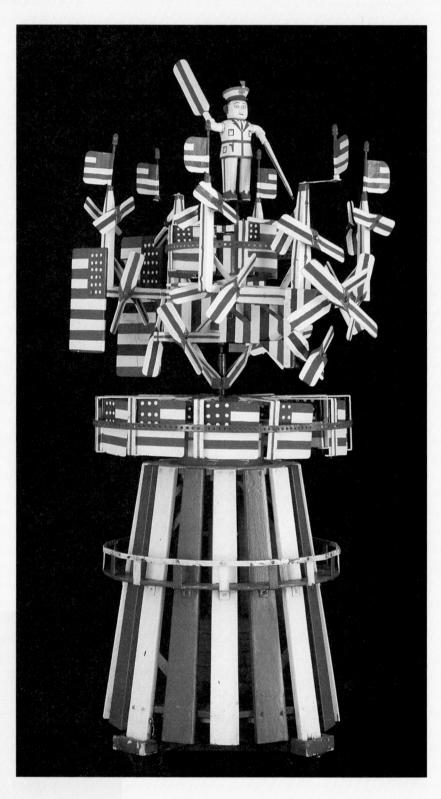

Fig. 2–6 The dragon robe was worn for daily official business. Chinese dress codes required a more elaborate robe for important state occasions. Why do you think that the bottom of the sleeve was called a horse-hoof cuff? China, *Dragon Robe*, late 19th century (Quing dynasty).

Embroidery on silk gauze, 53 ½ " x 84" (135.9 x 213.4 cm).

Asian Art Museum, San Francisco, The Avery Brundage Collection, 1988.3.

Fig. 2–7 This cross, decorated with gems, was a gift to a sixth-century pope from a Byzantine emperor. A cross—whether made of gems and precious metals or simpler materials—stands for the crucifixion of Christ and is a central symbol of Christian ideals and identity. Reliquary Cross of Justinian, Byzantine, 6th century.

Gold. Museum of the Treasury, St. Peter's Basilica, Vatican State. Scala/Art Resource, New York.

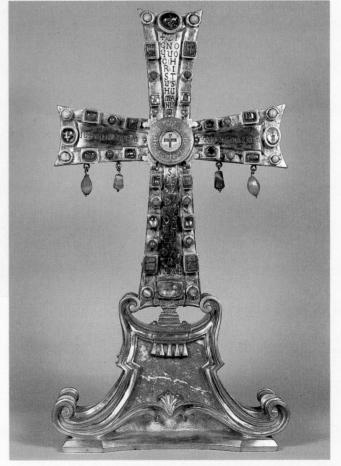

Sculpture in the Studio

Sculpting Your Identity

You've seen that artworks can show group identity and encourage group ideals, sometimes by using symbols. Think of the groups you

belong to that help make up your identity. The family is the first group to which most of us belong. You might also belong to a religious group, a sports team, or a club. What other groups do you belong to?

A **self-portrait** is an artwork you make that shows yourself. In this studio experience, you will make a papier-mâché self-portrait that uses symbols to tell about who you are and what is important to you.

You Will Need

- pencil
- scrap paper
- wire or pipe cleaners
- papier-mâché paste
- tape
- newspapers

- paper towels or tissues
- modeling tools
- assorted found materials
- acrylic paint, varnish, and paintbrushes (optional)

Try This

- **1.** Make a list of all the groups to which you belong. Then make a list of your ideals. Draw symbols to represent each item on the lists.
- **2.** Sketch portrait ideas, including poses and where you could include symbols.
- 3. Build an armature for your sculpture.

Bend wire into the pose you desire.

4. Wrap paper tightly on the wire armature. Add rolls or wads of paper towels or tissues for the head, hands and feet, and other special features.

Studio Background

Artworks About People

Art can show what a person looks like on the surface. It can also show deeper characteristics—what the person loves or hates and how he or she feels. A person's identity, including his or her ideals, values, beliefs, and principles, can be shown in different ways. The artist might show the person doing something. Or the person might be shown dressed a certain way. Artists also use facial expression to show emotions.

Fig. 2–8 The artist chose a symbol of this person's identity. Peter Vandenberge, *Hostess*, 1998.

Ceramic, stains, slips, underglazes, 46" x 22" x 13" (116.8 x 55.9 x 33 cm). John Natsoulas Gallery, Davis, CA.

5. Wrap the sculpture with four or five layers of pastesoaked newspaper strips. Add a final layer made from strips of blank newsprint paper.

6. When the sculpture is dry, decorate with paint, yarn, fabric, buttons, and small objects. Include symbols that represent your identity and ideals.

Check Your Work

Display the completed self-portraits and discuss them as a class. How does each self-portrait show identity and ideals? Can you tell which groups the person belongs to based on his or her self-portrait?

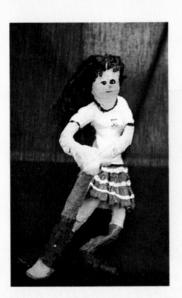

Fig. 2–9 Kelly O'Connor, Field Hockey Girl #10, 1999. Plaster gauze, over a wire and newspaper armature, and acrylic paint, 12" (30.5 cm) high. Pocono Mountain Intermediate School South, Swiftwater, Pennsylvania.

How did artists Peter Vandenberge (Fig. 2–8) and Alison Saar (Fig. 2–10) give us information about the people they sculpted? Can you guess some groups these people might belong to? What do the materials the artists chose tell us about the people they portrayed?

Both of the sculptures shown here include symbolic objects. Saar and Vandenberge very carefully chose the objects they included in their portrait sculptures. Notice where these objects are placed within the sculptures. What does the placement of the objects tell us about these people?

Sketchbook Connection

Practice drawing the human figure. Ask a friend or family member to pose for you in a standing position. The overall

figure should be about seven heads tall. Sketch the basic shapes. When you are pleased with shapes and proportions, you may wish to add details. To practice further, have the model pose in a new position or ask a different person to pose.

Core Lesson 2

Check Your Understanding

- **1.** How might the beliefs of a group of people affect the art they produce? Give examples with your answer.
- **2.** How can an artwork show the status of a person within a community?
- 3. What can the design of an artwork tell you about the identity of the people who made and used it?
- **4.** How can a papier-mâché sculpture show a person's identity?

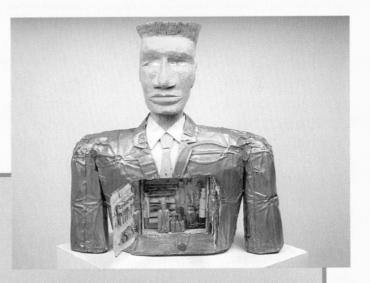

Fig. 2–10 This contemporary portrait bust has wild orange hair and a green formal suit. What do you think these features might symbolize? Do you think the artist promoted or challenged ideals by including the man's own medicine "chest"? Alison Saar, Medicine Man, 1987.

Wood and tin, 27" (68.6 cm) high. Jan Baum Gallery, Los Angeles.

The Art of Three Empires

Greece, Rome, and Byzantium

While civilizations in Mesopotamia, Egypt, and elsewhere flourished along great river valleys, others were developing along the shores of the Mediterranean Sea. The ideals of Greece, Rome, and Byzantium would have a great influence on art in many parts of the world.

In all areas of their lives, the Greeks tried hard to attain their ideal of the person who was perfect in both body and mind. Their art reflects this ideal.

When Greek culture was at its height, Rome was just a village of straw-roofed huts. The Romans eventually conquered Greece, much of the Mediterranean world, and vast areas beyond. Early Romans admired the Greek ideals of harmony and balance. The Romans copied many examples of Greek art. They also tried to make their art realistic.

In 330 AD, Rome's last important em-

peror, Constantine, moved the capital east, to Constantinople. Near his death, Constantine became a Christian. His eastern empire was called Byzantium. This new empire embraced

Christianity and its ideals.

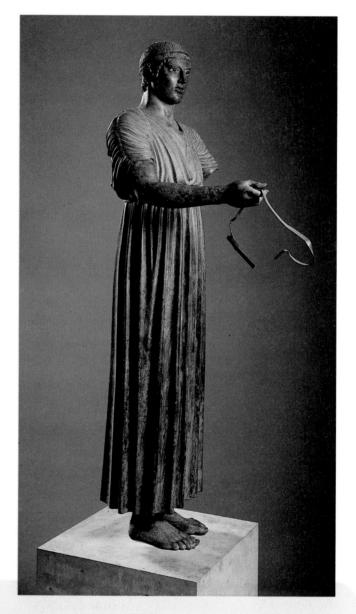

Fig. 2–11 This sculpture was once part of a grouping with a chariot and horses. Notice the calm pose and facial expression. How does this sculpture reflect Greek ideals? Greek (Classical), *The Charioteer of Delphi* (side view). Dedicated by Polyzalos of Gela for a victory either in 478 or 474 BC.

Bronze, 71" (180 cm) high. Archaeological Museum, Delphi, Greece. Nimatallah/Art Resource, New York.

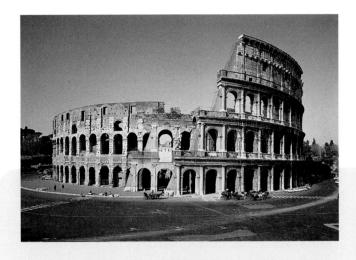

Fig. 2–12 Compare this Roman amphitheater (a kind of arena) to the Greek temple in Fig. 2–13. How does the use of the arch make the Roman example different? What modern structure does this remind you of? *The Colosseum*, 72–80 AD. Rome, Italy. Scala/Art Resource, NY.

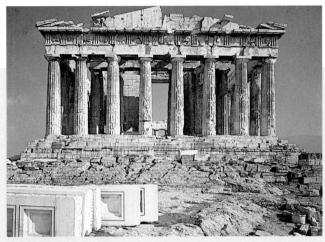

Fig. 2–13 Greek architecture reflects the ideals of order, balance, and proportion. Each part relates to the others harmoniously. Imagine if these columns were placed at greatly varying distances from each other. How would that change this temple? Iktinos and Kallikrates. West façade of the Parthenon, Acropolis. Athens, Greece, 448–432 BC.

Pentelic marble, 111' x 237' (33.8 x 72.2 m) at base. Scala/Art Resource, New York.

The Greek Search for Perfection

Artists in ancient Greece experimented with different kinds of art. They explored sculpture, painting, mosaics, and architecture. Their goal was to achieve harmony and balance. The Greek idea of beauty was based on perfect proportions and balanced forms.

Greek artists of the sixth and seventh centuries BC created sculptures of the human figure standing in a somewhat stiff pose with one foot forward. By the fifth century BC, the style had changed. Artists showed more natural-looking figures in realistic positions. These artworks are called classical.

Ancient Greek sculptures showed how people moved and looked in real life. They usually did not show people's wrinkles, freckles, or other features that make each person unique. Greek artists were trying to show the perfect person, rather than a specific one. Their art reflects the ideal that Greek people were trying to live up to: a perfect human being, both in body and in mind.

The Greeks used the human body as the basis for their architecture, too. They compared the parts of a building to the parts of the human figure. They noticed the way parts relate to one another, support each other, and work together in harmony. The Greeks wanted their architecture to have perfect balance and ideal proportions, just as the figures in their sculpture and painting did.

Roman Realism

Artists of ancient Rome learned many lessons from the Greeks. But art had different functions in the vast Roman Empire. The Romans wanted the identity of the people in their artworks to be easily recognized. So they created sculptures and paintings of people they knew or wanted to remember.

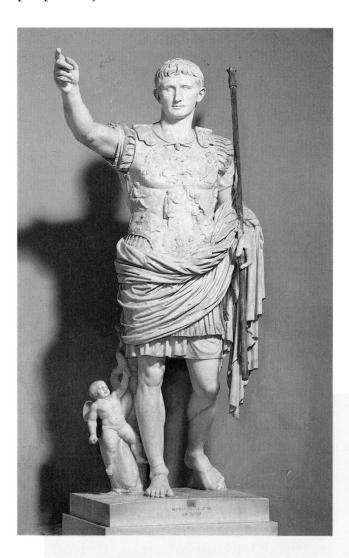

Fig. 2–14 This Roman sculpture looks like earlier Greek examples in its pose and overall proportions. How has this sculptor created a portrait that looks like the ruler himself? How does this differ from the Greek figure in Fig. 2–11? Augustus of Prima Porta, Roman Sculpture, Early first century AD.

Vatican Museums, Vatican State. Scala/Art Resource, New York.

These artworks showed their rulers, ancestors, and their own peers as they really looked.

For the rulers of the Roman empire, art was also a way to promote their own identity. Likenesses of Roman rulers appeared in sculptures, paintings, and on carved reliefs throughout the empire. Roman artists sometimes made the bodies look perfect to emphasize the perfect qualities of the ruler. But they also showed the ruler's own facial features and expressions. This way, subjects in any part of the empire would know what their ruler looked like.

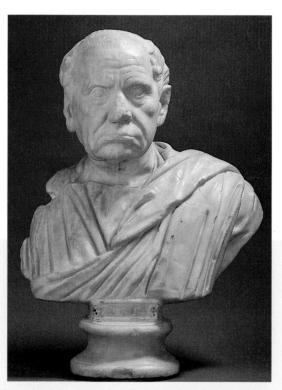

Fig. 2–15 Roman portrait sculptors showed the exact features and details of a person's face. They created a true record of how he or she looked. The Roman Gentleman, c.120 AD.

Marble, 17" x 23 5 /s" x 10 3 /4" (43.2 x 60 x 27.3 cm). Nelson-Atkins Museum of Art, Kansas City (Purchase: Nelson Trust). Photography by Robert Newcombe. ©1999 The Nelson Gallery Foundation. All Reproduction Rights Reserved.

Byzantine Ideals

After nearly four centuries of peace and prosperity, problems were beginning to appear in the mighty Roman empire. The empire was divided into a western half in Rome and an eastern half centered around what is today the city of Istanbul, Turkey. The strength and power of the empire were no longer certain. People began to look to new ideals for comfort and stability.

The popularity of Christian ideals marked a new age in Western art. People questioned Greek and Roman ideals of the perfect human being, physical beauty, and strength. They began to look to Christian teachings for ideals of how to live.

Much art of this time shows these new spiritual ideals. Artists frequently focused on scenes and figures from holy books. Such artworks reminded people that following these new teachings was the best way to live.

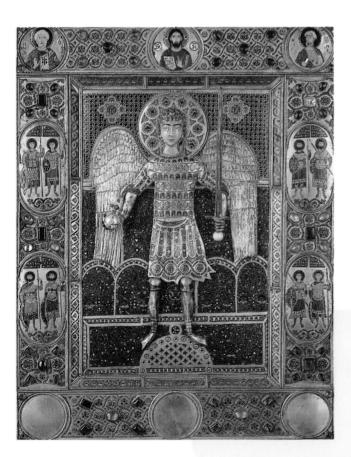

Studio Connection

As the detail below shows, the Greeks sometimes used statues of male or female figures as supports for buildings. How

are these different from the columns in the Parthenon (Fig. 2–13)? Create a collage of

your own building façade (outside front) using human figures as the architectural supports. The people you show in the columns should reflect the

identity of the people who will use the building. Photocopy pictures of people. Combine them with pictures of architectural details, such as windows, a roof, or doors. Give your building façade a name, such as *The House of the Football Players*.

2.1 Art History

Check Your Understanding

- 1. Select one artwork from each of the ancient empires. Tell how each one reflects what was important to the people living at the time.
- 2. Which sculptures show the identity of the individual more clearly: classical sculptures of ancient Greece or realistic sculptures of ancient Rome?
- **3.** How do the artworks produced by Roman artists reflect their admiration for Greek sculpture?
- **4.** What is a significant difference between the art of the Byzantine and the Roman empires?

Fig. 2–16 Christianity spread quickly throughout the eastern Byzantine empire. Artworks emphasized humanity's relationship to God and used images to tell stories about how to live a Christian life. Can you identify symbols of Christianity in this enameled artwork? The Archangel Michael with Sword, Byzantine, 11th century. Gold, enamel, and precious stone. Framed icon. Tesoro San Marco, Venice. Cameraphoto/Art Resource, New York.

Texture and Rhythm

Look at the people in Fig. 2–18. Who is the most important person in the group? How can you tell? In the Byzantine empire, people thought of Emperor Justinian as very nearly equal to God. Notice the golden halo around his head. The halo breaks the visual **rhythm** of the row of repeated round heads. It calls attention to the emperor. In the benches in Fig. 2–17, visual rhythm is used in another way to bring out a playful mood. In both works, the real **texture** of the mosaics reflects light and creates visual interest.

Looking at Texture

Texture is how a surface feels when you touch it. Every object has its own texture or combination of textures. In art, there are two kinds of textures. *Actual* textures are those you can really feel. For example, the actual textures of glass, stone, and clay feel hard and smooth. *Implied* textures are created textures that only look like actual textures. An artist can paint with smooth

watercolors a texture that looks like a soft, fuzzy surface.

Textures can also be described by the way a surface reflects light. A glossy surface has a shiny texture: It reflects light and glistens. A rough surface absorbs light and looks dull.

Artists use different media to create textures and the illusion of textures in artworks. If you wanted to create a heavenly look in your artwork of the emperor and empress, what art media would you choose? Byzantine artists chose a **mosaic**, which was made of cut and assembled **tesserae**—small pieces of colored glass, marble, and stones. They pressed each piece into wet plaster. The mosaic stood out from the wall at a slight angle. The texture helped express Byzantine ideals of what was divine or holy.

In Fig. 2–17, Antonio Gaudí chose to design a fanciful mosaic bench using larger pieces of ceramic tile. He combined a shiny texture with other design elements to create an ideal public space. How might the mood of this park space be changed if the bench were made of wood?

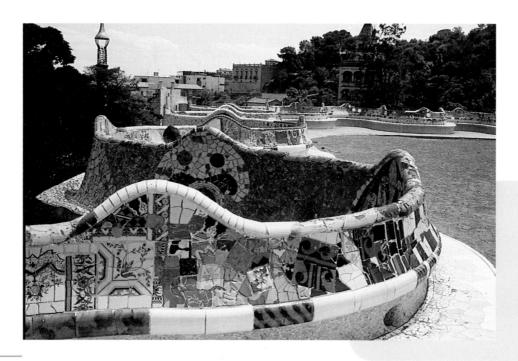

Fig. 2–17 To give this mosaic bench a curved surface, Gaudí broke flat tiles and arranged the pieces to follow the outlines. Where can you see rhythm in his design? Antonio Gaudí, Güell Park Benches, 1900–1914. Barcelona, Spain. Courtesy of Davis Art Slides.

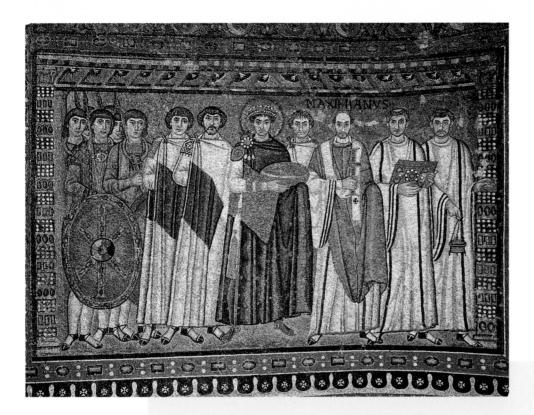

Fig. 2–18 Since Justinian had never been to Ravenna, the mosaic reminded people in Ravenna of his power. The mosaic's glittering texture and gold background suggest a spiritual world. Imagine the effect of light on this mosaic texture. How would the mosaic look different if it were a sunny day? A cloudy day? Byzantine, *The Court of Justinian*, c. 547.

Mosaic, 8'8" x 12' (2.64 x 3.65 m). S. Vitale, Ravenna, Italy. Scala/Art Resource, NY.

Looking at Rhythm

Feel your heartbeat. Tap your foot to music. You are responding to rhythm. In artworks, rhythms may be created by repeating visual elements. Flowing lines, changes in colors, or spaces between shapes can also create rhythm. Graceful, curving lines might create a flowing rhythm. Sudden changes in colors or shapes might create a jazzy or jumpy rhythm. If an artist carefully plans the rhythms, the artwork can become unified. Rhythms can lead the viewer from one point to another in a visually pleasing way.

Notice the rhythms created by repeating elements in the Byzantine mosaics. Do you sense a rhythm in the way the artist arranged the vertical folds of the gowns and robes? Do you sense a rhythm between the round heads and the spaces between them?

Studio Connection

Create your own mosaic by using an assortment of papers cut or torn into small pieces. Show someone you know in

an outfit or clothing that identifies them as belonging to a particular group. Add shiny paper or foil to create a surprise element and to reflect light. Use papers of different thickness and textures to create an interesting, rich surface.

2.2 Elements & Principles

Check Your Understanding

- **1.** How is the texture of the Byzantine mosaic similar to the texture of Gaudí's park bench? How is it different?
- **2.** Explain one way that artists can create rhythm in an artwork.

Native North American Art

Throughout human history, people have moved in groups from one continent to another. These movements are called migrations. North America has had migrations, too. Archaeologists now believe there may have been migrations as far back as 15,000 BC. With the help of modern technology, we continue to learn about and discover the many different peoples who lived in this part of the world.

Ancient and native peoples who migrated to North America did not keep written records. They shared their beliefs and traditions through spoken stories and tales of how life began. Each native group has its own history, language, and beliefs. However, when we compare their artworks, we can see that Native Americans share common ideals and a deep respect for nature.

Native peoples of North America have a long history. They show their identity and ideals through many different kinds of artistic objects. Today, native peoples continue to use traditional themes and techniques for inspiration. Art is the link that helps them hold onto the identity and ideals of their ancestors.

Group Identity: Unique Designs

Early in their settlement of North America, native peoples developed specific shapes, patterns, and designs on their artworks. For example, about 1000–1250 AD, ancient cultures of the American Southwest such as the Anasazi (Fig. 2–19) and Mimbres were creating black-and-white geometric designs and animal forms that are unlike any others. Today, it is often possible to know the identity of a community by looking at its unique designs.

Native Arts of North America

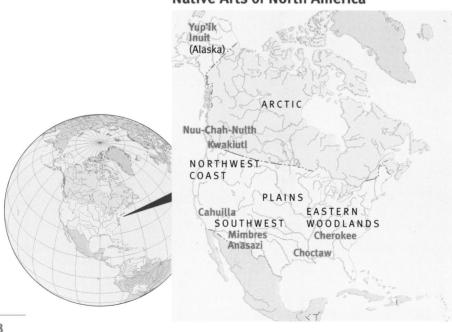

Fig. 2–19 Complex patterns such as the design on this jar were created by painting in black on a white background. How did the artist make the design fit the form of the jar? American, New Mexico, Anasazi people, Seed Jar, 1100–1300. Earthenware, black and white pigment, 10 5/8" (27 cm) high, diameter 14 1/2" (36.9cm). Gift of Mr. Edward Harris 175:1981. St. Louis Art Museum.

Family Identity: Crests and Totems

The Pacific coast of Canada and northern United States is known as the Northwest Coast. Northwest Coast peoples are known for artwork with simple shapes and strong outlines of human and animal forms (Figs. 2–20 and 2–21).

In native Northwest Coast communities, the **crest** is the most important way to show identity. A crest is a grouping of **totems**— animals or imaginary creatures that are the ancestors or special protectors of a family. Only that family has the right to use those crest images in their art.

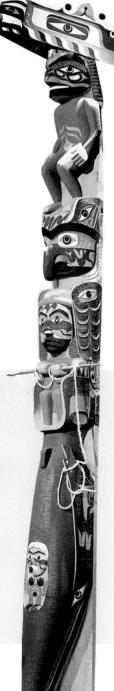

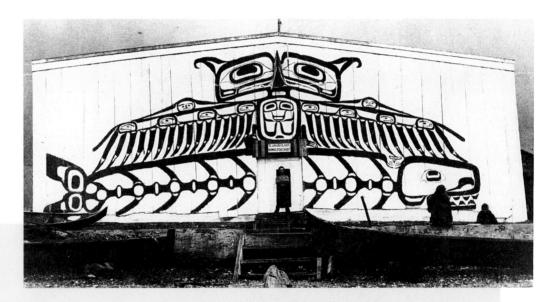

Fig. 2–20 Look closely at this Northwest Coast totem pole. What human or animal forms can you see? Nuu-Chah-Nulth people, Canada, *Totem*.

Painted wood. S92-4402. Canadian Museum of Civilization, Quebec.

Fig. 2–21 The façade of this house shows a Northwest Coast family's crest figures. The crest shows a thunderbird (a mythical bird) trying to lift a whale. What effect do you think this large painted image has on visitors? Kwakiutl Painted House. Kwakiutl, Alert Bay, British Columbia, Canada, before 1889. Courtesy of the Smithsonian Institution, National Anthropological Archives, Bureau of American Ethnology, neg. no. 49, 486.

Ideals of Nature

You have probably noticed that much Native North American art is made of natural materials. Many of these artworks have plants and animals in the designs. This is because Native Americans believe that living in harmony with the natural world is an important ideal. They believe they must form a special relationship with everything in the natural world: animals and plants, the sun and

water, earth and sky. They respect natural things and forces. They know they depend on nature and cannot live without it.

Making artworks from natural materials and using designs related to nature help native peoples form this special relationship. They believe they can receive power, strength, protection, and knowledge from the spirits that are part of all natural things.

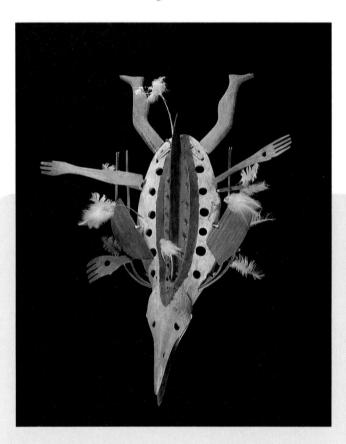

Fig. 2–22 Traditional Yup'ik (also called Eskimo) masks from Alaska were worn during dances or ceremonies. By wearing these masks, the Yup'ik hoped to connect with the spirits found in animals and nature. The spirits would ensure a good hunt or help heal someone who was sick. Yup'ik, Mask of a diving loon, before 1892.

Wood, paint, owl feathers, height: $31\frac{1}{2}$ " (80 cm). Sheldon Jackson Museum, Sitka, Alaska (11.0.11). Photo by Barry McWayne.

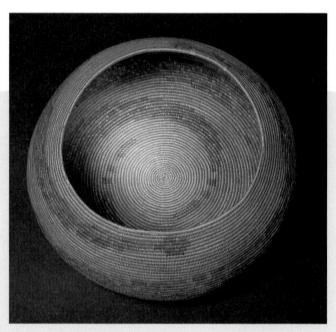

Fig. 2–23 From gathering the grasses to creating the designs on this basket, everything is a give-and-take process between human beings and the natural world. Why might someone living in the desert choose a snake design to decorate a basket? Cahuilla, *Basket with rattlesnake design*, California, n.d. 6 3/8 " x 14 1/8" (17.3 x 35.8 cm). National Museum of the American Indian, Smithsonian Institution. Photo by David Heald. 24.7735.

Fig. 2–24 The arrival of European settlers also brought new materials for artworks. Although glass beads replaced bird or porcupine quills to decorate objects, the designs often remained traditional. Choctaw, Eskofatshi (beaded Bandoliers), Mississippi, c. 1907. Wool with cloth appliqué, $46^{1}/2$ " x $3^{1}/4$ " (118 x 8.1 cm); $49^{1}/2$ " x $3^{1}/2$ " (125.6 x 8.8 cm). National Museum of the American Indian, Smithsonian Institution. Photo by David Heald. 1.8859 and 1.8864.

Fig. 2–25 This artist feels she lives a "double life" as a Native American living in a non-Native society. Why do you think she chose this two-part format for her artwork? Kay WalkingStick, On the Edge. 1989.

Acrylic, wax, and oil, 32 " x 64 " x 3 $\frac{1}{2}$ " (81.3 x 162.6 x 8.9 cm). June Kelly Gallery,

Changes in Identity: The Postcontact World

There was another great wave of migration to North America in the early 1600s. The arrival of European settlers greatly altered the lives of native peoples. Often the Native Americans were forced to accept a new way of life with different ideals and values. But some native cultures were able to retain their traditions and ideals. They continued

to produce works using age-old techniques and styles.

Today, many contemporary artists still work with traditional techniques and designs. They try to preserve a link with the past. Others choose to work in nontraditional ways, but use their art to reflect their native heritage and identity.

Studio Connection

If you could have a personal mascot or an animal to represent you, what would it be? Think about how animals are

used to advertise products or to identify sports teams. Think about phrases such as "wise as an owl," "fast as a rabbit," "clever as a fox," and "busy as a bee." Do any of these describe you? Think of the materials and techniques you might use to make an animal sculpture that would be your identity mascot. Use clay, wood, wire, or cardboard to make your sculpture.

2.3 Global View

Check Your Understanding

1. How does Native-American art promote identity and help keep groups together?

- **2.** How do traditional Native-American artworks reflect the ideals of Native Americans?
- **3.** What special features of Northwest Coast artworks make it easy to tell them from artworks made by Native Americans in the Southwest?
- **4.** How have contemporary Native-American artists dealt with issues of identity in their work?

Architecture in the Studio

Drawing Architectural Forms

Buildings and Identity

Studio Introduction

Imagine that you are designing a sports complex that expresses the identities and ideals of the local athletic teams. How

will you represent the teams' identities? How can you express the teams' ideals visually? If you were an architect, you would sketch your ideas, then you would probably draw an **architectural floor plan**—a diagram of an interior part of the complex seen from above. Or you might make an **elevation drawing**—a drawing that shows an interior or exterior side of the complex.

Architectural designs often convey important ideas about the people who will use the building. In this studio lesson, you will create an elevation drawing of a public building— a school, library, town hall, or the like—in your community. Pages 114 and 115 will tell you how to do it. The drawing will include visual clues related to the purpose of the building or the kinds of people who use it.

Studio Background

Architecture with Meaning

You have probably seen architecture around your town that looks something like the temples and public buildings of ancient Greece and Rome. Architects who design banks, libraries, and government structures often borrow shapes and forms that were first used by Greek and Roman architects. These features reflect ancient ideas about politics and beauty. They send the message that whatever is inside the building will last forever.

Some cultures use a more personal expression of identity in their architecture. The large plank houses built by Native Americans of the Northwest Coast are an impressive example. Every plank house has an enormous totem pole. The animals and crests on the totem pole declare the family's identity and history. Other features, such as house posts and exterior walls, are also decorated with family symbols.

Fig. 2–26 Plank houses of the Northwest Coast Haida people, which range in size from 20' x 30' (6 x 9 m) to 50' x 60' (15 x 18 m), were designed to house extended families and their slaves. What kinds of animal symbols do you see in the totem pole? What stories might they tell? Haida house model, late 19th century. British Columbia, Canada. Carved and painted wood, 35 3/8" x 18 7/8" x 16 1/2" (90 x 48 x 42 cm). National Museum of the American Indian, Smithsonian Institution. Photo by David Heald. 7.3031.

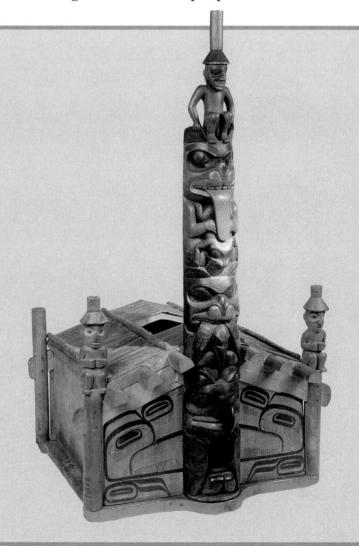

Identity and Ideals

Fig. 2–27 "I picked this house because I like the look of a Colonial house in the country. It reminds me of my house except a little smaller. Making the shingles and windows took a while because of all the lines. I had a fun time making it." Andrew T. Napier, The Big House, 1999.

Pencil, pen, $8\frac{1}{2}$ " x 11" (20 x 28 cm). Antioch Upper Grade School, Antioch, Illinois.

Fig. 2–28 You might think that this building is a well-preserved temple from ancient Greece, but it's actually the Philadelphia Museum of Art. The museum structure is like that of Greek temples built 2500 years ago. Why do you think the architects included features of Greek architecture in the museum design? Philadelphia Museum of Art, 1995.

Photo by Graydon Wood, 1998. (D. Winston, H. Armstrong Roberts, Inc.). Riverfront view.

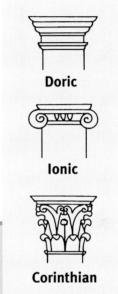

Fig. 2–30 The Greek ideals of elegance and beauty are clearly seen in the evolution of the culture's columns and capitals. How would you describe the differences between the capitals diagrammed here?

Drawing in the Studio

Creating Your Elevation Drawing

You Will Need

- sketchbook
- soft lead pencil (#2)
- eraser
- graph paper or drawing paper
- ruler
- fine-tip marker

Try This

- **1.** Discuss or visit a public building in your community. What clues to the building's identity do you notice? For example, what emblem or design does your school building feature? What does it tell people about the ideals of the school or the school's values?
- **2.** Select a building that interests you. Choose an interior or exterior wall that you think tells something about the building. Make some quick pencil sketches that show the basic features of the wall and how those features work together. Don't worry about drawing straight lines.

3. Estimate the size of the wall and its parts. Then create a scale at which you will draw the wall. For example, ½ inch might equal 1 foot of the wall's length.

4. Using a ruler, draw the wall to scale on graph paper.

5. After you draw the basic shape of the wall, add simple lines that suggest details such as windows, cabinets, decorative elements, and

the like. Think about how these architectural details can help show the ideals the building represents.

6. When the elevation drawing is finished, trace over the pencil lines with a fine-tip marker.

Check Your Work

Share your sketches and elevation with a partner or small group, and discuss any challenges you faced. What parts of the drawings are particularly successful? What would you change?

Display all the elevations and discuss ways they do or do not reveal the identity of the buildings portrayed. Which buildings borrow architectural details from the past?

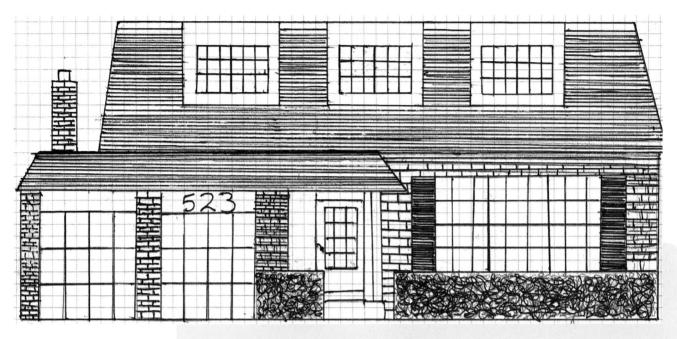

Fig. 2-31 "The hardest part was making the house to scale. The easiest part was the garage. I like the point of view from straight on. It looks different from the usual perspective drawing of a house." Tricia Moore, My House, 1999. Marker, $8\frac{1}{2}$ " x 11" (22 x 28 cm), Antioch Upper Grade School, Antioch, Illinois.

Sketchbook Connection

Sketching and doodling help artists and designers think visually. Experiment with doodles. Make a sequence of

fifteen doodles that start with a simple shape—a circle, square, or triangle. What ideas come to mind as you work with the shape? Which of your doodles could become a design for an architectural feature? Why?

Computer Option

Complete steps 1 through 3 of the Try This. For steps 4 and 5, use a drawing program to accurately create the eleva-

tion drawing. How can you use the power of the computer to increase the accuracy of your measurements? Use different line weights to show the importance of details

Connect to...

Other Arts

Theater

In this chapter, you learned that we can examine the art of a past civilization and begin to know how its people lived and what ideas they shared. By looking at the visual art of the ancient Greeks, we know that they sought perfection in mind and body. From their plays, we know they believed that the individual had a responsibility to act morally, even if that meant going against society's laws. The Greek playwright Sophocles (c. 496–406 BC) explored this idea in *Antigone*, a play about a young woman who dares to speak up against the cruel actions of Creon, the dictator king. Read the following scene from *Antigone*, and discuss who is right, Antigone or Ismene.

(Antigone and her sister Ismene are discussing their brothers, Eteocles and Polyneices, who have just been killed in battle.)

ANTIGONE: Eteocles is to be entombed with every solemn rite and ceremony to do him honor, but as for Polyneices, King Creon has ordered that none shall bury him or mourn for him. Polyneices must be left to lie unwept and unburied. So King Creon has decreed to all the citizens and to you and to me. The person who disobeys King Creon shall be put to death. Will you join hands with me and share my task?

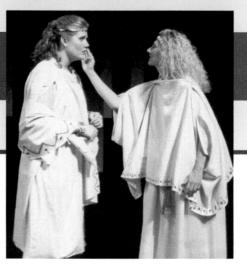

Fig. 2–32 **Antigone and Ismene.**Photo courtesy of The Southeast Institute for Education in Theatre, 1992, directed by Kim Wheetley, starring Susan Elder as Antigone and Tara McLeevy as Ismene.

ISMENE: What dangerous enterprise have you in mind?

ANTIGONE: To bury his body! Will you join me? **ISMENE:** Would you dare bury him against Creon's law?

ANTIGONE: My brother I will bury, and no one shall say I failed.

ISMENE: You are too bold! King Creon has forbidden it. **ANTIGONE:** He has no right to keep me from burying my own brother.

ISMENE: Antigone, please remember that we are not trained to fight. I yield to those who have the authority. **ANTIGONE:** I will not attempt to convince you, but I

shall bury him. If I have to die for this pure crime, I am content, for I shall rest beside him. But you, if you choose, may scorn the sacred laws of burial that heaven holds in honor.

Adapted from Cullum, Albert (1993). Greek and Roman Plays for the Intermediate Grades, Carthage, IL: Fearon Teacher Aides, p.36

Daily Life

With what groups do you identify? How do you show your attachment to these groups? Do you wear certain colors, hats, shoes, or uniforms? What part does peer pressure play in your choice of clothing?

Throughout history and across cultures, clothing has expressed identity and status. Evidence of this is seen in a Chinese *Dragon*

Robe (Fig. 2–6), a sculpture of *Augustus of Prima Porta* (Fig. 2–14), or the latest craze in name-brand jeans.

As a class, brainstorm answers to these questions: Why is it important to know when someone is dressed for a special occasion? Should a person's choice of clothing be accepted without question? Why or why not?

Other Subjects

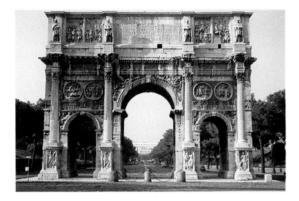

Fig. 2–33 **How is this arch similar to the arches in the Colosseum?** Rome, *Arch of Constantine*, 315 AD. East elevation. Courtesy of Davis Art Slides.

Mathematics

Ancient Roman engineers perfected the use of the **round arch**, a curved architectural element used to span an opening. Arches open up large spaces in walls, let in light, reduce the weight of the walls, and decrease the amount of building material needed. The Romans constructed arches from wedge-shaped pieces of stone that met at an angle perpendicular to the curve of the arch. One of the best surviving examples of the Roman use of the arch is the Colosseum, built in Rome from AD 72 to AD 80 (see page 103). What are some examples of arches in your community? In what kinds of buildings are arches most often used?

Social Studies

Our interpretation of an art object's meaning can be influenced by its classification and presentation. How would your understanding of **a cultural artifact** such as Chinese *Dragon Robe* (Fig. 2–6) be shaped by its presentation in an art museum? Would your interpretation change if instead you saw the work displayed in a natural-history museum? Why do you think it might make a difference?

Who makes the choices about placing objects in museums? What reasons would you consider if you were to decide whether an artifact should be placed in an art museum or in a natural-history museum?

Careers

You may know Thomas Jefferson as the third president of the United States, but did you know that he was also an **architect**? Jefferson incorporated classic ideals about architecture in his design for the University of Virginia. The university structures are similar to many government, university, and museum buildings throughout North America. Since Jefferson's time, an architect's primary role of designing buildings and supervising their construction has changed. Architects' designs must still reflect their clients' ideals. Today, however, the planning and construction of enormous structures requires teams of experts. Architectural firms employ specialists including drafters, modelmakers, and illustrators. These people, in turn, work with engineers, builders, construction companies, landscape architects, and interior designers.

Fig. 2-34 Elevation drawing of the facade of the rotunda at University of Virginia.

How might Jefferson feel about contemporary architecture? Would he think that it harmonizes art with nature? Would he want to design a building today?

Internet Connection

For more activities related to this chapter, go to the

Davis website at www.davis-art.com.

Portfolio

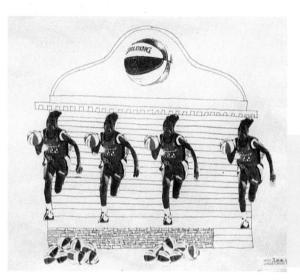

"I decided to do women's basketball because I love basketball and I am a fan; also I like to play it. I like the idea of basketballs as the bushes. I think that looks neat." Justine Larrabee

Fig. 2–35 Justine Larrabee, *Basketball Dome*, 1999. Magazine cutouts, pen, 18" x 24" (46 x 61 cm). Jordan-Elbridge Middle School, Jordan, New York.

"I have had an interest in komodo dragons for a while. I realized how badly it deserved to be vibrant. So, I made it the most vibrant red I could find. Also, we had to add a prop to it, so I chose an egg. For the sake of science I changed it to a gila monster because I heard they are much more fond of eggs."

Veronika Yermal

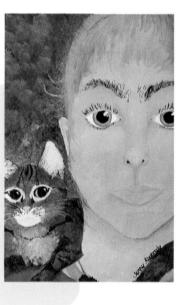

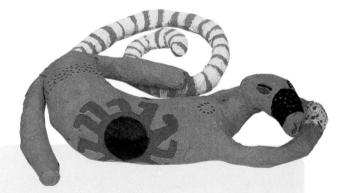

Fig. 2–37 The choice of an unusual animal, decorated with traditional symbols, makes an intriguing mascot. Veronika Yermal, *Epiphany*, 1999.

Papier-mâché, wire, tempera, 22" x 24" (56 x 61 cm). Copeland Middle School, Rockaway, New Jersey.

"I did this as an off-shoot of a Frida Kahlo work (the one with the monkey). I was having a hard time with this piece. Painting a self-portrait was something new and complicated. However, I did enjoy this project, which got me interested in painting." Jenny Abplanalp

CD-ROM Connection

To see more student art, check out the Global Pursuit Student Gallery.

Identity and Ideals

Chapter 2 Review

Recall

What did the Greeks believe the ideal or perfect person should be?

Understand

Use examples to explain how artworks reflect identity and promote ideals.

Apply

Identify features of an architectural structure that reflect important ideals of the community in which it is found.

Analyze

Both individuals and groups develop distinctive ways of making things. Compare the masks in Fig. 2–2 (Hopetown, *Mask of Born-to-Be-Head-of-the World*, below left) and Fig. 2–22 (Yup'ik, *Mask of a diving loon*, below right). Contrast their shapes, patterns, form, and use of materi-

Page 96

For Your Sketchbook

On a page in your sketchbook, write a list of words about identity. For instance, you might list words that

name or describe anyone's personality, physical appearance, or family and culture. Refer to this list for ideas for future artworks. als. Make statements about the distinctive features of each work. Your descriptions should help your classmates to identify other works made by the same group or individual.

Synthesize

Compose a dialogue between two sculptors—one who is from ancient Greece and the other who is from ancient Rome—who are trying to decide how to show, in marble, an ordinary citizen. What would the Greek position be? How would it be different from that of the Roman sculptor?

Evaluate

Identify certain ways of dressing that are currently "in style" for people your age. Make a judgment about which style best shows the ideals that are most important to you. Explain your position.

Page 110

For Your Portfolio

Choose an artwork in this book that sends a clear message about identity and ideals. Write a detailed description of

the work. Tell what its message is, and how the arrangement of the parts helps to send it. Date your report, and add it to your portfolio.

3 Lessons

Fig. 3–1 St. Matthew, shown here with pen in hand, is writing the Gospels—the stories of Christ's teachings and time on earth. How might the artist have wanted this portrait to inspire the viewer? German (Helmarshausen Abbey), *St. Matthew*, fol. 9v, Gospel Book, c. 1120–40. Tempera colors, gold, and silver on parchment bound between pasteboard covered with brown calf, $9" \times 6^{1/2}" (22.8 \times 16.4 \text{ cm})$. The J. Paul Getty Museum, Los Angeles.

Focus

- How can images and symbols inspire us and provide us with guidance?
- How do artists help teach important lessons?

You probably remember being read to as a child. Do you remember a story called "The Little Engine That Could"? It was about a very small train engine struggling to pull a large number of cars up and over a mountain. With determination and while repeating "I think I can," the little engine managed to keep going and reach the mountaintop.

The story about the little engine is familiar to millions of children. They like the main character, and they also learn an important lesson for living: Don't give up. When the going gets tough, don't despair; stay focused on your task, and you will make it.

Lessons for living are passed down in all cultures. Parents and other

adults use stories to teach children how to live healthy, productive, and meaningful lives. Adults also need lessons for living. Sometimes these lessons are in the form of artworks rather than written stories. For example, the twelfth-century manuscript illumination (Fig. 3–1), a hand-painted illustration, was used to teach important religious ideas. In this chapter, you will see how artworks have been created and used for centuries world-

wide for teaching

important ideas.

What's Ahead

- Core Lesson Learn how people worldwide and over time have used art to inspire and teach one another.
- 3.1 Art History Lesson
 Discover how people in the Middle
 Ages learned important lessons
 through artworks.
- 3.2 Elements & Principles Lesson
 Examine the use of shape and balance in artworks designed for teaching.
 - 3.3 Global View Lesson
 Learn how artworks in India teach about the Buddhist and Hindu religions.
- 3.4 Studio Lesson
 Create a paper box that uses symbols to teach classmates about yourself.

Words to Know

mural triptych Romanesque Gothic illuminated manuscript shape:
organic
geometric
positive
negative
balance:
symmetrical
asymmetrical
radial

Understanding Art's Lessons

Looking and Learning

We all wonder about our place in the world and ask, "Why am I here?" or "What should I do?" We want to know how the world came to be and what life is all about. Family members, teachers, and political and religious leaders help provide answers to these important questions. Artworks can help give us answers, too.

Many of our lessons for living come from customs and ideas passed from one generation to the next. Some lessons are political. They teach people how to live together peacefully. Other lessons are religious. They

teach a set of beliefs. Art can help us see and understand these lessons in new ways.

Artists can use words, images, and symbols to help tell others about important teachings, laws, and rules. *Symbols* are signs, letters, or figures that stand for other things. Pictures, simple shapes, and even colors can be symbols. Lessons are often told through artworks that have many symbols. These works are usually placed in public or shared spaces, such as government buildings, where many people can see them and discuss them with others.

Fig. 3–2 Carefully designed mosaic floors are often part of ancient Jewish synagogues. This balanced composition of stone and glass cubes shows the front of a temple with its sacred objects arranged on either side. What might you learn about fourth-century Judaism by looking at this design? Detail from mosaic pavement from a synagogue at Hammat Tiberias, 4th century AD.

Photograph: Zev Radovan, Jerusalem.

Fig. 3–3 The walls of the mosque, the Islamic building for worship, are covered with lessons. Geometric patterns and plant shapes are combined with writing that uses the Arabic alphabet. In any mosque, a small space in the wall called the mihrab (MIH-râb) is the most important site. The mihrab points to Mecca, believed to be the holiest of places. Iranian, Mihrab of the Medersa Imami, Isfahan, c. 1354. Composite body, glazed, sawed to shape and assembled in mosaic, height: 11'3" (342.9 cm). The Metropolitan Museum of Art, Harris Brisbane Dick Fund, 1939. (39.20) Photograph © 1982 The Metropolitan Museum of Art.

Fig. 3–4 Artists of the Buddhist religion sculpted many likenesses of their leader. This one shows Buddha's hands in the teaching position. India, Seated Buddha Preaching in the First Sermon, Sarnath, Gupta period, 5th century AD.

Stele, sandstone, 63" (160 cm) high. Archaelogical Museum, Sarnath, Uttar Pradesh, India. Borromeo/Art Resource, NY.

Religious lessons are often displayed in places of worship. The lessons might be shown in small portable paintings, altarpieces, holy books, windows, or on walls and floors. As you learn more about a religion's beliefs, the symbols you see in artworks gain more meaning. The lessons taught through images and symbols are

meant to help people achieve a stronger and more lasting religious faith.

The Islamic, Jewish, and Buddhist religions express teachings through the use of artworks, as do other world religions. Study the artworks in Figs. 3–2, 3–3, and 3–4. Do you learn anything about the religions from looking at these works? Are there symbols you can recognize?

Art Teaches About Events

Most people look for ways to live together peacefully. They work together to make rules about how to treat one another. They encourage one another to have pride in their history and heritage. Artworks are important sources of information about the past. For instance, the *Bayeux Tapestry* (Fig. 3–5) shows the Norman invasion of England in

1066. The events of the battle are retold in the embroidered images. Artworks such as this teach about events that dramatically changed the lives of the people of the time.

Artworks are a powerful teaching tool that may help us understand how to live together without conflict. Pablo Picasso created *Guernica* (Fig. 3–6) after the 1937 bombing

Fig. 3–5 We do not know the names of the people who made this amazing artwork, but most embroidery of the time was done by women. This was probably a group effort, with artists and an historian working together. The mural is over 230 feet (70.1 m) long and contains 626 human figures, 731 animals, 376 beasts, and 70 buildings and trees. Bayeux Tapestry, William preparing his troops for combat with English Army. Musée de la Tapisserie, Bayeux, France. Giraudon/Art Resource, New York.

Fig. 3–6 Guernica's message is not completely about the horror of war. Picasso included Liberty, who, with her lamp, is a symbol of peace and personal freedom. In doing so, what is he suggesting about civilization? Pablo Picasso, Guernica. 1937.
Oil on canvas, 11' 5 ½" x 25' 5 ¾4" (3.49 x 7.77 m).
Museo Nacional Centro de Arte Reina Sofia, Madrid. Photo: Museo Nacional Centro de Arte Reina Sofia Photographic Archive, Madrid. © 2000 Estate of Pablo Picasso/Artists Rights Society (ARS), New York.

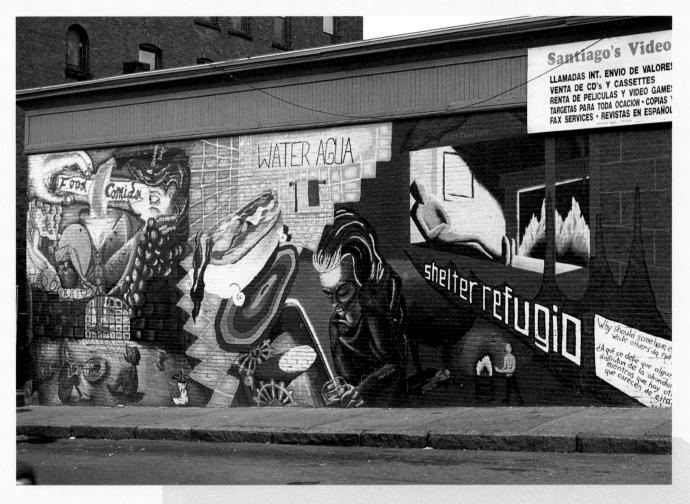

Fig. 3–7 This mural on the side of a market in Worcester, Massachusetts, makes a strong statement about poverty. What is the artist trying to say to her community? Lydia Stein, *Food, Water, Shelter.*Photo by Tom Fiorelli.

of the Spanish town of that name because he wanted to teach people about the horrors of war. Look carefully at the image. Notice how the positions of the bodies and the expressions on the faces tell of the terrible destruction and pain of the people.

Artworks can perhaps do their best teaching if they are displayed where many people can see them. **Murals**—large artworks usually designed for walls or ceilings—have long been used to present ideas about history and about how to live. Look for murals in government buildings and other public places in your town.

Some city neighborhoods have murals on outdoor walls (see Fig. 3–7, above). The people who live there can see and learn from them daily. If there is a mural near where you live, try to visit it. Look at it carefully. Does the mural tell you about an important event? Does it encourage people to get along with each other? What would you like to show in a mural that everyone could see?

Mixed Media in the Studio

Teaching Triptychs

How can you work with the format of a **triptych** (an artwork with three sections) as a creative way to teach something important? **In this stu-**

dio experience, you will make a foldout booklet or greeting card that teaches a lesson. You might make images that instruct someone about your religious, political, or social beliefs. You could use symbols to stand for important ideas. Or you might suggest a simple lesson for living, such as not giving up when things seem hopeless. You might choose to show an event—something that happened at home, in your neighborhood, or at school—that you think others can learn from.

You Will Need

- pencil
- drawing paper or light cardboard
- markers
- colored pencils
- glue
- magazine cutouts
- printouts of computer-generated designs

 (optional)
- gold and silver paint or markers (optional)

Try This

1. Make two folds in a piece of paper to form a central panel and two sides that fold out. If you wish, cut the triptych into a shape that will help teach your lesson.

2. Lightly sketch a plan for what you will show. Will you tell a story? Consider presenting your story in three scenes. Will you use symbols? Symbols might be simplified images of animals, birds, or plants.

3. When you have a plan, outline the shapes with markers. Combine collage and colored-pencil techniques to make each panel rich and colorful.

Fig. 3–8 This one-of-a-kind artist's book was designed to showcase natural materials collected on a nature walk. How is the format like that of medieval portable altars? Karen Stahlecker, *Golden Shrine*, 1995.

Shaped book with perforated covers, artist's handmade papers, natural materials, $7^{1}/4$ " x $4^{1}/4$ " x $1^{1}/3$ " (18.4 x 10.8 x 3.5 cm), when closed. Photo by K. Stahlecker.

The triptych format can be used to give shape to ideas about family, culture, history, or other important themes. A triptych does not require a religious focus.

Studio Background

About Triptychs

A triptych is an artwork with three sections. It has a central panel and two wings, which are attached with hinges. Some triptychs have architectural elements such as columns, arches, or windows. In the Middle Ages, triptychs showed religious subjects. Some of these triptychs were small enough to be carried by their owners, like portable altars. The images told religious stories and taught key beliefs. As with much medieval art, symbols represented important ideas. They also stood for the identities of saints.

Check Your Work

Does your triptych teach about something important to you? Exchange your triptych with a classmate. Each of you should guess what lesson is being taught. Do collage and colored pencil help present powerful messages? Are symbols used effectively?

Sketchbook Connection

Make a series of sketches to show where you are and what you are doing at various times of the day: before school, in

morning class, at lunch, after lunch, and after school. Design a symbol for each activity that will teach someone you don't know about your life.

Core Lesson 3

Check Your Understanding

- **1.** List at least three ways that artworks are used to inspire or teach others.
- **2.** If you were to teach someone about symbols, what are some things you would tell him or her?
- **3.** Choose one image in this lesson and tell how its parts combine to teach a lesson.
- **4.** Describe a social or cultural tradition you are familiar with that teaches a lesson.

Fig. 3–9 This card is folded into thirds and opens from the middle, like a door, to reveal a story that illustrates a lesson. "My artwork is about making an effort. This is a good topic because people should always give it their full effort." How would you illustrate this concept? See page 144 for the solution this student artist created. Rachel King, *Effort*, 1999. Colored pencils, $8\sqrt[3]{4}$ x 12" (22 x 30 cm). Yorkville Middle School, Yorkville, Illinois.

Fig. 3–10 The two side panels of this triptych depict scenes from the life of Roman Emperor Constantine I. Notice the two triptychs within the larger triptych. Mosan, *The Stavelot Triptych*, c. 1156–1158.

Gold, cloisonné enamel, inlay, $19^{1}/_{16}$ " x 26" (48.4 x 66 cm) when open. The Pierpont Morgan Library, New York/Art Resource, New York.

Art of the Medieval World

After the decline of the Roman empire in the fifth century, Europe entered a new and difficult era. Migrations of people swept across Europe. This era, called the Middle Ages or Medieval period, lasted nearly 1000 years.

The one stable element during this time was the comfort people found in the teachings of Christianity, Islam, and Judaism. Because most Europeans could not read or write, art continued to be an important way to communicate these lessons.

In early medieval times, art was often small and portable. Books and objects of adornment were easily carried by people on the move. But by the eleventh century, people began to settle in permanent communities or towns. They borrowed Roman art ideas. The style of the art and architecture of this period is called **Romanesque**.

Toward the end of the Middle Ages (from the 1200s through the early 1400s), churches became the center of religious and social activity. The art of this part of the Middle Ages is called **Gothic.** It shows the energy of the growing cities of the time.

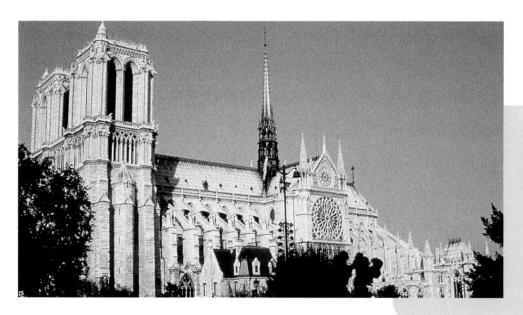

Fig. 3–11 The Gothic period was a time of new approaches in architecture. This Gothic cathedral shows the use of flying buttresses—angled arches held up by pillars—that support the high ceiling inside. Notre Dame Cathedral, exterior, begun 1163. Paris, France.

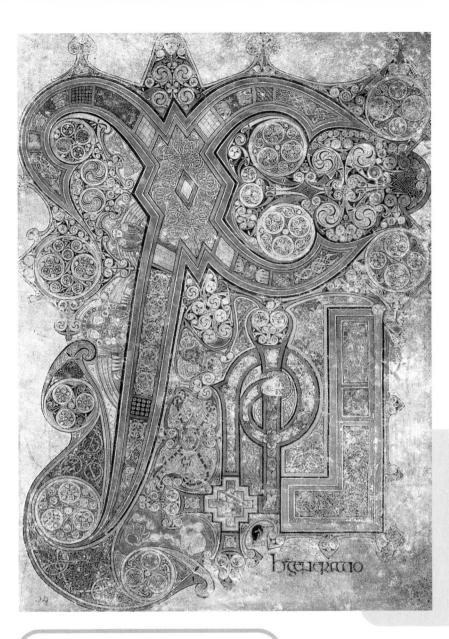

Fig. 3–12 Notice the geometric design on this illuminated page from an Irish manuscript. Do you see an X and P? This is a symbol for the name of Christ. It is pronounced ky-roh. Chi-rho Gospel of St. Matthew, chapter 1 verse 18, Irish (vellum). Book of Kells, c. 800.
The Board of Trinity College, Dublin,

Early Medieval Art

In early medieval times, books played an important role in preserving the lessons of Christianity, Judaism, and Islam. Scribes spent their lifetimes copying sacred manuscripts. Their goal was to preserve the lessons for future generations.

Illuminated Lessons

Scribes copied the sacred texts, and artists, called *illuminators*, illustrated certain parts of the scriptures. On the book pages, illuminators painted scenes with complex geometric patterns, figures, and fantastic animals. Often they added a thin layer of gold to

emphasize parts of the image. These illustrated texts, called **illuminated manuscripts**, were carried throughout the lands to teach religious ideas. The art of manuscript illumination was practiced throughout medieval Europe and the Middle East.

Ireland/Bridgeman Art Library.

Sketchbook Connection

Fill one or more pages of your sketchbook with playful ornamental alphabets. One alphabet might be plant forms, another

might be animals or insects, and so on.

Romanesque Art

The wars from the fifth through the tenth centuries destroyed many buildings in Europe. At the start of a new millennium in the year 1000, there was much building. New stone churches were built in the Romanesque style. For medieval Christians, the church became the center of teaching. Lessons for good living were shown in vivid images on walls and in sculptures.

Lessons Carved in Stone

Artists of the Romanesque period are known for bringing back the Greek and Roman tradition of carving large-scale sculptures. For Christian churches, they often carved scenes to fit in the arched space above church doorways, known as a *tympanum* (Fig. 3–13). These sculptural scenes, as well as other sculptures and paintings in the church interior, used figures and symbols to remind worshipers about their beliefs and the teachings of their faith.

Studio Connection

Illuminations can take the form of decorated letters, border pages, and scenes that include figures. Create an illu-

minated manuscript page with one or more decorated capital letters. Think of a lesson your page might teach. Look at books and cards with examples of historical and modern illumination and decorative borders. Or study Fig. 3–12 to help you get ideas.

Your illumination might consist of your initials or your favorite saying or poem presented in your best calligraphy. Experiment with different kinds of type: large or small, plain or fancy. Plan your composition carefully.

Fig. 3–13 This tympanum shows Christ weighing people's souls, on the way they have lived their lives. If you believed in this, imagine how you might feel walking under this scene. Giselbertus, *The Last Judgment*, 1130–1140.

West tympanum, St. Lazare. Autun, France.

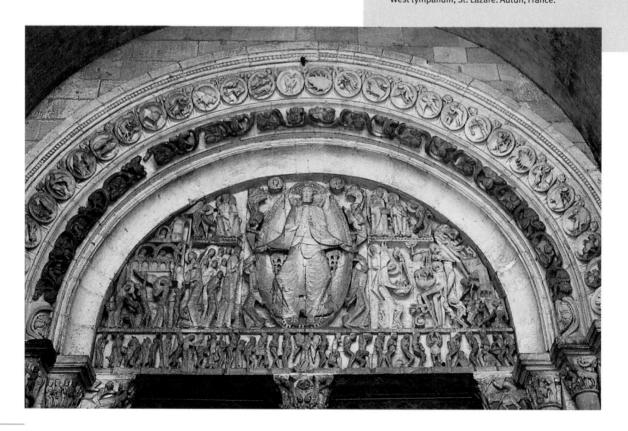

Gothic Art

Church-building continued well into the 1300s. Earlier, Romanesque structures had been made of thick stone walls. They had dark interiors with very few windows. For Christians, light symbolized the presence of God, and soon they wanted to fill their churches and cathedrals with light. As a result, architects began to find new ways to open up interior spaces. They developed a new system of architectural supports (Fig. 3–11) that helped them build taller buildings with thinner walls. More importantly, the walls could have many large windows to let in ample amounts of light.

Lessons in Glowing Light

The interiors of Gothic cathedrals were made even more beautiful by the use of stained-glass windows (Figs. 3–14 and 3–16). Rather than clear glass, the windows were made of small pieces of cut colored glass held together with lead. The colors glow like jewels as light passes through them.

Stained-glass windows changed church interiors into glowing places of worship. They also helped continue to teach the churchgoers. In the windows, scenes from the Bible were again depicted and served as visual reminders of how to live a good life.

3.1 Art History

Check Your Understanding

- 1. What is meant by Romanesque art?
- **2.** Name two differences between Gothic and Romanesque architecture.
- **3.** What is an illuminated manuscript?
- **4.** What special functions did stained-glass windows serve in cathedrals?

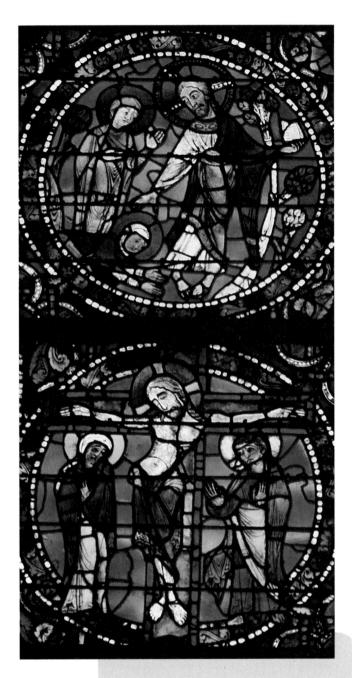

Fig. 3–14 Gothic church stained-glass windows often depicted scenes from the Bible. These two details show stories from the life of Jesus. How do the colors make you feel? Noli me tangere and Crucifixion (detail), Cathedral of Chartres, 12th century.

Stained glass. Photo by Edouard Fiévet.

Shape and Balance

Looking at Shape

Shape is a design element in two-dimensional artworks. Shapes have height and width but no depth. They can be defined by an outline or area of color. Many artists carefully plan their use of shape to help show a specific idea or teach a lesson. Some artists use shapes as symbols, to add meaning.

Organic shapes are often free-flowing and irregular. Most shapes found in nature are organic. Feathers, leaves, and puddles have organic shapes. **Geometric** shapes are precise and can be mathematically defined. Triangles, circles, rectangles, and squares are geometric shapes. In both of the artworks shown here, artists combined organic shapes and geometric shapes to express important ideas.

There is another way to describe shape. Shapes that you notice are called **positive** shapes. The subjects of artworks—the person in a portrait or the objects shown—are positive shapes. The area around the positive shapes creates **negative** shapes. In the stained-glass window, the shapes made of colored glass are positive shapes. The black area surrounding them is the negative shape. A successful design balances the use of positive and negative shapes.

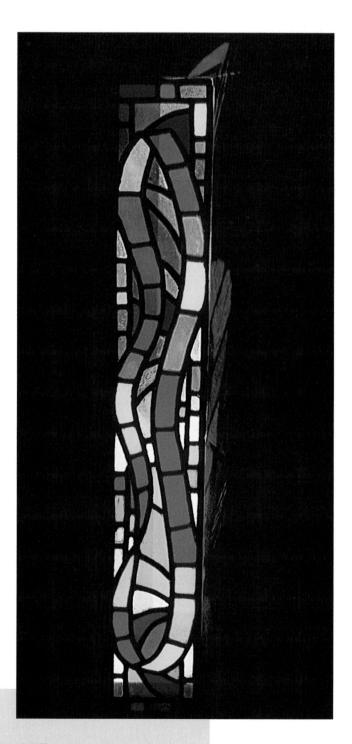

Fig. 3–15 Notice how this artist arranged different geometric shapes in an organic shape that resembles a ribbon. These shapes of different sizes and colors create a feeling of asymmetrical balance. What might this window symbolize? Harold Haydon, *The Path*, 1972. Stained-glass window. University of Chicago, Rockefeller Chapel.

Looking at Balance

Balance holds a design together. Different kinds of balance have different effects on the viewer.

Balance can be **symmetrical** or **asymmetrical**. In many cultures, symmetrical, or formal, balance is used to suggest a feeling of stability or quiet. A design with symmetrical balance looks the same on both sides, like a mirror image. Asymmetrical, or informal, balance is often used to express a feeling of motion or action. An asymmetrical design (Fig. 3–15) does not look the same on both sides. Instead, an area on one side of the design is balanced by a different type of area on the other side.

The Chartres stained-glass window (Fig. 3–16) teaches a religious lesson with the help of **radial** balance, a type of symmetrical balance with parts leading away from or toward a center point. Look at Fig. 3–15, a very different design. What lesson do you think *The Path* teaches?

Studio Connection

Make your own design for a symmetrically balanced Gothic arch or rose window. Draw the positive shapes of the design in

pencil on black paper. Cut out these shapes. The remaining parts of the black paper, which will be the negative shapes, will be unbroken and connected. Glue colored tissue pieces behind the cutouts.

Check Your Understanding

- **1.** What is the difference between positive and negative shapes?
- **2.** What type of balance would you use to depict a wild ride at an amusement park? Explain the reason for your decision.

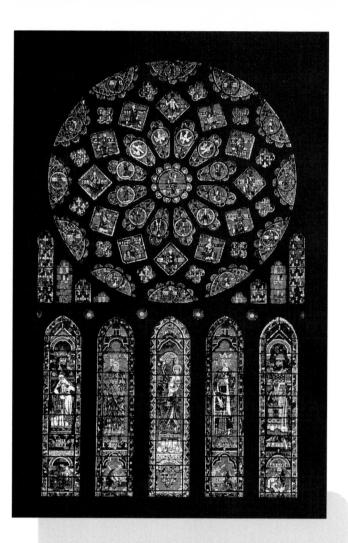

Fig. 3–16 This stained-glass work depicts religious history. Mary holds the Christ Child, enthroned in the center of the radial design and surrounded by doves and angels. Twelve kings and, beyond them, twelve prophets complete the balanced circular design. The tall lancets (pointed arches below the rose window) depict saints and Old Testament figures. How do repeated shapes and colors contribute to the formal sense of balance? North Transept Rose and Lancet Windows (Melchizedek & Nebuchadnezzar, David & Saul, St. Anne, Solomon & Herod, Aaron & Pharaoh), 13th century.

Stained glass, 42' (12.8 m) diameter. Chartres Cathedral, France. Scala/Art Resource, New York.

The Art of India

India is a land of variety and contrasts: from snow-covered mountains to rich valleys and fertile plains. Early peoples lived in this diverse region many thousands of years ago, probably as far back as 30,000 BC. Around 2700 BC, just as the ancient civilization of Egypt was emerging, the earliest Indian culture settled in the area of the Indus River. It is known as the Indus Valley civilization.

Throughout its long history, Indian art has reflected the teachings of its two main religions: Hinduism and Buddhism. Each religion produced its own unique style of sculpture and architecture. Each religion also used a rich variety of distinct symbols to teach followers important lessons.

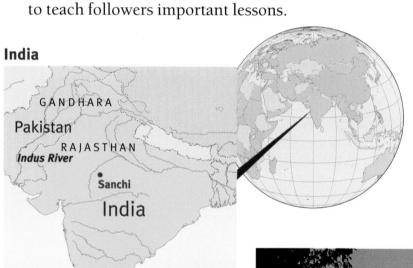

Fig. 3–18 The carvings on this stupa's gateways tell stories from the previous lives of the Buddha. Why do you think these carvings were placed at the entryways to the stupa? How could they help teach lessons? India (Sanchi), east gate, *Great Stupa*, 75–50 BC.

©Adam Woolfitt. All Rights Reserved.

Kanchipuram

Fig. 3–17 Vishnu, the Hindu god of love and forgiveness, is often associated with playing pranks and games. Here he is shown in animal form, as a lion. India, late Chola period (c. 13th century), Narasimha: Lion Incarnation of Vishnu.

Bronze, 21 ³/₄" (55.2 cm) high. ©The Cleveland Museum of Art, 1999, Gift of Dr. Norman Zaworski, 1973.187.

Buddha's Lessons

Buddhism is based on the teachings of a holy man known as Buddha, or the "enlightened one." Buddhism first appeared in India in the sixth century BC.

Buddhist art and architecture are meant to help followers reach their own state of enlightenment through meditation, just as the Buddha did. The earliest form of Buddhist architecture is called the *stupa* (*STEW-pah*). It is a type of rounded burial mound built to honor the Buddha (Fig. 3–18). Stupas may be built up from the ground or carved out of rock. They are often part of a complex of buildings where monks live, and they serve as places for meditation and prayer.

At first, the Buddha was shown in artworks only by a symbol. Sometimes it was a lotus flower, the symbol of purity. Other times it was a wheel, an ancient sun symbol that represented his teachings and the cycle of life. Beginning in the first or second century AD, images of the Buddha appeared. The symbols and gestures shown in the sculptures and reliefs make the image of the Buddha easy to recognize (Fig. 3–19).

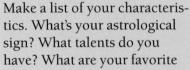

things? Think about yourself as a shape, a color, a line, a flower, an insect, or an animal. Plan a cut-paper collage in the form of a manuscript page with figures and a patterned background. Use colored and textured papers to create a collage that teaches others something about yourself.

Fig. 3–19 The Buddha is always shown with certain symbols. He makes hand gestures that are known as *mudras*. This mudra means "fear not." The coil of hair on top of his head is a symbol of *enlightenment*. India (Gandhara), *Standing Buddha*, 2nd–3rd century AD (Kushan period). Phyllite, 23 ½" × 13" (59.1 × 33 cm). Asian Art Museum of San Francisco, the Avery Brundage Collection, B60 S132+.

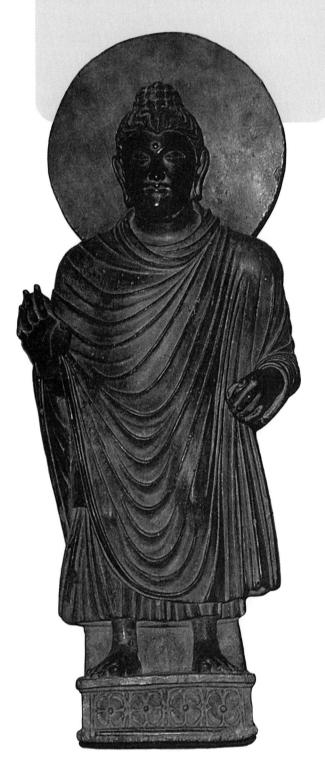

Hindu Lessons

Today, Hinduism is India's oldest religion. It has many different gods, or deities. The three main gods are: Brahma, the Creator; Vishnu, the Preserver; and Siva, the Destroyer. In bronze and stone sculptures and reliefs, artists show these gods in animal or human form. They are shown with symbols that stand for each god's special powers.

For example, Siva (Fig. 3–20) is often shown holding a drum in his back right hand. This symbolizes his power to create and contrasts with the fire in his back left hand, which represents his power to destroy. His inner right hand is raised in a gesture that means "fear not." His inner left arm points to his raised left foot that symbolizes escape from ignorance.

Architecture has also played an important role in the Hindu religion. Elaborate cave temples and square stone temples topped with towers were built as the residences of the gods. Inside, a sculpted image of the temple's god is placed in a sacred space.

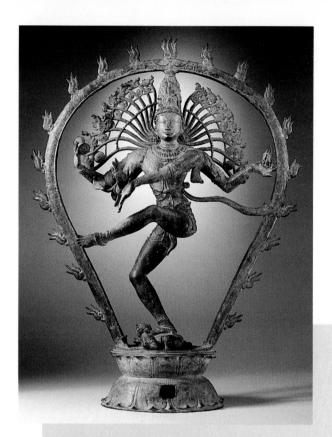

Fig. 3 –20 When the Hindu god Siva is shown dancing, he is called Nataraja, meaning "Lord of the Dance." The moves he makes and objects he holds stand for the rhythm of the universe. What type of balance does this sculpture show? Indian (Tamil Nadu), Siva, King of the Dancers, Performing the Nataraja, c. 950. Copper alloy, 30" x 22 1/2" x 7" (76.2 x 57.1 x 17.8 cm). Los Angeles County Museum of Art, given anonymously. M.75.1.

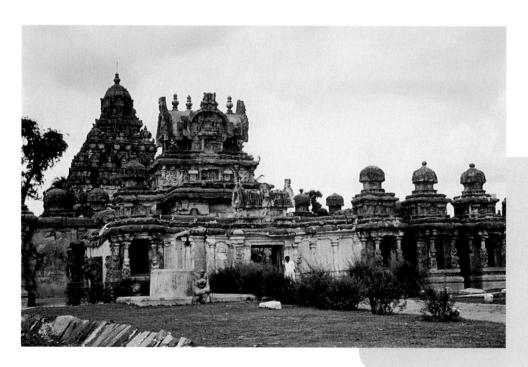

Fig. 3–21 Like Buddhist stupas, many Hindu temples were carved from rock. Inside, these temples are like caves, which are considered holy places in India. Each part of the building's design and construction is symbolic, based on important religious beliefs. India (Kanchipuram), Kailasanatha Temple, c. 700 AD.

Courtesy of Davis Art Slides.

Forces from the Outside

Hinduism and Buddhism have greatly influenced the art of India. Outside forces also affected Indian art styles. One such force was the religion called Islam.

The Influence of Islam

The Islamic religion was founded in Arabia in 622 by the prophet Muhammad. Islam spread into Europe and Africa. It first appeared in northern India in the eighth century. Islam was most powerful in India from the sixteenth until the eighteenth century. This era of Islamic influence is called the Mughal period.

Images of God and people are forbidden in Islamic religious art. Pictures of people and animals are only allowed in stories about everyday life. Figures and scenes from stories appear in small paintings called miniatures. During the Mughal period, Indian artists used Moslem miniature painting techniques to illustrate books and stories on paper (Fig. 3–22). Until this time, most Indian paintings had been on cave walls. The introduction of paper in the fourteenth century through trade with Arabia opened the way for new ideas. The Mughal empire artists created a unique style of colorful and richly decorated surfaces, intricate patterns, and realistic depictions of figures.

3.3 Global View

Check Your Understanding

- **1.** What major religious beliefs influenced the art of India?
- **2.** How did the influence of Islam change Indian art?
- **3.** How have the symbolic characteristics of Buddha changed over time?
- **4.** Describe some of the earliest forms of art in India.

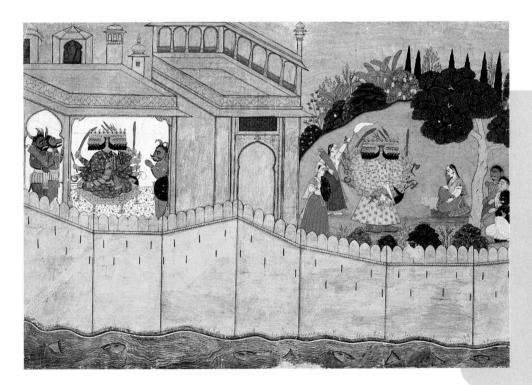

Fig. 3-22 This manuscript page shows a scene from the great Indian poem, the Ramayana. It teaches about good and evil, and gives information about the values and ideals of ancient India. India (Pahari, Guler School), Sita in the Garden of Lanka, from the Ramayana, Epic of Valmaki. Gold and color on paper, 22" x 31" (55.5 x 79 cm). The Cleveland Museum of Art, Gift of George P. Bickford, 66.143.

Sculpture in the Studio

Creating a Folded Box of Lessons

Teaching with Symbols

Studio Introduction

What do a hexagon, a fork and knife, and the alphabet have in common? They can all be used as symbols to

express important information. When seen from a distance, the red hexagon of a stop sign alerts a driver that it's time to slow down. A fork and knife symbolize food. And

just imagine how difficult it would be to communicate if we didn't have an alphabet!

Symbols like these help us get along in life. Symbols can also remind us of traditions passed down from generation to generation. Symbols that teach lessons can be found in families, communities, and cultures all over the world.

In this studio lesson, you will fold a box and decorate it with symbols that represent meaningful things in your life. Pages 140 and 141 will tell you how to do it. As you plan your box, think about the kinds of lessons you want to put inside.

Studio Background

Symbols in Time

Religions all over the world share the tradition of teaching. Their artworks often tell stories or incorporate symbols that have special religious meaning. If you look closely at religious artworks, you might see symbols that stand for important lessons or ideas. You may even be surprised to find symbols you didn't know were founded in religion, such as those on the Jewish zodiac table.

Judaism—the Jewish religion—began about the fourteenth century BC. It started as a way of thinking. By the Middle Ages, Jewish philosophy had developed into a full religion. The customs, traditions, and laws of Jewish life influenced a wide variety of ceremonial artworks. Many of these artworks are decorated with special symbols. The Star of David, the universal symbol of Judaism today, came into popular use during the seventeenth—nineteenth centuries AD. It appears on the flag of the state of Israel, in synagogues, and on Jewish ritual objects, such as the mezuzah pictured in Fig. 3–25.

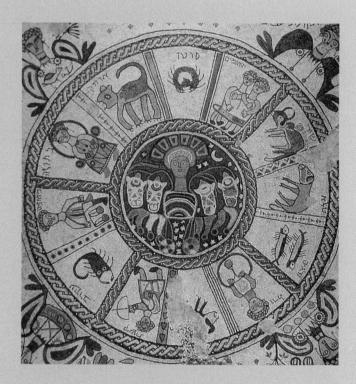

Fig. 3–23 Through the centuries, the study of astrology has been part of Jewish life. The signs of the zodiac, each labeled in Hebrew, are arranged around the sun in his chariot. *Zodiac Mosaic Floor*, 3rd–4th century.

Stone mosaic. Synagogue, Beth Alpha, Israel. The Jewish Museum, NY/Art Resource, NY.

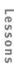

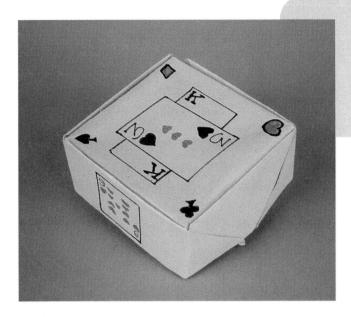

Fig 3–24 An interest in fortune telling prompted this student to decorate her box with symbols from a deck of cards. Inside the box are slips of paper that explain traditional meanings of hearts, aces, clubs, and spades. Abby Reid, *Untitled*, 1999.

Paper, markers, 3 $^1\!/_4$ " x 3 $^1\!/_4$ " x 1 $^5\!/_8$ " (8 x 8 x 4 cm). Shrewsbury Middle School, Shrewsbury, Massachusetts.

Fig. 3–26 The Star of David is made up of two triangles. The upward-pointing triangle represents the sun, fire, and masculine energy. The downward-pointing triangle represents the moon, water, and feminine energy. What kind of balance does the Star of David exhibit? Israel, Jerusalem, Star of David, Lion Gate, detail, 1st century AD. Courtesy of Davis Art Slides.

Fig. 3–25 A mezuzah is a small receptacle containing a tiny scroll, or *shema*, with scripture from the Torah. Traditionally, the mezuzah is positioned by the front door of a Jewish home. Notice the surface decorations. Galicia, *Mezuzah*, c.1850.

Carved wood, ink on parchment, 26.5 x 5.7 cm. Gift of Dr. Harry G. Friedman. The Jewish Museum, NY/Art Resource, NY.

Sculpture in the Studio

Creating Your Box of Lessons

You Will Need

- two squares of white drawing or construction paper
- newsprint paper
- pencil and eraser
- colored markers
- typewriter bond

Try This

1. Follow the steps illustrated on the Studio Master to construct a box and lid. Use the smaller sheet of white paper for the

bottom of the box and the larger sheet for the lid.

- **2.** After your box is constructed, design three or four symbols that represent meaningful things in your life. For example, what symbols might represent your family, your favorite pastime, a special place, or the like? Sketch your ideas on newsprint paper.
- **3.** When you're happy with your sketches, choose where you want to add the symbols to the box. Carefully decorate the box with colored markers.
- **4.** Your box can be a container for lessons or sayings that mean something to you. You may be fond of some proverbs or truisms, such as, "A penny saved is a penny earned." Write the sayings carefully on small pieces of paper. Place them inside your box.

Check Your Work

In what way does your finished product show your usual quality of work? What new skills or abilities did you demonstrate when you made this artwork? Share your box with classmates. See if they can identify the meaning behind the symbols you created. Ask them if they've learned anything new about you after looking at your box and reading the sayings inside.

Sketchbook Connection

If you look carefully, you will probably notice that symbols are used to decorate jewelry, bumper stickers, hats, coffee

mugs, and many other everyday objects. Choose a subject you're interested in, such as nature, sports, music, or the like. Design a symbol that shows what is meaningful to you about that subject.

Computer Option

In a drawing or painting program, design and create the side view of a container that teaches about your life.

Choose a geometric or organic shape for the container. The shape you choose should fit your idea of who you are.

Add symbols to show different aspects of your life. What colors will you use? Will you include a lid for your container?

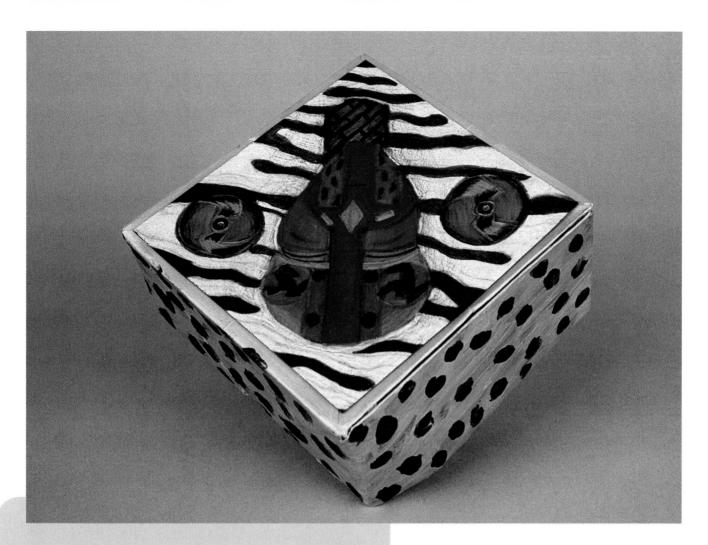

Fig. 3–27 "My ideas for designing the outside of the box came from looking at many African books. The top is a drawing of a mask surrounded by a zebra skin. The sides are painted like a leopard skin. I imagined the mask to be of an African king. The fur represents the king's robe. I have learned that my heritage has a respect for animals. My box will remind me of the culture I hope to make proud of me someday." Jonathan Nickerson, *African Me*, 1999.

Paper, colored pencil, acrylic, 4 ½ " x 4 ½ " x 2 (11.5 x 11.5 x 5 cm). Sweetwater Middle School, Sweetwater, Texas.

Connect to...

Careers

Inscribed on the stone of Notre Dame (see pages 128 and 143) is the name of Jehan de Chelles, the master mason responsible for overseeing the building of the cathedral. Under the medieval guild system of training, craftsmen, such as stained-glass artists, moved through three levels—apprenticeship, journeyman, master.

Today, a stained-glass designer may have trained at an art school, a university, or a trade school. Stained-glass artists make working "cartoons," or drawings. They then construct windows or other artworks by cutting and placing pieces of glass, and joining them with lead and solder. Many choices of glass are available to contemporary artists. Where do you think the craftsmen of the Middle Ages obtained their glass?

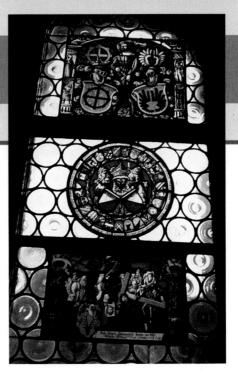

Fig. 3–28 In the days before electric lights, the brilliance of colors in windows such as this was unprecedented. How do you think such art influenced people to learn? Top third of window, 19th century. Swiss National Museum, Zürich.
Photo: H. Ronan.

Daily Life

Art records people's lives, from ordinary details to extraordinary events. The *Bayeux Tapestry* (page 124) documents the events of the Battle of Hastings, the Norman invasion of England on October 14, 1066. The battle—between Harold the Great and William the Conqueror for the crown of England—marked the last time that any foreign power conquered the English.

The tapestry is a visual record of events before, during, and after the battle. What kinds of contemporary events do we consider worthy to remember and tell? How do we memorialize such historic events? What far-reaching events have made an impact on your life? What memorials can you find in your community, state, and nation?

Other Arts

Theater

Theater may be used in a way similar to that of the visual arts: to teach lessons. The ancient Greeks noted that the purpose of theater was "to teach and to please," and by the Middle Ages, the **morality play** became perhaps the most obvious example of theater that teaches. Through characters who represent different vices and virtues, this type of medieval play was designed to teach the audience about Christian morals.

The most famous morality play, Everyman, was written in the fifteenth century. It depicts Everyman's attempt to escape Death through the help of Good Deeds and Knowledge. Everyman, Death, Good Deeds, and Knowledge are represented by individual actors, whose dialogue teaches a lesson. This teaching dialogue is the characteristic form of a morality play.

Other Subjects

Mathematics

The concept of **radial symmetry** is basic to both art and mathematics. Radial symmetry is a type of formal balance in which the elements of a composition move outward like rays from a central axis in a regularly repeating pattern. The elements on either side of a center line—the line of symmetry—mirror each other. Do you think that Chartres Cathedral's rose window, shown on page 133, has radial symmetry? Why or why not?

Fig. 3–29 What center line can you find in this image? Can you find two kinds of symmetry? Japanese, *Jizo Bosatsu*, 1185–1333.

Wood covered with lacquer and cut gold foil, height: $45\sqrt[3]{4}$ " (116.2 cm). The Metropolitan Museum of Art, The Harry G. C. Packard Collection of Asian Art, Gift of Harris G. C. Packard and Purchase, Fletcher, Rogers, Harris Brisbane Dick and Louis V. Bell Funds, Joseph Pulitzer Bequest and the Annenberg Fund, Inc. Gift, 1975. (1975.268.166a-d) Photo: Schecter Lee. ©1986 The Metropolitan Museum of Art.

Science

As builders in the Middle Ages experimented with more elaborate ways to decorate cathedrals for the glory of God, they developed an important scientific advancement in **Gothic architecture**. Because the heavy masonry walls of a cathedral could lean outwards and collapse if left unsupported, architects joined masonry columns to the upper walls of the exterior.

Fig. 3–30 The flying buttresses on Gothic cathedrals were decorated with complex gables and sculptures. Gothic cathedrals were also ornamented with figures of grotesque beasts and humans that taught lessons and served a practical purpose as waterspouts. *Notre Dame Cathedral*, 1163–1250. Paris, France. Courtesy of Davis Art Slides.

Internet Connection

For more activities related to this chapter, go to the

Davis website at www.davis-art.com.

Portfolio

"We studied about France and particularly stained glass in churches. While working on this piece I was thinking about the stained-glass windows that I've seen in churches. The easiest part was coming up with a design. The hardest part was cutting the shapes out and gluing them on." Kristen Lane

Fig. 3–32 Compare this artwork with the illuminated letter on page 145. Notice how the medieval artist used intricate detail to fill the space around the letter, while this work has more open space. What different effect does each have on the viewer? Rachel Jackson, *R*, 1999.

Tempera, 9" x 12" (23 x 30.5 cm). Fairhaven Middle School, Bellingham, Washington.

CD-ROM Connection

To see more student art, check out the Global Pursuit Student Gallery.

Fig. 3–31 How has this student balanced organic and geometric shapes? Kristen Lane, Round Stained-Glass Window, 1999.

Black construction paper, colored cellophane, 12" (30.5 cm) diameter. Johnakin Middle School, Marion, South Carolina.

"One girl is making an effort and one is not, and it shows the consequences—in this case bad grades. Then one girl helps the other girl and both come out with good results." Rachel King

Fig. 3–33 The inside of this card (the outside is shown on page 127) teaches a lesson. Rachel King, *Effort*, 1999.

Colored pencil, 8 $^3\!/_4$ " x 12 " (22 x 30 cm). Yorkville Middle School, Yorkville, Illinois.

Chapter 3 Review

Recall

Define "illuminated manuscript" (example below) and explain its use to teach important lessons.

Understand

Explain how art can be used to teach people how to live meaningful lives.

Apply

Create an outline drawing as a proposal for a stained-glass window for the school entranceway that would instruct new students about school life.

Analyze

Compare and contrast the use of symbolic imagery and pattern in Islamic, Christian, Judaic, Hindu, and Buddhist art.

For Your Portfolio

From this chapter, choose one artwork that was made before the twentieth century. Write a two-part essay. In the

first part, describe the work in detail. In the second part, summarize how the artwork shows or suggests local or world events at the time it was made (you may have to do some additional research). Add your name and date, and put your essay into your portfolio.

For Your Sketchbook

Use some of your sketchbook ideas to develop a decorative alphabet for an alphabet book.

Synthesize

Write a poem about the ways that art can instruct and inspire. Draw upon information in the text and in the captions. Make specific references to the artworks.

Evaluate

Based on what you consider to be the most important artworks in Chapter 3, recommend a foreign-travel tour for your class. Name the artworks you will see, and state why you think it would be important for your class to see them.

Page 129

4

Order and Organization

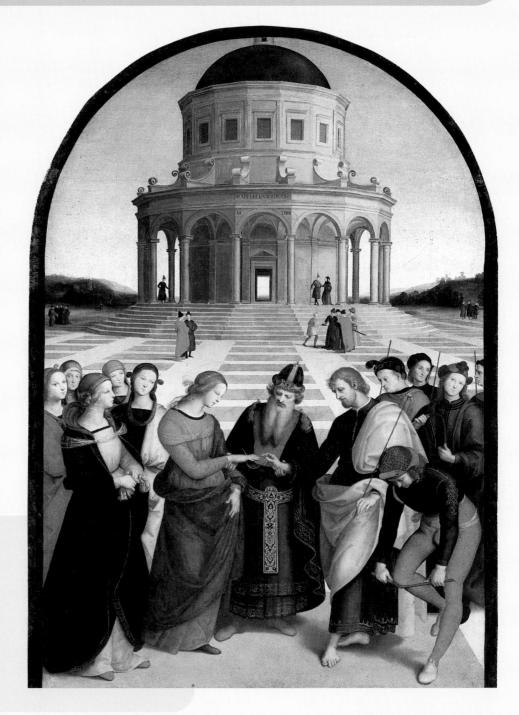

Fig. 4–1 Notice how your eyes move toward the space in the distance, beyond the main characters in the scene. How has the artist created the illusion of depth? Raphael Sanzio, Marriage of the Virgin, 1504. Wood panel, 67" x 46" (170 x 118 cm). Pinacoteca di Brera, Milan, Italy. Scala/Art Resource, New York.

Focus

- How does organizing help us in life and in art?
- What are some ways artists organize their work?

Do you line up your socks in the drawer according to their color? Do you have labels on your bookshelves showing where certain types of books belong? Or maybe you're a person who knows where all your possessions are, but you're the *only* person who can find them.

People tend to organize things. Sometimes the organizing system is obvious to others—like a color-coded sock drawer. Other times the system is obvious only to the person who created it. These are extremes. Most of us fall somewhere in the middle. Most people like to have *some* order in their lives. Organization certainly makes life easier. It allows people to focus on what really counts—the life that goes on around and inside all that order.

Art can work in a similar way. Artists have figured out how to organize artworks so that they are easy to view and understand. The organization of an artwork allows viewers to focus on what really counts—the mes-

sage, meaning, and use that it can have.

Raphael, a great Renaissance artist, organized his painting (Fig. 4-1) so that viewers can see what is going on in all parts of it. The flat surface of the panel was painted so that the scene looks as though it goes back in space. What is happening in the **fore**ground, or area that seems closest to you? The **background**, or area farthest away? Where do you think the middle ground lies?

What's Ahead

- Core Lesson Learn about perspective and other ways that artists organize their artworks.
- 4.1 Art History Lesson
 Discover what artists achieved during the time of the Renaissance in Europe.
- **4.2 Elements & Principles Lesson** Focus on ways to create unity and variety in artworks.
- **4.3 Global View Lesson**See how artists in China and Korea have used centuries-old systems to organize their artworks.
- **4.4 Studio Lesson**Explore ways to use perspective in a drawing.

Words to Know

foreground background middle ground linear perspective vanishing point patron atmospheric perspective unity variety porcelain horizon line

Organizing Artworks

Creating the Illusion of Depth

European artists of the Renaissance were fascinated by linear perspective. **Linear perspective** is a special technique used to show three-dimensional space on a two-dimensional surface. Renaissance artists observed that objects that are far away seem smaller. Artists interested in linear perspective found that parallel lines seem to move away from the viewer and appear to meet at a point on the horizon. You can see this for yourself if you stand in a long hallway and look at the lines formed by the walls at the ceiling and the floor.

Fig. 4–2 Notice how we look directly down on the pool, whereas we see the plants around the pool from the side. What methods of organizing space has the artist used here? Thebes, XVIIIth dynasty, *Garden with Pond*, c. 1400 BC.

©The British Museum.

Fig. 4–3 David Hockney creates and explores his own system for organizing space. David Hockney, Merced River Yosemite Valley Sept. 1982, 1982.

Photographic collage, 52" x 61" (131.1 x 154.9 cm). © David Hockney.

Not surprisingly, the point at which parallel lines seem to meet and disappear is called the **vanishing point.** As artists experimented with linear perspective, they found that they could create the illusion of depth with one, two, and even three vanishing points.

There are other ways to organize a flat surface to create the illusion of depth. One

way is overlapping. Objects that overlap others seem closer than whatever is covered up. Artists also work with size, color, and placement to help suggest depth. Larger objects seem closer to the viewer than smaller objects. Things look more distant if their colors are dull or their shapes are blurred and less detailed.

Islamic and Persian artists (see Fig. 4–4) created the illusion of depth by "stacking" space. Viewers see things shown in the lower portions of an image as close by. Objects in the upper portions appear farther away.

Some systems of creating perspective are cultural, with all artists in a particular culture following the same rules. This was true with the ancient Egyptians, who set forth principles for drawing human beings

(see page 78). Other systems are personal. Contemporary artist David Hockney has experimented with ways of showing places and people. For instance, he combined many photographs (Fig. 4–3) to show more in two dimensions than a photograph or painting can usually show.

Fig. 4–4 In this scene, space is "stacked."

Some activities—such as the students' dyeing and tinting paper—take place in the foreground, at the bottom of the image. The chef prepares noodles outdoors in the distance, at the middle left. A man and boy perform their prayers on the faraway roof. Mir Sayyid-Ali, A School Scene, c. 1540. Opaque watercolor, ink, and gold on paper. Arthur M. Sackler Gallery. Smithsonian Institution, Washington, DC. S1986.221.

Design as an Organizational Tool

Artists in every culture organize their artworks. They pay attention to how the parts add to the entire work. But artists around the world think about the parts of an artwork in different ways. Within the Western tradition, artists mostly use principles of design (such as unity, pattern, and repetition) to guide their use of the elements of design (such as line, shape, and color).

Notice how the sculptor of the terra-cotta dog with a human face (Fig. 4–7) used a smooth burnished surface to add a unified look to the artwork. Repeating simple rounded forms also adds to this sense of unity. What other principles of design did the artist use?

Nancy Graves organized her sculpture (Fig. 4–6) by repeating similar shapes and forms. Do you see how her use of color adds an element of rhythm? Do your eyes move from part to part? From color to color?

George Tooker used repeated colors, values, and shapes to help unify his painting (Fig. 4-5). Note how all but the central character are wearing drab-colored coats and have a similar form. The red dress and the wearer's worried expression also add contrast to the composition. Many lines point to the woman, including the bars on the revolving gate. The lines add tension and interest. This painting clearly shows how an organizing system can help an artist hold the viewer's interest. Such a system can also help direct the attention of the viewer. With the elements and principles of design as organizational tools, an artist has the power to convey mood and meaning.

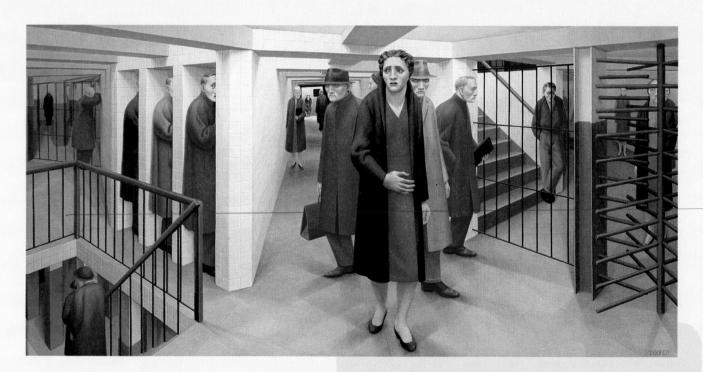

Fig. 4–5 The artist organized lines, forms, and colors to create a feeling of anxiety in this painting. Can you determine how he used perspective? George Tooker, *The Subway*, 1950. Egg tempera on composition boards 26" x 44" (66 x 111.8 cm). Collection of Whitney Museum of American Art. Purchased with funds from the Juliana Force Purchase Award. 50.23. Permission of the artist, courtesy D.C. Moore Gallery, NY. Photo by Sheldon C. Collins.

Fig. 4–6 At first glance, this sculpture may appear so lively as to seem chaotic. Yet the sculptor has organized her work very carefully. How would you describe her use of the principles of unity and balance? Nancy Graves, Zaga, 1983. Cast bronze with polychrome chemical patination, 72" x 49" x 32" (182.8 x 124.5 x 81.3 cm). Nelson-Atkins Museum of Art, Kansas City, Missouri (Gift of the Friends of Art). ©1999 The Nelson Gallery Foundation. All Reproduction Rights Reserved. ©Nancy Graves Foundation/Licensed by VAGA, New York, NY.

Fig. 4–7 Sculptures of dogs were common in ancient Mexico. Experts are not certain why some of them wear masks with human faces. Mexico (Colima), *Dog Wearing a Human Face Mask*, 200 BC–AD 500.

Ceramic with burnished red and orange slip, 8 ½2 " x 15 ½2 " x 7" (21.6 x 39.4 x 17.8 cm). Los Angeles County Museum of Art, The Proctor Stafford Collection, Museum Purchase with funds provided by Mr. and Mrs. Allan C. Balch. M.86.296.154.

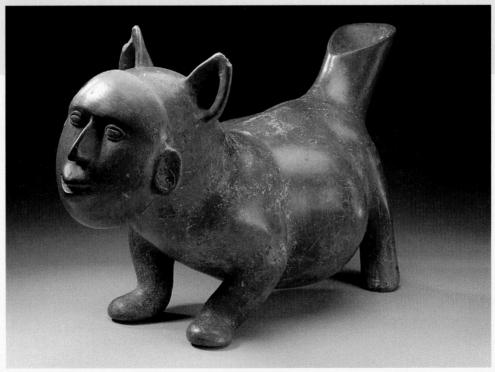

Sculpture in the Studio

Organizing a Sculpture

Pablo Picasso first used his system called Cubism in his drawings and paintings (Fig. 4–8). Then, while looking at one of his Cubist paintings,

he realized it would only have to be cut up and reassembled to be sculpture. So, Picasso created a kind of sculpture (Fig. 4–9) that had never been seen before. He began cutting simple shapes out of flat pieces of metal and cardboard and assembling them.

In this lesson, you will experiment with Cubist ideas, first by drawing and then in a sculpture. As you work, consider how you are organizing the space in your composition.

Try This

- **1.** Select an object that interests you. Look at the object from many different angles. What features of the object do you think are most important?
- **2.** Sketch the main shapes of the object from different points of view. Draw your object repeatedly until you feel you know it well. Which shapes will you simplify for a sculpture?

You Will Need

- · object to draw
- · sketch paper
- pencil
- posterboard
- scissors
- tape

Studio Background

Picasso and Cubism

When Pablo Picasso was a young child in the late nineteenth century, people said that he could "draw like Raphael." Picasso continued to draw and explore other art media for more than seventy years. During this time, he experimented with many different ways to organize his artworks. The system for which he is most famous is called Cubism.

Like the Renaissance artists, Picasso wanted to show figures as they really exist in space. But he noted that figures in space are actually seen from many changing viewpoints. Therefore, the Cubist system broke up natural forms into tilting, shifting planes and geometric shapes.

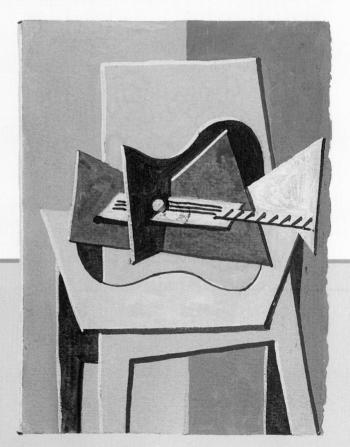

Fig. 4–8 This painting is an example of Cubism. Cubism is an art movement that began when Picasso noticed that forms could be simplified into shapes and shown from more than one point of view. Pablo Picasso, *Guitar on a Table*, 1919. Gouache on paper, 4 %/16" x 3 7/16" (11.6 x 8.7 cm). Musee Picasso, Paris, Dation Picasso. © Photo RMN. ©2000 Estate of Pablo Picasso/Artists Rights Society (ARS), New York.

- **4.** Cut out each shape. How will they interlock? Cut the slots.
- **5.** Construct your sculpture. Secure the parts with tape.

Check Your Work

As a class, discuss each student's sculpture. How were the simplified shapes combined to provide different viewpoints? How have you organized your forms in space? What effect might the work have on the viewer?

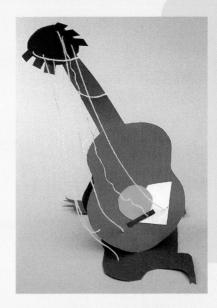

Fig. 4-10"I got the idea for this project because I love to play the guitar. I thought it would be nice to do a simple object that I like. Making and cutting the body was easy. The hardest part was to connect the strings to the guitar and base." Amanda Sacy, Strings of Life, 1999. Mixed media, 22" x 14" x 6" (56 x 36 x 15 cm). Avery Coonley School, Downers Grove, Illinois.

Sketchbook Connection

Select two or three everyday objects that have simple forms and shapes. Sketch each object from different points of view.

Then arrange the objects into a still life. Using your sketches for reference, create a still-life drawing in the Cubist style. Which views of the objects will work best together? Combine views to make the drawing interesting.

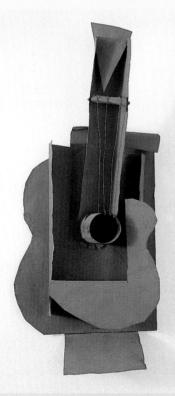

Core Lesson 4

Check Your Understanding

- **1.** Use examples to explain two ways an artist can unify an artwork.
- **2.** Show by example how an artist can create the illusion of depth in an artwork.
- **3.** How was the development of Cubism similar to the development of linear perspective?
- **4.** How would you use information in this lesson to support the position that Cubist artworks are well organized?

Fig. 4–9 Before Picasso created this work, all sculpture had been either carved or modeled. Why do you think this new kind of sculpture was called constructed sculpture?

Pablo Picasso, *Guitar*, 1912–13. Construction of sheet metal and wire, $30^{1}/2$ " x $13^{3}/4$ " x $7^{5}/8$ " (77.5 x 35 x 19.3 cm). Museum of Modern Art, New York. Gift of the artist. Photograph ©2000 The Museum of Modern Art, New York. ©2000 Estate of Pablo Picaso/Artists Rights Society (ARS), NY.

The Art of the Renaissance

As the Middle Ages came to a close in the late 1300s, people in Europe were looking for ways to improve their lives. In Italy, new ideas were being formed about the individual's place in the world. New ways of thinking based on science and inquiry were taking hold.

Individual participation in trade and commerce increased. Towns and cities grew. The middle and upper classes controlled the wealth and government of the cities. They also became **patrons** for local artists by hiring them to create special artworks for their use. Along with the church and royalty, wealthy merchants and bankers provided

artists with financial support. Artists paid tribute to their patrons by sometimes including their portraits in religious scenes.

Fifteenth-century artists knew they were living in a special time. They wanted to create their own golden age of art. They called it the Renaissance. The term *renaissance* means "rebirth." It refers to the return to classical ideals of ancient Greece and Rome.

Renaissance scholars, scientists, and artists searched for order in a world that often seemed confused. Many looked to the ancient Greeks and Romans as guides to help them discover the great things that individuals could achieve.

Art: A New Perspective

The Renaissance was a great age for art. Artists used new knowledge about the natural world. They established new theories and systems for drawing. They created special new portraits, landscapes, and religious paintings. Art criticism, art history, and new theories about architecture and linear perspective were written.

Fig. 4–11 Compare this dome with the Greek Parthenon (Fig. 2–13) and the Roman Colosseum (Fig. 2–12). Can you see the lessons in architecture Michelangelo learned from the ancient Greeks and Romans? Where else have you seen domes such as this one? Michelangelo Buonarroti, *Dome of St. Peter's*, 1546–64.

The Vatican, Rome. Courtesy Davis Art Slides.

Through the use of linear perspective, Renaissance artists were able to arrange their works in an orderly way. Linear perspective is a system based on geometry. Linear perspective helps show how the shapes of things seem to change as they recede in space. A scene painted using linear perspective appears orderly to our eyes because it shows how we see things in real life.

To make things seem very far away, artists used pale colors, fuzzy outlines, and almost no details. This technique is called **atmospheric perspective.** It can help give order to an artwork by separating it into distinct sections, such as foreground, middle ground, and background. Artists such as Leonardo da Vinci became masters of this type of perspective.

Fig. 4–12 Like other artists of the Italian Renaissance, Leonardo was interested in many things, including science and technology. His notebook is filled with ideas for inventions as well as nature sketches and studies of human anatomy. Leonardo da Vinci, *Study of a Flying Machine*, Codex B, folio 80r.

Institut de France, Paris, France. Scala/Art Resource.

Fig. 4–13 Masaccio was one of the first artists to experiment with different techniques of perspective. Look at the diagonal lines of the building in this fresco. They show linear perspective. The paler colors of hills and mountains are examples of atmospheric perspective. Masaccio, *The Tribute Money*, c. 1427. Fresco. Brancacci Chapel, S. Maria del Carmine, Florence, Italy. Scala/Art Resource, New York.

Sculpture: A Classical Order

The work of Michelangelo clearly expresses the Renaissance world. His sculptures and paintings are a mixture of calm and energy. The figures appear serene and balanced, but they also seem filled with life.

Like many artists of his time, Michelangelo studied anatomy. His artworks reveal this new knowledge of the human body. Look at Michelangelo's *Pietà* (Fig. 4–16). Despite the heavy folds of clothing, Michelangelo gives us the sense of a real body underneath. This sculpture is an example of the Renaissance interest in showing the underlying structure of things.

Fig. 4–14 Dürer was skilled at the printmaking medium called *engraving*. From a single copper plate he was able to make hundreds of prints. His prints were then sold throughout Europe. Notice all the details he has included in this print. It is smaller than a piece of notebook paper. Albrecht Dürer, *Knight, Death, and Devil*, 1513.

Engraving, $9\frac{3}{4}$ " x $7\frac{3}{8}$ " (24.8 x 18.7 cm). Art Resource, New York.

The Renaissance in the North

Like the Italians, northern Renaissance artists wanted their artworks to look real. But while Italian artists focused on the structure of things, artists of the north were more interested in showing their surface, or how they appeared. The new medium of oil paint helped them show richly colored, carefully detailed surfaces.

Often, northern Renaissance artworks are filled with everyday objects. These objects might stand for religious ideas, but they also create a real setting for the scene. Northern artists succeeded in arranging all the different elements into organized compositions. They created a sense of balance and order by using size, color, and placement to draw the eye to areas they wanted to emphasize.

Fig. 4–15 Do you feel as though you're sitting right across from these two people? This artist draws you into the painting by showing the very edge and top of the table. He emphasized the figures by making them large and placing them in the center of the composition. What do you see reflected in the round mirror on the table? Quentin Matsys, *The Moneylender and His Wife*, 1514.

Oil on wood, $27^{3}/4$ " x $26^{1}/2$ " (70.5 x 67 cm). Louvre, Paris, France. Erich Lessing/Art Resource, NY.

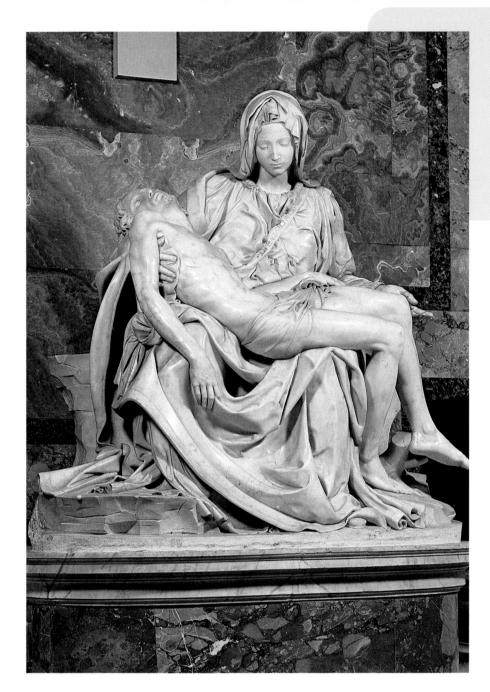

Fig. 4–16 During the Renaissance, the church remained an important patron of the arts. This sculpture was commissioned by a cardinal in the Vatican. Notice the triangular shape made by the arrangement of the figures. How does this overall shape create a feeling of stability and calm? Michelangelo Buonarroti, *Pietà*, 1499.

Marble, height: 5' 6" (1.7 cm). St. Peter's

Basilica, Vatican State. Scala/Art Resource, NY.

Studio Connection

in a twenty-first-century setting. Consider the following: What clothing and hair style will you include? What setting will you depict? How will your viewers know what century you have depicted? How will your viewers recognize the subject of your portrait?

4.1 Art History

Check Your Understanding

- **1.** Explain why the fifteenth and sixteenth centuries in Europe are referred to as the Renaissance.
- 2. What are two ways Renaissance artists organized their paintings to create an illusion of depth?
- 3. How did northern Renaissance artists approach the challenge of making artworks look real?
- **4.** How did Italian Renaissance artists approach the same challenge?

Unity and Variety

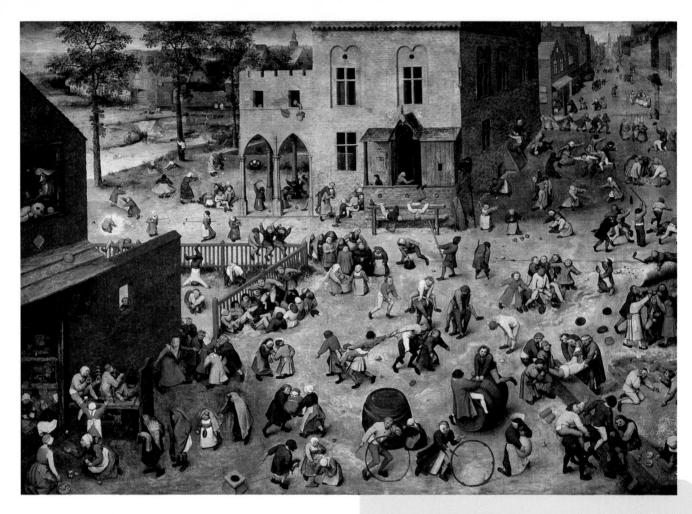

Even though consistency and change are opposites, people seem to like both. Too much order can be monotonous. Too little order may seem confusing. This is true in life and in art. By using the design principles of unity and variety, artists can express ideas and capture our interest.

Looking at Unity

Unity is the sense of oneness in a work of art. It is about how parts work together in harmony. In art, unity is often created by:

• repetition: the use of a design element again and again. Notice the repetition of shapes and colors in Figs. 4–17 and 4–18.

Fig. 4–17 **How does Brueghel unify this painting of a town filled with activity?** Pieter Brueghel, *Children's Games*, 1559–60.

Oil on wood, 46 $^{1}\!/_{2}$ " x 63 $^{1}\!/_{2}$ " (118 x 161 cm). Kunsthistorisches Museum, Vienna

- dominance: the use of one major color, shape, or element. What one color unifies Brueghel's work?
- harmony: the comfortable relationship among similar colors, textures, or materials. Notice how both artists carefully chose colors that go well together.

There are other ways to create unity. Some artists show one major element in several different ways throughout the work. The human figure in action, shown in many different poses, would help unify a work.

Order and Organization

Carefully placed shapes can lead the viewer's eye around the work and create unity. Can you find the zigzag "path" that starts in the lower left corner of Brueghel's panel? It ends in the bottom right. Follow the fence and then the row of trees; next move across the top of the building and back down the open street. Can you see how this "path" helps pull the work together?

Looking at Variety

Variety, unity's opposite, is the use of different or contrasting design elements to make a composition livelier. Artists try to use variety wisely so that the artwork is interesting but not confusing.

Notice how the slight changes in texture and color within the dresses of the three sisters create variety (Fig. 4–18). It can also be created by adding visual surprises, such as unexpected contrasts, exaggerations, or bright colors in a dull-colored area.

Studio Connection

Use markers and cut-paper shapes to show people involved in an activity. You might show close-ups of one

person or more. Or you could show many people and poses from afar.

How can you use shapes, colors, lines, or textures to create unity? How will you create variety? If most areas of your composition are filled with lots of shapes and textures, you might add variety by keeping one area very simple.

4.2 Elements & Principles

Check Your Understanding

- **1.** Describe three ways an artist might plan for unity in an artwork.
- 2. Why might an artist want to create disunity in a work of art? What feelings might such a work cause in its viewers?

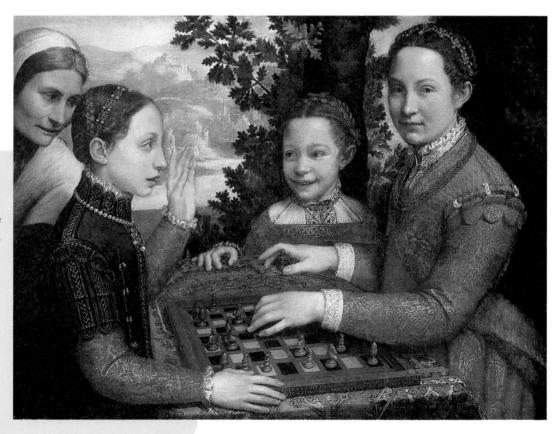

Fig. 4–18 Sofonisba
Anguissola was the
first famous woman
artist in the history of
Italian painting. Does
she successfully
achieve a balance of
unity and variety in
this work? Why or
why not? Sofonisba
Anguissola, Three
Sisters Playing Chess,
1555.
Oilon canvas, 28 3/8" x

Oil on canvas, 28 3/8" x 38 1/4" (72 x 97 cm). MNPM039. Muzeum Narodwe, Poznan, Poland. Photo by Jerzy Nowakowski.

The Art of China and Korea

Very often, the peoples of one country influence those of another, either by taking over the country or simply by example. These influences can be seen in the ways people live, how they think, and in the art they create. This is particularly true of the east Asian countries of China and Korea.

The long histories of China and Korea are usually divided into dynasties. China has the longer history, going back some 8000

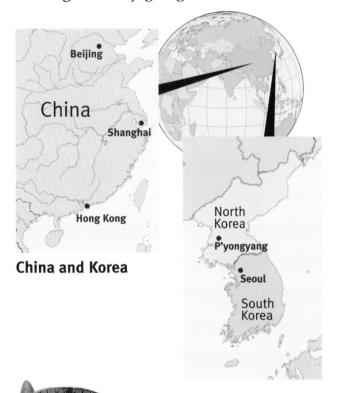

years. But Korea helped spread China's influence into other parts of east Asia, especially Japan.

The art of both China and Korea spans thousands of years. Chinese ideas and culture greatly influenced Korea, but Korean artists developed their own unique style of art. Artists from both countries have worked in varied media, perfecting their techniques over time. Their works range from ceremonial sculpture and architecture to paintings and everyday objects.

In this lesson, we will look at ceramic and bronze objects, as well as painting, to discover some of the ways Chinese and Korean artists have organized their artworks over time.

Patterned Vessels

Over the centuries, the Chinese have developed unique and elegant forms for their bronze and ceramic vessels.

Chinese artists have decorated these vessels and other objects with designs and patterns that have special meaning to them. Look at the early Chinese bronze vessel in Fig. 4–19. Notice the many different patterns and textures. How was the artist able to create a sense of order on the surface?

Fig. 4–19 This vessel was probably used only for ceremonies. Can you see how the overall form of this vessel looks like a bird? The bird's neck and head are the pouring handle. The front of the lid is shaped like a tiger, while the back changes into the face of an owl. China (Shang Dynasty, c.1600–1045 BC), Kuang Ceremonial Vessel, 12th century BC.

Bronze, $9\frac{1}{4}$ " x $12\frac{3}{16}$ " (23.5 x 31.0 cm). Courtesy of the Freer Gallery of Art, Smithsonian Institution, Washington, DC.

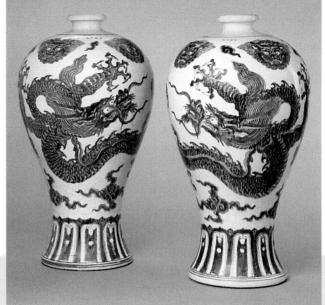

Fig. 4–21 The dragon has always been an important element in Chinese designs. It is associated with the sky, rain, and thunder. During the Ming Dynasty, when this jar was made, the dragon represented the emperor. China, Ming Dynasty (1368–1644), Pair of Vases, 1426–35. Porcelain with blue underglaze decoration, 21 3/4" x 11 1/2" (55.2 x 29.2 cm). The Nelson-Atkins Museum of Art, Kansas City, Missouri (Purchase: Nelson trust).

Fig. 4–20 This vase shows the Korean inlay technique. Korea, Koryo Dynasty (918–1392), *Meiping Vase with Crane and Cloud Design*, late 13th–early 14th century. Porcelaneous ware, celadon with inlaid design, 11 ½" (29.2 cm) high. The Metropolitan Museum of Art, Fletcher Fund, 1927 (27.119.11). Photograph ©1987 The Metropolitan Museum of Art.

The Order of Patterns

Designs and patterns cover the surface of many Chinese objects. This is called an *allover pattern*. In artworks, patterns help organize and unify the different parts. The artist of the bronze vessel on page 160 organized the allover pattern into different sections that you can easily see.

Chinese artists have organized their designs in other ways, too. Sometimes the designs were placed only in bands around the vessel's form. The Chinese vase shown above has one such band at the bottom.

Korean ceramics (Fig. 4–20) show the influence of the Chinese. Chinese artists taught the Koreans the techniques of glazing and working with **porcelain** (*POR-suh-len*), a type of fine white clay. Like the Chinese, Korean artists used allover patterns and bands to organize surface designs. They carved a design into the main clay form and then placed black and white clays in the grooves. This technique, known as *inlay*, was much admired by the Chinese.

Painted Spaces

Painting has always been an important art form in east Asia. Chinese artists had a long tradition of landscape painting, which they transferred to Korea. But Korean artists treated the subject in their own way. They often added humorous elements or exaggerated certain parts of the landscape.

Early Chinese artists painted on walls or silk, and both materials decay easily over time. These early examples no longer exist today, but they are not really lost. Other Chinese artists have copied them for centuries.

In China, artists copied older artworks they considered perfect. Because of this, Chinese paintings from many different periods in history have a similar look. From past masters, artists learned how to create the scene they wanted to show. But each painter also brought original ideas to the works while learning from the past.

Organizing Space

Chinese and Korean paintings are carefully organized. It is sometimes helpful to imagine taking a walk inside these artworks. On long horizontal paintings (called *handscrolls*), start on the right-hand side. On long vertical paintings (called *hanging scrolls*), start at the bottom. Try to notice

Fig. 4–22 Follow the order of this painting from the rocks and small figure near the bottom through the mountains near the top. Here a large unpainted space forms the middle ground. It represents the wide open space of the river. How does it help link the foreground to the background? Lu Zhi (Ming Dynasty, 1368–1644), Pulling Oars Under Clearing Autumn Skies ("Distant Mountains"), 1540–1550.
Hanging scroll, ink and color on paper, 41 5/8" x 12 1/4" (105.7 x 31.1 cm). W.L. Mead Fund 1953.159. overall. Photograph ©1999, The Art Institute of Chicago. All Rights Reserved.

where the artist wants you to look first. Perhaps the artist has used changes in value, color, or different kinds of lines to direct your eye. Contrasts in light and dark or colored and uncolored parts can make certain things stand out and draw your attention.

Study a detail from a Korean screen painting (Fig. 4–23). Look at all the things going on: textured trees, calm water, and curving mountains. How did the artist give a sense of order to this composition? Notice how the rounded shapes of the mountains contrast with the jagged shapes of the trees. This contrast helps balance the different parts of the painting and organizes them into a unified composition.

Another way Chinese and Korean painters create a sense of order in their artworks is by arranging objects carefully. Objects in the foreground are usually shown lower in the painting. Objects in the background are shown higher in the work.

Fig. 4–23 **How does the contrast between light and dark unify this work?** Korea (Choson period, late 18th century), *Seven Jewelled Peaks (Ch'ibosan)*.
Ten-panel screen, ink and color on cloth, 62 ½ 1 × 172 ½ (158.1 × 438.2

Ten-panel screen, ink and color on cloth, $62\,^1/^4$ " x 172 $^1/^2$ " (158.1 x 438.2 cm). ©The Cleveland Museum of Art, Mr. and Mrs. William H. Marlatt Fund, 1989 6

Studio Connection

Make a scroll painting that leads your viewer on a "walk" across the surface. Borrow the Chinese and Korean system for

showing distance. Think carefully about:

- the path of the journey
- the format (vertical or horizontal)
- · colors

Place the closest parts of the scene at the bottom of the painting and the distant parts at the top.

4.3 Global View

Check Your Understanding

- **1.** What are some of the similarities between Chinese and Korean art?
- **2.** Explain how the surface decorations of Chinese and Korean vessels are organized.
- **3.** How does the way that Chinese and Korean artists represent space and distance differ from that of European Renaissance artists?
- **4.** What cultures were most directly influenced by the arts of China and Korea?

Drawing in the Studio

Drawing in Perspective

Organizing Sensational Space

Studio Introduction

Have you ever wondered what it might be like to step into a landscape painting? Suddenly, everything in the

painting would come alive. What seemed flat would have depth.

Artists can create that sense of wonder when they draw or paint with linear perspective. In this studio lesson, you will draw a scene in one-point perspective. Pages 166 and 167 will show you how to do it. Use one-point perspective to add a sense of real life to the picture. Think about other methods of perspective that you can use. (See Studio Background.) Make your scene as inviting to viewers as you can.

Studio Background

Organizing a Picture's Space

For hundreds of years, artists practiced many methods of perspective. Until the Renaissance, the most common methods included overlap, variation of size, placement of subject matter, amount of detail, and use of color (see Organizing Artworks, page 148). While artists of the Renaissance knew these methods well, they wanted to paint with greater realism.

In the early 1400s, artist and architect Filippo Brunelleschi discovered linear perspective. An artist painting or drawing a scene in linear perspective creates a **horizon line**—a level line where the earth seems to end and the sky begins. The horizon line is usually located at eye level. It can be high, low, or in the middle of the artwork, depending on where the artist wants you to see the scene from. Vanishing points are placed on the horizon line.

From the 1400s on, artists could combine linear perspective with other methods of perspective. This helped them achieve realism. The picture surface became an open window that invited the viewer in.

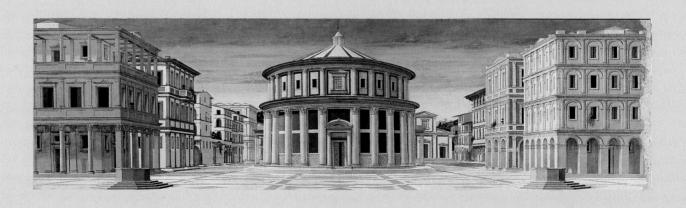

Fig. 4–24 In addition to exploring one-point perspective, this student gave thought to which colors would work best to make her drawing more interesting. She made the windows yellow to suggest a time of day: late afternoon just before dark. Joanna Lim, *A City of Color*, 1999. Colored pencil, 9" x 12" (29 x 30.5 cm). Samford Middle School, Auburn, Alabama.

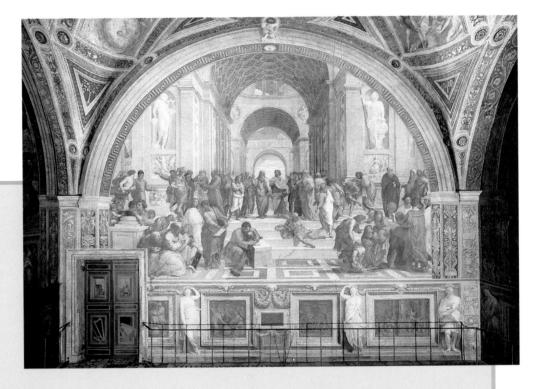

Fig. 4-25 Raphael used architectural features to create linear perspective in this painting. The floor tiles and moldings along the tops of the walls meet at a vanishing point behind the two central figures. He has also created a foreground, middle ground, and background. What do you see in the foreground? What do you see in the background? Raphael Sanzio, The School of Athens, 1509-11. Stanza della Segnatura, Vatican Palace, Vatican State. Scala/Art Resource, NY.

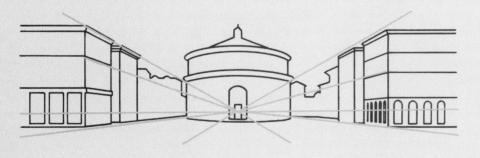

Fig. 4–26 This cityscape (far left) is an excellent example of linear perspective. The vertical lines of windows, arches, and columns are perpendicular (at right angles) to the horizon line. Horizontal lines are parallel to the horizon line, unless they recede into space. Notice how the roof and foundation lines, building stories, and lines of the pavement meet. Piero della Francesca, The Ideal City, 1480.

Galleria Nazionale delle Marche, Urbino, Italy, Scala, Art Resource, NY.

Drawing in the Studio

Drawing Your Scene

You Will Need

- drawing paper
- pencil and eraser
- ruler
- colored pencils

Try This

- 1. On your way to or from school, find an indoor or outdoor scene that interests you and lends itself to one-point perspective. The scene should have features with lines that clearly come together to a single vanishing point—a tree-lined road, rooftops, railroad tracks, a long hallway, or the like.
- **2.** Study the scene. Where is the horizon line? Which lines in the scene come together to a vanishing point? Sketch the scene to help you remember the linear perspective qualities and details.

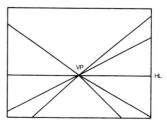

3. When you're at school, begin your drawing. First, draw a light horizon line. Will it be high, low, or in the middle of your

paper? Mark a vanishing point on the horizon line. Then use a ruler to add light guides for the lines that come together at the vanishing point.

4. Lightly sketch the main features of the scene. Follow the guidelines as needed to keep the linear perspective.

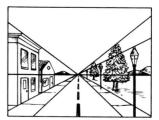

Fig. 4–27 Perspective drawings can be challenging but worth the effort as you see a realistic-looking city grow on paper. "It was very difficult drawing the buildings on the far side of the river. I like it because I worked hard on it." Dan Hartman, *City Life*, 1999.

Colored pencil, 12" x 18" (30.5 x 46 cm). Samford Middle School, Auburn, Alabama.

- **5.** When you are happy with your sketch, add color and the details you remember with colored pencils. You may wish to add details from your imagination. As you work, think about other methods of perspective that will help you create the illusion of space. Are objects in the distance smaller than those up close? Do objects overlap? Do they get lighter in color as they recede into space?
- **6.** When you are finished, carefully erase any unwanted guidelines.

Check Your Work

Discuss your drawing with classmates. What was the most difficult challenge you faced when drawing in one-point perspective? How did you solve the problem? See if your classmates can find your horizon line and vanishing point. Can they point out other methods of perspective that you used?

Sketchbook Connection

Sketch the same scene again, but do not use linear perspective this time. Instead, emphasize another method of per-

spective. When you are finished, compare the two drawings. Write a paragraph or two describing the similarities and differences you notice in the illusion of space shown in each drawing.

Computer Option

Plan a landscape by sketching a basic idea on paper. Then use the "layers" feature in a drawing or painting program.

Create and save perspective guidelines in one layer. In a second layer, make your landscape, including trees, fence posts, buildings, or another repeating subject.

Create depth realistically by using size and detail while following your guidelines for placement. Disable the guideline layer occasionally to view your work. When you are happy with your landscape, print the layer without the guidelines.

Connect to...

Careers

Graphic designers are artists who bring order and organization to visual communication. Once known as commercial artists, graphic designers are hired by services and industries to provide information that is essential to business success. These artists use the elements and principles of design every day to create memorable advertisements, presentations, books, commercials, displays, web pages, signs, and packaging. Some of their "building blocks" are words (typography), corporate-identity symbols (logos), photography, illustration, and digital special effects.

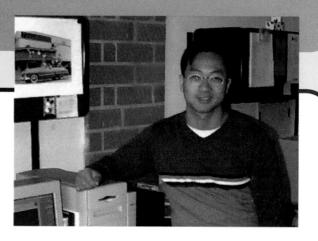

Fig. 4–28 Graphic designer David Lai develops web sites and CD-ROMs, writes books on design, and teaches web design. He is now using his organizing skills as chief executive officer of Hello Design in Culver City, California (www.hellodesign.com).

Photo courtesy of the artist.

Daily Life

What kind of a bowl do you use for your break-fast cereal? Perhaps it is made from a type of ceramic clay. **Clay containers** found from the earliest civilizations in China and Korea range from undecorated food vessels of rough earthenware clay to beautifully formed porcelain clay pieces decorated with a variety of brilliant colors. An appealing, ordered simplicity of form and design, and delicate visual scenes of nature's beauty are the traditional characteristics of Asian ceramics.

Fig. 4–29 Look closely at any vessel in your home—see if you can find any similarities to the characteristics of Asian ceramics. China, Yuan Dynasty (14th century), *Jar.* Porcelain with underglaze blue decoration, 15 $^{1}/_{2}$ " (39.3 cm) high. ©The Cleveland Museum of Art, John L. Severance Fund, 1962.154.

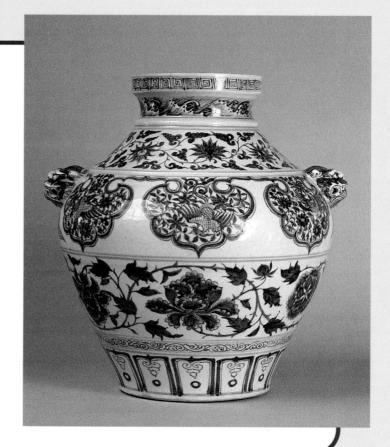

Internet Connection

For more activities related to this chapter, go to the

Davis website at www.davis-art.com.

Other Subjects

Language Arts

Until the mid-1400s, books or manuscripts had to be copied carefully by hand. As a result, they were rare and expensive. Because most people did not know how to read or write at the time, the demand for reading materials was not great. The **invention of the printing press** and movable type changed these circumstances.

Around 1450, Johannes Gutenberg, a German printer, began to print with movable type, in which a mirror image of each letter was carved in relief on a small block of wood. Individual letters were put together to form words; the words filled a page; and the pages made a book.

Social Studies

Have you noticed that few women are identified as artists during the Renaissance? At that time, a **woman with artistic talent** who wanted to become an artist usually had to be from a wealthy family whose position allowed her to receive instruction. Even so, women's training was somewhat limited because they were not allowed to study live male models.

Sofonisba Anguissola, who was encouraged by her aristocratic father to paint and play music (see Fig.4–18 on page 159), showed

Fig. 4–30 John Amos Comenius, *Typographers (Die Buchdruckerey)*, *Orbis Sensualium Pictus*. *Nuremburg*, 1658, p. 190.

PML 83013 The Pierpont Morgan Library/Art Resource, NY.

artistic talent early in her childhood. Her family's support helped her become the first woman to achieve international fame as a portrait painter. Do you think women today face difficulties in achieving success as artists?

Other Arts

Music

In musical works, **composers organize sounds** to create a melody, the tune that captures our attention and that we perceive as a unit. To the melody, the composer adds harmony, which adds musical "space" to the work and is often performed by instruments other than those playing the melody. If we compare music and art, we might say that harmony is like a painting's perspective: it provides a sense of depth.

Listen to "Courante," a dance piece written by Michael Praetorius in 1612. Notice which instrument plays the melody and what other instruments play the harmony. The piece has two sections, A and B, each of which repeat, so the order can be stated as AABB. What instrument is added during the B section of the piece? When the A section repeats, is the repetition the same as the first, or is there a difference? Which section is longer, A or B?

Portfolio

"I have been coloring and drawing ever since I was a little kid. I took art this year so I would have a chance to explore different kinds of art." Rebecca Lamb

Fig. 4–32 Linear perspective can help you draw something that looks real, even when it's from your imagination. Can you identify where the two vanishing points are located? Rebecca Lamb, City of the Future, 1999.

Colored pencils, pastels, 12" x 18" (30 x 46 cm). Yorkville Middle School, Yorkville, Illinois.

Fig. 4–31 For a celebration honoring important women, this student chose to do a portrait of someone who fought for women's rights in the nineteenth century. Rather than just copy an image from a photograph, the student created a colorful style of her own. For unity, the head is in a strong, central position; creative use of multiple colors adds variety. Lesly Cruz, Lucy Stone, 1999.

Pastel on toned paper, 8 $^{1}/_{2}$ " x 11" (22 x 28 cm). McGrath School, Worcester, Massachusetts.

Fig. 4–33 This student's use of color provides unity; how has variety been introduced? Katie Atkinson, *River in Desolate Mountains*, 1999.
Acrylic, 12" x 36" (30.5 x 91.5 cm). Johnakin Middle School, Marion, South Carolina.

"I did this artwork when my school studied different cultures this year. We studied China, France, Africa, and then South Carolina. We had to research China and create a Chinese artwork. I chose to do a scroll with washed-out neutral colors." Katie Atkinson

CD-ROM Connection

To see more student art, check out the Global Pursuit Student Gallery.

Chapter 4 Review

Recall

Define "vanishing point" (example below).

Understand

Compare the Islamic and Persian way of creating the illusion of depth with the system used by European artists of the Renaissance.

Apply

Use linear perspective to create an orderly view of a futuristic city.

Analyze

Select an artwork in the chapter and explain how the artist organized the parts.

Synthesize

Work with a group of classmates to create a display of the different ways to represent the illusion of depth. To illustrate the display, use reproductions of artworks from several cultures. Add labels to identify the systems that artists have used.

Evaluate

Select an artwork from this chapter in which you think the visual elements are especially well organized and carefully arranged. To justify your choice, refer to specific details such as lines, shapes, and patterns. Tell why their placement is effective in this particular piece.

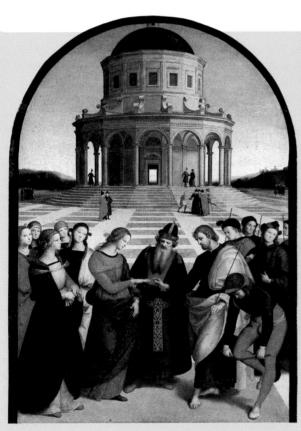

Page 146

For Your Portfolio

Choose one of your works that you believe is well organized. For instance, the work might show the use of unity

with variety, or it might have an effective illusion of depth. Write a short review of your portfolio entry: explain how it shows good organization, and what you might change if you were to recreate the work.

For Your Sketchbook

Fill a page with thumbnail sketches of various views through a doorway—from indoors looking out, and from

outdoors looking in. Try out different ways to organize your sketches: create the illusion of deep space in some views, and shallow space in other views.

5 Daily Life

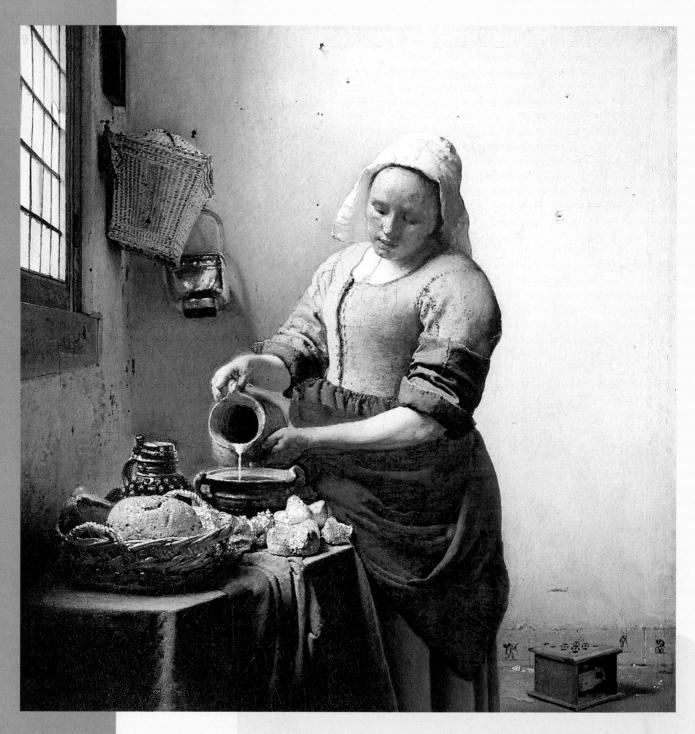

Fig. 5–1 Vermeer shows a quiet scene from daily life and allows us to see that our everyday actions have a special beauty. Jan Johannes Vermeer, *The Milkmaid*, c. 1658. Oil on canvas, 18" x 16 $^{1}/_{8}$ " (45.5 x 41 cm). Purchased from the heirs of Jonkheer P.H. Six van Vromade, Amsterdam, 1908, with aid from the Rembrandt Society. Rijksmuseum, Amsterdam.

Focus

- Why do people keep records of their everyday life?
- How do artists show daily life and create everyday objects?

Lots of people keep a journal or diary to record what they do each day. Do you? Many people now use cameras—either still or video—to record daily life and special events. Keeping such records is important, and people have been doing so for centuries. Even in an ancient village

in Egypt, archaeologists have found small rocks carved with descriptions of daily-life events. They are like journals from another time and place.

If you were to travel around the world, you would find that people do many of the same basic things. We rest, prepare food, and eat. We work and we play. But where we rest or work and what we eat may differ from place to place.

We might spend our free time in many different ways. But whatever our

daily activities, art plays a role. Most of the objects we use daily were designed and crafted by people. Look around you now. Note the objects that resulted from someone's plan or creation. Artists have also found daily-life objects and events to be important subject matter for artworks. So the way we work and play and the things we have in our homes and workplaces have also found their way into paintings and sculptures.

What's Ahead

- **Core Lesson** Learn how art enters and reflects our daily lives.
- **5.1 Art History Lesson**Discover how Baroque and Rococo artists showed scenes and objects from daily life.
- 5.2 Elements & Principles Lesson Explore ways artists use value and contrast to make everyday scenes look real.
- 5.3 Global View Lesson
 Learn how daily life is reflected in the art of Latin America, past and present.
- **5.4 Studio Lesson**Decorate an everyday container.

Words to Know

still life Baroque Rococo value contrast

Rococo pre-Columbian genre

Fig. 5–2 Workers in ancient Egypt who built Nefertari's tomb recorded their daily activities on these small limestone chunks.

Limestone Flakes. Photo by J. Hyde.

Art and Daily Life

Artistic Objects

Even when daily life is difficult, people care about having beauty around them. They carefully design objects to help them with their work and play. Crafted tools, containers for storing and serving food, and clothing and blankets for staying warm are all created with care. In cultures worldwide and throughout time, functional objects for daily

use have been decorated with traditional patterns and symbols.

Prehistoric people probably used oil lamps to light the caves where they created wall paintings. These early oil lamps (Fig. 5–3) were practical, but they were also decorated.

Useful objects are usually made from materials that are easy to find nearby. Have you ever made something useful from materials around you? Have you seen wind-catchers made from plastic soda containers? Can you imagine how an artist might use empty cans to make a toy (Fig. 5–6)?

Fig. 5-3 From the earliest times, people have decorated objects. Note the decoration on this lamp used to light caves. Lascaux, *Decorated lamp*, 15,000–13,000 BC.

Musée des Antiquities Nationale, St. Germaine-en-Laye, France. Photo © RMN, Jean Schormans.

Fig. 5–4 Look closely at all the parts of this basket. How do you think it was made? Why might someone take such care to create a fish trap? Hiroshima Kazuo, Fishtrap Basket, 1986.

Bamboo, rope, metal wire, and synthetic string, $20^{1}/8$ " x $20^{1}/8$ " x $20^{1}/8$ " x $20^{1}/8$ " x $20^{1}/8$ " (51 x 51 cm). National Museum of Natural History Collections, Smithsonian Institution.

Daily Life

Fig. 5-5 Mary Carpenter made the top part of this quilt when she was only thirteen. Do you think her sole interest was in making something that would keep her warm? Mary Carpenter Pickering, Quilt appliqued with fruit and flowers, 1850-54.

Cotton fabric, 89 ½ x 89 ½ (226.4 x 226.7 cm). National Museum of American History.

Fig. 5–6 Daily objects can be recycled to create new forms. Here, a milk can is turned into a toy. South Africa (Johannesburg), Deux Chevaux (Toy Car), 1994. Johannesburg, South Africa. Nestle concentrated milk can. Collection of the International Folk Art Foundation, Museum of International Folk Art, Santa Fe. Photo: John Bigelow Taylor, NYC.

Daily-Life Events

Lots of different events make up your daily life. You sometimes gather with friends and family. Perhaps you dance or sing. You play games. Many people also work hard every day. On your way home today, notice the people at work. What are they doing? How are they working? Are they alone or are they working with others? Do they use special equipment? Must they dress in a special way? How might they feel about their work?

Artists notice how people work and play together and alone. Sometimes artists make daily life the subject matter of their artworks. For example, Carmen Lomas Garza likes to show the ways that people in families and communities get together. In her work showing a family get-together for

making tamales (Fig. 5-7), we see people working together on an important activity. She also shows us the steps of the process.

Most adults, no matter where they live, spend much of their time working to make a living. Some people find their work satisfying and enjoyable. Others spend years just putting up with a daily struggle. Look closely at a Dutch artist's view of a tailor's shop (Fig. 5–9). What do you think the artist wanted you to know about this kind of work?

Free time is another important part of daily life. The special atmosphere created by people relaxing often appeals to artists. In Jaime Colson's painting (Fig. 5–8), notice the poses of the people. What has the artist done to help show an easy-going atmosphere?

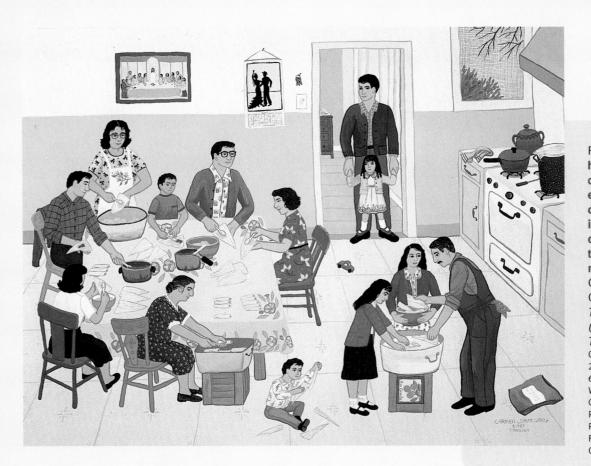

Fig. 5-7 We see here that families can work together to get a job done. From what is shown here, can you describe the process of making tamales? Carmen Lomas Garza, La Tamalada (Making Tamales), 1984. Gouache painting, 20" x 27" (50.8 x 68.6 cm). Photo: Wolfgang Dietze. Collection of Leonila Ramirez, Don Ramon's Restaurant, San Francisco, California. Courtesy of the artist.

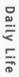

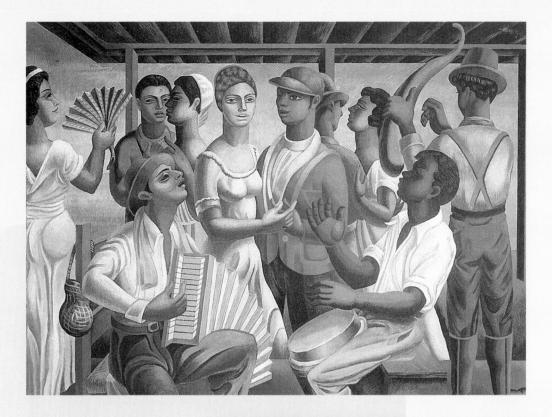

Fig. 5–8 Artists often show the many ways we spend our free time. Jaime Colson, from the Dominican Republic, showed people dancing the merengue. Jaime Colson, Merengue, 1937. Tempera on board. Museo Juan Jose

Tempera on board. Museo Juan Jose Bellapart, Santo Domingo, Dominican Republic.

Fig. 5–9 In this painting, the artist provided a glimpse of work in seventeenth-century Holland. What clues reveal that the setting is a tailor's shop? Quinringh Gerritsz van Brekelenkam, *The Tailor's Workshop*, 1661.
Canvas, 26" x 20 7/s" (66 x 53 cm). Rijksmuseum, Amersterdam.

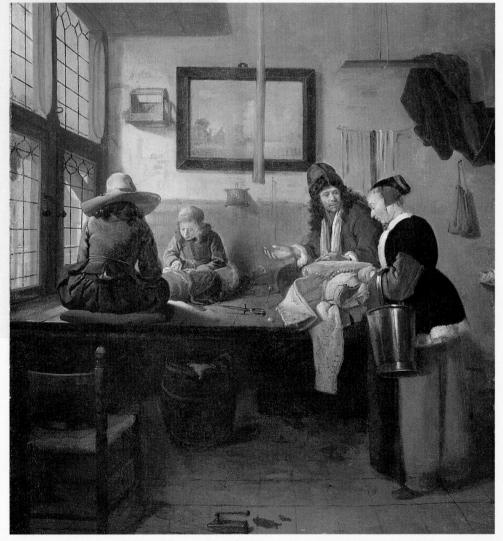

Painting in the Studio

A Still-Life Painting

In this studio experience you will create your own still-life painting of objects from your daily life. Think about objects you collect or like to arrange.

Why are they important to you? Do they tell something about who you are? Choose objects that have special meaning to you or that might symbolize something else, like the flowers and fruits in early Dutch paintings.

Try This

1. Arrange your objects in several different ways. Think about how your arrangement can express something about your daily life. Choose the arrangement you like the best.

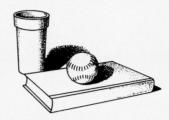

2. If you can control the lighting, direct the light in a way that creates shadows that you like.

3. Sketch your arrangement. Draw the main forms first. Then add the smaller ones.

You Will Need

- paper
- pencils
- tempera paint
- brushes

Studio Background

Paintings of Everyday Objects

Since early times, artists have drawn and painted groups of ordinary objects. In seventeenth-century Holland, artists began to use the term **still life** for paintings in which objects were most important. Dutch artists used food, flowers, and precious objects as symbols to caution people to live good lives. For example, because the beauty of flowers or fruit does not last long, Dutch artists used them in paintings. They wanted to remind people that their lives were also short.

Fig. 5–10 This painting was made at a time when Dutch merchants were traveling to faraway lands. They often brought back new and unusual foods and objects. The artist arranged a collection of such objects. He also used them symbolically. Can you see any objects that might stand for an idea? Jan Davidsz de Heem, A Still Life with Parrots, late 1640s. Oil on canvas, 59 ¹/₄" x 46 ¹/₄" (150.5 x 117.5 cm). Bequest of John Ringling, Collection of the John and Mable Ringling Museum of Art, the State Art Museum of Florida.

4. Paint your composition. Mix and use tints and shades. As you paint, pay careful attention to where light and dark areas are in your arrangement.

Check Your Work

Talk with your classmates about your artworks. Try to use at least five adjectives to describe the qualities of light you see in them. What makes each composition work well? How does the use of light make the objects look? Do they look important? Mysterious? Cheerful? Discuss whatever personal or symbolic meaning the objects seem to have to the artist.

Fig. 5–12 This student composed a simple still life featuring a bowl of rice, her favorite food. "Rice, mmmm! It is so tasty dressed in soy sauce; even better, butter. Rice can have so many flavors, why wouldn't you like it?" Abby Reid, Bowl of Rice, 1999.

Tempera, 20" x 30" (51 x 76 cm). Shrewsbury Middle School, Shrewsbury, Massachusetts.

Fig. 5–11 This painting was made about 300 years after the de Heem still life, yet its message is similar. Plastics were not commonly used until the early twentieth century. Why would a plastic parrot live forever? Audrey Flack, *Parrots Live Forever*, 1978.

Oil over acrylic on canvas, 83 " x 83 " (210.8 x 210.8 cm). Courtesy of the Louis K. Meisel Gallery, New York.

Sketchbook Connection

Arrange some fruits, such as apples and oranges. Look closely at the organic forms. Make a series of drawings that

capture the colors and textures of the surfaces. Next cut each fruit in half and arrange the halves. Examine the shapes, patterns, and textures on the inside. Make a series of drawings of the inside surfaces.

Core Lesson 5

Check Your Understanding

- **1.** What are some ways that art enters our daily lives?
- **2.** What can a still life painting tell about daily life?
- **3.** What do we mean when we say that Dutch artists used objects as symbols?
- 4. How are artists observers of life?

European Art: 1600-1750

		1656 Velázquez, <i>Las Meninas</i>			1732 Hôtel de Soubise, Paris		
Renaissance page 154			Rococo		Neoclassicism page 206		
The second secon	c. 1650 Rembrandt, <i>V</i>	iew of Amsterdam	1658 de Hooch	, Courtyard of	ā House	c. 1755 Soup Turee	7

Around 1600, exciting changes were taking place in the art world. Artists throughout Europe were competing to paint works of art for people who wanted them.

To please their patrons, artists created fancy works that were full of drama and energy. Artists searched for dramatic ways to show familiar subjects: portraits, still lifes, and scenes of everyday life. Tastes were

changing. A bold new art style was formed.

This new art style is called **Baroque**. It began in Italy, but artists throughout Europe liked its power and drama. They used rich textures to add realism. Diagonal lines helped them express movement. Often, Baroque artworks are dramatically lit, like a theater stage. Bright-colored figures or objects emerge from a dim background.

Some words that describe the Baroque style are *grandiose*, *emotional*, and *exuberant*.

In the 1700s, artists in France took Baroque drama and grandeur one step further. They developed the witty and playful **Rococo** style. Rococo artists used contrast, texture, and movement in their art and architecture. Rococo artists wanted to create a light and airy feeling. Their paintings had shimmering highlights and textures. Their pastel-colored sculptures appeared delicate and fragile.

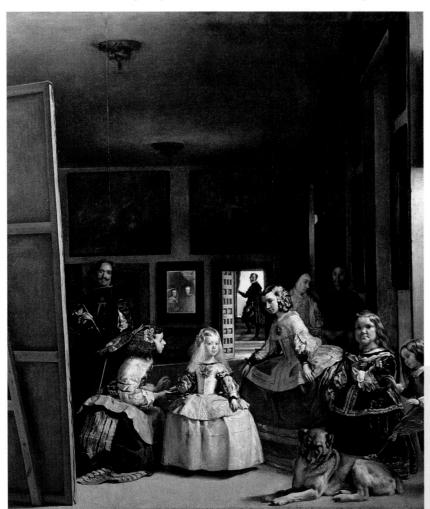

Fig. 5–13 Notice how Velázquez used light in this painting of himself, the princess of the Spanish royal court, and her ladies-in-waiting. What direction does the natural light come from? How does this add drama and contrast to the figures? Diego Velázquez, Las Meninas (The Maids of Honor), 1656.
Oil on canvas, 10' 7" x 9' 1/2" (3.23 x 2.76 m). Derechos Reservados ©Museo Nacional Del Prado, Madrid.

Fig. 5–14 Prints, especially those showing landscapes, were inexpensive and very popular with the Dutch middle class. Dutch landscape artists such as Rembrandt created realistic scenes of the towns and countryside they saw around them.

Rembrandt van Rijn, View of Amsterdam, c. 1650.

Rijksmuseum, Amsterdam.

Fig. 5–15 Rococo architecture was generally lighter and more graceful than the earlier Baroque style. How does this kind of architecture make you feel? Germain Boffrand, Salon de la Princesse, Hôtel de Soubise, Paris, begun 1732.

Scala/Art Resource, NY.

A Glimpse of Daily Life

We know a lot about daily life in seventeenth-century Holland thanks to the visual record the artists and patrons have left behind. Dutch artists were experiencing an exciting time. The middle class in Holland was growing. As people became wealthier, more and more of them were able to buy artworks to decorate their homes. Art was no longer just for the rich and powerful. Almost anyone could buy it.

For their homes, Dutch people wanted art that reminded them of their everyday, comfortable world. This made artists focus on landscapes or on images of everyday life, called **genre** scenes, as their subjects. Artists such as Judith Leyster (Fig. 5–17) and

Pieter de Hooch (Fig. 5–16) became known for their paintings of people and places in Holland. These genre scenes showed ordinary people enjoying their free time. The Dutch saw themselves, their lives, and their activities reflected in these artworks.

Fig. 5–16 Dutch Baroque artists had a specific audience in mind when they created their artworks. Why do you think this painting would have appealed to the country's new middle class? Pieter de Hooch, Courtyard of a House in Delft, 1658. Canvas laid down on panel, 26 5/8" x 22 5/8" (67.8 x 57.5 cm). Private collection. Courtesy Noortman Ltd.

Fig. 5–17 This interior genre scene shows an ordinary Dutch family enjoying themselves at a popular game, similar to backgammon. Judith Leyster, *Game of Tric-Trac*. Oil on panel, 16" x 12 ¹/4" (40.7 x 31.1 cm). Worcester Art Museum, Worcester, Massachusetts. Gift of Robert and Mary S. Cushman.

Everyday Splendors

Rococo artists took the lessons of Baroque art to new heights. They decided to trade Baroque heaviness and seriousness for wit and whimsy. Rococo art reflected the tastes of the wealthy upper class of French society. French patrons valued elegance and wit. They wanted whimsical artworks that showed them enjoying their leisure time.

Soon these patrons wanted furniture, statues, and other household decorations in the Rococo style. Even everyday objects—salt shakers, clocks, dishware—showed the frills and charm of this new style. Look at the everyday object used to serve soup in Fig. 5–18. What does it tell you about life in eighteenth-century France?

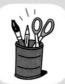

Studio Connection

Combine drawing, painting, and collage to create an interior scene from everyday life. Use perspective and overlap-

ping to show foreground, middle ground, and background. Think about how you might use a light source, color, and value for dramatic effects.

To add interest to your scene, create a series of crayon rubbings. Cut shapes from these rubbings. You might also combine them with magazine cutouts to add pattern and detail to some surfaces.

5.1 Art History

Check Your Understanding

- **1.** How was the use of art in seventeenth-century Holland different from that in other parts of Europe at the time?
- **2.** What are the characteristics of Baroque art?
- **3.** What kind of daily life was depicted in Rococo art?
- **4.** How is the art of Spanish court artist Velázquez similar to and different from the art of Dutch painters of this time?

Fig. 5–18 The Rococo style appeared in all kinds of objects. What do you think it would be like to serve soup from this tureen? Soup Tureen, Cover, and Stand, c. 1755.
Faience with enamel decoration, 11 ⁷/₈" x 14" x 17 ⁷/₈" (30.1 x 35.5 x 45.4 cm). Sceaux Pottery and Porcelain Manufactory, France. Nelson-Atkins Museum of Art,

14" x 17 ⁷/s" (30.1 x 35.5 x 45.4 cm). Sceaux Pottery and Porcelain Manufactory, France. Nelson-Atkins Museum of Art, Kansas City, Missouri (Purchase: Nelson Trust). Photography by E.G. Schempf. ©1999. The Nelson Gallery Foundation. All Reproduction Rights Reserved.

Light, Value, and Contrast

We need light to see what is around us. The artists of the works shown on these pages lived in a time before the invention of the electric light bulb. They painted objects from their daily lives lit only by the sun or by lanterns. The objects in these paintings have deep shadows and strong highlights. Using the language of art, we say these paintings show contrast between dark and light values. This contrast helps make the items look three-dimensional, as if they exist in space.

Looking at Value

Value is the range of light and dark in a color. The artists of these works carefully chose light and dark values of paint. They used these values to make the objects seem real to viewers. They used dark values of

paint to make the shadows that provide a sense of depth. They painted the lightest values in the areas facing the source of light. Can you identify the direction light comes from in each painting?

Shading is a gradual change in value. It is used to show the shift from dark areas to light ones. Notice how Clara Peeters used shading to show the round forms of fruit in her painting (Fig. 5–20). Gradual changes in value can give the sense of a misty atmosphere or a mood of calmness or quiet. More sudden changes in value create a strong contrast between very light areas and areas of deep shadow, as in Rembrandt's Side of Beef (Fig. 5–21).

Fig. 5–19 **How would you describe the artist's use of contrast in this work?** Jean-Baptiste Simeon Chardin, *The Silver Goblet*, c. 1760.
Louvre, Paris, France. Giraudon/Art Resource, NY.

Fig. 5–20 People in seventeenth-century Holland enjoyed decorating their homes with artworks of objects and scenes they saw every day. Where did this artist use the most contrast in her work? Clara Peeters, Still Life with Nuts and Fruit, after 1620. ©Ashmolean Museum. Oxford.

Fig. 5–21 Would you want to decorate your home with this painting? What do you think interested the artist about this scene?
Rembrandt van Rijn, Side of Beef, 1655.
Oil on canvas, 37" x 27 1/8" (94 x 69 cm). Louvre, Paris. Giraudon/Art Resource, NY.

Looking at Contrast

Contrast is a great difference between two things. A contrast in values creates a noticeable difference between light and dark in a composition. This design principle allows artists to add excitement or drama to their work, as we can see in these paintings of daily life. Often, the area of an artwork with the greatest contrast captures our attention first.

Value is only one element artists can contrast in their work. Peeters and Chardin (Fig. 5–19) used color contrast in their paintings. Rembrandt contrasted the smooth texture of meat and muscle in the animal carcass with the rough wood and stone of the building. Can you find other examples of contrast in these three works?

5.2 Elements & Principles

Check Your Understanding

1. How do value and shading help artists make objects look more realistic?

2. How might the artworks on these pages look different if a strong spotlight had been used to illuminate the objects in each?

Studio Connection

Use pencil or charcoal to make a careful drawing of an everyday object. Locate the light source. Notice where

the light creates highlights and shadows on the object. Experiment with shading. Apply pressure to the pencil or charcoal to create dark values. Use less pressure to create light values.

The Art of Latin America

Artists of Latin America have always been interested in decorating objects they use every day. They often show scenes of their daily life, activities, and work.

You may be wondering: Where is Latin America? Latin America is really a term that groups together many different countries on two continents: Mexico, countries in South America and Central America, and the Caribbean islands. The history of each of these countries is very different. But they all share one important historical event. All these countries were taken over by European settlers in the 1500s.

In the next pages, you will see examples of

Latin American art from ancient to modern times. The art of these countries is varied and diverse, just like the countries themselves. But all these artworks provide valuable clues about the daily life of the people.

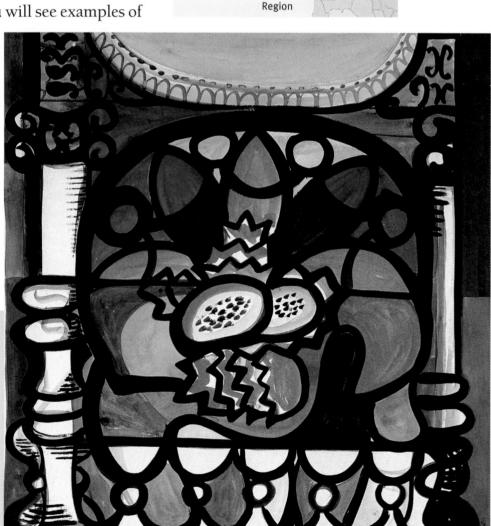

WEST

Puerto Rico

Dominican

Republic

SOUTH

Inca

Inca

Paracas

AMERICA

Mexico

Aztec

CENTRAL

AMERICA

Moche Civilization

Fig. 5–22 This Cuban artist often painted interior scenes and still lifes of fruits. The strong black outlines and bright-colored shapes look like the stained-glass windows in old-fashioned Cuban homes. Amelia Pelaez, Still Life, 1942.
Gouache and watercolor, 29⁷/s" x 28³/s" (75.7 x 72 cm). ©Christie's Images, Ltd, 1999.

Pre-Columbian Art

Many civilizations were flourishing in the Americas long before the arrival of Europeans. We call the art these cultures made before the arrival of European settlers **pre-Columbian**, meaning "before Columbus." This art was created without influences from Europe. After the settlers arrived, the style and content of much of this art changed.

Clues to Daily Life

People of these early cultures are known for the many kinds of objects they decorated. They painted pottery, carved stone calendars, formed metal vessels, and wove colorful patterned textiles. Each culture became skillful at working with certain art materials. They used these materials to craft everyday and ceremonial objects. Art was part of people's everyday lives. They decorated the objects they wore with human and animal designs. These designs reminded them of nature and their gods, which were important to their survival.

Unfortunately, when some European settlers arrived, they destroyed many objects the native cultures had produced. Those made of gold, silver, and other precious metals were most often destroyed. But many examples have been uncovered from tombs or found in the ruins of ancient cities. These objects allow us a glimpse into daily life in these ancient cultures.

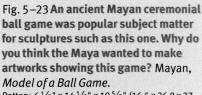

Pottery, $6^{1/2}$ " x $14^{1/2}$ " x 10^{5} /s" (16.5 x 36.8 x 27 cm). Worcester Art Museum, Worcester, Massachusetts. Gift of Mr. and Mrs. Aldus Chapin Higgins. Photo ©Worcester Art Museum.

Fig. 5–24 Pre-Columbian cultures in Peru are known for their textiles, including ponchos (a kind of cape) and tapestries. Like many Peruvian textiles, this one was buried in the desert and has been preserved in perfect condition. Find the cats that make up part of this poncho's design. Do you think cats were important to this culture? Peru, Paracas, Poncho, 300–100 BC.

Wool embroidery on cotton, 30" x 23 $^5/8$ " (76 x 60 cm). 24:1956. St. Louis Art Museum.

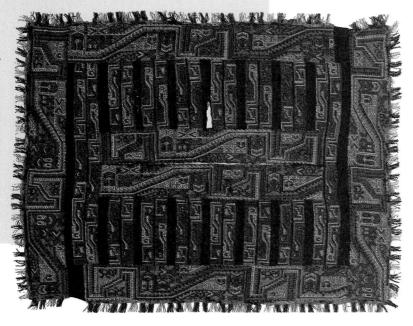

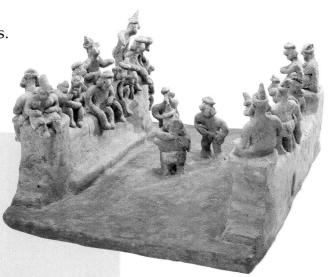

Modern Latin American Art

After centuries of European rule, the countries of Latin America eventually gained their freedom. Some Latin American artists decided to return to the themes and images

from their past. They wanted to show a connection with their nearly forgotten native heritage.

A Celebration of the Worker

Like pre-Columbian art, modern Latin American art also gives us clues about everyday life. But modern artists seem to be sending us a different message about the

Fig. 5–25 This work is a criticism of the difficult labor many people had to face in the artist's homeland of Puerto Rico. Why do you think he gave this painting showing a man carrying bananas the title Our Daily Bread? Ramon Frade, Our Daily Bread, c. 1905. Puerto Rico. Institute de Cultura Puertoriquans, Galeria Botello, Hato Ray, PR. Photo by John Betancourt.

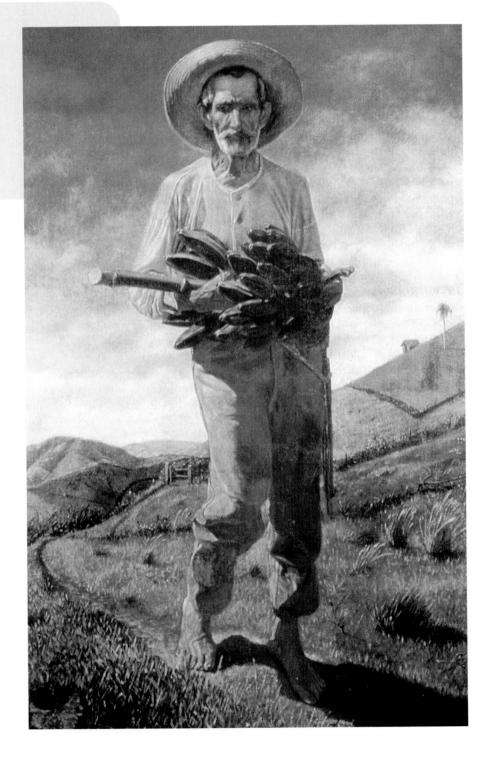

Daily Lif

daily life around them. These artists often focused on the life of the worker, showing scenes of daily household chores or farm work. They showed the hard labor of people who worked the land. They pointed out how

such workers helped their country prosper. Through their celebration of the worker, modern Latin American artists hope to make others aware of the often overlooked value and dignity of work.

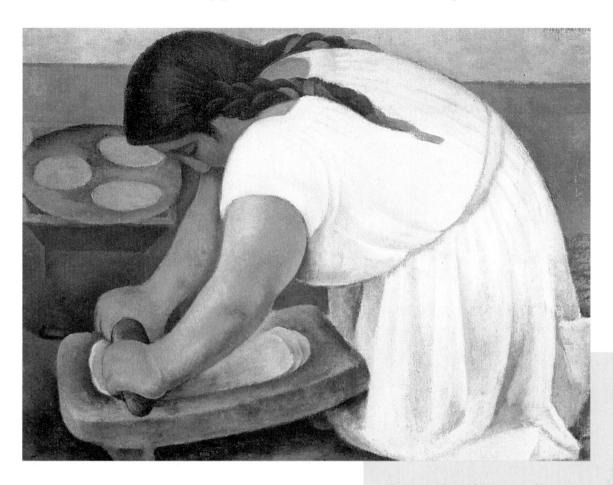

Studio ConnectionScenes of everyday life

Scenes of everyday life, or genre paintings, often show people in their homes.
Outdoor genre scenes might

show life in the city, in the suburbs, or on a farm.

For your genre painting, choose an outdoor scene of people at work or play. Think of your favorite weekend activity, one of the outdoor chores you do, or a recess game at school. Try using a mixed-media technique. For example, you might use oil pastels with collage and tempera paints. What other combinations are possible? Which one is best for your subject?

Fig. 5–26 Diego Rivera wanted to present native Mexicans with dignity and show their everyday lives. How has he shown that grinding corn is hard work? Diego Rivera, Woman Grinding Maize, 1924.

Mexico. Museo Nacional de Arte, Mexico City CNCA-INBA.

5.3 Global View

Check Your Understanding

- **1.** What major event occurred in Latin America in the early 1500s?
- **2.** What do we call the art made by Latin American cultures before the arrival of Christopher Columbus and European settlers?
- **3.** Name two kinds of objects for which early Latin American cultures are known.
- **4.** Why have some modern Latin American artists chosen to show workers in their artworks?

Sculpture in the Studio

Decorating a Container

Adding Meaning to Daily Life

Studio Introduction

Picture your favorite drinking glass, lunchbox, or other container that you use every day. How is it decorated? Is it

painted with a design? Were decorations added to its surface? Is the form itself decorative?

Now think about other things you see in your daily life: furniture, lamps, linens, dinnerware. Cultures all over the world decorate objects like these. Many objects are simply patterned, while others appear complicated and overdone. Some are not decorated at all.

In this studio lesson, you will decorate an everyday container. Pages 192 and 193 will tell you how to do it. The features and decorations you add to the container should express something about your daily life.

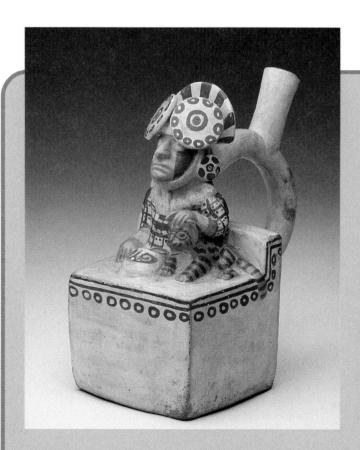

Studio Background

Decorating for Daily Life

The Rococo art style, which started in eighteenth-century France, is known for its extreme amount of detail. Porcelain pieces (Figs. 5–29 and 5–30) from this period are highly decorated and playful. You might think that Rococo artists "went overboard" with intricate detail, but the ornate style was an expression of a new lighthearted spirit in Europe.

Pre-Columbian vessels and sculpture contrast sharply with the delicate forms and pastel colors of Rococo objects. Pottery from the pre-Columbian period (Fig. 5–27) is fairly plain and is decorated with simple, often geometric, shapes that resemble symbols. Its colors are usually soft and dull. Most pre-Columbian objects that have lasted to the present had ceremonial uses. They generally have a more serious tone than Rococo objects.

Fig. 5–27 Stirrup vessels have a hollow handle and spout through which liquid is poured. Many take the form of an animal or human head and are painted with colored clay slips. What might the forms and decorations you see on this vessel represent? What main shapes do you see? Peru (Mochica culture), Stirrup Vessel representing seated ruler with pampas cat, 250–550 AD. Ceramic, 75/8" x 71/2" (19.4 x 19.1 cm). Kate S. Buckingham Endowment, 1955.2281. Photograph ©1999 The Art Institute of Chicago, All Rights Reserved.

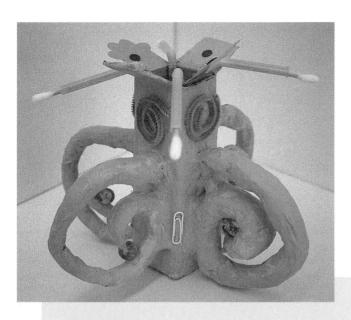

Fig. 5–28 "Creating a Rococo style container was a real challenge at first. Then I was inspired! An origami gift box was perfect for the project. Papier-mâché gave the basic form a whole new look." Claire Whang, *Rococo Container*, 1999.

Papier-mâché, acrylic, found objects, 7" x 9" x 9" ($18 \times 23 \times 23$ cm). Plum Grove Junior High School, Rolling Meadows, Illinois.

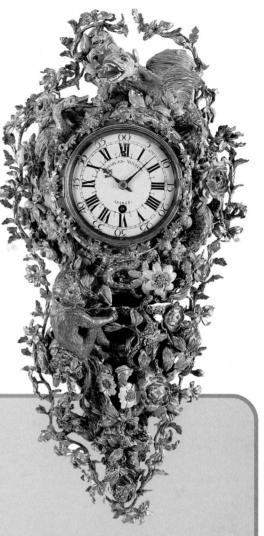

Fig. 5–29 This clock may have been intended to hang over a bed. At the pull of a string, it would strike the time to the nearest hour and a quarter. How would you describe the textures you see in the clock's decoration? Movement made by Charles Voisin and Chantilly manufactory, Wall Clock, c. 1740.

Soft-paste porcelain, enameled metal, gilt-bronze, and glass, $29^{1}/2$ " x 14" x $4^{3}/8$ " (74.9 x 35.6 x 11.1 cm). The J. Paul Getty Museum, Los Angeles.

Fig. 5-30 This Rococo sculpture was a table centerpiece. How is this centerpiece different from one you might find in your own home? How many patterns can you find? Johann Peter Melchior (modeled by), The Audience of the Chinese Emperor, c. 1766.

Hard-paste porcelain, height: 15 $^{7}/8$ " (40.3 cm). The Metropolitan Museum of Art, Gift of R. Thornton Wilson, in memory of Florence Ellsworth Wilson, 1950. (50.211.217) Photo © 1990 The Metropolitan Museum of Art

Sculpture in the Studio

Decorating Your Container

You Will Need

- sketch paper
- pencils
- container
- cardboard
- newspaper
- scissors

- tape
- wheat paste
- paints
- brushes
- found objects
- glue

3. Using the container as your base, build an armature onto which you will apply papier-mâché. Tape features made from cutout cardboard or wads of newspaper securely to the container.

Try This

- 1. Discuss the artworks shown in this lesson. How do the decorations on the clock, centerpiece, and stirrup vessel reflect the ideas or interests of each culture? Which decorative style appeals to you more? Why? How might you use features from that style to decorate your own everyday container?
- **2.** Look at your container. What kinds of decorative features and decorations can you add that will express something about your life? Sketch your ideas.

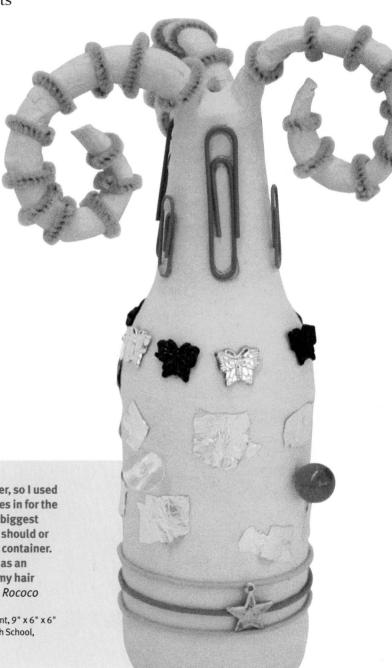

Fig. 5–31 "I often drink root beer, so I used the empty plastic bottle it comes in for the basic shape of my project. The biggest challenge was deciding what I should or shouldn't use to embellish the container. I plan to use my finished piece as an incense burner or a holder for my hair scrunchies." Stephanie Maher, Rococo Container, 1999.

Papier-mâché, found objects, acrylic paint, 9" x 6" x 6" (29 x 15 x 15 cm). Plum Grove Junior High School, Rolling Meadows, Illinois.

4. When all the parts are in place, cover the whole form with five or six layers of papiermâché. Make sure that each layer is smooth and even. Let the work dry completely.

5. Paint your container. Choose a color scheme that best fits your daily life. When the paint is dry, decorate the container with buttons, sequins, beads, ribbons, foil, tissue papers, or other found objects.

Identify the best features of your work. What do your decorations say about your culture or your daily life? Why is the decorative style you chose appropriate for your container? Is this a container you could use every day? Why or why not?

Sketchbook Connection

Sketch an ordinary object—a telephone, vegetable peeler, remote control, or the like—that you see or use every day

but never really paid attention to. When you are finished, write a brief paragraph describing something new that you learned about the object while sketching it.

Computer Option

Design a "virtual" pet's food or water dish. Decorate with fanciful details such as a pedestal, handles, or mirrors. Add as

much detail as possible. What kind of a pet will use the dish? For example, a pet with a long neck could reach high up off the floor. How can you use pattern, color, and contrast to embellish the dish?

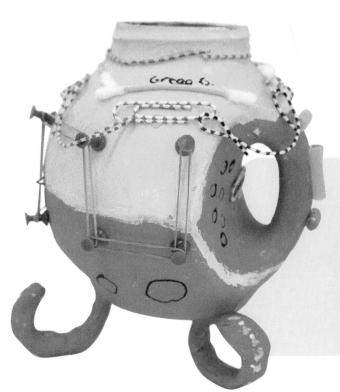

Fig. 5–32 "One of my interests is baseball, so when I was looking for a ready-made container, I chose a plastic mug I had saved that was in the shape of a baseball. I was surprised to see that I could use something like rubber bands and push pins to create a decorative repeated pattern that I really liked. My Rococo-style container will make a neat pencil holder for my desk at home."

Greg Greener, Rococo Container, 1999.
Papier-mâché, found objects, acrylic paint, 8" x 6" x 6" (20 x 15 x 15 cm).
Plum Grove Junior High School, Rolling Meadows, Illinois.

Connect to...

Careers

What products do you constantly see advertised on TV? Automobile commercials appear frequently, advertising the latest designs and features. Some ads even include computer-generated images that detail the design blueprint of a car. Automobiles are one type of product developed by industrial or product designers. Look around the classroom for ordinary objects that were designed to be both useful and attractive.

Product designers work in every manufacturing industry, usually in collaboration with a design team. They must be creative, aware of their specific audience and style trends, and knowledgeable

Fig. 5–33 Product designers often sketch their ideas.

Some sculpt foam models. This sketch for a camera design is the work of José Pérez.

Courtesy Kodak.

about manufacturing processes and materials. Product designers might work with samplemakers to create presentation models. They often use computer-aided industrial design (CAID) systems to make working drawings.

Other Arts

Theater

At first glance, Velázquez's painting Las Meninas (Fig. 5–13) looks realistic. But look closely, and you will notice that the painter carefully manipulated elements such as light to show the subject in a certain way. Playwrights do something similar with **dramatic dialogue**.

Often, a conversation among the characters in a play seems very realistic, as though it could happen in real life. But, if you listen closely, you will hear a difference. The dialogue does not wander off topic, as with

many real-life conversations. Also, the characters use very few words to express their ideas. Many playwrights carefully structure the dialogue to "highlight" certain ideas.

Fig. 5-34 Tennessee Williams uses realistic dialogue in the play *The Glass Menagerie*.

Photo courtesy of The Southeast Institute for Education in Theatre, directed by Kim Wheetley, 1992, starring Susan Elder as Laura and Julia Martin as Amanda.

Other Subjects

Mathematics

We all need to keep track of time, but how were ancient peoples able to do so? The early Maya—who lived in what today are parts of Mexico, Honduras, Guatemala, Belize, and El Salvador—developed sophisticated **calendars** and an advanced number system. They kept track of the solar and lunar years, eclipses, and the cycles of visible planets.

In their number system, used for astronomical and calendar-related calculations, they used a few simple symbols in varying combinations to express numbers: a dot had the numerical value of 1; a bar stood for 5; and a shell-shaped symbol represented 0. The written numbers were read from bottom to top, in vertical columns. The Maya are one of the first people to have a numerical symbol for zero.

Fig. 5–35 Do you hang a calendar on your wall? Where might these stone calendars have been located? Pre-Columbian Maya, Calendar disk, c. 200 BC–1521 AD. Chiapas, Mexico. Courtesy of Davis Art Slides.

Physical Education

Before the arrival of Columbus in North America, the Maya played a **ball game** that was taken quite seriously. It was played on a large outdoor court framed by two parallel stone walls. The walls sloped at the bottom so that a ball in play would bounce upward and remain airborne.

The game was played as two opposing teams, facing each other from opposite sides of the court, tried to score points by sending a hard rubber ball through a stone hoop.

Fig. 5-36 To make their game balls bouncy, Mayans added juice from morning glory vines to the latex. Is their game similar to any games you play? Mayan, *Model of a Ball Game*.

Pottery, 6 1 / $_{2}$ " x 14 1 / $_{2}$ " x 10 5 / $_{8}$ " (16.5 x 36.8 x 27 cm). Worcester Art Museum, Worcester, Massachusetts. Gift of Mr. and Mrs. Aldus Chapin Higgins. Photo ©Worcester Art Museum.

Internet Connection

For more activities related to this chapter, go to the

Davis website at www.davis-art.com.

Portfolio

"I was thinking of a playful and imaginative room where I could feel free and easy. See a cuddly stuffed animal on my bed and my art books on the chest of drawers. Smell my sweet flowers. Listen to my radio or call me on the phone. Oops, I forgot to hang up my blue jean jacket." Stephanie Kreider

Fig. 5–37 A room created from the imagination can look realistic when it includes details from daily life. Stephanie Kreider, *Bed Room*, 1999. Mixed, collage, 18" x 24" (46 x 61 cm). Laurel Nokomis School, Nokomis, Florida.

Fig. 5–38 Genre paintings (scenes of everyday life) capture the interest in ordinary moments. This student chose to portray herself getting ready for a dance lesson. Lindsay Voss, Full-size Self Portrait, 1999. Conté, 24" x 18" (61 x 46 cm). Verona Area Middle School, Verona, Wisconsin.

"It was important to me that Becky looked like Becky, so I worked especially hard on that part." Lindsay Voss "The easier part is drawing the pre-sketch or outline, because you get a picture of what the final piece is going to look like. Gradation and value are more difficult. It is hard to make a pencil blend from dark to light. I think that my artwork looks the best when I try my hardest to put in a lot of detail." Kaelin Burge

Fig. 5–39 When drawing a common object in your daily life, you may notice details you never saw before. Kaelin Burge, *Sketchbook*, 1999.
Pencil, ink, colored pencil, 8" x 11" (20 x 28 cm). T. R.
Smedberg Middle School,

Sacramento, California.

CD-ROM Connection

To see more student art, check out the Global Pursuit Student Gallery.

Chapter 5 Review

Recall

Identify two general ways in which art is connected to our daily life.

Understand

Summarize the major difference between Baroque and Rococo styles. Note the degree to which each deals with daily-life activities.

Apply

Use what you have learned about Latin American cultures as a starting point for finding out more about their art. Plan a bulletin-board display to inform others in your school about this artistic tradition.

Analyze

Compare the ways artists presented in this chapter have used light, value, and contrast in genre scenes of daily-life activities. Note which artists used the brightest colors, the darkest colors, the strongest light, and the darkest shadows.

Synthesize

Transform a simple, everyday object—such as a picture frame—into an artwork in the Rococo style.

Evaluate

Defend the use of Vermeer's *The Milkmaid* (Fig. 5–1, shown below and on page 172) as an introduction to Chapter 5's theme of daily life.

Page 172

For Your Portfolio

Create two portfolio artworks with the theme of daily life. Make one work—such as a bicycle—provide an obvious

function in a daily-life activity. Make the other artwork show a daily-life activity that you enjoy, such as playing sports or reading. Use the artworks in this chapter for ideas.

Write a short explanation of how the chapter artworks influenced your two artworks. Put your name and date on your artworks, and add them to your portfolio. (If your work is three-dimensional, provide a mounted photograph of it.)

For Your Sketchbook

Design an attractive border on a sketchbook page where you can write your thoughts or make sketches about ways

that art enters your daily life. Add to the page from time to time, and use your ideas for future artworks.

6 Place

Fig. 6–1 This artist saw beauty in a scene of sheep resting beside the ocean. How would you describe the mood of this painting? Rosa Bonheur, *Sheep by the Sea*, 1869.
Oil on cradled panel, 12 ³/₄" x 18" (32 x 45.7 cm). Gift of Wallace and Wilhelmina Holladay. The National Museum of Women in the Arts.

Focus

- Why are special places important in people's lives?
- What can artworks tell about places and their meaning?

Is there a place you go when you want to be alone? Most of us have that kind of place—our room, a spot under a tree, or our neighborhood. We also have places for certain activities, such as places for working, playing, shopping, or learning. Places—and a sense of place—are important to us. We want to know where we are, and we usually like to feel comfortable.

Because we can remember places, we can "return" to them in our minds. We do this especially for places that have special meaning for us. We may wish to remember where important things happened, such as learning to read or winning a basketball game. Places are also important to groups of people. A community might remember some

of its history with a marker or plaque. The marker could tell what happened, who was there, and why the place is important.

All over the world, at many different times in history, individuals, groups, and whole nations have used art to show that certain places are special. Artist Rosa Bonheur looked around her world and saw beauty in ordinary settings (Fig. 6–1). What beautiful places do you know?

What's Ahead

- **Core Lesson** Discover various ways that artists show places in their art.
- 6.1 Art History Lesson
 Learn about the Western art styles of
 Neoclassicism, Romanticism, and
 Realism.
- **6.2 Elements & Principles Lesson**Consider how artists use space and emphasis when showing a place.
- 6.3 Global View Lesson
 Learn how Oceanic artists have included places in their artworks.
- 6.4 Studio Lesson
 Use stitchery to create an image of a dream-like place.

Words to Know

document negative space
Neoclassicism implied space
Romanticism center of interest
Realism motif
emphasis fiber artist
positive space appliqué

Telling About Places

Places to Notice

People often see the same places again and again, and they become familiar with the plan of these places. When you enter a place, pay attention to its design. How does the structure remind you of what the place is used for? How does the design of a church, for instance, match its purpose? Look at the mosque in Fig. 6–3. What feeling do you get from this place?

Fig. 6–2 This beautifully carved pole was made to stand in a special place. It was created as a memorial to a deceased person. Why might the artist have painted the animals and faces in different colors? Niu Ailand People, Melanesia (New Ireland), *Memorial Pole*, early 20th century.

Wood, fiber, operculum, vegetable paste, and paint, 98 $^{7}/_{16}$ " x 9 $^{7}/_{8}$ " x 5 $^{15}/_{16}$ " (240 x 25 x 15 cm). Gift of Morton D. May, 60:1977. St. Louis Art Museum.

Fig. 6–3 This mosque is an important place to the people of Djénné, Mali, in West Africa. They come here to worship, to shop, to learn, and to socialize. Every spring, the citizens work for weeks to replaster the surface to protect it from the summer rains. Ismaila Traoré, *The weekly market at the Great Mosque of Djénné*, 1906–07. Adobe. Mali, West Africa. Photo by Rob van Wendel de Joode.

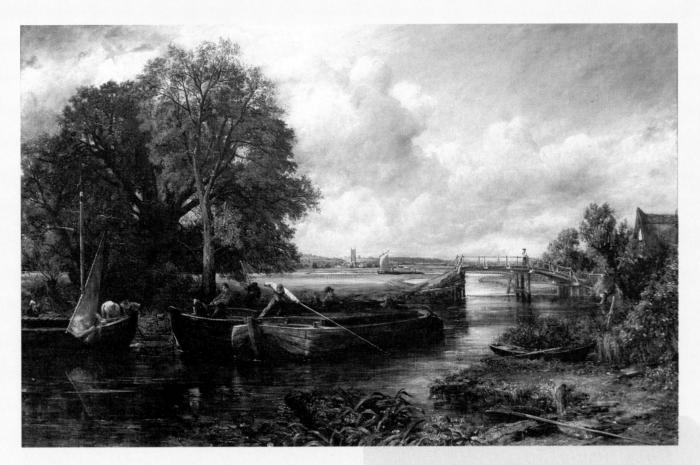

Artworks are sometimes created to mark a place. Entryways can tell visitors that they are crossing into a special place. Carefully designed gardens and grounds add beauty to the building they surround. The Maori people of New Zealand use art to add to the significance of their buildings. They carve and decorate wood poles and beams like the one shown in Fig. 6–2.

Artists make artworks to show us places. They might illustrate places from the past that actually existed. They might show imagined places that we wish were real. They might even show places that we are glad do not exist—places that frighten us.

Fig. 6–4 Constable painted a landscape near his home in Suffolk, England. From his painting, we learn how things looked in the past. How might this view look different today? John Constable, View on the Stour near Dedham, 1822.

Oil on canvas, $20\,^1\!/\mathrm{s}$ " x $29\,^1\!/\mathrm{s}$ " (51 x 74 cm). The Huntington Library, Art Collections and Botanical Gardens, San Marino, California/SuperStock.

When you look at an artwork that shows a place, think about what the artist might have wanted you to experience. Are you drawn to the place, wishing you could visit it? Does the place have qualities that could not possibly be found in real life? Was the artwork created mainly to **document**, or record, how a place looks? In Fig. 6–4, for example, artist John Constable recorded the Stour River's appearance in 1822.

Places to Remember

Artworks can show us how things looked in the past. They can also show how a place was used. Canaletto did this in his painting of St. Mark's Plaza (Fig. 6–5). If we focus on how people used places in the past, we can see that some purposes haven't changed much. The shopping malls of today may look different from eighteenth-century Italian plazas, but they do serve similar purposes for large groups of people.

Artworks can also show us places that are important to the artist as an individual.

Faith Ringgold created a story quilt (Fig. 6–6) about a place she called "Tar Beach." She shows that this rooftop is a magical place where everyday troubles aren't allowed to enter. Do you think this is a real or imagined place? What evidence did the artist provide that supports your opinion?

Artists show some places because the places—and the stories about them—are special to whole communities. In Fig. 6–7, Joe Nalo tells such a tale. The legend is already familiar to the people of this island, but Nalo's art gives the community a new way to see the story.

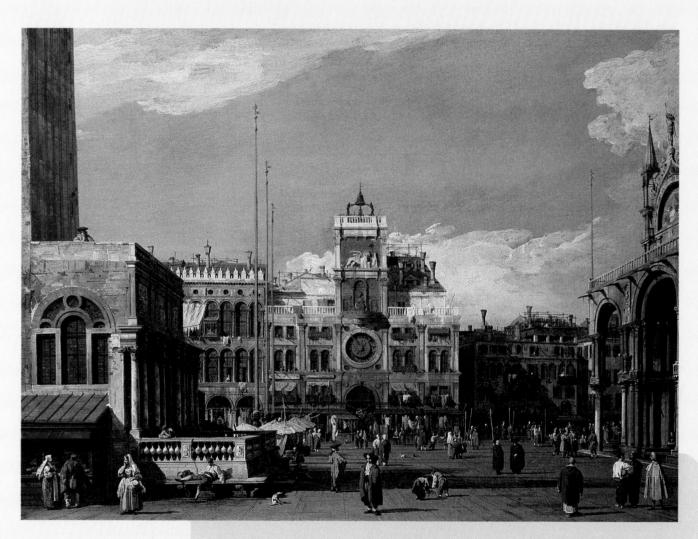

Fig. 6–5 Even today, St. Mark's Plaza in Venice is a place people gather to socialize, rest, shop, and feed the birds. Which details in Canaletto's painting tell us how this important place looked in the past? Giovanni Antonio Canale, called Canaletto, *The Clock Tower in the Piazza San Marco*, c. 1728–30.

Oil on canvas, $20^{1}/2$ " x $27^{3}/8$ " (52.1 x 69.6 cm). The Nelson-Atkins Museum of Art, Kansas City, Missouri (Purchase: Nelson Trust). ©1999 The Nelson Gallery Foundation. All Reproduction Rights Reserved.

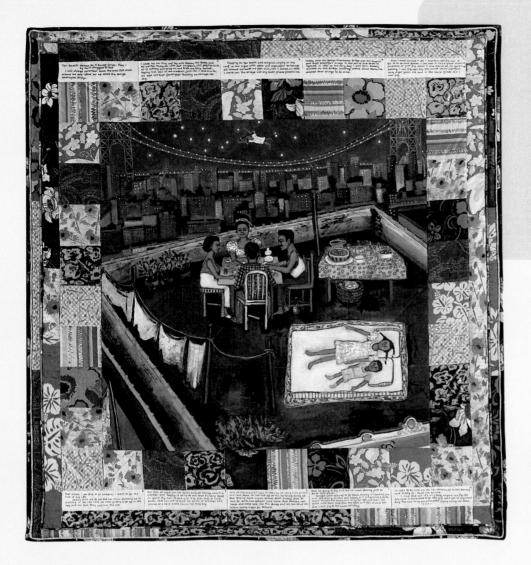

Fig. 6-6 The rooftop of a city apartment building can be a special place. What feeling does the artist give us about this place? How do we know it is a special place to her? Faith Ringgold, *Tar Beach*, 1988.

Acrylic paint on canvas bordered with printed and painted quilted and pieced cloth, 74 \(^5/8\)" x 68 \(^1/2\)" (189.5 x 174 cm). Solomon R. Guggenheim Museum of Art, New York. Gift, Mr. and Mrs. Gus and Judith Lieber, 1988. Photograph by David Heald ©The Solomon R. Guggenheim Foundation, New York. (FN 88.3620)

Fig. 6–7 This composition tells about the origin of Leip Island, in Papua New Guinea. Without being familiar with the legend, can you identify what is important to people from this island? Joe Nalo, The Legend of Leip Island, 1993.

Oil on canvas, 59" x 78 3/4" (150 x 200 cm). Collection: Museum für Völkerkunde, Frankfurt am Main. Photograph: Hugh Stevenson.

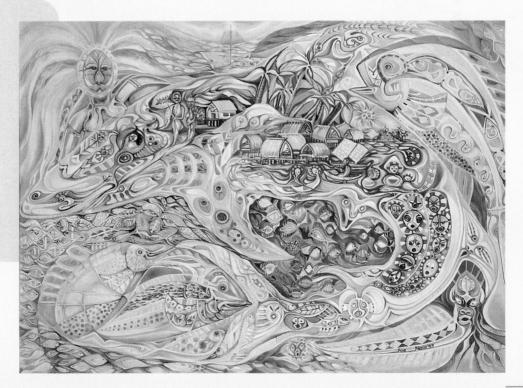

Creating a Place for Thought

Imagine a place you can go to relax and think deep thoughts. The place might be a room, a park, a garden, or a spot surrounded by trees. It

can be a real or made-up place.

What would you like to show others about this place? In this lesson you will use clay to create a three-dimensional artwork of your calm, peaceful place. Think about how you might use space to make the place seem more peaceful. What will you emphasize in your work?

Fig. 6–8 "I picked this location because I went on a boat before and found it relaxing. I did the color in the project like it would look in nature. I found this calming because you can listen to nature without being interrupted." Nicolle Pacanowski, *Untitled*, 1999.
Clay, 5 ½" x 7" x 1 ¼" (14 x 18 x 3 cm). Daniel Boone Middle School.

Clay, $5\frac{1}{2}$ " x 7" x $1\frac{1}{4}$ " (14 x 18 x 3 cm). Daniel Boone Middle School Birdsboro, Pennsylvania.

You Will Need

- square of cloth
- work board
- clay
- slip
- paintbrush
- two sticks and a rolling pin
- clay tools or a knife and fork

Try This

1. Start by making a clay slab for the base. Place a cloth flat on your work board or table. Put your clay on the cloth and

place a flat stick on each side of the clay. Press a rolling pin down on the center of the clay, letting it rest on top of the sticks. Roll back and forth until the clay is flat. Use a table knife to trim the edges into the shape you want.

2. Think about the best way to create your environment. Will you build up the sides with additional slabs? Will you add coils, balls, or modeled forms?

Studio Background

Peaceful Places in Art

Why do you think it is valuable to have a place to go for time alone? Most people seem to need such a place. Gazebos, benches shaded by trees, and rock outcroppings are examples of such places. Public gardens are known as special places where people can sit quietly and enjoy their surroundings. Can you think of others?

Some artists show these places in their work so that we can enjoy them without actually visiting. We can imagine being there as we view the work. Traditional Chinese landscape painters were skilled at creating a visual path for viewers to follow through a beautiful natural area. Look at the works in Figs. 6–9 and 6–10 to see how calm, peaceful places have been created by two Chinese artists.

3. To join two pieces of clay, always score their surfaces and use slip. How might you create negative space in your

environment? Can you leave open space between forms? Can you carve holes or other shapes in the clay?

4. Will you show people in your environment? How can you use textures and small details to add emphasis to parts of your quiet place? As you work, remember that clay will shrink slightly when it dries.

Check Your Work

Compare your artwork with that of your classmates. What features did you include to suggest a quiet place? What are the effects of the positive and negative spaces in everyone's work? How are parts of the peaceful places emphasized?

Fig. 6–9 A Chinese artist created this place. Can you see the positive and negative space? What areas did the artist emphasize? China, Qing Dynasty, Qianlong period (1736–95), *Mountain Landscape*, 18th century.

Jade, 6⁷/8" (17.5 cm). ©Cleveland Museum of Art. Gift of the Misses Alice and

Jade, $6\frac{7}{8}$ " (17.5 cm). ©Cleveland Museum of Art, Gift of the Misses Alice and Nellie Morris, 1941.594.

Core Lesson 6

Check Your Understanding

- 1. Why are places important to people?
- 2. Name two ways that people use places.
- **3.** What are two reasons artists have depicted places?
- **4.** Give an example of a place especially designed to serve human purposes.

Fig. 6–10 Where can you see negative space here? How does it help emphasize the figures? Ch'iu Ying, Passing a Summer Day Beneath Banana Palms.

Section of a hanging scroll (cropped at top and bottom). Ink and colors on paper, 39" (99 cm). National Palace Museum, Taipei, Taiwan, Republic of China.

European Art: 1750–1875

	1784 David, <i>Oath of the Horatii</i>		1857 Millet, The Gleaners	
Rococo page 180	Neoclassicism	Romanticism	Realism	Impressionism page 232
on the state of th	1785 Kauffmann, <i>Pliny the Younger</i>	1860 Delacroix, <i>Horses</i>	c. 1863 Daumier, <i>Third Class</i>	Carriage

The nineteenth century was a time of different political and social points of view in Europe. Revolutions gave rise to new governments. Ideas were changing in many societies.

The art of this period reflected these differing views. Lighthearted Rococo art was replaced by three new, more serious art styles. Each style was a reaction to the one before it. Each was inspired by a different place in history and the world.

The first style was called **Neoclassicism**. Like artists of the Renaissance, Neoclassical artists looked to the classical Greek and Roman past as models for their art. Their calm, carefully organized paintings, sculpture, and architecture reminded people of the Greek and Roman ideals of order and harmony.

Some artists rejected the strict rules of Neoclassicism and began an art style called **Romanticism.** These artists were interested in medieval times and distant places such as Africa and the Orient.

Toward the mid-1800s, artists of the style known as **Realism** did not want their artworks to show faraway places or times. They thought art should be about the places and things they saw every day.

Fig. 6-11 This is an example of a history painting, or a painting that shows an event from history, mythology, or the Bible. Why, do you think, were the event and place shown in this painting a popular subject for Neoclassical artworks? Angelica Kauffmann, Pliny the Younger and His Mother at Misenum, AD 79. Oil on canvas, 3' 4 1/2" x 4' 2 1/2" (103 x 128 cm). The Art Museum, Princeton University. Museum purchase, gift of Franklin H. Kissner. Photo Credit: Clem Fiori. ©2000 Artist Rights Society (ARS), New York/VG Bild-Kunst, Bonn.

Fig. 6–12 Notice the classical setting and the way the figures appear frozen in action, almost like sculptures. The darkened background and highlighted figures make the painting look like a dramatically lit stage. How does this use of light and dark compare to the Baroque example in Fig. 5–13, *Las Meninas?* Jacques-Louis David, *Oath of the Horatii*, 1784–85. Oil on canvas, 129 ¹¹/₁₂" x 167 ⁵/₁₆" (330 x 425 cm). Louvre, Paris, France. Erich Lessing/Art Resource, New York.

Neoclassicism

Why did artists once again become interested in the classical past? In 1738, there was a great discovery: The ancient Roman cities of Pompeii (pom-PAY) and Herculaneum (her-kew-LAY-nee-um) were found. The two cities had been destroyed by the volcano, Mount Vesuvius, in 79 AD. They were perfectly preserved under layers of volcanic ash. This new source of information on life in ancient Roman times inspired many artists.

Places of the Past

Artists began to base their paintings on ancient places. They often painted scenes of Roman ruins. Some showed people from their own time in a classical setting of arches

and columns. Some artists, like Angelica Kauffmann, even chose the eruption of Mount Vesuvius as the subject for artworks (Fig. 6-11).

Artist Jacques-Louis David wanted his paintings to teach a lesson. In *Oath of the Horatii* (Fig. 6–12), he chose the story of the heroism and patriotism of the Horatius brothers of ancient Rome. In this time of revolutions and rebellions, David hoped his paintings would inspire patriotism and a sense of duty among the people of France.

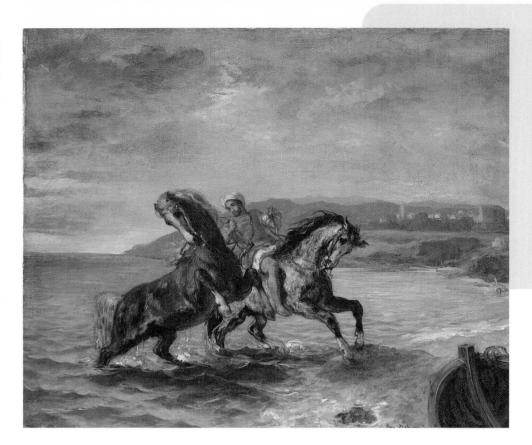

Fig. 6-13 What feeling does the use of color and brushstrokes create in this painting of a place in northern Africa? Compare this arrangement of a figure and horses with the arrangement of figures in David's painting (Fig. 6-12). Do you see how both groups form a similar overall shape? How are the two groups different? Eugène Delacroix, Horses Coming Out of the Sea, 1860. Oil on canvas, 20 1/4" x 24 1/4" (5.4 x 61.5 cm). The Phillips Collection, Washington, DC. (0486).

Romanticism

In the nineteenth century, "romances" were medieval stories of heroism and bravery. Maybe you have read about King Arthur and his knights or the search for the Holy Grail. Romantic artists were inspired by these tales of adventure. They rejected the ordered style of Neoclassicism in favor of a style filled with emotion.

Faraway Places

For the Romantics, feeling was everything. Neoclassical artists concentrated on line and careful brushwork, but Romantic artists applied color with wilder, more active brushstrokes. They wanted you to look at a painting and actually *feel* the emotion of the scene. They chose stormy seas, faraway beaches, and dangerous battlefields as settings for their works.

French Romantic painter Eugène Delacroix visited countries in northern Africa and made many watercolor sketches during his travels. When he returned home, he made paintings of the new and exciting people, architecture, and colors he had seen (Fig. 6–13).

Realism

Showing people, places, and things realistically has always been important in Western art. But the realism of the nineteenth century was different from that of other times. Artists in this new movement insisted on showing only things they had seen in real life. They believed that a good painting could come only from patiently observing reality.

Everyday Places

Scenes of people working in the countryside or going about their daily lives were the favorite subjects of the Realists (Fig. 6–15). The Realists believed their artworks recorded simple ways of life that were quickly disappearing as new technologies took over.

Some Realists, such as Honoré Daumier, used their art to point out the faults of modern society. In *The Third Class Carriage* (Fig. 6–14), Daumier places us, the viewers, in the poor section of a horse-drawn bus. Notice how the poor family is separated from the wealthier passengers by the back of the seat. What do you think Daumier was trying to say about modern life in the city?

Studio Connection

How can you express the idea of a secret place, an exciting place, a romantic place, or maybe even a frightening

place in a painting? Decide whether to show a city place, a country place, or somewhere in between. Paint the largest forms first. Think about the brushstrokes that will help show the mood of the place. Then choose different size brushes, and practice your brushstrokes on newsprint. Do your final painting on white paper.

6.1 Art History

Check Your Understanding

- **1.** What inspired the style known as Neoclassicism?
- **2.** What interested artists in the Romantic movement?
- **3.** How was the new Realism of the nineteenth century different from realistic representation in previous centuries?
- **4.** What are three different ways that artists in the nineteenth century thought about places?

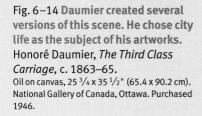

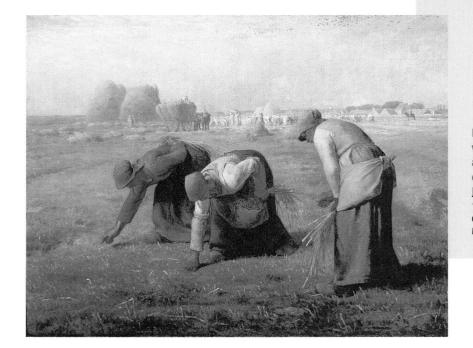

Fig. 6-15 Gleaners are farmworkers who pick up the seeds left behind after a harvest. What kind of mood did Millet create for this scene?

Jean-François Millet, *The Gleaners*, 1857.
Oil on canvas, 33" x 44" (83.8 x 111.8 cm).

Musée d'Orsay ©Photo RMN.

Space and Emphasis

Space can be three-dimensional: buildings and sculptures take up space. It can also be two-dimensional: a painted canvas can show space in many ways. You can look at any space from different places and angles, from inside or outside, in bright light and in shadow.

Regardless of your viewpoint, there will always be something that you notice first about an artwork. **Emphasis** gives importance to part of a work. It makes you notice one part or element before all the others.

Looking at Space

Artists refer to a space as **positive** (the object itself) or **negative** (the area surrounding the object). As they plan the spaces in their work, artists decide whether each area in the artwork will be filled (positive space) or empty (negative space).

You create space by the way you place objects or shapes. In three-dimensional art, artists organize space by carefully placing solid forms. They also plan negative spaces, which are between and around the forms. In two-dimensional art, artists organize space by the placement of shapes.

Implied space is the illusion, or appearance, of three-dimensional space in a two-dimensional artwork. On a flat surface, artists create the illusion of space by overlapping, shading, placement, size, sharpness of focus or detail, and linear perspective (see pages 40 and 148).

Note how Friedrich created the illusion of deep space in Fig. 6–16. The ships seem to get smaller as they move away from shore. There are more details in the foreground figures than in those farther away. Friedrich helps us experience the vastness of the seascape by giving the sky so much space.

Fig. 6–16 German artist
Caspar David Friedrich had
deeply personal experiences
with the sea and perhaps
saw the coast as a place for
thought. Can you locate this
painting's center of interest?
Caspar David Friedrich,
Periods of Life
(Lebensstufen), c. 1834.
Oil on canvas, 28 ³/₄" x 37 ¹/₈" (73 x
94 cm). Museum der Bildenden
Kuenste, Leipzig, Germany. Erich
Lessing/Art Resource, NY.

Fig. 6–17 How would you describe this artist's use of space? Did he show a short distance or a great distance? How can you tell? Joseph Mallord William Turner, *The Shipwreck*, 1805.

Oil on canvas, $6^3/4$ " x $9^1/2$ " (17.1 x 24.2 cm). Clore Collection, The Tate Gallery, London/Art Resource, NY.

Looking at Emphasis

You can create emphasis by planning a work so that some features are more dominant, or stronger, than others. Viewers usually notice the dominant feature first. What do you notice first in Turner's painting (Fig. 6–17)? How did Turner draw attention to the people trying to survive a catastrophic shipwreck?

A bright patch of color in a painting with many dull colors can create emphasis. A repeated element can also create emphasis. For example, look at the shapes of people in Turner's work. Other ways to create emphasis include size and placement. The most important element—the subject of the work—might be larger than other elements. It might be placed near the center of the work or be given a lot of space.

When an area is strongly emphasized, artists say it is the **center of interest** in a work. The center of interest is not always the middle (physical center) of the work. It can be anywhere the dominant element shows up—top, side, or bottom.

Why, do you think, might an artist pay attention to emphasis when showing a particular place?

6.2 Elements & Principles

Check Your Understanding

- **1.** What are some ways to create the illusion of space and distance in two-dimensional art?
- **2.** What are some ways to achieve emphasis in two-dimensional art?

Studio Connection

Think of an imaginary place to depict, and then use emphasis to show deep space. What part or feature of the

work do you want viewers to notice first? Experiment with different color combinations of watercolors or pastels.

You might create a colorful and dramatic evening sky and then blend colors to show gradual changes. Use two pieces of construction paper (a dark value and a middle value) and experiment with cut silhouettes. Use the silhouettes to create a middle ground and foreground.

Isolated in Place: Oceanic Art

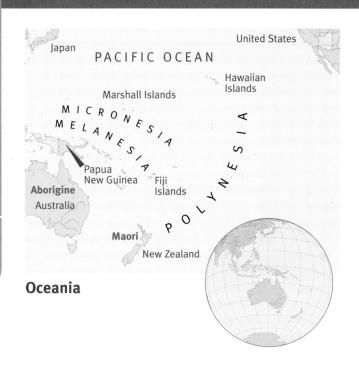

Can you find Oceania on a map? Oceania is the name we give to a large area in the Pacific Ocean that contains thousands of islands. Many of the islands are grouped into one of three regions: Micronesia, Polynesia, or Melanesia. Within those regions are countries such as New Zealand and Papua New Guinea. The Hawaiian islands are part of Oceania, too. Oceania is a cultural name, not a political name. This means that the people of this huge area of islands share many similarities, even though they may be from different countries.

Fig. 6–18 Oceanic peoples have a long tradition of teaching and practicing ocean navigation. This map made of sticks shows how to travel to a place by tracking wave formations and patterns created by the ocean water bouncing off of the islands. Marshall Islands, Micronesia, Stick Chart.

Wood and shell. Peabody Museum of Art, Salem, Massachusetts. Photo by Jeffrey Dykes.

Fig. 6–19 This model for a miniature temple is woven from sennet, a local plant fiber in the Fiji Islands. Small idols, often made of ivory, are placed in the miniature temples as an offering to the spirits. Why do you think this model has two spires? Fiji Islands, Melanesia, *Double Spired Temple Model*. Sennet, 43 ½" (110.5 cm). Peabody Museum of Art, Salem, Massachusetts. Photo by Jeffrey Dykes.

The ocean forms a natural barrier around the islands of Oceania. There are people on these islands who have had very little contact with other cultures, although some parts of Oceania have been settled for more than 40,000 years. Being isolated has allowed the people to keep their cultural and artistic traditions. Many Oceanic peoples, especially those living far from cities and towns, still practice traditional ways of making art.

Oceanic art is usually created to be used in everyday life or for special ceremonies.
Artists use local natural materials such as

raffia, barkcloth, shells, and feathers in their work.

Some traditional art forms are wood carving, tattooing, maskmaking, and weaving. Many of these art forms show complicated repeated patterns and curving designs. These designs often reflect the animals and plants of the region. The designs also relate to the region's spiritual beliefs. In many Oceanic cultures, ancestor spirits are believed to rule the land and sea. People make offerings to these spirits, and their art shows the spirits in special places.

Fig. 6–20 Some native peoples of New Guinea build highly decorated houses for ceremonies. The inside of the house is a sacred space, open to only the initiated. New Guinea, Hut of Spirits. Muscom Missionario Etnologico, Vatican Museums, Vatican State. Scala/Art Resource.

Dreamtime Places

The Aborigines are Australia's most ancient peoples. They use a sense of place in their art in a very special way.

Much Aboriginal art is based on a belief in what is called Dreamtime. Dreamtime is thought to be a time of creation. Giant animals with great power arose from the earth and wandered the land, shaping and changing it as they went. These animal spirits and their journeys have inspired many customs and artworks. The shapes and patterns of

places where Dreamtime spirits have been. The twentieth century was a time of great change for the Aborigines. After European settlers came to Australia in the late nineteenth century, the Aborigines tried to keep

some Aboriginal artwork might remind you

of maps. The works show you the special

their land, their customs, and their traditions. They showed their feelings about the land through artwork.

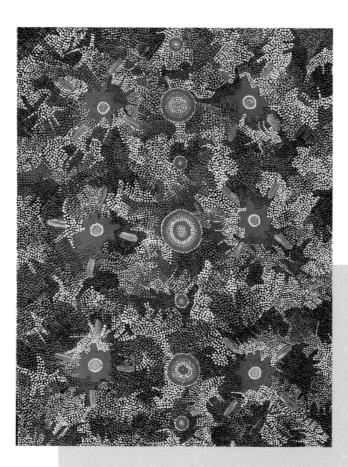

Fig. 6-21 Watering holes are very important in the dry land of Australia. Do think watering holes are shown in this painting? Can you find animal shapes in this Dreamtime scene? Keith Kaapa Tjangala, Witchetty drub dreaming, 20th century. Acrylic on canvas. Aboriginal Artists Agency, Sydney, Australia. Jennifer Steele/Art Resource, NY.

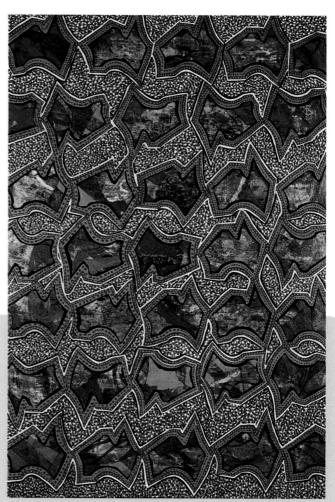

Fig. 6-22 The repeated shape of the Australian continent reflects this Aboriginal artist's connection to place. What might the artist be saying about his land? What does he think about change? Jeffrey Samuels, This Changing Continent of Australia, 1984.

Oil on composition board, $73^{5/8}$ " x $48^{7/8}$ " (187 x 124 cm). Art Gallery of New South Wales, Sydney.

Today, Aboriginal artists still stay connected with the land and the spirit world through their paintings. Traditionally, these paintings are made on barkcloth, a wood fiber that is beaten instead of woven. The artists often use bright colors and **motifs**, or repeated elements that create a pattern. Barkcloth paintings often seem to show a view from high up in the air. Their patterns symbolize the sacred connection between people and the land.

6.3 Global View

Check Your Understanding

- **1.** What belief is much of Australian Aboriginal art based on?
- **2.** What do the patterns in Aboriginal barkcloth paintings symbolize?
- **3.** What is the main purpose of Oceanic art?
- **4.** What kinds of materials are used by artists in Oceania?

Studio Connection

Use stencils or found objects to print a map of a place that is special to you. Choose motifs to stand for certain locations.

Invent a way to show typical travel routes between areas within your place. Make your map both informative and interesting to look at. Try different ways of repeating the basic motif. Motifs can lock together or form alternating patterns. Some motifs can be diagonally stepped (dropped) to create complex patterns in several directions.

Natural pigments on eucalyptus bark, 59 $^1/8$ " x 16" (150.1 x 40.4 cm). National Gallery of Australia, Canberra.

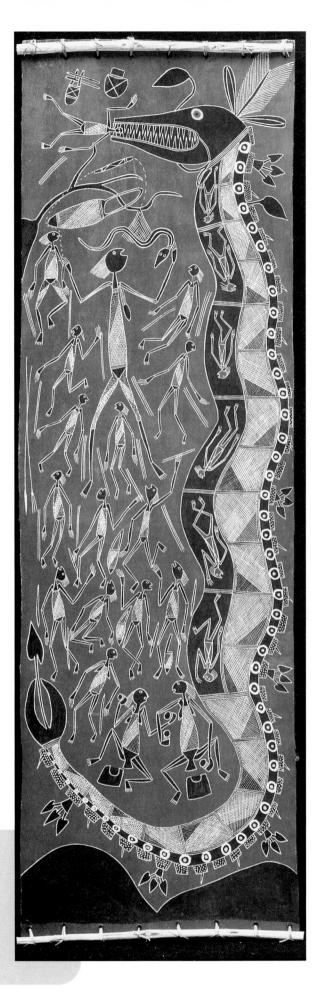

Fiber Arts in the Studio

Stitching an Artwork

Dream-like Places

Studio Introduction

If someone asked you to create an image of a magical place, what would you show? An exotic landscape? A

mountain range on another planet? A city of the future? Perhaps you have actually visited a place that seemed magical to you or remember such a place from a dream you once had.

Now imagine that your only art materials are scraps of cloth, thread, yarn, and a few buttons or beads. What would you do? You would have to think like a **fiber artist**—an artist who creates artworks with cloth, yarns, threads, and other materials. You could cut shapes from fabric and **appliqué**, or sew them onto, a fabric background. You could create details with decorative stitches. You might even sew the buttons or beads onto the artwork.

Artists can express their feelings about places in stitched artworks just as they can in paintings and other forms of art. In this studio experience, you will create a stitched wall hanging that shows a dream-like place. Pages 218–219 will tell you how to do it. You might choose to show a place that seems ordinary in real life, but create the image with magical or dream-like qualities. Or you might create a dream-like place that is entirely imaginary.

Studio Background

Creative Quilts

When you hear the word *quilt*, you probably think of a patchwork bedspread. Its colorful fabrics and shapes add feelings of comfort and cheer to a room. But do you know that many cultures create quilts for reasons that go way beyond the bed? They make

Fig. 6–24 When she was first invited to Carlsbad Caverns, Barbara Watler was reluctant to go because she doesn't like very small places. Finally, she gave in and loved the visit. She created this quilt several weeks after the experience. How did she turn what could have been a terrifying place for her into one that is dream-like and inviting? Barbara W. Watler, Cavern Gardens, 1996.

Mixed thread painting and mixed fabrics, machine stitched and appliquéd, 24" x 16" (61×40.6 cm). Courtesy of the artist. Photo by Gerhard Heidersberger.

Fig. 6–25 "While I was planning my art project, I was thinking about the Simpsons where they eat so many donuts. Then I thought of many breakfast items. The difficulty with the cloth is getting the needle in the right spot and getting the yarn through the cloth." Jason Garber, *Eat Me*, 1999. Fabric, yarn, thread, 12 x 19" (30 x 48 cm). Yorkville Middle School, Yorkville, Illinois.

quilts for ceremonies, for weather insulation, and for honoring people. In certain cultures, people spread them on the ground before they sit. Quilt designs can represent ideas about marriage and freedom. And they can tell stories.

The materials used to make quilts can also go beyond what you might expect. In addition to scraps of colorful cloth, many of today's quiltmakers use threads and yarns of all textures and colors. They use ribbon, beads, paper, buttons, lace, mirrors, silk flowers—anything that can be stitched to the cloth. Artists who use such surprising materials have turned the traditional craft of quiltmaking into an expressive form of art.

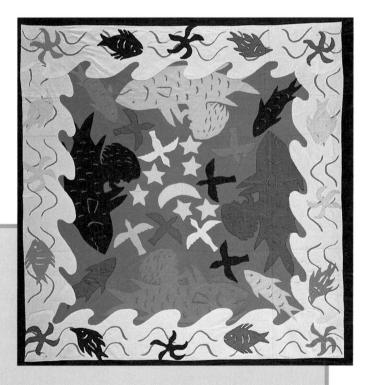

Fig. 6–26 Women in the Cook Islands of Polynesia work together to create patchwork quilts. The quilts are often used in ceremonies. The designs usually show flowers, birds, fish, and other wildlife seen on and around the islands. Does the place you see here seem realistic or dream-like? Why? Maria Teokolai and others, Cook Islands, Ina and the Shark, c. 1990.

Tivaevae (ceremonial cloth), 101" x 97" (257 x 247 cm). Collection of the Museum of New Zealand Te Papa Tongarewa, Wellington, New Zealand, B.24769. Photo by Alan Marchant.

Fiber Arts in the Studio

Stitching Your Dream-like Place

You Will Need

- sketch paper and pencil
- · sewing needle
- background fabric
- yarn and thread
- cloth scraps
- scissors
- · decorative materials
- dowels
- white glue

Safety Note

To avoid cuts and jabs, handle sharp objects, such as needles and scissors, very carefully.

When you are finished with the sharp objects, return them to your teacher or put them away in a safe place. Do not leave them unattended on desks, chairs, or the floor.

Try This

1. Choose a format for your artwork. Will it be horizontal or vertical?

2. Sketch a design that shows an inviting dream-like place. Will you show an imaginary place? Or will you show a real place that has

magical qualities? Sketch the main shapes first. Remember that you will be creating your place from fabric. Keep the design simple.

- **3.** Cut the main shapes of your design from fabric scraps, and stitch them to the background.
- **4.** Using thread and yarn, stitch other shapes and details onto the appliquéd parts and background of the artwork. Try a variety of thread and yarn colors and textures. Which stitches will work best in your design? Can you create any new stitches? Leave some parts of the background blank.
- **5.** Sew decorations onto the artwork wherever you want them.

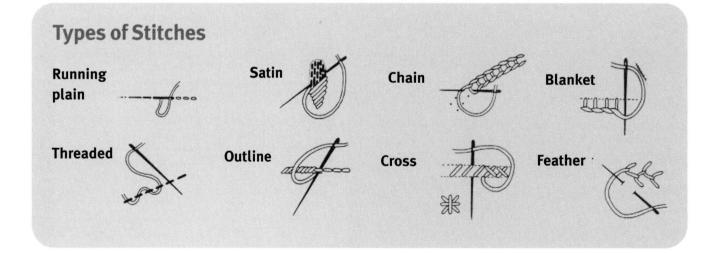

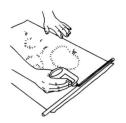

6. When you are finished with your stitching, turn the artwork over. Carefully apply white glue along the length of a long

dowel. Lay the glued side of the dowel along the top edge of the back of the artwork.

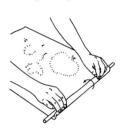

Apply another line of glue to the exposed length of dowel.
Carefully roll the dowel, with background fabric attached, until the dowel is wrapped tightly

with fabric. The fabric should be glued securely to the dowel.

7. Repeat the gluing process on the bottom edge of the artwork. When the glue has dried, tie a yarn hanger onto the ends of the top dowel.

Check Your Work

Discuss your artwork with classmates. What challenges did you face when you designed the artwork? Does the place you show look dream-like and inviting? How did you use stitches, shapes, colors, and decorations to create the look? How did you choose which stitches and materials to use?

Sketchbook Connection

Many cloth designs and stitched artworks show simplified patterns and figures from nature. Go outside and

sketch some plant matter—leaves, flowers, trees, and the like—on a few pages of your sketchbook. Then create a simplified shape to represent each subject.

Computer Connection

Create a dreamlike place in a drawing, painting, or imageediting program. Obtain images of textiles by scan-

ning, photographing with a digital camera, or from a CD-ROM or Internet collection. Choose several to work with. Using cut and paste features, make a digital version of appliqué. Save different versions; print your best one in color.

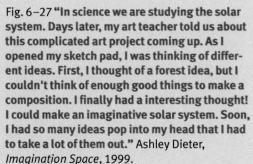

Fabric, 12" x 19" (30 x 48 cm). Yorkville Middle School, Yorkville, Illinois.

Connect to...

Careers

Are there public sculptures or murals in your community? What special places or people do they honor? Are they historic or contemporary? Artists who create such works might be sculptors who produce three-dimensional forms or muralists who work with paint or mosaic tiles. Both are public artists: they plan their art for display in public places, such as parks, buildings, or roadsides.

Many public artists make works that are sitespecific—designed to fit or memorialize a specific space. **Public artists** purposely create art with a public audience in mind, often

Fig. 6–28 Public artists are knowledgeable about the durability and weather resistance of their materials. This elephant supports an Egyptian obelisk from the 6th century BC. Gianlorenzo Bernini and Ercole Ferrata, 1667. Piazza della Minerva, Rome, Italy, Photo: H. Ronan.

expressing social or political ideas in their work. For large public-art projects, the artists often hire assistants or apprentices.

Other Arts

Music

If you created a "musical picture" of a favorite place, how would it sound? What instruments could depict this place? Would the tempo be fast or slow? Would you choose loud or soft dynamics? Would the rhythm be smooth or bouncy?

Composers sometimes write music about places they have visited or would like to visit. George Gershwin wrote *An American in Paris*, one of his best-known works for orchestra, after living in Paris for several months. The music realistically depicts the bustling sidewalks and noisy taxicabs of that city. Gustav Holst, however, never visited the subjects of his masterpiece, *The Planets*. He combined his fascination with astronomy, rich imagination, and musical skills to create this well-known orchestral work.

Fig. 6–29 Ferde Grofé, who got his idea for *Grand Canyon Suite* as he stood on the canyon rim in 1922, represents in the composition the awesome sights and sounds of the national landmark. Grand Canyon.

Photo by H. Ronan.

Internet Connection

For more activities related to this chapter, go to the

Davis website at www.davis-art.com.

Other Subjects

Science

Adobe structures are made from a mud-andstraw mixture that is formed into bricks or built up into solid walls and then coated with mud plaster. **Adobe design** is folk architecture: it developed from the use of natural building materials available in a particular place; in this case, a desert environment like the Southwest United States and parts of Africa, India, and Saudi Arabia.

Adobe buildings are simple, economical, and thermally efficient in hot, dry climates. Walls up to two feet thick, along with small window and door openings provide insulation, which keeps the indoor temperature fairly constant. The nature of adobe as a building material limits its design characteristics.

Geography

What tools do we use to help us find our way from one place to another? **Maps** of many kinds have helped people find their way to where they want to go. What concepts must we understand in order to "read" these visual images? Knowledge of measurement, scale and proportion, compass directions, and longitude and lat-

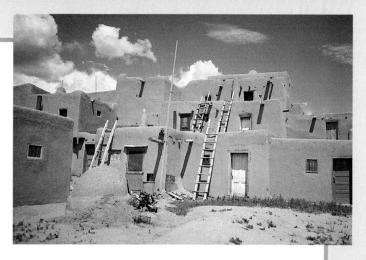

Fig. 6–30 Adobe forms are simple, organic, and rounded, and are often molded by hand. See page 200 for another type of adobe architecture. Taos Pueblo, New Mexico. Photo by H. Ronan.

itude is necessary for the careful interpretation of maps.

How do you think that future technological advances will affect maps and how we use them? Already, we can go online to locate a detailed map to many addresses. The Global Positioning System, which can tell us exactly where we are on the earth, is available in handheld receivers and is also offered in some cars. What mapping tools do you think the future might bring?

Fig. 6-31 Imagine having this garden as your back yard — what would you do there? Hampton Court, William and Mary Gardens.
London, England. Courtesy of Davis Art Slides.

Daily Life

We generally attach meaning—perhaps joyful or sad—to special places that we use for either **personal or public contemplation.** What places are important to you? Your bedroom? A particular place where you meet your friends? A church or synagogue that you attend? What are some reasons that these places are meaningful to you?

What public places have people commemorated as special? In recent times, public memorials have become more common, as people leave flowers, candles, photographs, and other items to show respect and to honor those who have died. What memorials are found in your community?

Portfolio

"We were picking out old magazine clippings and designs for a painting when I found a photograph in a book. I loved it so much, I decided to paint it. The blending of the sky was easy, but the trees and branches were hard with their very fine lines. I like the upside-down sky in the water the most." Julie Gunnin

Fig. 6-32 How does time of day affect the mood of a piece? Julie Gunnin, *Sunset*, 1999.
Acrylic, 12" x 18" (30 x 46 cm). Johnakin Middle School, Marion, South Carolina.

Fig. 6–33 Over the summer, two students went to a concert and decided to use their experience as inspiration for this sculpture. Using small parts, the students created the impression of a large space. What does the artwork tell us about this place? Indu Anand and Jamie Lee Breedlove, Goo Goo Dolls in Concert, 1999.

Sculpture made from computer parts, 17" x 17" x 7" (43 x 43 x 18 cm). Avery Coonley School, Downers Grove, Illinois.

Fig. 6–34 Use of color in this artwork adds emphasis to foreground, middle ground, and background. Kendra Mooney, *Vacation Time*, 1999.

Mixed-media collage with tissue paper and magazine photos, 12" x 18" (30.5 x 46 cm). Asheville Middle School, Asheville, North Carolina.

CD-ROM Connection

To see more student art, check out the Global Pursuit Student Gallery.

"I got the idea for my collage by putting in things that I would like to do in my spare time—like go see places on a vacation. I put in a lot that deals with water, because I like going to places where I can swim." Kendra Mooney

Chapter 6 Review

Recall

Name the three major art styles in Western art in the nineteenth century, and describe how each dealt with the idea of place.

Understand

Explain how a painting of a landscape or seascape can convey moods or feelings.

Apply

Create two pastel drawings, each based on careful observation of a place, so that each expresses a mood or feeling very different from the other.

Analyze

Compare and contrast the navigational map (*Stick Chart*, Fig. 6–18) and the ancestral map of the land (*Witchetty drub dreaming*, Fig.6–21, both shown at right) with maps used by boaters and drivers. Consider how shapes, lines, and colors are used to help people "read" the maps.

For Your Portfolio

Look at the images in each chapter's Global View lesson, and choose one work that interests you. Research the

place where the artwork was made, and then prepare a written report. Include a description of the area's geography, climate, natural resources, cultural beliefs, and so on; and provide a map of the area. Add a paragraph that describes what characteristics of the region are shown in the artwork.

For Your Sketchbook

Do a series of sketches of the same place, changing the center of interest in each view.

Synthesize `

Write a conversation that might have taken place between Angelica Kauffmann (Fig. 6–11) and Rosa Bonheur (Fig. 6–1) while looking at the work of Delacroix (Fig. 6–13). They are to express their ideas about how to represent places.

Evaluate

Recommend what should be written on a gallery information card to explain and to justify why the works by John Constable (Fig. 6–4) and Faith Ringgold (Fig. 6–6) have been displayed together as the only two works in a gallery. Include suggestions for what viewers might seek when comparing these two works.

Page 212

Page 214

7 Nature

Fig. 7–1 How does this artwork encourage the viewer to feel close to nature? Berthe Morisot, *Girl in a Boat with Geese*, c. 1889. Oil on canvas, $25\sqrt[3]{4}$ x $21\sqrt[4]{2}$ (65 x 54.6 cm). Ailsa Mellon Bruce Collection, Photograph © 1999 Board of Trustees, National Gallery of Art, Washington, DC.

Focus

- In what ways are humans strongly connected to nature?
- How do artists show nature, and use materials from nature, in their works?

How does nature affect your life? Do you notice it only when it keeps you from doing something you enjoy—like when it's too rainy to play basketball outside or a big storm knocks out the electricity and you can't watch TV? Or do you sometimes look at the sky and see shapes in the clouds? Do you notice the patterns on the ground beneath a leafy tree?

Whether you realize it or not, you are connected to nature. Soil, water, and growing things allow you to survive. The buildings you live in are made of materials from nature. And nature's power is still greater than the power of human beings. Humans can't stop tornadoes, prevent earthquakes, or turn back floodwaters. We depend on nature, and we often can't control it.

People throughout time and across cultures have been awed by the natural world. They have been frightened by storms and volcanoes. They also have been inspired and comforted by the beauty of sunsets, trees, and waterfalls.

Our lives have always been linked to nature. So has our art. Artists depend on nature to provide the materials for art. They also study

natural patterns and scenes to use as subject matter for their artworks, as you can see in Fig. 7–1. The history of art-making is full of examples of how humans have observed and interpreted the natural world.

What's Ahead

- Core Lesson Discover how artists have used nature subjects and materials.
- 7.1 Art History Lesson
 Learn how some late nineteenth-century artists painted their impressions of nature.
- 7.2 Elements & Principles Lesson
 Focus on how artists use color to create mood.
- **7.3 Global View Lesson** Explore how nature is included in the art of Japan.
- **7.4 Studio Lesson**Create natural forms out of paper.

Words to Know

simplified Post-Impressionism relief print atmospheric color Impressionism complementary

Art Connects with Nature

Inspired by the Natural World

Have you ever collected seashells, rocks, fossils, or leaves? Artists are attracted to these natural forms.

Sometimes, artists make natural forms part of larger compositions. Other times, the forms serve as the main subject of an artwork. Before photography was invented, people relied on artists to record the details of plants, animals, and natural features throughout the world (Fig. 7–2).

Artists are not always interested in showing all of nature's details. Instead, they choose to show the feelings or moods that natural scenes inspire. They use color and other elements to show nature's expressions. Their artworks may appear close up, showing carefully studied details, or at a distance, as if the artist is standing back in awe (Fig. 7–4).

Some artists return to the same scene over and over. Each time, they try to see it in a new way or capture it in a different light.

Impressionist painters, such as Berthe Morisot (see Fig. 7–1), were fascinated with the effect of light on color. They studied the color changes they saw during a single day.

Look around your home. Can you find shapes or decorations that are borrowed from nature? Look for plant shapes in fabric and china patterns and on eating utensils. **Simplified** plant, animal, and insect shapes—shapes that are not as detailed as the actual object—are part of furniture and architectural designs in many cultures worldwide (Fig. 7–3).

Fig. 7–2 Engravings like this one showed people what plants and insects looked like. How might the invention of photography have affected artists who worked in this style? Maria Sibylla Merian, *Plate 2 from Dissertation in Insect Generations and Metamorphosis in Surinam*, second edition, 1719.

Hand-colored engraving, approximately 12 ³/₄" x 9 ³/₄" (32.4 x 24.8 cm). The National Museum of Women in the Arts.

Fig. 7–3 People around the world use simplified natural forms as decoration. In what other way does this artwork connect humans with nature? Zuni Pueblo (New Mexico), Olla (Storage Jar), 1850–75.

Painted earthenware, 9 ½ " x 11 ½" (24.1 x 29.2 cm). The Nelson-Atkins Museum of Art, Kansas City, Missouri (Gift of Mrs. Frank Paxton in memory of Frank Paxton, Sr.). Photography by Robert Newcombe. ©1999 The Nelson Gallery Foundation. All Reproduction Rights Reserved.

Fig. 7–4 How did this artist use color and light to create a dramatic vision of the natural world? Thomas Moran, Grand Canyon, 1912.
Oil on artist's composition board, 15 15/16" x 23 15/16" (40.4 x 60.8 cm). The Nelson-Atkins Museum of Art, Kansas City, Missouri (Bequest of Katherine Harvey). Photography by Robert Newcombe. ©1999 The Nelson Gallery Foundation. All Reproduction Rights Reserved.

Art Materials from Nature

People have always created artworks from materials such as clay, wood, and fiber. It is sometimes hard to tell that an artwork is made of natural materials, however. When you look at a ceramic vase, for example, you might not believe that it began as a lump of clay in the earth. In other artworks, such as a marble sculpture, the natural materials are easier to recognize.

Artists might shape natural objects to create small works, as when they use plant reeds to make a basket. Or they might shape nature on a large scale, as in the design and creation of a public garden (Fig. 7–5). Architect Frank Lloyd Wright combined a waterfall with rock outcroppings and other natural materials to create a home that was an artwork (Fig. 7–7).

Fig. 7–5 Artists carefully arranged rocks and sand to create this peaceful garden. Soami, Zen Stone Garden, symbolizing sea and islands. Muromachi period (founded 1473). Ryoan-ji Temple, Kyoto, Japan. SEF/Art Resource, NY.

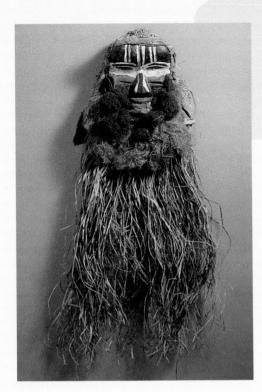

Fig. 7-6 Can you easily see the natural materials used to create this mask? The geometric design painted on the face, known as the leopard pattern, was also inspired by nature. Kran culture (Liberia), Mask Dance, 20th century.

Painted wood, raffia, and fabric, 12" x 8" (30.5 x 20.3 cm). Collection of the University of Central Florida Art Gallery, Orlando, Florida.

Fig. 7-7 In this architectural work, which materials are provided by nature? Which are humanmade? Frank Lloyd Wright, Fallingwater (Kaufmann House), 1936. Bear Run, Pennsylvania. Ezra Stoller © Esto. All rights reserved.

Printmaking in the Studio

Nature in Relief

Printmaking is the process of transferring an image from one surface to another.

In this lesson, you will make a relief print of a subject from

the natural world. You might show a natural object, or you might create an entire nature scene. Whatever you choose, you may simplify the shapes.

You Will Need

- sketch paper
- pencil
- linoleum block
- linoleum cutting tools
- bench hook
- carbon paper
- printing ink
- brayer
- drawing paper

Fig. 7–8 In these very large woodcut prints, the artist used powerful lines and bold black-and-white shapes. The close-up images of nature appear as abstract designs. Kitaoka Fumio, *Woodcuts*, 1984–85. Ink on paper, each 78 ³/4" x 19 ¹/4" (199.9 x 48.9 cm). Arthur M. Sackler Gallery, Smithsonian Institution, Washington, DC. S1986.530.

Safety Note

To avoid cuts, use extreme care when using linoleum tools!

Try This

- **1.** Sketch your design. Think of ways to simplify the shapes of your subject.
- **2**. Use carbon paper to transfer your design onto the linoleum block. With your pencil, lightly fill in areas on the block that you want to print in color.

- **3.** Cut away the areas you do not want to print. These areas will be white on the print itself.
- **4.** Ink the block. Using the brayer, apply a thin, even coat of color to the raised areas of your design.
- **5.** Carefully place your printing paper on the block. Press or rub the paper with your hand. Begin at the center and work toward the edges, rubbing the whole surface gently but firmly.

Studio Background

The Japanese Woodcut

A **relief print** is made from a raised surface that receives ink. The Japanese woodcuts you see here are examples of relief prints.

Japanese woodcut printing was first developed in 1744. The process was usually a collaboration of the artist, engraver, and printer. First, the artist created a brush drawing on transparent paper. The engraver then pasted the drawing to a block of wood and carved the outlines of the drawing. He or she made as many prints of the block as the number of colors chosen for the final print. On each copy, the

6. Pull the print by slowly peeling it away from the block.

Check Your Work

Examine your completed artwork, along with your classmates' works. Are shapes, lines, and other elements clearly defined? Discuss the ways that nature is shown in the artworks. Do any show nature in a dramatic or expressive way?

Core Lesson 7

Check Your Understanding

- **1.** Name two ways that artists can include objects from nature in their work.
- **2.** Why were careful drawings from nature important in the past?
- **3.** How might an artist convey moods or feelings in an image of nature?
- **4.** What is a relief print?

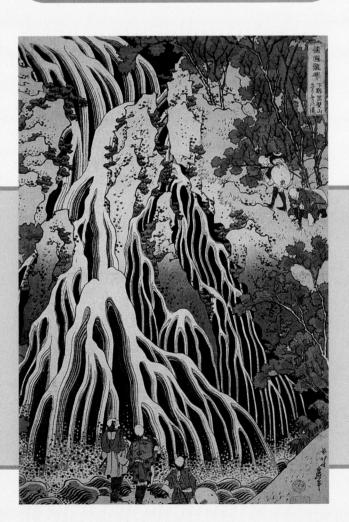

Fig. 7–10 Simple shapes and expressive lines illustrate a moonfish, native to Hawaii. Zeenie Preston, Fish, 1999.

Two-color block print, 4" x 6" (10 x 15 cm). Colony Middle School, Palmer. Alaska.

Sketchbook Connection

Practice simplifying natural shapes. First draw the natural shape you see—leaf, shell, branch, animal. Then draw it

again, but this time leave out some lines in detailed areas. Draw it a third time, leaving out even more detail. Try drawing the shape with straight lines only. As you draw, decide which lines are absolutely necessary. What happens when you make those lines thicker? Try making both heavy outlines and solid shapes (called silhouettes).

engraver marked areas that would appear in one of the colors. Then he or she cut one block per color. Finally, the printer applied an ink color to each of the blocks and pulled the print one color at a time.

Fig. 7–9 How did the artist simplify the shapes of the falling water, trees, and rock formations? By emphasizing the color and shape of the waterfalls, he showed their dramatic power. Katsushika Hokusai, *Kirifuri Waterfall at Mt. Kurokami, Shimozuke Province*, Series: *The Various Provinces*, c. 1831.

Color woodblock print, $14 \frac{5}{8}$ " x $9 \frac{5}{8}$ " (37.2 x 24.5 cm). Nelson-Atkins Museum of Art, Kansas City, Missouri (Purchase: Nelson Trust). © 1999 The Nelson Gallery Foundation. All Reproduction Rights Reserved.

European Art: 1875–1900

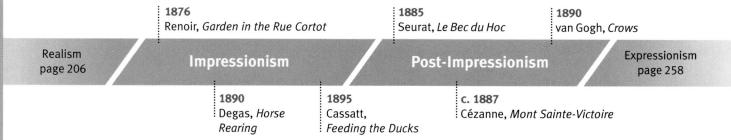

As you learned in the last chapter, the first decades of the 1800s were filled with political revolutions. People struggled for more just systems of government. By the second half of the century, another type of revolution—the Industrial Revolution—was also changing societies. Cities were growing. Exciting inventions and new technologies were changing the way people lived and worked. It was the beginning of modern life.

In this time of great social and technological change, there were also revolutions in art. French artists created two new art styles: **Impressionism** and **Post-Impressionism**.

Why were artists of these two groups so revolutionary? Like many artists throughout history, the Impressionists and Post-Impressionists were inspired by nature and the world around them. They were also learning about exciting new influences and technologies. They created new ways of painting. For them, it was not enough to make things look real on a flat canvas. Instead, they were interested in color and the way it affects how we see and feel about things. They felt that true colors could only be seen outdoors, in nature.

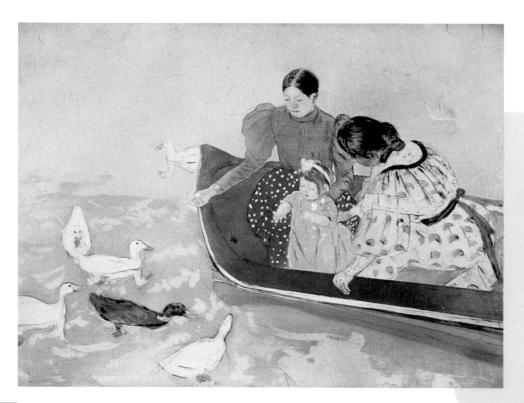

Fig. 7-11 Many Impressionist artists were inspired by non-European art-especially Japanese prints—and the new medium of photography. How does this print resemble a snapshot? Compare it to the print by Hiroshige in Fig. 7-22. Mary Cassatt, Feeding the Ducks, 1895. Drypoint, soft ground etching, and aquatint printed in colors, 11 11/16" x $15^{3}/4$ " (29.7 x 40 cm). The Metropolitan Museum of Art, Bequest of Mrs. H. O. Havemeyer, 1929. The H. O. Havemeyer Collection (29.107.100). Photograph © 1980 The Metropolitan Museum of Art.

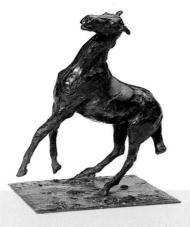

Fig. 7–12 In addition to painting and printmaking, Edgar Degas also made sculptures. How has he captured the movement of the horse?
Edgar Degas, Horse Rearing, c. 1890.
Bronze. Musée d'Orsay ©Photo RMN.

Fig. 7–13 What details do you think Renoir left out of this scene? What colors might you expect if this scene had been painted on a cloudy, rainy day? Pierre-Auguste Renoir, The Garden in the Rue Cortot, Montmarte, 1876. Oil on canvas, 59 ³/₄" x 38 ³/₈" (151.8 x 97.5 cm). Carnegie Museum of Art, Pittsburgh; Acquired through the generosity of Mrs. Alan M. Scaife, 65.35. Photography by Peter Harholdt.

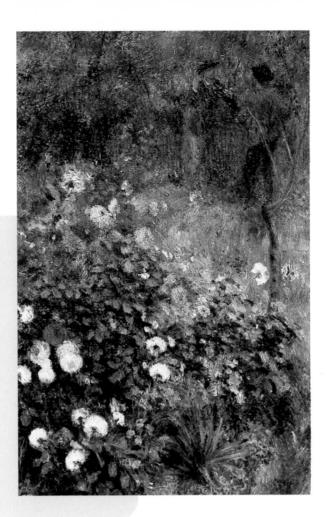

Impressionism

The Impressionists hoped their artworks would give an impression of what a natural scene looked like at one moment in time. They wanted to capture a split second, when you look at something quickly and then it changes. Painter Claude Monet even named some of his paintings *Impression*. An art critic saw one and made up the term "impressionism." This is how the art style got its name.

The Colors of Nature

Many Impressionists loved nature and were interested in landscapes and natural objects. They painted outdoors, studying the way colors in nature change in different kinds of light. Working outside helped the Impressionists understand how light affects the way we see things.

Look at the painting by Renoir in Fig. 7–13. Imagine you are the artist painting this garden outdoors. You must work fast

to record the colors and light. Like Renoir and the other Impressionists, you might leave out details as you race to capture the scene before everything changes again. As you look quickly from your canvas back to the scene, you use short, fast brushstrokes. When you look at shadows, you notice they are made of many different colors—purples and dark blues. You see that areas in sunlight have the brightest colors—yellows, greens, and reds. And this is what you paint.

The Impressionists' quick brushstrokes blurred the outlines of objects. Shapes seem to merge together. The small strokes of color make their artworks shimmer and sparkle. As you look closely at Impressionist artworks, you will see brushstrokes of different colors placed next to each other. The Impressionists knew that, at a distance, people's eyes would mix the colors.

Post-Impressionism

Not all artists agreed with the Impressionists' ideas about painting. The Post-Impressionists were a group of artists who felt that Impressionist artworks were too unplanned. They were not interested in trying to capture the momentary effects of light on objects. Instead, they focused on arranging objects into an organized composition. They wanted their artworks to have a strong sense of design.

Color and Composition

The Post-Impressionists used color to help give order to their paintings of nature. Each artist in the group developed a unique way of working with color.

Look at a painting by Georges Seurat (Fig. 7–14), for example. You might think its dabs of color and shimmering light look just like an Impressionist artwork. But notice how each part—the sky, water, and cliff—is care-

fully painted. Seurat placed thousands of small dots of color very close together. Edges—although not sharp—are clearly defined. Do you see how the placement of the dark and light colors also helps show the form of the cliff?

Paul Cézanne also used color to build up form. Look at *Mont Sainte-Victoire* (Fig. 7–15). Cézanne placed flat patches of color side by side. Some of the patches are dark values, and others are light. Do you see how the light and dark values help show the form of the mountain?

Some Post-Impressionist artists used color to express feelings. In *Crows in the Wheatfields* (Fig. 7–16), Vincent van Gogh did not show the changing colors of nature. Rather, he chose to paint the landscape using the most intense colors—dark blues and bright yellows and oranges. Notice how he created long lines of color on the canvas. What do these brushstrokes and colors tell you about van Gogh's feelings toward nature?

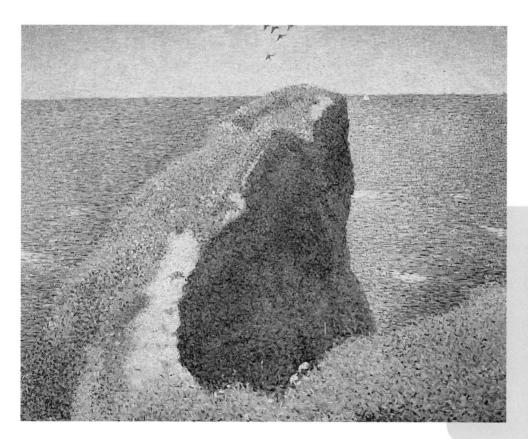

Fig. 7–14 This scene of nature shows a seascape.

Notice how Seurat carefully placed the large shape of the cliff in the center of the composition. Do you think an Impressionist artist would have chosen this placement? Georges Seurat, Le Bec du Hoc at Grand Champ, 1885.

Oil on canvas, 25" x 32" (64 x 81 cm). The Tate Gallery, London. Photo by John Webb. Art Resource, NY.

7.1 Art History

Check Your Understanding

- **1.** What interested and inspired Impressionist painters?
- **2.** How did the term Impressionism come to be used?
- **3.** Name two important characteristics of Post-Impressionist art.
- **4.** How did Post-Impressionists' use of color differ from the Impressionists' use of color?

Studio Connection

Create two different paintings of one of your favorite scenes from nature. Choose different brushstrokes for each paint-

ing. You might choose fast, short strokes, carefully placed dots of color, flat patches of color, or swirling strokes. Use one kind of brushstroke to show the scene on a sunny day. Use another kind of brushstroke to show the scene on a cloudy day. Think about the colors you will use to show the weather and the type of light during that season.

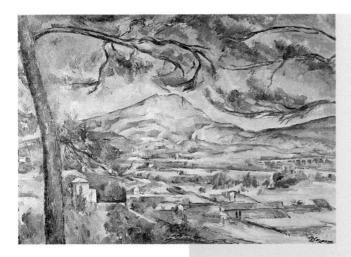

Fig. 7–15 Does there seem to be a light source in this scene? Would you say that this artist tried to capture a particular season or time of day? Paul Cézanne, Mont Sainte-Victoire, c. 1887.
Oil on canvas, 26 1/4 " x 36 3/8" (66.8 x 92.3 cm). Courtauld Gallery, London.

Fig. 7–16 Like the Impressionists, Vincent van Gogh created many paintings of the same scene from nature. Notice how he used warm colors in the field and cool colors in the sky. How does this color combination make you feel? Vincent van Gogh, Crows in the Wheatfields, 1890.

Oil on canvas, $19^{\,7}/8$ " x $40^{\,5}/8$ " (50.4 x 103 cm). Amsterdam, Van Gogh Museum (Vincent van Gogh Foundation).

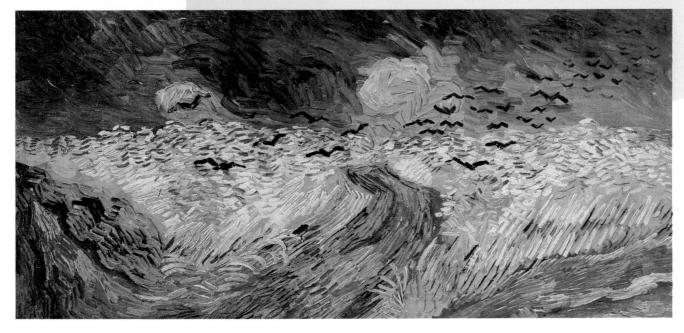

Color

Color forms the background of our daily lives. A color can be bright and intense, light and pastel, or dark and dull. Some artists feel that color is the most important element they work with. Artists must know how colors work together. They learn to mix the colors they need to create certain moods, or feelings, in their artworks.

Looking at Color in Nature

You have probably noticed that the colors of objects in nature can change in different light. Perhaps walking on a sunny summer afternoon, you have seen bright green trees. As the sun sets, the trees may look almost dark blue or purple. Colors in nature change as the light changes. We call these changeable colors **atmospheric color**.

Impressionist artists, like Claude Monet, were interested in atmospheric color. They often painted the same subject at different times of day or in different seasons. They might show the scene in the misty light of

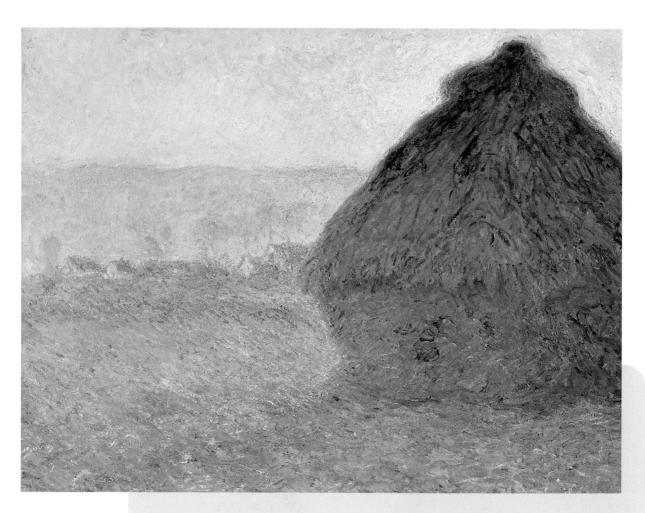

Fig. 7–17 Warm and cool colors help create this painting's mood. How would the painting be different if it had been painted in the early morning? Claude Monet, Grainstack (Sunset), 1891. Oil on canvas, $28\frac{7}{8}$ " x $36\frac{1}{2}$ " (73.3 x 92.6 cm). Juliana Cheney Edwards Collection. Courtesy of the Museum of Fine Arts, Boston.

dawn, on a sunshine-filled afternoon, or in the gloom of a winter twilight.

Study an example of one of Monet's favorite subjects, haystacks in a field (Fig. 7–17). Notice the bright, intense colors. Even the shadows are painted with bright colors, mostly light greens and blues. Look especially at the triangular shape of the haystack against the sky. The warm colors—yellow, orange, and red—capture the warmth of the setting sun.

Now look at a painting by Post-Impressionist artist Paul Gauguin (Fig. 7–18). Why is the mood of this painting so different from Monet's? Gauguin chose mostly dark colors for his painting. He also chose shades of green and red to create a **complementary** color scheme.

(Complementary colors are across from each other on the color wheel. See pages 36 and 38.)

Complementary colors can help create contrast in an artwork. Do you see how the reddish and orange shapes stand out against the green shapes? Gauguin did not want to

show how light changed the haystacks. Instead, he wanted to create a sense of order in his composition. He used contrasting colors to make the forms easy to see.

7.2 Elements & Principles

Check Your Understanding

- **1.** Why does the local color of an object change throughout the day?
- **2.** What was one influence on the Impressionists' use of color?

Studio Connection

Many artists show the changing colors of nature in their artworks. They often use color to create different moods.

Create a monoprint of a natural object. A monoprint is a single image made by painting onto a metal, glass, or plastic printing plate. Paper is pressed against the plate to create the print. Choose two or three colors that help create a mood.

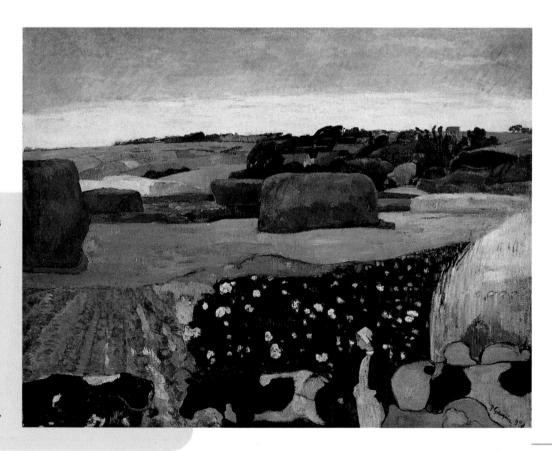

Fig. 7-18 The dark colors in this painting create a serious mood. Compare this sky to the one painted by Monet. What colors might the artist have used in each? Paul Gauguin, Haystacks in Brittany, 1890. Oil on canvas, 29 1/4" x 36 7/8" (74 x 93.7 cm). Gift of the W. Averell Harriman Foundation in memory of Marie N. Harriman. Photograph © 1999 Board of Trustees, National Gallery of Art, Washington, DC.

The Art of Japan

Simplicity, elegance, and love of nature—all are found in the art of Japan. The Japanese worshiped nature gods at Shinto shrines long before Buddhism was introduced to their culture. Shinto gods are thought to occupy places in nature, such as trees, waterfalls, and rocks. They are also believed to inhabit animals. The earliest Shinto shrines used as their main hall not a building, but a mountain or forest.

Buddhism came from China in the sixth century AD. Shinto and Buddhist beliefs exist peacefully side by side. Shinto shrines and Buddhist temples and monasteries are found throughout Japan. The world's oldest wooden structures, dating from the early eighth century, are found at the Buddhist temple of Horyu-ji in Kyoto.

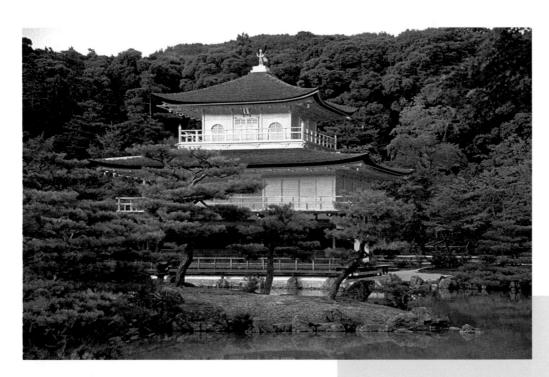

Fig. 7–19 How does this building blend harmoniously with its environment? Golden Pavilion (Kinkaku-ji). Kyoto, 1398. Photo by W. Wade.

Japanese architecture ranges from castles and palaces to the simple home with room spaces created by sliding screens. Architecture includes not only the building itself, but the natural landscape and gardens around the building. The *Golden Pavilion* (Fig. 7–19) served as both a residence and temple. It is a harmonious combination of several cultures and styles.

The Buddhist religion inspired many traditional arts, such as the tea ceremony, ink painting and calligraphy, flower arranging, and garden design. Many people study these art forms for private reflection or meditation. They think about the natural world as they improve their artistic skills. This practice is thought to lead to a healthy, balanced life.

Fig. 7–20 Japanese paintings were usually done on scrolls or screens. They often were made with calligraphic brushstrokes. How has this artist combined elegance and simplicity to show a scene from nature? Japan, *The River Bridge at Uji*, Momoyama period (1568–1614). Ink, color, and gold on paper. Six-fold screens, 64 ½ x 133 ½ (171.4 x 338.4 cm). The Nelson-Atkins Museum of Art, Kansas City, Missouri (Purchase: Nelson Trust).

Natural Subjects

Nature and the environment are very important in Japanese art. Landscapes, plants, and animals are often used as subject matter. Many Japanese artists are skilled at simplifying natural forms. For example, study how water is represented in the folding screen (Fig. 7–20). How would you describe the way water is shown here? What other natural features have been simplified?

In the nineteenth century, Japanese artists developed the process of multicolored woodcuts, which became very popular. Hundreds of prints, showing scenes from nature and everyday life, were made from the inked blocks. Hiroshige, Hokusai, Utamaro, and Harunobu are among the masters of multicolor woodcut printing (Fig. 7–22).

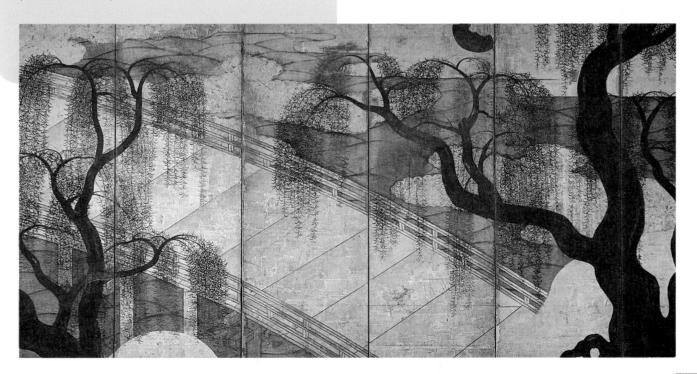

Natural Materials

Japanese artists have traditionally used natural materials. The beauty of the material becomes part of the design. For example, wooden sculptures or structures are often unpainted.

In garden design, natural materials are especially important. Gardens may include trees or other plants, water, sand, stones, a wooden tea house, shrine, or bridge. See Fig. 7–5 (page 228) for an example of a Japanese garden.

Ceramic arts in Japan have traditionally been an important focus. Special handmade bowls are needed for the tea ceremony, and vases are required for ikebana—the art of flower arranging (Fig. 7–21). Influenced by early Korean ceramic arts, the Japanese designs are usually inspired by nature.

Studio Connection

Choose a natural form, such as an artichoke, seashell, or water lily. Create a ceramic vessel based on your close

observation of this natural form. Try the pinch pot method. Focus on the details of your selected object as you decorate and finish your vessel. Coils, thin slabs, and small balls of clay can be pressed onto the basic vessel for petals, leaves, or vines.

7.3 Global View

Check Your Understanding

- **1.** What do Shinto shrines have to do with nature?
- **2.** What kinds of Japanese art traditions are inspired by Buddhism?
- **3.** Name two famous printmakers in Japan.
- **4.** How do Japanese artists take advantage of the qualities of natural materials in their work?

Fig. 7–21 For hundreds of years, only Buddhist priests, royalty, and samurai were taught ikebana. Eventually, this traditional art form became accessible to all. Besides using natural materials, how might this art relate to nature? Sen'ei lkenobo, 45th generation lkenobo Headmaster, Rikka style Ikebana arrangement, 1999.

Lily, oncidium orchid, miscanthus grass, willow leaf spirea, Japanese balloon flower, and hydrangea. Courtesy of Ikenobo Society of Floral Art, Japan.

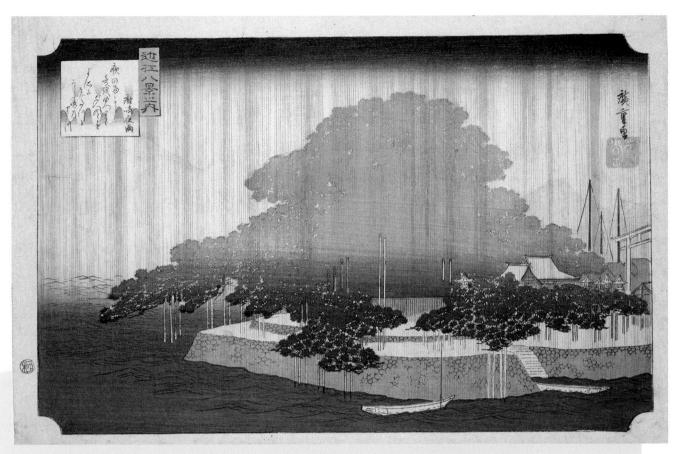

Fig. 7–22 Printmaking was a way to bring nature scenes into the homes of many people. Woodcut prints of familiar landmarks were popular as gifts. What does the artist say about nature in this work? Ando Hiroshige, Evening Rain on the Karasaki Pine, 19th century. From the series "Eight Views of Omi Province." Woodblock print, 10 ½ " x 15" (26 x 38 cm). The Metropolitan Museum of Art, H. O. Havemeyer Collection, Bequest of Mrs. H. O. Havemeyer, 1929. (JP 1874). Photograph © 1983 The Metropolitan Museum of Art.

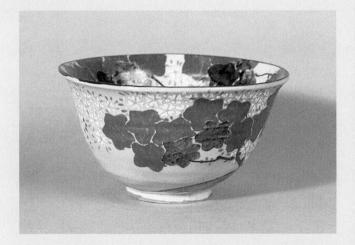

Fig. 7–23 This bowl was created for use in a tea ceremony. The special ceremony of making and drinking tea was first developed by Zen Buddhist monks as a form of contemplation. Nin'ami Dohachi, Footed Bowl, Edo Period (1615–1867). Kyoto ware, porcelaneous stoneware, with underglaze iron-oxide and overglaze enamel decoration, $3^5/8^* \times 6^1/2^*$ (9.2 x 16.5 cm) diameter. The Nelson-Atkins Museum of Art, Kansas City, Missouri (Gift of Mr. W. M. Ittmann Jr. in honor of Mrs. George H. Bunting Jr.).

Fig. 7–24 Netsuke are small carved objects used to fasten a pouch or purse to one's kimono sash. Okakoto, *Two Quail*, late 18th–early 19th century. Ivory, 1 ³/₈" (3.2 cm) wide. Los Angeles County Museum of Art, Gift of Mrs. G. W. Mead. M.59.35.24

Sculpture in the Studio

Making a Paper Relief Sculpture

Forms in Nature

Studio Introduction

When was the last time you made a newspaper hat? A gum-wrapper chain? A house of cards? Or a paper airplane?

When you made these things, you probably didn't realize that you were practicing some paper-sculpture techniques.

Curling, folding, crumpling, and slitting are just some of the ways to turn ordinary paper into a jungle of wild animals or a garden paradise. Sculptors who work with paper make amazing and beautiful three-dimensional forms. When they put the forms together, they can create fantastic artworks!

In this lesson, you will create three-dimensional forms from paper. Pages 244–245 will tell you how to do it. Then you will assemble the forms to make a relief sculpture. Choose any object or scene from nature for your subject.

Studio Background

Paper in Art

Paper is all around us. We use it to write on and to wrap things. We feel its many textures and thicknesses in books and magazines. It fills our homes, schools, and offices. For thousands of years, paper has been an important part of daily life. It has also made its mark in the world of art.

From its earliest time, paper has provided artists with a surface for drawing, painting, and printing pic-

tures. In the early 1900s, paper's role in art expanded into collage and sculpture. Artists invented new ways to express themselves with paper. Many were inspired by the traditional paper-folding and paper-cutting techniques they saw in Europe and Asia. Today, artists create exciting sculptural forms just by cutting, folding, scratching, tearing, piercing, bending, punching, rumpling, gluing, and decorating paper.

Fig. 7–25 Notice how this artist simplified the forms of exotic flowers. What paper-sculpture techniques do you see here? Why might the artist have also chosen to simplify the color scheme? Ron Chespak, *Birds of Paradise*, 1997.

Paper sculpture, 70" x 44" x 8" (177.8 x 111.8 x 20.3 cm). Courtesy of the artist.

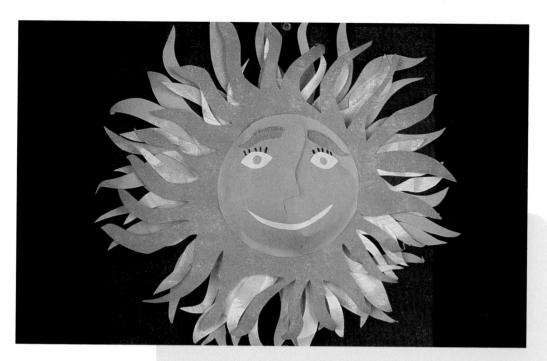

Fig. 7–26 Can you determine how these student artists manipulated their paper? The face was made from a cone—what other forms do you see? Danielle M. DeMars and Brittany Leftwich, *Sun Shine*, 1999. Construction paper, sponge paint, 12" x 12" (30.5 x 30.5 cm). William Byrd Middle School, Vinton, Virginia.

The next time you pick up a letter or open a box of cereal, think about the paper that was used to make it. Then look at the paper with the eyes of an artist. What could you do with it?

Fig. 7–27 How has this artist created texture? Is it real texture or implied texture? Denise Ortakales, *Peacock*, 1998. Paper sculpture, 10" x 35" x 4" (25.4 x 89 x 10 cm). Courtesy of the artist.

Sculpture in the Studio

Making Your Paper Relief Sculpture

You Will Need

- sketch paper and pencil
- colored construction paper
- lightweight cardboard
- scissors
- tools for scoring
- white glue
- paper clips or removable tape

Try This

1. Choose a subject from nature that interests you. You might consider animals, trees, flowers, the ocean, or mountains. How might you create a paper relief sculpture of your subject?

- **2.** Sketch your ideas. Simplify the shapes and forms of your subject. Will you use geometric shapes and forms, or organic shapes and forms?
- **3.** Practice the paper-sculpture techniques shown in the diagrams. Try scoring and bending straight and curved lines. Compare the results. Experiment with other techniques, such as tearing and twisting paper. Come up with ideas of your own. Which techniques will work best for your sculpture? Think about the colors and forms that will create the effect you want.

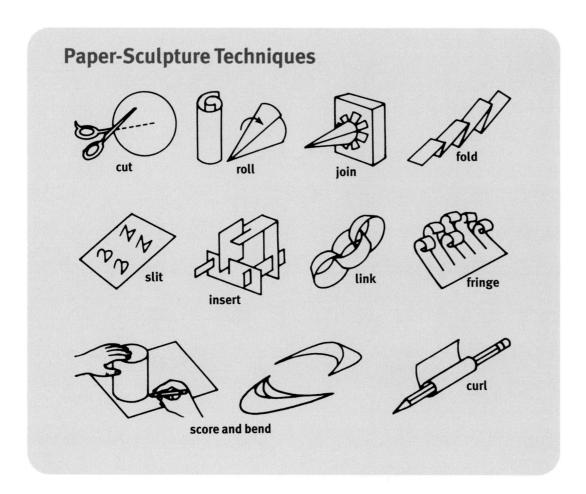

4. When you are finished shaping the forms for your sculpture, carefully arrange the parts on a piece of lightweight cardboard. Change and rearrange

the forms so all parts fit together well.

5. When you are happy with your arrangement, glue the forms in place. Use paper clips to hold the forms in place until the glue dries.

Check Your Work

Explain to classmates why the forms you chose work best for your subject. How many different paper-sculpture techniques did you use to create the forms? How clearly does your sculpture represent nature?

Sketchbook Connection

Creating close-up sketches of plants and other forms in nature is a good way to learn about the subject. Take your

sketchbook outside and choose a quiet spot to sit. Find a leaf, flower, or other natural object that interests you. Make some sketches of it. Draw large to fill the page. Include as many small details and textures as you can.

Computer Option

Think about the constant changes in nature. In a paint or multimedia program, create a scene that shows a

change such as a flower blooming, an animal growing, or the sky changing at sunset. Use color, values, placement, and special effects to give your design a 3D feeling.

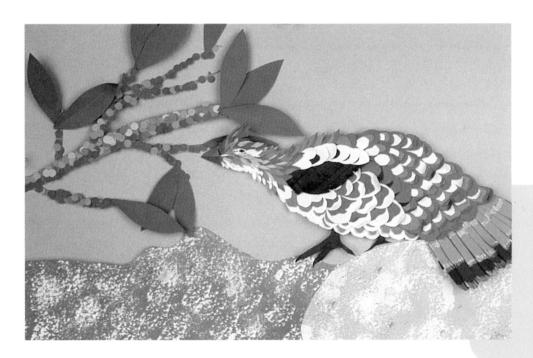

Fig. 7–28 How did the artist use paper to show the variety of the natural world?

N. Elizabeth Kite, Feathers, 1999.
Construction paper, sponge paint, 11" x 17" (28 x 43 cm). William Byrd Middle School, Vinton, Virginia.

Connect to...

Careers

In a science textbook, you can find illustrations that depict scientific concepts, natural objects, and living things. These images are created by science illustrators, artists with special skills in one or more areas of science.

Science illustrators must have a strong scientific curiosity and a keen interest in both art and science. They might specialize in one of the science domains: life science, physical science, and earth and space science. For instance, an artist who specializes in life science might create medical or botanical illustrations.

Science illustrators use a variety of media and techniques, and often work closely with doctors and scientists to create accurate drawings and paintings for textbooks, field guides, and other science-based publications. No matter what their field of study, all science illustrators must be expert at seeing detail and drawing accurately what they observe.

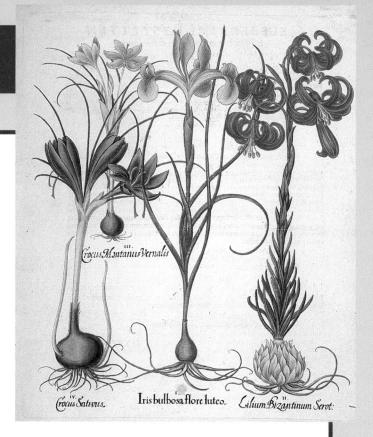

Fig. 7–29 What are some reasons that scientific illustrations, instead of photographs, are used in publications? Basil Besler, *Crocus Sativa*, *Bulbosa Flora Luteo*, *Lilium Bizantinum Serot*, 1613.

Colored engraving, 18^{7} /s" x 15^{3} /4" (47.9 x 40 cm). Philadelphia Museum of Art, Purchased: Harrison Fund.

Other Arts

Music

As with many artworks, the natural world is a frequent subject in musical works. The direct **representation of animals or natural events** (wind, water, storms) in music is known as imitation. For instance, a composer might use the full range of orchestral sounds to present the dramatic effect—the musical imitation—of a storm.

Listen to three compositions that depict storms: the storm section from Rossini's William Tell Overture; the fourth movement of Beethoven's Sixth Symphony; "Cloudburst" from Grofé's Grand Canyon Suite. How are these pieces similar in the way they represent storms? How do they differ? How did the composers use instruments, dynamics (volume), tempo, rhythm, and harmony to represent storms? Which piece do you think is the most effective? Why?

Internet Connection

For more activities related to this chapter, go to the

Davis website at www.davis-art.com.

Other Subjects

Language Arts

One of the most important forms of traditional Japanese poetry is linked to nature. **Haiku** is a thoughtful, unrhymed poem that expresses an essential quality or spirit of the natural world. Well-written haiku contrasts elements such as movement and stillness, or change and stability.

Haiku usually has a particular season and focus on fully appreciating the present moment. A haiku has seventeen syllables in three short lines. How could you learn to write haiku? What natural subjects would you choose to interpret in your haiku?

Fig. 7–30 The words of a poem are combined with skillful calligraphic brushstrokes in this work about nature.

Tamaraya Sotatsu and Hon'ami Koetsu, *Poem-Card* (*Shikishi*), 1606.

Gold, silver, and ink on paper, 52" x 17" (132.1 x 43.2 cm). ©The Cleveland Museum of Art, John L. Severence Fund, 1987.60.

Mathematics

Symmetrical balance is a concept shared by math, science, and art. Symmetrical, or bilateral, balance is produced by the repetition of the same shapes or forms on opposite sides of a center dividing line. Examples of symmetrical balance can be found in nature, especially in living things that have a backbone; or, in mathematical terms, a line of symmetry.

Fig. 7–31 Can you identify six living creatures that are symmetrically balanced? Michael Colucci, *Digital Tortoise*, 1998.

Computer graphic, 8" x 8" (20.3 x 20.3 cm). Haverford High School, Havertown, Pennsylvania.

Daily Life

Do you fully experience nature in your every-day life? Each day, are you inside a climate-controlled building in which the windows can't be opened? Do you shop and go to movies inside a mall? Would you rather stay inside—watching TV or playing computer games—or go outside and play sports or explore nature?

Even though we depend on the natural environment, we can easily let ourselves become removed from it. Thomas Moran's extraordinary paintings of Yellowstone and the Grand Canyon (page 227) were crucial in convincing the United States Congress to establish and preserve the areas as national parks. What are some ways to encourage people to better appreciate and enjoy the natural world?

Portfolio

"I enjoyed making this because I liked the cool designs that showed up. This project was easy to make and it did not take a long time to finish it." Tory Velardo

Fig. 7–33 How has this student used color to express her impressions of nature? How would you describe her style? Kaitlin Carleton, *Birch*, 1999.
Watercolor, 7 ½ " x 13" (19 x 33 cm). Bird Middle School, Walpole,

Fig. 7–32 Students experimented with different contrasting colors to see which would work best together. Tory Velardo, *Untitled*, 1999.
Printing ink, cardboard, 18" x 24" (46 x 61 cm).
Copeland Middle School, Rockaway, New Jersey.

Massachusetts.

CD-ROM Connection

To see more student art, check out the Global Pursuit Student Gallery.

"I kept thinking that I needed just enough details to make the teapot stand out, but not so many that it would make the teapot become too wild." Amanda Hill

Fig. 7–34 In choosing an object from nature for her clay vessel, this student thought about how the shape of the rose would complement the shape of the teapot. Amanda Hill, *The Rose Teapot*, 1999. Clay, 6" x 6" x 5" (15 x 15 x 12 cm). Atlanta International School, Atlanta, Georgia.

Chapter 7 Review

Recall

What are two ways that humans connect with nature through art?

Understand

Use examples to explain how the Impressionists used color and light to interpret nature (*example below*).

Apply

Produce a small painting of three apples using the pointillist technique to visually mix the three primary colors.

Page 236

Analyze

Compare and contrast Japanese and Impressionist interpretations of nature in the artworks in this chapter.

Synthesize

Create a poster showing different interpretations of nature in artworks from around the world. Refer to the core lesson and its development of the theme "nature" as you plan your work.

Evaluate

Recommend three artworks from this chapter that you think everyone should revisit from time to time as reminders of the beauty of the natural world. Give reasons for your selections.

For Your Portfolio

Create an artwork especially for your portfolio, based on the theme of nature. Exchange your artwork with a peer, and

write a critique of your peer's work. Describe the work, and interpret its meaning, making connections between the details and the work's message about nature. Explain how the artwork is successful. You might also offer suggestions for improvement, with reasons or questions. Exchange critiques, and write a response. Put the response, critique, and artwork into your portfolio.

For Your Sketchbook

Select one object from nature. Draw the object in several different ways, with various media and colors, from differ-

ent views and in different light.

8

Continuity and Change

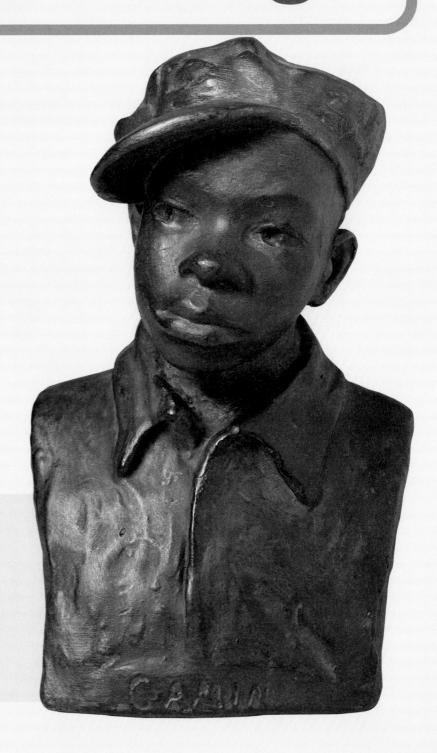

Fig. 8–1 With this sculpture, the artist broke with the portrait tradition in Western art.

The boy, modeled after her nephew, was meant to represent other homeless children of the Depression in the United States. Augusta Savage,

Gamin, c. 1930.

Painted plaster, 16 ½" (41.9 cm) high.
National Museum of American Art,
Smithsonian Institution, Washington, DC.

Focus

- · How can traditions both continue and change?
- What are some artistic traditions and how do they change?

Do you celebrate a certain holiday or a special date year after year? How do you celebrate? Do you always do the same things or eat the **same foods?** Are the same family members and friends present? Most people celebrate at least one holiday as part of a group, in a traditional way, year after year. You maintain *continuity* by carrying on traditions and following holiday customs.

Artists in every culture throughout the world also carry on traditions. European artists have created still lifes using oil paint since the medium was first developed before the fifteenth century. African sculptors have carved masks out of wood since before recorded history.

Think again about your holiday tradition. Would you agree that, from year to year, your celebrations are never exactly the same?

Perhaps someone has a new home, and the gathering

is moving there. Perhaps a baby was born since last year or maybe someone died. So while there is continuity, there is also change.

Artistic traditions can also change. For centuries, artists sculpted bronze portraits of royalty, famous people, or the well-to-do. Augusta Savage made the sculpture in Fig. 8–1 during the Depression. She broke with a portraiture tradition by sculpting an ordinary boy in bronze.

What's Ahead

- Core Lesson Discover how traditions in art continue and change.
- 8.1 Art History Lesson Learn about the rapid changes in Western art traditions in the early twentieth century.
- 8.2 Elements & Principles Lesson Focus on the use of simplified shape and form in art.
- 8.3 Global View Lesson Find out about continuity and change in the arts of Southeast Asia.
- 8.4 Studio Lesson Create a montage, an art form related to collage.

Words to Know

assemblage additive process Expressionism nonobjective Fauves form Surrealists Abstract art

Cubism

representational montage

Continuity and Change in the Art World

Types of Traditions

Some art traditions are shared by most cultures around the world. For example, nearly every culture decorates objects that are used every day. But cultural groups also have their own special artistic traditions. Here's one that you may know about: skateboard decoration. Most skateboarders decorate the bottom of their skateboards. This makes each skateboard unique, even though they have similar designs.

There are many different types of traditions in art. The media, or materials, used for artworks are one kind of tradition. For example, oil paint is a material traditionally used on canvas. Materials are often related to places, because they depend on available local resources. For instance, African sculptors traditionally carve the wood from trees grown near their village.

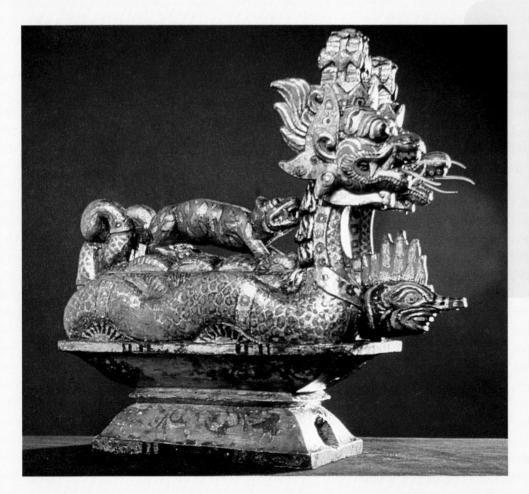

Fig. 8-2 This box was made for a traditional purpose-to hold a symbol of a god. The design also is traditional, telling a legend of the island of Bali sitting on an underworld turtle held between the coils of two serpents. How would understanding the culture of Bali help you to understand this artwork? Bali, Wahana (miniature vehicle for a votive figure), 20th century. Wood, pigments, gold leaf, fish glue medium, lacquer, 19 1/8" x 19 1/4" x 8 5/8" (48.5 x 49 x 22 cm). Australian Museum/Nature Focus.

An artwork's purpose might also be traditional: to decorate, to teach, to use in a ceremony or celebration, to show power, to record a historical event, or to tell a story. An artwork can have more than one traditional purpose. The Balinese box (Fig. 8–2), for example, is part of a storytelling tradition as well as a ceremonial tradition.

The subject matter of art can be traditional. You have seen some examples in previous chapters: nature in Japanese art, beauty and harmony in classical Greek art, and Christianity in early medieval art.

Certain art forms are considered traditional. Drawing, painting, and sculpture are very old traditions in art. Carved-wood sculpture in Africa (Fig. 8–3) is an art form handed down from one generation to the next. Older, experienced sculptors teach it to younger apprentices.

Each art form has its own customs and traditions. A painting might follow the tradition of landscape or still life (Fig. 8–4). A sculpture might follow the tradition of monuments or portraits.

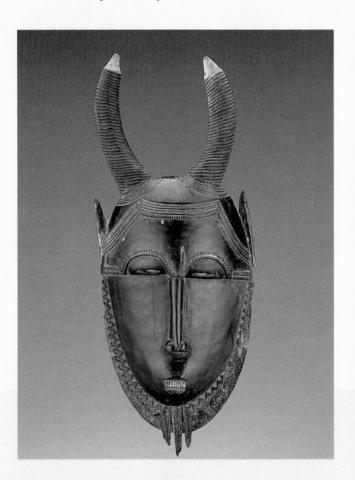

Fig. 8-3 Carving sculpture from wood is one of the oldest artistic traditions in Africa. What sculpture traditions have you been taught? Yaure peoples, Ivory Coast, Mask, early 20th century.

Wood and pigment, $14^{3}/_{4}$ " (37.5 cm). Museum purchase, 91-21-1. National Museum of African Art, Smithsonian Institution, Washington, DC.

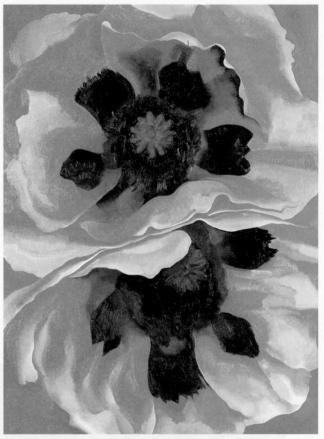

Fig. 8–4 Does this painting seem traditional to you? Why or why not? Georgia O'Keeffe used a traditional art form and showed traditional subject matter. But the way she chose to show the flowers was not traditional. Her new style used simplified flower shapes that filled the canvas. Georgia O'Keeffe, *Oriental Poppies*, 1928. Oil on canvas, 30" x 40 ½" (76.2 x 101.9 cm). Collection Frederick R. Weisman Art Museum at the University of Minnesota, Museum purchase. ©2000 The Georgia O'Keeffe Foundation/Artists Rights Society (ARS), New York.

Breaking, Borrowing, and Building on Traditions

Traditions in art change over time. Artists develop new interests. They learn new ideas from others. They come upon new technologies, tools, materials, or processes. A painter might start using a software program instead of watercolors to create his or her landscapes. Let's look at three ways that change occurs in art.

Fig. 8–5 Brancusi made sculpture out of marble, a tradition that dates to ancient times. How did he break tradition with his work? Constantin Brancusi, Mlle. Pogany (III), 1931.

White marble, base of limestone and oak, $17" \times 7^{1/2}" \times 10^{1/2}"$ (43.3 x 19 x 26.6 cm). Philadelphia Museum of Art: The Louise and Walter Arensberg Collection, 1950. Photo: Graydon Wood, 1994. ©2000 Artists Rights Society (ARS), New York/ADAGP, Paris.

Artists sometimes decide to *break with tradition*. Constantin Brancusi (Fig. 8–5) made sculpture out of marble, an ancient tradition. Yet he broke with tradition by not sculpting realistic portraits out of the marble. For over twenty years, Brancusi explored the egg-shaped form shown here. In some ways, he created his own lasting tradition.

Change also occurs when artists *borrow traditions*. You have seen how the Impressionist painters borrowed ways of

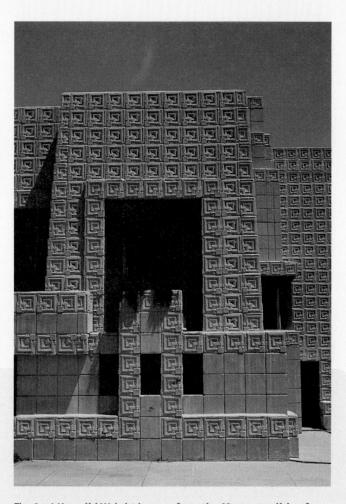

Fig. 8-6 How did Wright borrow from the Mayan tradition for this design? Frank Lloyd Wright, *Ennis-Brown House*, 1924. Photo by H. Ronan.

organizing their compositions from the Japanese woodcut tradition (see page 230). The *Ennis-Brown House* (Fig. 8–6) shows a style borrowed from a Mayan architectural tradition. Although these examples are relatively recent, cultures have borrowed traditions from one another since the earliest times.

In addition to breaking or borrowing traditions, artists might *build on traditions*. Refer to the story quilt *Tar Beach* (Fig. 6–6 on page 203) by Faith Ringgold. Ringgold was inspired by traditional quilt patterns and the stories they suggest. She made the

story the focus in her quilt, actually writing and illustrating the story on fabric.

Since the seventeenth century, Navajo weavers made blankets to be worn while traveling. Then, in the late nineteenth century, traders who came to the Southwest found that they could sell the blankets as rugs. The Navajo weavers built on their tradition in response to a change in their world (Fig. 8–7).

When you study an artwork, think about what traditions might be part of it. Does the artwork break with, borrow from, or build on a tradition? Are there other ways that art traditions can change?

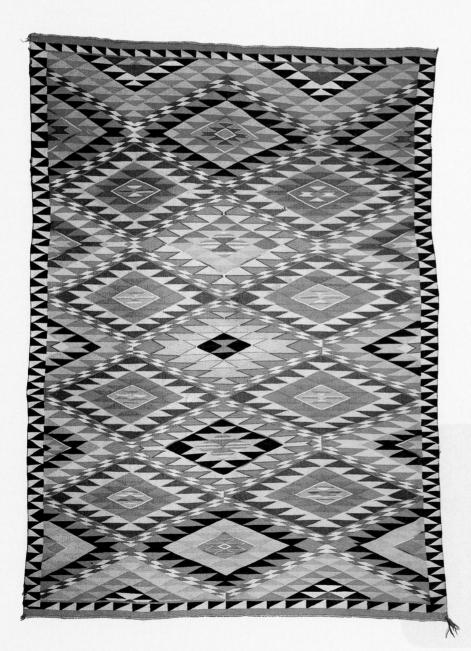

Fig. 8–7 Traders brought new pigments and yarn to Navajo artists, which allowed them to build on the tradition of weaving. A rug like this is called a Germantown, named after the Pennsylvania town where the yarns were produced. Navajo, Germantown "eye-dazzler" rug, c. 1880–90.

Extremely rare split yarn, two, three, and four ply, 72" x 50" (182.9 x 127 cm). Courtesy of Museum of Northern Arizona Photo Archives, F3176

Making an Assemblage

Building on a Sculptural Tradition

In this studio lesson, you will make a different kind of sculpture. An assemblage—also called "junk sculpture"—is a combination of found objects

that form a sculpted artwork. You may choose either a traditional subject (such as a person or a group of animals) or a traditional purpose (such as to honor a person or show humor).

Begin collecting materials well in advance. Any object you are able to combine by gluing, tying, or otherwise joining could be part of your assemblage.

Fig. 8–8 **How do the objects used to make this sculpture** change its meaning? How is it different from a traditionally carved or modeled penguin? Leo Sewell, *Penguin*, 1979. Assemblage-reclaimed objects, 31" x 20" x 9" (79 x 51 x 23 cm). Courtesy of the artist.

You Will Need

- sketch paper
- pencil
- found objects
- bonding materials (glue, nails, screws, bolts, wire)
- tempera paint
- paintbrush
- tools (hammer, screwdriver, wire cutters, wrench)

Try This

1. Sketch some ideas before you begin your assemblage. Think about the possible meanings of the objects you have collected. Will your sculpture have a traditional purpose? Or will your artwork show a traditional subject?

- **2.** When your design is finished, arrange the collected objects. Move them around to get the effect you want. Look at the arrangement from several angles.
- **3.** Begin your final assemblage with one or two larger pieces. Add smaller forms to these. Try several positions for each form before you attach it.

Studio Background

Assemblage sculpture is an additive process, which means that materials are added or built up to create a form. Assemblages were made popular by twentieth-century artists such as Louise Nevelson (Fig. 8–9). They are usually organized around a theme or idea. Often, the materials themselves suggest the idea. Sometimes, the artist joins the same kind of objects—such as wooden chair legs. Other times, a

4. As your work takes shape, look at it again from several angles. Are there details you can add that will contribute to its traditional purpose or subject? Will you paint

these details or create them with additional materials?

5. Allow any glue to dry before painting your assemblage, if you wish to paint it.

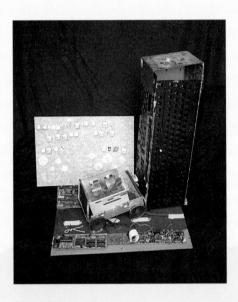

Fig. 8–10 This found-object sculpture was made from old computer parts. A clever play on words, spelled out with keyboard parts, puts a new twist on an age-old problem. Co-artist Berger says, "The artwork represents a crucial message to American teens and gets people thinking about drinking and driving." Elizabeth Berger and Sarah Gallagher, *Drunk Driving Crashes More Than Just Hard Drives*, 1999. Computer parts, 20" x 17" x 15" (51 x 43 x 31 cm), The Avery Coonley School, Downers Grove, Illinois.

combination of objects is used—such as chair legs and plastic sunglasses.

An assemblage might be made of ordinary materials—scraps of cardboard, wood, metal, or plastic—that are also in the form of objects, such as tubes, old machine parts, or foam plastic egg cartons.

Check Your Work

Display your finished sculpture along with your classmates' sculptures. Note the similarities and differences. Discuss how the objects help show each sculpture's overall theme or idea.

Sketchbook Connection

Sketching ideas for two-dimensional artworks can be easier than sketching them for three-dimensional ones. Practice

sketching three-dimensional groups of objects. Set them up on a square table. Make four different sketches, one from each side of the table. How is each sketch different? How might this help you construct a sculpture?

Core Lesson 8

Check Your Understanding

- **1.** What do we mean by artistic tradition?
- **2.** Name three types of artistic traditions.
- **3.** If someone borrows an artistic tradition, what does that person do?
- 4. How might tourism affect artistic tradition?

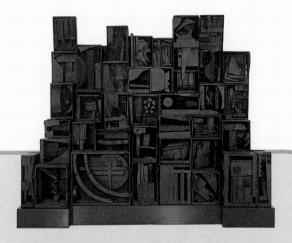

Fig. 8–9 Where can you see pieces of furniture in this assemblage? The artist also used pieces of wood from old buildings. Louise Nevelson, *Sky Cathedral*, 1958. Wood, painted black, 101 ¹/₂" x 133 ¹/₂" x 20" (260 x 339.1 x 50.8 cm). George B. and Jenny Mathews Fund, 1970:1. Albright Knox Gallery, Buffalo, New York: ©2000 Estate of Louise Nevelson/Artists Rights Society (ARS), New York.

European Art: 1900-1950

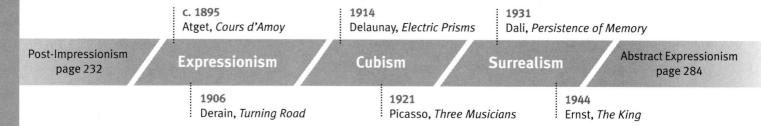

The early twentieth century was a time of rapid change. There were great inventions, including the airplane, the car, and the television. There were also great changes in business and industry as more people moved to the city to work and live.

Art was also changing rapidly. Photography was an important new art form. Artists were trying to create their own unique styles. Some artists built on earlier artistic styles. Others experimented with traditional art materials and subjects. Still other artists tried to break completely with the past.

The artworks on these pages are a few examples of the many styles that developed from 1900 to 1950. They show the continu-

ity of past traditions as well as the great changes taking place in the art world.

Building on Traditions

The artists of the Impressionist and Post-Impressionist movements greatly influenced early twentieth-century artists.

Expressionism

The term **Expressionism** refers to artists in the early twentieth century who used color and line with great feeling. Their main goal was to show feelings such as sorrow, joy, or fear in their artworks.

Many Expressionist artists formed groups to share ideas and techniques. One group was known as the **Fauves** (*fohv*). *Fauve* is a French word that means "wild beast." These artists got their name from the wild, intense colors they chose.

The Fauves liked the way the Impressionists broke down natural forms

Fig. 8–11 What mood is created by the unusual colors in this work? André Derain, *Turning Road*, *L'Estaque*, 1906. Oil on canvas, 51" x 76³/₄" (129.5 x 195 cm). Museum of Fine Arts, Houston; Gift of Audrey Jones Beck. ©2000 Artists Rights Society (ARS), New York/ADAGP, Paris.

into different colored brushstrokes. They admired the Post-Impressionists' expressive use of color and line. Compare *Turning Road*, *L'Estaque* (Fig. 8–11) by André Derain with the Post-Impressionist painting by Gauguin in Fig. 7–18, on page 237. Notice how both artworks have clear shapes and a strong composition. But Derain used wild, bright colors.

Changing Traditions

Many early twentieth-century artists were interested in finding new ways to show traditional subjects such as portraits, landscapes, or still lifes. Many turned to their dreams and imaginations for inspiration. These artists were called Surrealists.

Surrealism

Fantasy art can be found in works by the classical Greeks, medieval artists, and artists of the Northern Renaissance. The **Surrealists** experimented with new ways to create fantastic artworks. In Fig. 8–12, Max Ernst used bronze to create a sculpture of large chess pieces. Bronze was usually used to create portraits. By choosing surprising subject matter, Ernst made people think about the question, "What is art?"

Surrealist painters created compositions full of things that don't seem to go together. In Fig. 8–13, Salvador Dali made objects in his painting *look* real.

But Dali upset the tradition of realistic painting. He showed things that are not from real life. What kind of message about change do you think Dali was sending?

Fig. 8–12 Notice how this artist has broken down the parts of the figures into distinct geometric forms. Where do you see exaggeration in this artwork? Max Ernst, The King Playing with the Queen, 1944.

Bronze (cast 1954, from original plaster), height: 38 ½" (97.8 cm), at base 18 ¾" × 20 ½" (47.7 × 52.1 cm). The Museum of Modern Art, New York. Gift of D. and J. de Menil. Photograph ©2000 The Museum of Modern Art, New York. ©2000 Artists Rights Society (ARS), New York/ADAGP, Paris.

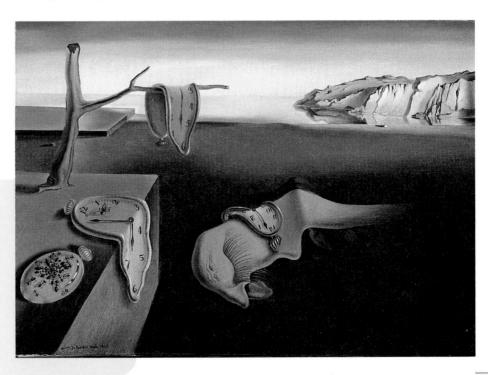

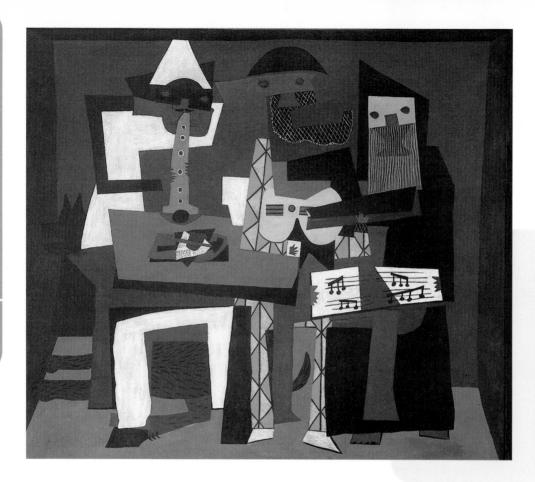

Fig. 8-14 Can you find the musicians and their instruments? If you did not know the title of this painting, how could you tell what it is about? Pablo Picasso, Three Musicians, Fontainebleu, summer 1921. Oil on canvas, 6' 7" x 7' 3 3/4" (200.7 x 222.9 cm). The Museum of Modern Art, New York, Mrs. Simon Guggenheim Fund. Photograph ©2000 The Museum o+f Modern Art, New York. @2000 Estate of Pablo Picasso/Artists Rights Society (ARS). New York.

A New Tradition

Abstract art was invented by early twentieth-century artists. These artists built on earlier art traditions, but also made an important break with the past. They felt that art did not always need to show subjects that you could easily recognize.

Cubism

Early Abstract artists were influenced by the Post-Impressionist Paul Cézanne. They were interested in Cézanne's idea that everything can be broken down into three basic geometric forms: the cylinder, sphere, and cone. **Cubism** was an Abstract art style that developed from this idea. The Cubists broke down objects and the space around them into different shapes. They then rearranged the shapes into a composition. The new arrangement of shapes sometimes makes it hard to recognize the original subject matter of the artwork.

Study the Cubist painting by Pablo Picasso (Fig. 8–14). Do you see how the artist broke down the faces and bodies of the figures into colored circles, rectangles, and triangles?

Some Cubist artists created **nonobjective** art—art that has no recognizable subject matter. In Fig. 8–16, Sonia Terk Delaunay chose connecting disks of bright colors as her subject.

8.1 Art History

Check Your Understanding

- **1.** What were the major concerns of artists in the early part of the twentieth century?
- **2.** Use examples to support or reject the statement, "Artists of the early twentieth century didn't pay attention to the art of the past."
- **3.** Explain, using examples, how Surrealist artists broke with tradition.
- **4.** What were some influences on early twentieth-century art?

Fig. 8–15 Photography became an exciting new art form in the early twentieth century.

Where do you see unity and variety in this photograph? Eugène Atget, Cours d'Amoy 12, Place de la Bastille, c. 1895.

Aristotype, 7 ½ " x 8 ¼ " (18 x 21 cm). Chicago, formerly the Exchange National Bank Collection.

Fig. 8–16 What do you think this artwork is about?
Sonia Terk Delaunay, *Electric Prisms*, 1914.
Oil on canvas, 93 ³/₄" x 98 ³/₄" (238 x 251 cm). Collections
Mnam/Cci–Centre Georges Pompidou. ©L & M Services B.V.
Amsterdam 9911.6. Photo: Phototheque des collections du Mnam/Cci.

Studio Connection

Surrealist artists liked to experiment with artworks that are random, or unplanned. They created a technique

called decalcomania (DEE-cal-coh-MAY-nee-ah).

Try out the decalcomania technique to create a painting from your imagination. Choose a color scheme (warm, cool, analogous, and so on). Mix several colors of tempera or acrylic paint. With a spoon or stick, place a small amount of each color on two sheets of damp paper. Place the painted side of each sheet face-to-face. Lightly press and rub several areas, then slowly pull the papers apart. What unusual shapes and colors have formed? Use a brush or other tools to change each painting slightly if you wish. Let some of the random shapes and colors remain as part of the final painting.

Shape and Form

If someone asked you to draw a shape, what would you draw? A square? A circle? Or would you draw an irregular shape? Artists can use geometric shapes and organic shapes in their compositions. They can also use positive shapes and negative shapes (see Looking at Shape, page 132).

Can you think of ways to show a shape without drawing a line around it? In *Sorrows*

Fig. 8–17 Matisse painted sheets of paper and then cut the sheets into shapes for his collages. He called this process "cutting the color out alive." Henri Matisse, Sorrows of the King, 1952.
Collections Mnam/Cci-Centre Georges Pompidou. Photo: Phototheque des collections du Mnam/Cci. ©2000 Succession H. Matisse, Paris/Artist Rights Society (ARS), New York.

Fig. 8-18 Did the artist just want to experiment with forms? What might these side-by-side forms symbolize? Barbara Hepworth, Two Figures, 1947-48.

Elm wood with white paint, 40" x 23" x 23" (101.6 x 58 x 58 cm). Collection Frederick R. Weisman Art Museum at the University of Minnesota. Gift of John Rood Sculpture Collection.

of the King (Fig. 8–17), Matisse has used color, value, and texture to make shapes.

If you add depth to a shape, you have a **form.** A form has height, width, and depth. It can be simple or complex. A pear has a simple form. The form of a tree is complex and made up of many parts. Just as shapes can be geometric or organic, forms can be categorized this way. And just as shapes can be positive and negative, so can forms.

Barbara Hepworth's sculpture (Fig. 8–18) is made up of two main forms. You can see smaller forms in each of the forms. Are the forms organic or geometric? Hepworth changed a sculptural tradition. She was one of the first artists to explore positive and negative forms in Abstract sculpture.

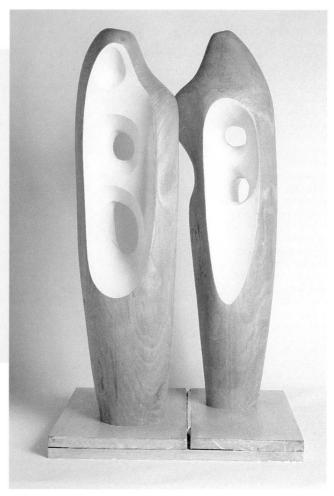

Fig. 8-19 A metamorphosis is a specific kind of change. It is often associated with the stages a caterpillar passes through as it becomes a butterfly. Is there a part of this artwork that might be called traditional? What is the artist saving about continuity and change? Herbert Bayer, Metamorphosis, 1936. Gelatin silver print, 9 13/16" x 13 1/2 (24.9 x 34 cm). Courtesy Herbert Bayer Collection and Archive, Denver Art Museum. ©2000 Artists Rights Society (ARS), New York/ UG Bild-Kunst, Bonn.

Showing Forms in Two Dimensions

If you were asked to draw or paint a cube on a flat piece of paper, how would you do it? Would you use perspective lines? If you didn't want to use lines, would you change the flat shapes by shading them?

In a two-dimensional artwork, an artist may simply wish to show the shapes of objects. Or the artist may wish to create the illusion of three-dimensional form. Perspective and other devices can give the illusion of depth (see Creating the Illusion of Depth, page 148). The illusion of depth can also be created by adding shading to the flat shape of an object.

Study Fig. 8–19, *Metamorphosis*. It is a two-dimensional artwork. Yet, we can easily see the geometric shapes as three-dimensional forms. That is because of the shading on each form. There are other ways the artist creates the illusion of depth. How many can you find?

Studio Connection

Make a collage by gluing cut or torn paper, fabrics, or other flat materials to a background. Create the illusion of depth

by adding shading to shapes. Your collage can be representational (showing a subject, such as a still life, portrait, or landscape). Or it can be nonobjective (showing no subject). Use both geometric and organic shapes. Add shading with markers. When you are finished, look at your artwork. Which shapes look the most like three-dimensional forms?

8.2 Elements & Principles

Check Your Understanding

- **1.** Select two two-dimensional artworks from this chapter. Tell how each artist used shape and created the illusion of form. How have the artists used shape and form in similar ways? In different ways?
- **2.** Select a three-dimensional artwork from this chapter and describe the forms as simple or complex, geometric or organic.

The Art of Southeast Asia

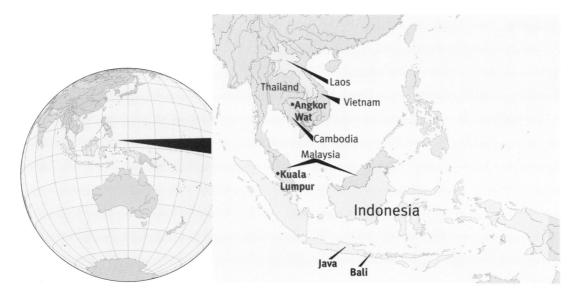

Southeast Asia is made up of many different countries and islands. Some countries are on the continent of Asia, and they include Thailand, Vietnam, and Cambodia. Indonesia, another part of Southeast Asia, is made up of thousands of islands that stretch from Asia almost to Australia.

So far in this book, you have studied the Asian countries of India, China, Korea, and Japan. As you have learned, these countries often shared ideas, cultures, and art styles. Southeast Asian countries have also been influenced by the people and cultures around them. In this lesson, you will see

how artists in these countries used such influences to create a unique and special kind of art in Southeast Asia.

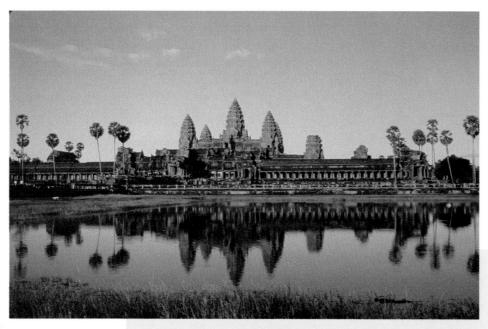

Fig. 8–20 This shrine was built in Angkor, the capital city of the Khmer empire. Look back at the Hindu Temple, Fig. 3–21. What similarities do you see between Southeast Asian and Indian architecture? Angkor Wat, 12th century, Cambodia. ©Leo Touchet. All Rights Reserved.

Fig. 8-21 This jar shows how Chinese pottery techniques influenced artists in Thailand. Si Satchanalai, *Coconut Oil Jar*, 14th-mid-16th century.

Stoneware, height: $5\,^9/16$ " (14.2 cm), diameter: $6\,^7/8$ " (17.5 cm). Asian Art Museum of San Francisco, The Avery Brundage Collection, The James and Elaine Connell Collection of Thai Ceramics, 1989.34.69.

Early Traditions

Southeast Asia was most influenced by India and China. Probably as early as the first century, Southeast Asian cultures borrowed and changed many Indian and Chinese ideas to fit their own ways of life. Southeast Asian artists also admired Indian and Chinese art styles. They used them to create unique traditions in art that continue today.

Religious sculpture and architecture became important art forms in Southeast Asia. The sculptures were made of stone or bronze. They have rounded forms and curving lines. Most sculptures showed gods from the Buddhist and Hindu religions. They were kept in religious *shrines* (sacred places).

In 1150, a king began building one of the largest shrines in Southeast Asia. The king was from the Khmer empire that ruled Cambodia. He built a national shrine called a *wat*. This shrine, shown in Fig. 8–20, is

Fig. 8–22 Notice all the cutout parts and painted details on this puppet. Why would an artist add such details and decoration to something that is seen only in shadow? Java, Indonesia, Wajang purwa shadow puppet: Bima, the Brave Giant, late 19th–early 20th century.

Painted and gilded leather, $27^{3}/8$ " x $14^{1}/4$ " (69.5 x 36 cm). Gift of the museum in 1947 by Mr. G. Tillman Jr. London. Tropenmuseum, Amsterdam.

known as Angkor Wat. The buildings of the temple are covered with carved decorations showing figures and animals.

Lasting Art Forms

The islands of Indonesia also have special art forms. Today, many artworks are made in the same way as when they were first created centuries ago.

Making puppets has been popular on the Indonesian island of Java for at least 1000 years. The puppet shown in Fig. 8–22 is a Javanese shadow puppet. It is flat and has moveable arms. In a show with shadow puppets, the audience is in front of a screen. Behind the screen, a puppeteer uses rods to move the puppet in front of a light. The audience sees only the puppet's shadow.

Indonesian artists have also created special ways of decorating cloth. They developed a technique called *batik* (Fig. 8–23). To create a batik, artists use melted wax to paint a design on a piece of cloth. They dip the cloth into colored dye. The wax protects the cloth from the dye. When the cloth dries, the waxed design stands out against the colored background. Indonesian artists have created many traditional designs and patterns for their batiks. Some have special meaning.

Changes in Modern Times

Artists in Southeast Asia have been exposed to art styles from Europe since the seventeenth century. But for centuries, traditional techniques and art forms remained the most important.

In the twentieth century, some Southeast Asian artists began to experiment with modern European art trends. Many studied in European art schools. Modern art styles have changed the way some Southeast Asian artworks look. But many Southeast Asian artists have tried to maintain their own special art by showing traditional subjects and themes.

Fig. 8–23 This is called a Javanese fairy tale batik. It tells the story of Cinderella. How did the artist tell the story without using words? L. Metzelaar, Woman's Sarong in batik canting technique, early 20th century.

Cotton, 41" × 86 5/8" (104 × 220 cm). Tropenmuseum, Amsterdam.

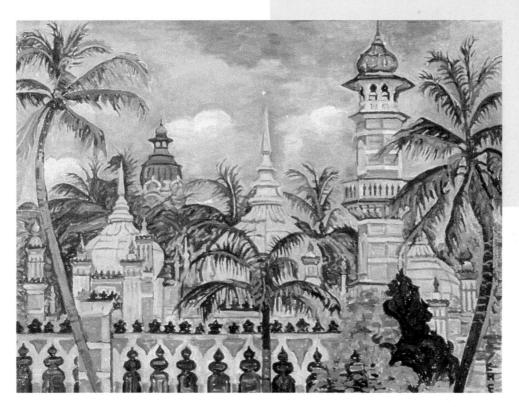

Fig. 8–24 Many contemporary artists show the unique environment of Southeast Asia. What visual clues did the artist include to help tell what her special surroundings looked like? Georgette Chen, Mosque in Kuala Lumpur, 1957.
Oil on canvas, 28 ³/₄" 36 ¹/₄" (73 x 92 cm). Singapore. Collection of the Singapore Art Museum.

Fig. 8–25 This Indonesian artist's use of color has been compared to the Fauves. How would you describe his brushstrokes? Affandi, Self-portrait, 1948. Oil on canvas, 24 ½ " x 21" (61.5 x 53.5 cm). Tropenmuseum, Amsterdam.

Studio Connection

Design a paper batik with a continuous, overall pattern. Select a simple motif to repeat, making slight changes in each

unit as it is repeated. Apply heavy crayon or brush melted wax over the sketched lines before applying a dark watercolor or thin tempera paint wash. You can use more than one color of wax crayon and more than one color of wash.

8.3 Global View

Check Your Understanding

- **1.** Describe two traditional art forms of Southeast Asia.
- **2.** Explain, using examples, how art in Southeast Asia has borrowed traditions from other places.
- **3.** How have today's Southeast Asian artists maintained continuity with the past?
- **4.** What method of decorating cloth was developed in Indonesia?

Collage in the Studio

Creating a Montage

Art with Power

Studio Introduction

When you see a large photograph in a newspaper, magazine, or someone's photo album, do you take a closer

look? Photographs can have a powerful effect on people. Photos can show just about anything—nature, buildings, and even artworks such as those in this book—but they most often show people. Photographs capture a real moment in time, which can make them especially moving or emotional. Think about photographs you've seen of people involved in a natural disaster or a celebration. How did they make you feel?

Artists know that photographs can affect the way people feel. Some artists use photographs to create a **montage**—a collage that combines photographs or parts of them with other flat materials. Montages often express ideas about life.

In this studio lesson, you will create a montage that shows continuity and change in a family or cultural tradition. Pages 270–271 will show you how to do it. Look carefully at photographs you see in newspapers and magazines. How do they relate to your life? How might you use them in your work?

Studio Background

Collage: A Change of Expression

In the early 1900s, collage was a new form of expression. Artists could create exciting images by tearing, cutting, and pasting different papers and fabrics onto a flat background. Collage also added a new element to paintings. As artists experimented with collage materials, many began to use photographs. Montage became a popular technique that remains popular today.

Through their artworks, montage artists often make statements about current events, politics, or their society. People feel they can understand these artworks because they include photographs from the everyday world. As a result, montage artworks can sometimes make a stronger impression on people than paintings.

Fig. 8–26 The artist mixed politics with an interest in images of women in her artworks. Repeated curves add grace. Contrasts of light and dark create a sense of power and drama. What do you think the artist was trying to say? Hannah Höch, *Priestess*, c. 1920.

Collage on cardboard, 13" x 9" (33 x 22.9 cm). ©Christie's Images, Ltd, 1999. ©2000 Artists Rights Society (ARS), New York/VG Bild-Kunst, Bonn.

Fig. 8–27 In this collage, a student explores and expresses her viewpoint on the impact of computers. "No matter how far technology takes us, we will always need a human touch." Kate Riegle-Van West, A Human Touch, 1999.

Collage, montage, 12" x 18" (30.5 x 46 cm). Metcalf School, Normal, Illinois.

Fig. 8–28 Romare
Bearden is considered
one of America's greatest
collage artists. He often
combines collage with
painted areas. Which
parts of this image are
made from photographs?
How, do you think, did the
artist decide where to use
photographs and where
to use paint? Romare
Bearden, Eastern Barn,
1968.

Collage of glue, lacquer, oil, and paper, 55 ½ " x 44" (141 x 112 cm). Collection of Whitney Museum of American Art. Purchase. Photo by Peter Accettola, NY. ©Romare Bearden Foundation/Licensed by VAGA, New York, NY.

Collage in the Studio

Creating Your Montage

You Will Need

- photographs
- wallpaper samples
- gift wrap
- construction paper
- scissors
- tagboard
- glue

Try This

1. Think of ideas for your montage. What tradition or traditions can you show that are still practiced in your culture today? These will express continuity. What ideas break away from the tradition? These will express change. How can you show the way you feel about these concepts?

2. Look for photographs that illustrate the main ideas of your montage.

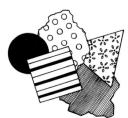

3. Create background shapes and details with assorted colored and printed papers. Try cutting some shapes with scissors. Tear the edges of others for a different effect.

4. Arrange your pieces on tagboard. Try several arrangements. When you are satisfied with the composition, glue the pieces in place.

Check Your Work

Discuss your work with others in the class. How have you expressed the theme of continuity and change in the tradition you chose? What feelings have you shown in your composition?

Computer Option

Create a montage that shows cultural traditions and change. You might focus on your own culture or another

that interests you. Think about what you want to show. People? Artifacts? Buildings? Words? Find images and import to a paint or image-editing program. Combine with color backgrounds, type, and effects.

Sketchbook Connection

Develop the habit of cutting out photographs to use in future collages or to get ideas for other artworks. You may

find photos in magazines, newspapers, or advertisements. Save personal snapshots, too! If you find a photograph in a book, make a photocopy of it for your files. Keep your collection in your sketchbook, perhaps in an envelope attached to a page.

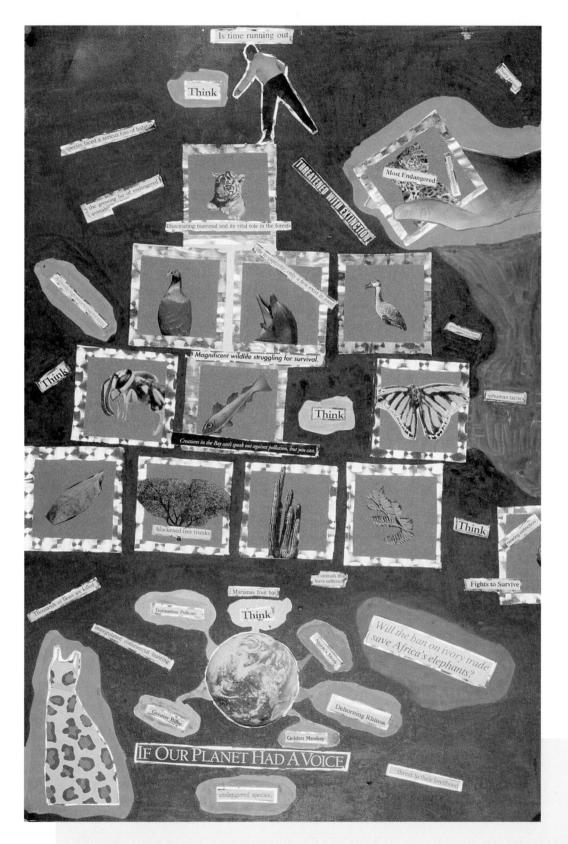

Fig. 8–29 The negative impact of changes to the environment is represented in this collage. The artist explains, "Every living creature on this planet is part of an impressive pyramid, each species with its own cube or block. When we kill off one species of frogs, there will be more bugs, which in turn means the death of many plants, which means the death of any animals who survive off those plants, until the whole pyramid crumbles with the loss of those cubes." Sithru Gamage, *If Our Planet Had a Voice*, 1999.

Montage, markers, 12" x 18" (30.5 x 46 cm). Metcalf School, Normal, Illinois.

Connect to...

Careers

What was the first animated movie you ever saw? Just in your lifetime, animated film production has undergone tremendous change. These changes created a demand for new skills from **animation artists**. Originally, all animated films were created by photographing individually painted "cells" to show action (similar to making a "flip" book).

Technological advances in computer-generated imagery have created a need for animation artists with a particular blend of originality, artistic talent, and computer mastery. If you are interested in a career in animation, you can find academic programs in cities such as Los Angeles and New York.

Fig. 8–30 "I am a creative director and I art-direct the animators. I mostly do the drawings and design the digital sets, then give those designs to the animators to build digitally. The drawings over my board are examples of scenes that I designed for the Spiderman film that we produced for Universal Studios' Islands of Adventure in Orlando." — Kent Mikalsen.

Digital image courtesy of the artist.

Other Arts

Music

Like artworks, many musical compositions demonstrate **continuity and change.** Some remain popular over time and represent cultural traditions; others are altered to reflect change, perhaps in tastes or technology. In music, the adaptation, or arrangement, of an existing composition might feature a variation in instrumentation, style, or vocals. Although a musician receives credit for an arrangement, the original composer continues to own the composition.

To learn how a composition can change over time, listen to an original musical piece and to an arrangement of it. In the arrangement, you'll hear how the original—a more traditional piece—was changed to sound more contemporary.

After listening to the original and to an arrangement of a selection such as "A Boy Like That," answer these questions:

- **1.** How are the pieces alike? How are they different?
- **2.** Discuss the ways that you can tell one piece is more contemporary than the other.
- **3.** What changes make the arrangement sound more contemporary?
- **4.** How was the style changed from that of a Broadway musical to that of contemporary rock piece?

Internet Connection

For more activities related to this chapter, go to the

Davis website at www.davis-art.com.

Other Subjects

Mathematics

How have the tools for performing mathematical **calculations** changed over time? Early mathematical devices were the abacus, for counting with beads that slide along rods or grooves; the ruler, a straightedge for measuring; the protractor, for measuring angles; and the compass, for making circles and measuring distances.

More recent instruments are the slide rule, a ruler with a sliding center section, for making quick calculations; the individual electronic calculator; and the personal computer. How, do you suppose, has the study of mathematics been affected by these tools? How could you find out?

Fig. 8–32 What impact does artificial lighting have on artists or photographers? Charles Christian Nahl, Saturday Night at the Mines (detail), 1856.
Oil on canvas, 120" x 192" (345.5 x 530.9 cm). Iris & B. Gerald Cantor Center of Visual Arts at Stanford University, Palo Alto, CA, Stanford Family Collections, 12083.

Fig. 8–31 If you were to draw a modern Chinese person making or using a calculator, how might your artwork look different from this? Chinese Merchant Making Calculator.

©Baldwin H. Ward & Kathryn C. Ward/Corbis.

Social Studies

Technological advances often produce significant cultural change. One important advancement that we take for granted today is artificial lighting. Before the development of oil, gas, and electric lamps, the only light available after dark came from candles and indoor fires. Consequently, people tended to go to sleep at nightfall and to wake at sunrise.

In the late 1800s, the development and availability of the incandescent lamp produced a dramatic effect: with artificial lighting, people could produce a likeness of natural daylight at any hour. How would your life be different if there were no electric lights?

Daily Life

How do you photographically record family and friends? Do you take pictures frequently? Do you photograph only special events? Do you use a point-and-shoot camera or a digital or video camera? When you have film processed, do you ask for color prints? A CD-ROM? How do you display your photographs?

Though the interest in **photographic images** has continued since the invention of photography, processing has changed dramati-

cally. Early processes were too expensive for widespread use, so photography was not generally used to record daily events. Most people might have been photographed only a few times in their life, on special occasions.

Advances in photography now allow us to print photographs on objects such as coffee mugs, T-shirts, and mouse pads. What advances in photography do you think might occur in your lifetime?

Portfolio

Fig. 8–33 For this monoprint, the student prepared his paper by smearing it with baby powder (to make it smooth). Then he rubbed it with pastel shavings. He then painted an expressive line on a slick surface with black ink. By pressing the paper down gently, then peeling it up, a surprise abstract design was formed. Dustin Bennett, *Untitled*, 1997.

Ink, pastel, 17" x 23" (43 x 58 cm). Sweetwater Middle School, Sweetwater, Texas.

"Using lots of different colors makes it stand out more." Randy K. Krieg

Fig. 8–34 Young students commonly draw a mountain as a plain, pointed triangular shape. This Alaskan student lives in a town surrounded by mountains, and was encouraged by his art teacher to change the way he looked at them. By studying the contours and details of mountains, he created a more realistic image. Randy K. Krieg, *Untitled*, 1999. Batik on cotton, 13" x 9" (33 x 23 cm). Colony Middle School, Palmer, Alaska.

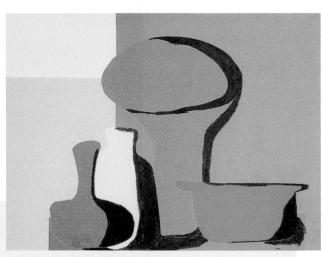

Fig. 8–35 This student used simplified organic shapes to create a still life. Geometric shapes were used in the background. Black marker shading is added to give the shapes an illusion of depth and form. Use of vibrant colors helps change common objects into abstracted shapes. Julian Wade, Untitled, 1999.

Collage, markers, $9" \times 12" (23 \times 30.5 \text{ cm})$. Forest Grove Middle School, Worcester, Massachusetts.

CD-ROM Connection

To see more student art, check out the Global Pursuit Student Gallery.

Continuity and Change

Chapter 8 Review

Recall

Give three examples of ways that artists can use tradition in their approach to art making. (example below)

Understand

Explain the differences between Expressionism, Surrealism, and Cubism.

Apply

Use photocopies of a magazine photo to demonstrate how Cubist artists might have approached their work.

Analyze

Classify the artworks in this chapter into two groups: those which represent continuity and those which represent change. Identify specific features to explain your choices.

For Your Portfolio

Keep your portfolio in good order. Once in a while, check the contents, and choose what to keep in your portfolio and

what to remove. Check that each entry is well presented and identified with your name, date, and title of work. Protect each entry with newsprint or tissue paper.

For Your Sketchbook

Think about your portfolio artworks in terms of continuity and change. What subjects or themes do you con-

tinue to explore throughout your artworks? Do you use the same colors or types of line? Decide what has changed the most in your work over time. Use a page for your sketchbook to describe your findings.

Synthesize

Research the history of product design or graphic design. For product design, focus on objects that you use daily (such as a telephone). For graphic design, focus on packaging that promotes products you use daily (such as salt). Prepare a display, on the theme of continuity and change, based on your research.

Evaluate

Select and rank three artworks from this chapter that you think should be in a twentieth-century art hall of fame. Justify your number one choice.

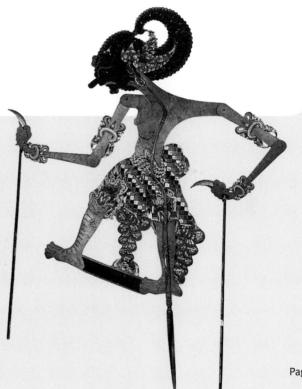

Page 265

9

Possibilities

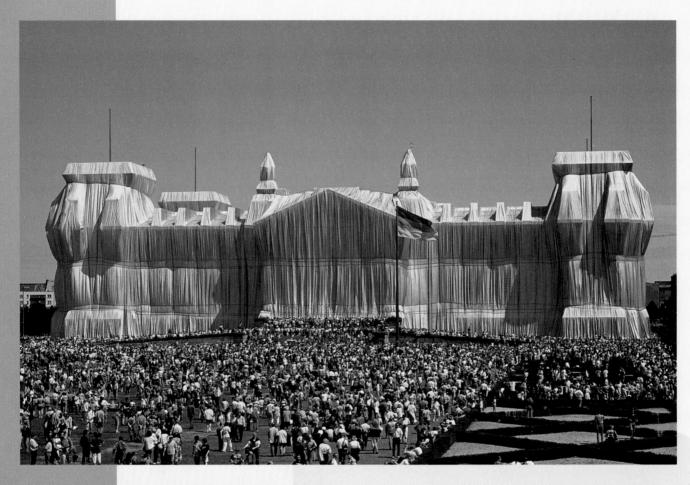

Fig. 9–1a Sometimes, it takes many years to achieve an artistic goal. How is this artwork like the Parthenon (Fig. 2–13, page 103)? How is it different? Christo and Jeanne-Claude, Wrapped Reichstag, Berlin, 1971–95. Silver polypropylene fabric, blue polypropylene rope. © Christo 1995. Photo: Wolfgang Volz.

Fig. 9–1b Paul Wallot, architect, *Reichstag (Parliament)*, 1884–94. From the west. Burned 1933, destroyed 1945, restored 1958–72. Photo: Oliver Radford, 1991.

- Why is it important to ask what is possible?
- How do artists make new ideas tangible?

Have you ever done something that you thought might not be possible? Perhaps you completed a five-mile race or hit a grand-slam home run. Maybe you sang a solo or painted the walls and ceiling of a room. We often amaze ourselves by what we can accomplish. Most of our accomplishments begin with a simple question: "Is this possible?"

Someone once asked, "Is it possible to create a machine that will fly?" More recently, someone asked, "Is it possible to get to Mars?" Our history is one of responses to questions about what is possible.

We ask "Is it possible?" in all disciplines, including art. People who made images on cave walls asked this question. So did those who built enormous temples and cathedrals, created linear perspective, carved objects out of trees, and put oil paint into tubes and went outdoors to paint. All these artists probably wondered whether they could do what they dreamed of doing.

In the last half of the twentieth century, artists explored more possi-

bilities than ever before.

Communication became almost instant. New materials, techniques, and ways of reaching viewers became available. For example, Christo and Jeanne-Claude (Fig. 9–1a) used industrial fabrics and ropes for their wrapping projects. In what ways might their work and the work of other contemporary artists change people's ideas about art?

What's Ahead

- **Core Lesson** Discover how contemporary artists have expanded the concept of art.
- 9.1 Art History Lesson
 Learn about art developments since
 1950.
- 9.2 Elements & Principles Lesson
 Explore possibilities through looking at proportion and scale in artworks.
- 9.3 Global View Lesson
 Focus on the art of contemporary artists worldwide.
- 9.4 Studio Lesson
 Make an artwork that helps expand the definition of a book.

Words to Know

installation art earthworks maquette proportion scale caricature scroll fan concertina

Expanding the Possibilities of Art

Artists in the twentieth century wanted people to help them answer the question "What is art?" As this question became familiar to people throughout the world, artists explored the possibilities of answering it. They experimented with subject matter, media, point of view, size, location, and other traditionally defined art concepts.

A Twist on the Traditional

How many ways could art change? Artists thought about all different art forms and media. They began to see vast possibilities

for moving beyond familiar traditions. Painters changed the shape and size of their canvases. They designed huge paintings to fill the walls of a gallery. They experimented with ways of applying paint—pouring, dripping, and spraying paint became accepted techniques.

Sculptors expanded the ideas traditionally associated with their art form. They assembled found objects such as televisions, automobiles, umbrellas, and furniture. They constructed sculpture out of new and unusual materials such as industrial steel, plastic, and neon lights. Artists looked around, saw what was happening, and asked, "What else is possible?"

Fig. 9–2 How does Bartlett's work push the boundaries of what we traditionally consider a painting? Jennifer Bartlett, *Sea Wall* (detail), 1985.
Oil on 3 canvases, 84" x 369" (213.4 x 937.3 cm); houses and boats: wood and paint; sea wall: poured concrete and CorTen steel. Collection of artist.

Fig. 9–3 The artist suspended mattresses—rolled, tied, and decorated with mashed cakes—from the ceiling. Why might some people think that her work is about the lack of permanence in our society? Nancy Rubins, Mattresses and Cakes, 1993. 250 mattresses and cakes. Paul Kasmin Gallery, NY, New York.

New Approaches, New Materials

Artists played with what viewers expected to see. Don't you expect a painting to hang on the wall? Jennifer Bartlett and other artists made paintings that seem to spill from the wall onto the floor (Fig. 9–2). Don't you expect a sculpture to stand on a floor or pedestal? Nancy Rubins (Fig. 9–3) and other artists made sculptures that hung from the ceiling.

Advances in electronic media led artists to use video, lasers, and computer technology

Fig. 9–4 This artist used computer technology to create a condor moving on-screen. Each feather looks exactly like the parent bird. If you zoom in, you find that the feathers on these "feathers" also look just like the parent bird. And so do the feathers on the feathers on the feathers!

J. Michael James, Infinite Condors, 1994.

Digital image, still frame from animation of 3-D computer graphic sculpture. Courtesy of the 911 Gallery, Newtwonville, Massachusetts.

in their art. Instead of making traditionally silent, motionless art, more artists began to use sound, light, movement, interactive components, and other high-tech features in their work. Some contemporary artists explored the potential of computers, creating new and unusual artworks (Fig. 9–4).

New Audiences

Along with asking the questions "What is art?" and "How can art change?" artists asked: "Who is art created for?" They began

to look beyond the traditional art market toward a broader audience for their work. Some wanted the art viewer to be part of the artwork itself. This idea led to new kinds of experiences with art.

Fig. 9–5 This installation combines various art forms and media. It deals with political and personal identity issues of Caribbean island cultures. Antonio Martorell, *Blanca Snow in Puerto Rico*, 1997. 15' x 12' (4.6 x 3.7 m). Courtesy Hostos Center for the Arts & Culture. Photo by Frank Gimpaya.

Possibilities

New Art for Sites, **New Sites for Art**

Technology-based ways of creating art have resulted in new places for art and new ways of exhibiting it. For example, installation **art**—art created for a particular site—often requires a large space in which to be displayed. Instead of a traditional gallery space, an installation might be shown in a converted factory. The art might include sounds or projected images. Viewers might be asked to participate and alter the art.

In Blanca Snow in Puerto Rico (Fig. 9–5), Antonio Martorell presented an installation. He wanted to create a dialogue among the viewers. At the exhibit's opening the audience

was given play money to "bid" for sections of the island. Suddenly, in a moment totally unplanned, people began tossing the money from the balcony until the air resembled a snowstorm. Do you think this kind of art made a lasting impression on the viewer? Why or why not?

When an installation has been taken down, only photographs or videos remain to show us what it looked like. Twentieth-century artists challenged the idea that artworks must be permanent. They explored the possibility of creating works that don't last. They looked for new definitions of public art and saw the Internet as a place to display and create—art. What kinds of audiences can today's artists reach?

Contemporary artists might show their work outdoors, sometimes in urban areas or in places that are difficult to visit. Once outdoors, artists need to consider the way an artwork will respond to or fit in with the natural elements. Andy Goldsworthy creates artworks with natural materials outdoors and then photographs them (Fig. 9-6). After he leaves the site, he allows natural forces to determine what happens to his work.

Like Goldsworthy, other artists have created artworks that celebrate and otherwise bring attention to the natural environment. Artworks designed for particular outdoor places in nature are called **earthworks**. Like installation art, some earthworks depend on photographs or videos to allow audiences to view them.

Fig. 9-6 After Goldsworthy's sculptured forms are left alone and nature has run its course, only photographic documents remain. Which do you think is more important: the original work or the photograph? Why do you think so? Andy Goldsworthy, The coldest I have ever known in Britain/ as early/worked all day/reconstructed icicles around a tree/ finished late afternoon/catching sunlight, Glenn Marlin Falls, Dumfriesshire, 28 december 1995, 1995. Cibachrome print, 23" x 19" (58 x 48.3 cm) square. Galerie Lelong, New York,

New York. Courtesy of Private Collector, New York.

Making a Painting/Sculpture

Exploring Possibilities

Both Frank Stella and Miriam Schapiro (see below) pushed the possibilities of traditional painting into different directions. Each artist also blurred

the line between sculpture and painting by making the canvases into forms.

In this studio exercise, you will use cardboard and paint to make an artwork that explores the boundaries between sculpture and painting.

You Will Need

- sketch paper and pencil
- cardboard or foamcore
- scissors or X-acto knife
- glue and tape
- found objects
- tempera paints and brushes

Safety Note

Use extreme caution when using sharp tools to prevent cuts and accidents.

Try This

1. First decide what you want to explore with your artwork. Like Frank Stella, you may wish to focus on shapes and forms alone. Or like Miriam Schapiro, you may wish to convey a message about something you think is important.

2. Sketch your ideas. Decide what forms you will use. Will you make a painting that also seems to be a sculpture? Or a

sculpture that also seems to be a painting?

Fig. 9–7 What is a painting? Describe the ways that this artwork fits your definition of a painting. Frank Stella, *The Chase*, Second Day, 1989.

Mixed media, 101" x 229" x 50" (256.5 x 581.6 x 127 cm). Photograph by Steven Sloman. ©2000 Frank Stella/Artist Rights Society (ARS), New York.

Studio Background

Breaking Boundaries

In the late 1950s, Abstract artist **Frank Stella** painted huge geometric canvases with simple shapes, colors, and lines. In the 1970s, he began to "explode" his paintings into three dimensions. He used aluminum and Fiberglas™ to make multilayered organic forms and swirls. We usually think of Stella's works as paintings. But because they jut out from the wall or stand on the floor, we may also think of them as sculpture.

Miriam Schapiro shaped her paintings into recognizable forms such as hearts, fans, and houses. Throughout her career, she explored the roles, artistic work, and symbols associated with women. She

4. Paint your artwork when you are sure it is stable. If you wish, add found objects or other materials to help show your meaning.

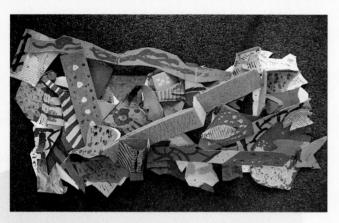

Fig. 9–8 Three students worked together to make this impressive work that measures over four feet long and hangs on the wall. Thinking about a major earthquake in Taiwan and the effect it had on the people living there, these students used their artwork to express the destruction of such an event. Nick Hampton, Rebakah Mitchell, Alexander Moyers Marcon, *Earthquake*, 1999.

Tempera, 33" x 52" (84 x 132 cm). Mount Nittany Middle School, State

College, Pennsylvania.

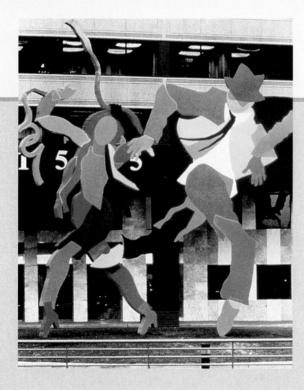

Check Your Work

Arrange the artworks most like sculptures in one area and those most like paintings in another area. Discuss the artworks with your classmates. Decide which ones are mostly about form and which ones represent an idea or message.

Sketchbook Connection

Plan two additional artworks. In each one, try to blur the boundaries between two art forms. For example, consider

printmaking and weaving, sculpture and jewelry-making, or graphic design and painting. Think about traditional and new approaches to each art form. Explore the possibilities.

Core Lesson 9

Check Your Understanding

1. In what ways was the twentieth century a time of exploring new possibilities in art?

2. Use two examples to tell how new technology has influenced contemporary artworks.

3. How have some contemporary artists challenged the expectations of their viewers?

4. How does *The Chase* (Fig. 9–7) blur the line between painting and sculpture?

put doilies, handkerchiefs, and quilt pieces traditionally made by them into her paintings. Simple human figures, often posed for dancing, also appeared. Her artwork *Anna and David* (Fig. 9–9) looks like a huge colored-paper cutout. Unlike Stella's forms, which move into and through space, this sculptural form is relatively flat—very much like a painting.

Fig. 9–9 Why would passersby consider this artwork a sculpture? What might cause them to think of it as a painting? Miriam Schapiro, *Anna and David*, 1987. Stainless steel and aluminum, 35 " x 39" x 9" (88.9 x 78.7 x 22.9 cm). Courtesy Bernice Steinbaum Gallery, Miami, Florida.

Art Since 1950

	1959 Krasner, <i>The Bull</i>		Lichtenstein, Little Big Painti	1985 Ing Puryear, Ol	d Mole
Surrealism page 259	Abstract Expressionism	Color Field	Pop Art		?
		1962 Frankenthaler, F	Rock Pond	1985 Scharf, Opulado Teeveona	1997 D.A.ST., Desert Breath

Most of the art movements you have studied in this book began in Europe. By the 1950s, though, New York had become the new art center of the world. Art styles began in the United States and spread throughout the world.

American artists brought new possibilities to their artworks. Like the artists of the early 1900s, they worked in many different styles and created a variety of art movements. Some artists experimented with exciting materials no one had used before. Other artists used traditional materials in new ways.

Today, artists continue to challenge what is possible in art. They search for ways to change people's ideas about art. They challenge how we see things and what we think of them. Their explorations create new kinds of art and make us wonder, "What's next?"

New Possibilities in Painting

: 1065

By the 1950s, artists were asking themselves, "What new things are possible in creating a painting?" Now that painters no longer had to show realistic scenes, they looked for other ways to change what people thought of as a "painting." Many tried using the traditional medium of paint in new ways. Others searched for new ways to show traditional subject matter.

Abstract Expressionism

Abstract Expressionist artists tried different ways of painting. Some dripped, poured, or splashed paint on a canvas. They concentrated

Fig. 9–10 Why do you think Abstract Expressionism was also called "action painting"? Lee Krasner, *The Bull*, 1959.
Oil on canvas, 77" x 70" (195.6 x 177.8 cm). Photograph courtesy of the Robert Miller Gallery, New York. ©2000 Pollack-Krasner Foundation/Artists Rights Society (ARS), New York.

on the action of creating a brushstroke. Look at the work in Fig. 9–10 by Lee Krasner, an Abstract Expressionist painter. Can you see some of the brushstrokes she used? Imagine you are the artist creating this large painting (it is over six feet tall). You would need to use long, sweeping strokes to cross the canvas. You would probably choose a large brush—maybe even the kind used for painting a house—to create the brushstrokes you see in Krasner's painting.

Color Field

Another group of artists also experimented with new ways to put paint on a canvas. The Color Field painters allowed paint to soak and seep into the canvas. In Fig. 9–11, Helen Frankenthaler poured paint onto the canvas and created fields, or shapes, of color. She used an idea from nature—a pond—for her painting. Then she simplified the scene to only large shapes of color.

Pop Art

Some artists wanted to change what artworks could show. Some of their subjects were soup cans, soda bottles, or other every-

Fig. 9–11 This artist lets paint seep into the canvas. What kind of shapes has she created with this technique? Helen Frankenthaler, *Rock Pond*, 1962.

Acrylic on canvas, 80" x 82" (203 x 208 cm). The Edwin and Virginia Irwin Memorial. ©Cincinnati Art Museum. © 2000 Helen Frankenthaler.

day objects. Because their subjects came from popular ("pop") culture, their movement was called Pop Art.

Pop artists worked in many different styles. Roy Lichtenstein created paintings

that looked like comic strips. Look at his work in Fig. 9–12. Can a brushstroke be a subject for a painting? How has this artist, and other Pop artists, opened up the possibilities for a painting?

Fig. 9–12 Compare this work to Fig. 9–10. Would you call this artwork an "action painting"? Why or why not? Roy Lichtenstein, *Little Big Painting*, 1965.

Oil and magna on canvas, 68" x 80" (172.7 x 203 cm). Whitney Museum of American Art, New York. Purchased with funds from the friends of the Whitney Museum of American Art. \circledcirc Estate of Roy Lichtenstein.

New Possibilities in Sculpture

Twentieth-century sculptors have also explored the possibilities of new techniques, materials, and places for their works. They have taken the art form of sculpture in new directions.

Some sculptors have used traditional materials in new ways. In Fig. 9–13, Martin Puryear used wood to create an abstract sculpture. Other artists, such as Kenny Scharf, combined different materials in one sculpture. In Fig. 9–14, Scharf chose unusual

materials to make into a sculpture: a TV set, toys, and jewelry. At first, a sculpture made of television sets was new and shocking. Today, many artists use them in their work. Why do you think they have become a common art material?

Four artists worked together to create the artwork you see in Fig. 9–15, *Desert Breath*. The artists moved sand to create coneshaped hills and holes in an Egyptian desert. This artwork is not meant to last. It is meant to change, and even disappear, as the desert winds blow over it. What do you think are possible materials for future artworks?

Fig. 9–13 Perhaps this sculpture reminds you of a mole, as the title suggests, or a bird's beak, or maybe something else. The artist used a simple abstract form to suggest many possible meanings. Martin Puryear, Old Mole, 1985.

Red cedar, 61" x 61" (154.9 x 154.9 cm); diameter: 34" (86 cm). Philadelphia Museum of Art: Purchased with gifts (by exchange) of Samuel S. White III and Vera White, and Mr. and Mrs. Charles C. G. Chaplin and with funds contributed by Marion Boulton Stroud, Mr. and Mrs. Robert Kardon, Mr. and Mrs. Dennis Alter, and Mrs. H. Gates Lloyd.

Scharf/Artists Rights Society (ARS), New York.

Fig. 9–14 This artist feels art should be fun. What other materials could he have used to make a "fun" sculpture? Kenny Scharf, *Opulado Teeveona*, 1985. Acrylic, jewels, toys on Sony trinitron TV with plastic pedestal, 56" x 17" x 16" (142 x 43.2 x 40.6 cm). Courtesy Tony Shafrazi Gallery, New York. Photo by Ivan Dalla Tana. Copyright Kenny Scharf. ©2000 Kenny

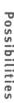

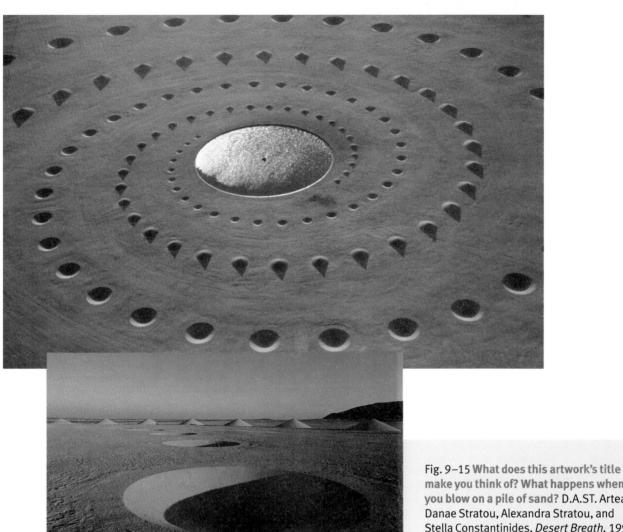

Studio Connection

Sculptures for public places are often selected by holding a competition. The sponsors of the project invite artists to sub-

mit their ideas for the sculpture. Many artists prepare a maquette, a small-scale model of what their final sculpture will look like.

Imagine that you are a sculptor hoping to win a competition for a work that reflects new directions in sculpture. Create a maquette of your sculpture designed for a public place. A maguette can be made of any material that suggests how the final sculpture will look. For example, if your sculpture were made of metal sheets, you might use cardboard for your maquette.

9.1 Art History

Check Your Understanding

- **1.** How did many painters in the last half of the twentieth century try to change what people thought of as "painting"?
- 2. Identify and distinguish among three important art movements of the last half of the twentieth century.
- **3.** How did some sculptors of the last half of the twentieth century explore the possibilities of materials for sculpture?
- **4.** Why do you think there have been so many styles of art in the last half of the twentieth century?

Proportion and Scale

There are many ways to answer the question "What is possible in art?" Artists in the twentieth century developed some answers by experimenting with proportion and scale. They invented ways to transform our relationship with space.

Some Pop artists asked, "What if I make a colossal monument out of an ordinary object?" Artists such as Red Grooms (Fig. 9–16) and Nek Chand (Fig. 9–17) seem to be asking, "How can I create humor or surprise by presenting unexpected scale and proportion?"

Using the language of art, we can talk simply about proportion and scale. We say artworks are life-size, monumental (much larger than life-size), or miniature (very small).

Looking at Proportion

Proportion refers to how a part of something relates to the whole. Our sense of proportion in art comes from the human body. Proportions can be normal and reflect what we see around us. They can also be exaggerated and distorted.

Look at Nek Chand's sculptures (Fig. 9–17). Which figures are proportioned differently than an actual human body? Which ones have the most exaggerated proportions?

Fig. 9–16 Red Grooms combines the styles of Pop Art and Expressionism. This scene is part of a large work about New York City. How does his choice of sizes affect your sense of scale? What are some clues to its humorous intent? Red Grooms, The Woolworth Building From Ruckus Manhattan (detail), 1975–76. Mixed media, 17' x 14' x 15' (5.2 x 4.3 x 4.6 m). Courtesy of the Marlborough Gallery, New York. Photograph by Richard L. Plaut, Jr. ©2000 Red Grooms/Artists Rights Society (ARS), New York.

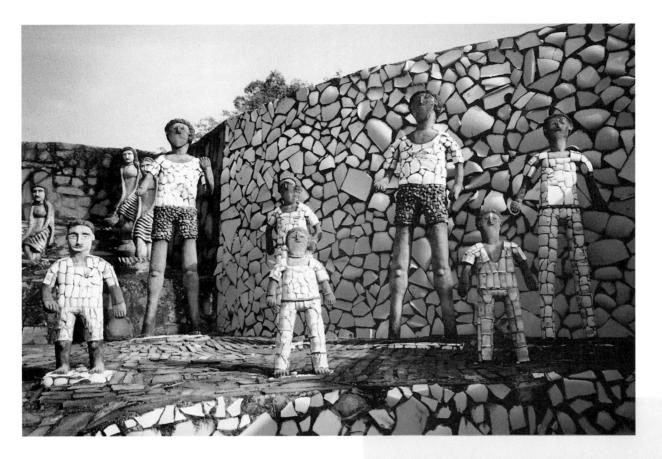

Looking at Scale

Scale is the size of an object compared to what you expect it to be. You do not expect to see a toothbrush bigger than a bed.

In *The Woolworth Building From Ruckus Manhattan* (Fig. 9–16), Red Grooms has presented the building's entrance in monumental scale as compared to its surroundings. Artists often change the normal size, scale, or proportion of things to show their importance.

9.2 Elements & Principles

Check Your Understanding

- **1.** What does proportion refer to?
- **2.** Why might you change the scale of something?

Fig. 9–17 These figures are one small part of a sculpted environment that occupies more than twenty-five acres. *Rock Garden* includes fountains, waterfalls, and giant arches with swings to ride on. Considered an "outsider" artist because he lacks formal training, Nek Chand created his artworks from stones and discarded industrial materials. How do these figures make you feel? Nek Chand, *Rock Garden at Chandigarh*, 1983–1995. Concrete, broken tile and other items, stone, and brick. Photo by Carl Lindquist.

Studio Connection

By "stretching" the possibilities of portraits, artists create caricatures —exaggerations— of people, animals, or

objects. Draw a portrait caricature of yourself or a famous person. First exaggerate the proportions of the whole shape of head and hair. Then draw the most prominent feature or features, exaggerating the proportions. If the eyes look small in reality, make them very small in the caricature. If the chin is wide, make it very wide. See page 300, Portfolio, for an example of a caricature drawn by a student.

Global Possibilities

You have probably heard the phrase, "The possibilities are endless." This is particularly true in today's world. Lots of possibilities can be a good thing. You can make any kind of art and use many different materials. But sometimes, you might feel that there are too many possibilities. You might wonder where to begin, where to look for inspiration, or what materials to use.

Artists throughout the world have also been faced with these challenges. As you have learned in this book, artists look for

ways to send messages, communicate ideas, teach lessons, and connect with nature. Sometimes, their artworks show a link with the past; other times, they break free from it. But each time, artists explore new possibilities for creating art that is meaningful to their lives and to ours.

Notice the variety of artworks by living artists from around the world on these pages. As you look at the artworks, think of what you have learned about art so far. How do some of these artists connect to past art traditions? What new techniques have they used? What possibilities do you think they are exploring?

Studio Connection

cussed elsewhere in the book. It may have roots in Europe, Africa, North America, or a combination of several cultures. Perhaps you have learned about your cultural heritage from the people you live with.

Create a work of art in any medium you have already worked with in this book. Your challenge is to explore new possibilities with the medium. In this work, try to express something about your cultural heritage. Research the artistic traditions of your cultural heritage. Play with the past as you envision possibilities for the future.

Fig. 9–18 What patterns and images do you see in this artwork? Look back to Chapter 1, Lesson 3. Do you see similar images in the artworks on these pages? Zerihun Yetmgeta, *Scale of Civilization*, Ethiopia, 1988. Mixed media on wooden looms, 39 ³/s " x 24 ³/s" (100 x 62 cm). Inv. 90-312 959, Staatliches Museum fur Volkerkunde, Munich.

Fig. 9–19 Why do you think the artist chose animal bones for her artwork?

Does her choice of media show a break with past traditions? Yolanda Guiterrez, Umbral (Threshold), Mexico, 1992.

Cow jaw bones and wood, installation of variable dimensions: 26 elements of 3 ¹⁵/16" x 23 ⁵/8" x 11 ⁷/8" (10 x 60 x 30 cm) each. Galerie Yvonamor Palix, Paris.

Fig. 9–20 This artist calls her paintings "landscapes of the mind." How is she exploring new possibilities for showing a landscape? Jaune Quick-to-See Smith, *Tree of Life*, 1994.

Oil, collage, mixed media, 60" x 100" (152 x 254 cm). Courtesy of the artist and the Jan Cicero Gallery.

Fig. 9–21 This artist combines traditions of India, her native country, with ideas about life in America. She has explored new approaches to the traditional Indian art of miniature painting.

Shahzia Sikander, *Ready to Leave Series II*, 1997. Vegetable and watercolors on handmade paper, 7 ³/₄" x 6 ¹/₄" (19.7 x 15.9 cm). Collection of Richard and Lois Plehn, New York. Courtesy of Hosfelt Gallery and the artist.

Fig. 9–22 How has this artist explored the possibilities of new spaces for artworks? How does his choice of a site help him communicate something about place? Jae Hyun Park, *Toward Unknown Energy*, 1998.

Resin, hempen cloth, and pigments, 85" x 66" x 27" (215.9 x 167.6 x 68.6 cm).

Represented by CS Fine Art, Montrose, CA.

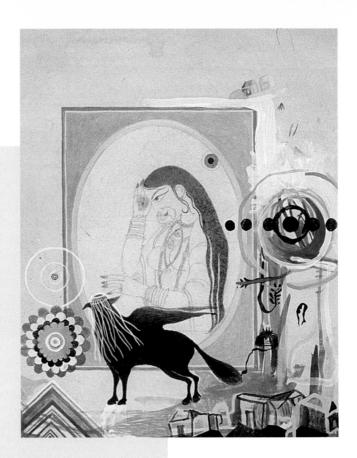

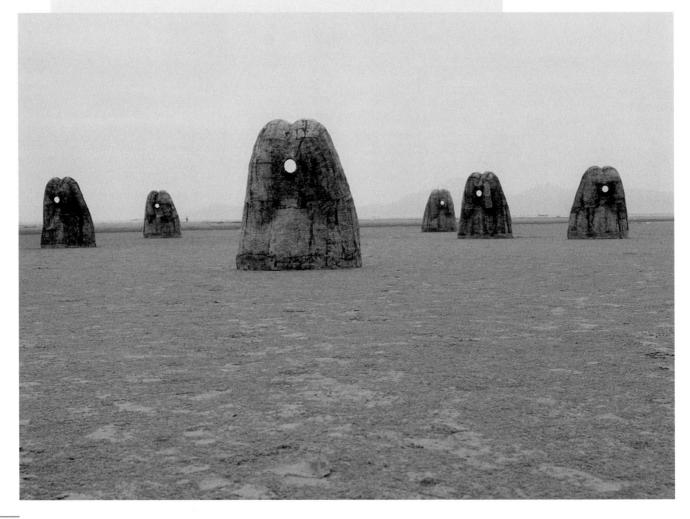

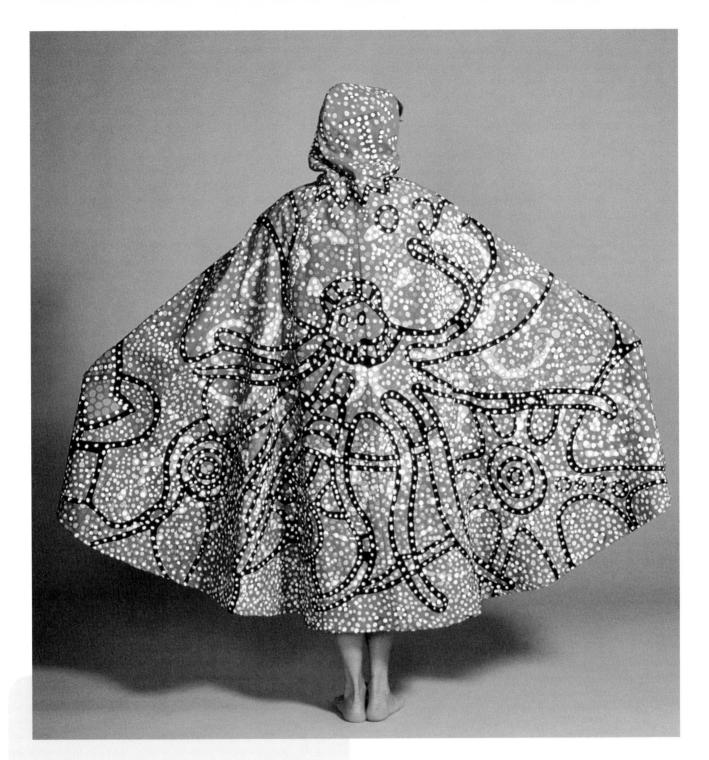

Fig. 9–23 Do the patterns on this cape remind you of any examples of Oceanic art you studied in Chapter 6? What message do you think this artist was trying to send? Bronwyn Bancroft, *Cycle of Life Cape*, 1987.

Australian Museum/Nature Focus. Photo by Carol Bento.

9.3 Global View

Check Your Understanding

- **1.** What big issues do artists all over the world seem to be concerned with?
- 2. What is meant by international style?
- **3.** Why is preservation of artistic heritage important?
- **4.** How can people approach art with an open mind?

Sculpture in the Studio

Making a Book

Create the Unexpected

Studio Introduction

When you hear the word "book," what do you think of? You probably think of the kind that's bound with front

and back covers. But imagine seeing a book that unrolls as one sheet of paper. Or one that opens like an accordion or a hand-held fan. Or one that is designed simply as an artwork: a sculpture, painting, or collage. All these can be thought of as books, too.

In this lesson, you will break the bounds of what you think of as a book. Pages 296–297 will show you how to do it. You will see several ways to make a book. Then you will choose a format—scroll, concertina, or fan—and create a book of your own.

Fig. 9–24 A concertina tunnel book can contain many layers, like a little stage. Windows and an open door invite the viewer to look inside. "I got the idea for the book I made by staring at my dogs as they begged for food. When I was in the process of making my book, I was thinking how bad it looked, but now that it's done, I love it!" Amy Baumbach, Who's at My Door, 1999. Colored pencil, 7" x 9" (18 x 23 cm). Camel's Hump Middle School, Richmond, Vermont.

Studio Background

Pushing the Bounds of Books

While the kind of book you're familiar with is seen most often on library shelves, there are other older forms of books that are still in use today.

A **scroll** is a long strip of paper or other material that can be written or drawn on and then rolled up. A rod attached to one or both ends of the scroll makes use and storage easy.

A **fan** is made like a hand-held fan. Its pages—usually strips of paper—are loosely bound at one end. With a fan, you can see any of the pages or a combination of them at one time. The order of the pages is not important.

A simple **concertina** can also be made from a long strip of paper. Only this time, the paper is folded accordion style to create the pages. Because the con-

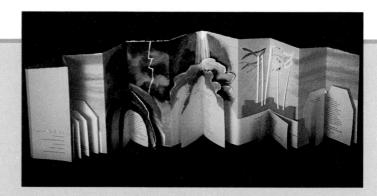

Fig. 9–25 This artist has sewn booklets made from different papers into a concertina book. Notice how each booklet is a different size and shape. Claire Van Vliet, *Dido and Aeneas*, 1989. Handmade paper, 14 $\frac{3}{8}$ " x 70 $\frac{3}{4}$ " x 1" (37.1 x 179.7 x 2.5 cm), when closed. Paper made at MacGregor/Vinzani, Maine. Courtesy of the artist.

certina is a continuous strip, you can show a single continuous idea on all of the pages or individual ideas on single pages.

Possibilities and Ideas

Scroll

- Create a handscroll to be unrolled and viewed a little at a time. Or create a hanging scroll to be viewed all at once.
- A scroll can be horizontal or vertical, wide or narrow.
- Wrap the ends of a scroll sheet around sticks or twigs, dowels, spools, crayons, straws, or other rod-shaped objects.
- Tie the rolled-up scroll with a cord. Or create a container for it from a film canister, cardboard tube, bottle, or empty flashlight.

Fan

- Make each page a different shape.
- Add different borders to each page.
- Try making a hole in the middle of the pages for a double fan. Or create an irregular fan shape by making a hole a little higher on each page than the previous page.
- Bind the pages together with a nut and bolt, a colored ribbon, a pipe cleaner, a key ring, or some other imaginative object.

Concertina

- Glue several folded sheets together end-to-end for a long concertina.
- Add pockets to the page panels and fill them with pictures, leaves, secret messages, whatever you can think of. Write special words on the panels.
- Gather together several sheets of paper and fold them in half. Stitch the little "booklets" into the concertina folds.
- Fold a narrow concertina for a spine. Attach single pages to the panels created by the folds.

Fig. 9–26 In this scroll, the artist shows us the history and rituals from an imaginary world. Notice how there do not appear to be any words. What art techniques has the artist used to create the images? Inga Hunter, *Imperium Scroll*, 1994. Collage on canvas with a case; etching, woodblock, and linoleum prints; paint and mixed media, 5 ½ x 39 ½ (13 x 100 cm). Courtesy of the artist.

Fig. 9–27 Each of these fan books has a distinct theme. Will your fan book have a theme? Or will it break the bounds of theme? Jean Kropper, 1999.

Left: Faces of the World; Right: Go Fish.

Left: Collage and beads, 6 ½ " x 2 ¾" (15.9 x 7 cm).

Right: Collage, paint chip samples, and beads, 4 ¾" x 1 ¾4" (10.8 x 4.5 cm). Courtesy of the artist.

Sculpture in the Studio

Making Your Book

You Will Need

- papers and fabrics
- art media and tools
- · crafts materials
- small found objects
- binding materials and tools
- scissors
- glue
- tape
- stapler

Try This

- **1.** Think of a subject for your book. You can make a book about nature, history, fantasy, alphabets, numbers, stars and planets, a story, dreams, poetry, photographs, religion, culture, anything you want.
- **2.** Choose a format for your book: scroll, concertina, or fan. Which format will show your subject the best? How can you break the bounds of the format?

scroll

concertina

- 3. Sketch your ideas. Think of your book as an artwork. Make it as creative and surprising as you can! How big or small will it be? Will it be tall and thin or short and wide? How will the pages be shaped? What will you show on each page? What will your book cover or scroll container look like?
- **4.** As you plan your book, think about materials. What kind, color, and texture of paper will you use? Will you use the same paper on every page or will each be different? Will you tear or cut the edges? What will you make the cover with? What will you bind the book with?

- **5.** When you're happy with your design, start making your book. Carefully create each page or scroll section. Design a cover or container that fits the subject.
- 6. Bind and finish your book.

Check Your Work

Get together with a few classmates, exchange books, and spend some time looking through them. Then talk about each book separately. How do the subject and design surprise the reader? For example, a book might be designed to open in a unique way, or its words or images might appear in an unexpected order.

Sketchbook Connection

When artists plan an illustrated story or a film, they often create a *storyboard*—a sequence of pictures and

words that becomes a "map" for the finished piece. Think of a story you're familiar with or make one up. Create a storyboard that can then become the plan for a book.

Computer Option

Make an animated scroll using multimedia software. Your extraordinary scroll might unroll to reveal pictures,

words, and sounds. Think of ways to surprise the viewers of your animated scroll. Who will see your scroll? What possibilities exist?

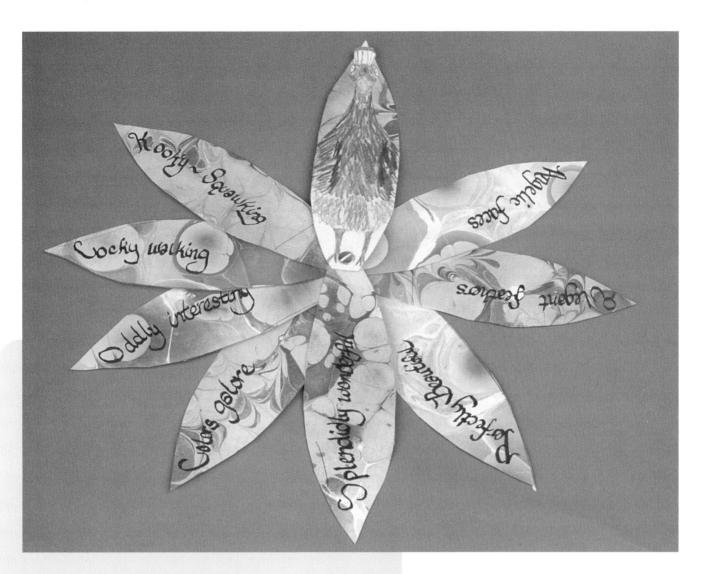

Fig. 9–28 Unusual shapes, calligraphy, and a circular format make this fan book a creative departure from the ordinary. Words that describe the peacock, such as "cocky walking" and "elegant feathers," are written on each tailfeather.

Amanda Hebert, *Peacocks*, 1999.

Marblized paper, colored pencil, calligraphy ink, 9" (23 cm) long, closed. Camel's Hump Middle School, Richmond, Vermont.

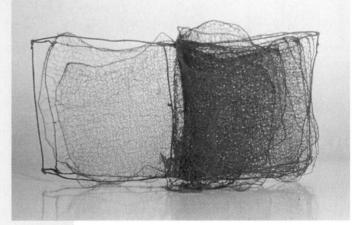

Connect to...

Daily Life

What was your first experience with a computer? Perhaps it was the use of an early version of a hand-held game or a TV remote control. The technological advances in just your lifetime have been tremendous and speedy, possibly catching your parents off-guard and looking to you for help.

How many **computer devices** do you think you see or use in your daily life? Make a list of those you notice throughout one day. Since many of us take computers for granted, you might be surprised by some of your findings. Remember to include wireless telephones, all

Fig. 9–30 Jim Borgman, *Cincinnati Enquirer* ©1998. Reprinted with special permission of King Features Syndicate.

kinds of remote controls, CD and tape players, clocks, ATMs, and automatic thermostats. Which of these could you least live without? What new possibilities of computer use might be achieved in your future?

Other Arts

Theater

Similar to visual artists' asking "Is it possible?" **theater artists ask "What if ...?"** To get an idea for a play, a playwright might ask "What if ...?": What if a visually impaired woman overheard the planning of a crime? What if the guests started disappearing from a weekend party?

Actors might ask "What if...?" to figure out how to portray a particular character: What if this character used his hands a lot while talking? What if this character had a funny skip as she walked? By asking "What if ...?", theater artists explore possibilities from which they can make artistic choices.

For a scene in a play, create at least three possible story lines by asking a "What if ..." question. Write each idea on a separate slip of paper. Put your slips of paper into a bag along with those of your classmates.

Working in groups of four, pick a paper from the bag, and create a scene based on that idea. Take time to plan the scene so that it has a clear beginning, middle, and end. Rehearse the scene several times.

Perform the scene, and ask classmates to complete the original "What if..." question.

Fig. 9–31 These students are improvising a scene from a Cherokee legend. What might be the "What if ..." question behind this scene?
Photo courtesy of Carol Cain, Westside Magnet School, LaGrange, Georgia, 1999.

Other Subjects

Language Arts

You can buy **books in electronic form** and then read them on a personal or hand-held computer. Some people think that reading a book on an electronic device will eventually eliminate reading the old-fashioned way, from words printed on bound-together sheets of paper. What do you think will happen? Do you think you would miss reading a book that you can hold?

Science

Did you know that the age of the oldest people now living is about the same as that of the oldest people who lived 1000 years ago? How could that be possible? Due to better nutrition and health care, more people live longer than did people in the past, but the maximum life expectancy for humans remains between 100 and 110 years. What developments do you think will increase life expectancy?

Genetic engineering may offer the possibility of **extending the human life span.** What ethical, religious, and legal problems might this bring?

Fig. 9–32 Maria Izquierdo, *Retrato de Mujer*, 1944. Watercolor on paper, 20" x 14" (50.7 x 35.5 cm). ©Christie's Images, Ltd,

Careers

Rapidly advancing computer technologies are creating new possibilities for **museum curators**. Generally, curators are art historians, experts in a particular period or style of art who do scholarly research and writing. They also make recommendations for the purchase of artworks, develop traveling exhibitions, and stay informed of developments in their area of expertise. Because of technology, however, curators must now expand these skills to apply to the Internet. What specific skills do you think museum curators now need to stay current with technology?

Internet Connection

For more activities related to this chapter, go to the

Davis website at www.davis-art.com.

Portfolio

"I learned that my heritage is very different from others. I looked at some African designs before picking the boy. I painted him like myself. I wanted my pot to mean that my kingdom at night is very calm and motionless." Jonathan Nickerson

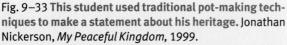

Low-fired clay, painted with acrylic and sealed with a medium gloss polymer, $5" \times 4" (13 \times 10 \text{ cm})$. Sweetwater Middle School, Sweetwater, Texas.

Fig. 9–34 When planning a maquette sculpture for a public place, this student thought of a dragon. He pictured it "in a mini golf course. It is supposed to be one of the obstacles for the holes." Josh Gross, *Dragon*, 1999. Clay, acrylic paint, 8" (20 cm) long x 3.5" (9 cm) tall. Plymouth Middle School, Plymouth, Minnesota.

"We were to study a student's face and look for one major characteristic. When I drew my caricature, I was supposed to make that feature stand out. I liked using my sense of humor in drawing. But creating caricatures isn't so easy because you have to be sensitive to the feelings of the person you are drawing." Elizabeth Miles

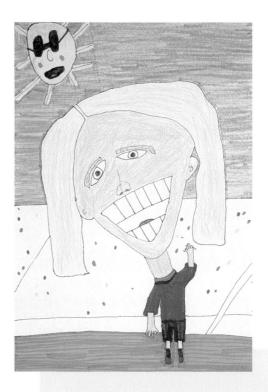

Fig. 9–35 Elizabeth Miles, *Untitled*, 1999. Marker, colored pencil, 12" x 18" (30 x 46 cm). Avery Coonley School, Downers Grove, Illinois.

Chapter 9 Review

Recall

What are two ways that sculptors explored possibilities in the last half of the twentieth century? (example below)

Understand

Explain how the impact of mass communication in our global village has affected the look of art around the world at the end of the twentieth century.

Apply

Use a small, discarded, ordinary object—such as a paper clip, old spoon, golf ball, toy car—as the basis for a public sculpture. Alter the object in some way, mount it on a base, and display it within a diorama to give a sense of the new proportion and scale.

Analyze

Make a collection of editorial cartoons from newspapers and magazines. Analyze how the artists have manipulated proportion and scale to make their points.

For Your Portfolio

By studying your portfolio entries, you can see your growing ability to create artworks. To see your improve-

ment in presenting meaningful themes, choose four portfolio artworks from among the theme chapters (1–9). For each piece, write a paragraph that explains why the piece is a good example of focus on a theme.

Synthesize

Compose a poem, or rap, about the many different art styles that emerged in the last half of the twentieth century. Do research on several styles, identifying a major artist and characteristics of each style. Present your research findings through rhyme.

Evaluate

Pose the advantages and disadvantages of the globalization of art styles around the world from two perspectives: 1) We all live in a global village and readily move across cultural boundaries. 2) Every culture is unique and cultural traditions should be preserved.

For Your Sketchbook

Study the artworks in each chapter's Global View lesson. On a page in your sketchbook, draw a simple object,

such as an apple, in the style of each global area.

Acknowledgments

We wish to thank the many people who were involved in the preparation of this book. First of all, we wish to acknowledge the many artists and their representatives who provided both permission and transparencies of their artworks. Particular thanks for extra effort go to Michael Slade at Art Resource, The Asian Art Museum, Roberto Prcela at The Cleveland Museum of Art, Anne Coe, Kenneth Haas, Charles McQuillen, Paul Nagano, Claes Oldenburg/Coosje Van Bruggen Studio, Bonnie Cullen at The Seattle Art Museum, and Bernice Steinbaum.

For her contributions to the Curriculum and Internet Connections, we wish to thank Nancy Walkup. For contributing connections to the performing arts, we thank Ann Rowson, Kathy Blum, and Lee Harris of the Southeast Institute for Education in the Arts. We offer special thanks for the invaluable research assistance provided by Kutztown University students Amy Bloom, Karen Stanford, and Joel Frain and the staff at Kutztown University Library. Abby Remer's and Donna Pauler's writing and advice were greatly appreciated. Sharon Seim, Judy Drake, Kaye Passmore and Jaci Hanson were among the program's earliest reviewers, and offered invaluable suggestions. We also wish to acknowledge the thoughtful and dynamic contributions made to the Teacher's Edition by Kaye Passmore.

We owe an enormous debt to the editorial team at Davis Publications for their careful reading and suggestions for the text, their arduous work in photo and image research and acquisition, and their genuine spirit of goodwill throughout the entire process of producing this program. Specifically, we mention Colleen Strang, Jane Reed, Mary Ellen Wilson, Nancy Burnett, and Nancy Bedau. Carol Harley, our consistently upbeat "point person" on the project, provided thoughtful and substantive assistance and support.

Our editors, Claire Golding and Helen Ronan, carefully guided the creation of the program, faithfully attending to both its overall direction and the endless stream of details that emerged en route to its completion. We thank them for their trust and good faith in our work and for the spirit of teamwork they endorsed and consistently demonstrated.

For his trust in us, his vision and enthusiasm for the project, and for his willingness to move in new directions, we thank Wyatt Wade, President of Davis Publications.

Although neither of us has had the privilege of being her student in any formal setting, we owe our grounding in the theory and practice of art education to the scholarship of Laura Chapman. She has been both mentor and friend to each of us throughout the years and especially in this project. We thank her for her loyal support and for providing us the opportunity to continue her work in art curriculum development in this program.

We offer sincere thanks to the hundreds of art teachers who have inspired us throughout the years with their good thinking and creative teaching. We also acknowledge our colleagues at Kutztown University, Penn State University, Ohio State University and other institutions who have contributed to our understanding of teaching and learning.

Finally, we wish to thank our families, especially Adrienne Katter and Deborah Sieger, who have provided loving support and balance in our lives during the preparation of this book.

Eldon Katter Marilyn Stewart

Educational Consultants

Numerous teachers and their students contributed artworks and writing to this book, often working within very tight timeframes. Davis Publications and the authors extend sincere thanks to:

Louisa Brown, Atlanta International School, Atlanta, Georgia Monica Brown, Laurel Nokomis School, Nokomis, Florida

Doris Cormier, Turkey Hill Middle School, Lunenburg, Massachusetts

Cappie Dobyns, Sweetwater Middle School, Sweetwater, Texas

Reginald Fatherly, Andrew G. Curtin Middle School, Williamsport, Pennsylvania

Donna Foeldvari, Reading-Fleming Middle School, Flemington, New Jersey

Diane Fogler, Copeland Middle School, Rockaway, New Jersey

Carolyn Freese, Yorkville Middle School, Yorkville, Illinois

Cathy Gersich, Fairhaven Middle School, Bellingham, Washington

Connie Heavey, Plum Grove Junior High School, Rolling Meadows, Illinois

Maryann Horton, Camel's Hump Middle School, Richmond, Vermont

Craig Kaufman, Andrew G. Curtin Middle School, Williamsport, Pennsylvania

Darya Kuruna, McGrath School, Worcester, Massachusetts

Karen Lintner, Mount Nittany Middle School, State College, Pennsylvania Betsy Logan, Samford Middle School,

Auburn, Alabama

Publisher: Wyatt Wade

Editorial Directors:

Claire Mowbray Golding, Helen Ronan

Editorial/Production Team: Nancy Burnett, Carol Harley, Mary Ellen Wilson

Editorial Assistance:

Laura Alavosus, Frank Hubert, Victoria Hughes, David Payne, Lynn Simon

Illustration

Susan Christy-Pallo, Stephen Schudlich

Acknowledgments/Artist Guide

Artist Guide

Sallye Mahan-Cox, Hayfield Secondary School, Alexandria, Virginia Patricia Mann, T. R. Smedberg Middle School, Sacramento, California Deborah A. Myers, Colony Middle School, Palmer, Alaska Gary Paul, Horace Mann Middle School, Franklin, Massachusetts Lorraine Pflaumer, Thomas Metcalf School, Normal, Illinois Sandy Ray, Johnakin Middle School, Marion, South Carolina Amy Richard, Daniel Boone Middle School, Birdsboro, Pennsylvania Connie Richards, William Byrd Middle School, Vinton, Virginia Katherine Richards, Bird Middle School, Walpole, Massachusetts Susan Rushin, Pocono Mountain Intermediate School South, Swiftwater, Pennsylvania Roger Shule, Antioch Upper Grade, Antioch, Illinois Betsy Menson Sio, Jordan-Elbridge Middle School, Jordan, New York Karen Skophammer, Manson Northwest Webster Community School, Barnum, Iowa Evelyn Sonnichsen, Plymouth Middle School, Plymouth, Minnesota Ann Titus, Central Middle School, Galveston, Texas Sindee Viano, Avery Coonley School, Downers Grove, Illinois Karen Watson-Newlin, Verona Area Middle School, Verona, Wisconsin Shirley W. Whitesides, Asheville Middle School, Asheville, North Carolina Frankie Worrell, Johnakin Middle School, Marion, South Carolina

Photo Acquisitions: Colleen Strang, Jane Reed, The Visual Connection, Mary Ellen Wilson, Rebecca Benjamin

Student Work Acquisitions: Nancy Wood Bedau

Design: Douglass Scott, Cara Joslin, WGBH Design

Manufacturing: Georgiana Rock, April Dawley

Affandi (ah-FAHN-dee) Indonesia. 1907-1991 Anasazi culture (ah-nah-SAH-zee) US Anguissola, Sofonisba (ahn-gwee-SOHlah, so-fahn-EES-bah) Italy, 1527-1625 Anthemius of Tralles (an-tem-ee-us of TRA-less) Turkey, c.474-c.534 Asante culture (ah-sahn-tee) Ghana Atget, Eugène (aht-zhay, oo-zhen) France, 1857-1927 Aztec culture (AZ-tek) Mexico Balla, Giacomo (BAHL-lah, JAH-komo) Italy, 1871-1958 Bancroft, Bronwyn (BANG-kroft, BRAHN-win) Australia, b. 1968 Bartlett, Jennifer US, 1941 Bayer, Herbert (BUY-ur, HUR-burt) Austria, 1900-1985 Bearden, Romare (BEER-dun, ro-MAIR) US, 1912-1988 Benin culture (beh-NEEN) Nigeria Bernini, Gianlorenzo (bair-NEE-nee, jon-loe-REN-zoh) Italy, 1598-1680 Besler, Basil (BAYZ-ler, BAH-zel) Germany, 1561-1629 Bete culture (be-tay) Ivory Coast Boffrand, Germain (BOHF-frahnd, zher-men) France, 1667-1754 Bonheur, Rosa (bon-ER, roh-zah) France, 1822-1899 Brancusi, Constantin (BRAN-koo-zee, KON-stahn-teen) Rumania, 1876–1956 Bravo, Claudio (BRAH-vo, KLAU-deeo) Chile, b.1936 Bruegel, Pieter (BRUE-gul, PEE-tehr) Flanders, c.1525-1569 Burson, Nancy US, b.1948 **Cahuilla culture** (ke-WEE-ah) California, US Canal, Giovanni Antonio (known as Canaletto) (kah-NAHL, jo-VAHN-nee ahn-TON-yo) Italy, 1697-1768 Cassatt, Mary (kuh-SAT, MAIR-ee) US, Cézanne, Paul (say-ZAHN, pol) France, 1839-1906 Chagall, Marc (sha-GAHL, mark) Russia, 1887-1985 Chand, Nek (tchand, nek) India, 21st

Chapman, Neil US, b.1950

France, 1699-1779

Chardin, Jean-Baptiste Siméon (shar-

DA, zhahn-bah-TEEST see-may-OHN)

Chen, Georgette (tchen, jor-JET) Singapore, 1907-1993 Cherokee culture (CHER-eh-kee) US Chespak, Ron US, b.1960 Choctaw culture (chahk-taw) US Christo and Jeanne-Claude (KREEStoh, ZHUN-klohd) Bulgaria and Morocco, both b.1935 Coe, Anne US, b.1949 Colima culture (ko-lee-ma) Mexico Constable, John England, 1776–1837 Courbet, Gustave (koor-BAY, GUEWStahv) France, 1819-1877 Dali, Salvador (DAH-lee, SAHL-vahdor) Spain, 1904-1989 Dan culture Ivory Coast, Liberia D.A.ST. (Danae Stratou, b.1964; Alexandra Stratou, Stella Constantinides) Greece, 21st century Daumier, Honoré (DOHM-yay, OH-noray) France, 1808-1879 David, Jaques-Louis (da-veed, zhakloo-ee) France, 1748-1825 Degas, Edgar (deh-gah, ed-gahr) France, 1834-1917 Delacroix, Eugène (deh-lah-krwa, oozhen) France, 1798-1860 Delaunay, Sonia Terk (deh-lo-nay, SON-yah terk) France, 1885-1979 **Derain, André** (deh-ra, ahn-dray) France, 1880-1954 Dohachi, Ninnami (doe-ha-chee, ninna-mee) Japan, 1783-1855 **Dürer, Albrecht** (DUR-er AHL-brekt) Germany, 1471-1528 Edo culture (eh-DO) Nigeria Ernst, Max (airnst, mahks) Germany, 1891-1976 Escobedo, Helen (es-ko-VAY-tho, ay-LEN) Mexico, b.1936 Ferrata, Ercole (fair-RA-ta, AIR-ko-lay) Italy, 1610-1686 Finster, Howard US, b.1916 Flack, Audrey US, b.1931 Fogle, Clayton US, b.1956 Frade, Ramon (FRA-day, RA-mohn) Puerto Rico, 1875-1954 Frankenthaler, Helen (FRANG-kunthah-lur, HEL-un) US, b.1928 Friedrich, Caspar David (FREED-rik, KAS-par DA-vit) Germany, 1774–1840 Fumio, Kitaoka (foo-me-oh, kee-tahoh-ka) Japan, b.1918 Garza, Carmen Lomas (GAR-tha, CAR-

men LO-mahs) US, b. 1948

o) Spain, 1852-1916

Gaudí, Antonio (gow-dee, an-toh-nee-

Gauguin, Paul (go-GAN, pol) France, 1848–1903

Giselbertus (zhis-ul-BER-tus) France, 12th century

Goldsworthy, Andy England, b.1956 Graves, Nancy US, 1940-1995 Grofé, Ferde (Ferdinand Rudolph von Grofé) (GRO-fay, FAIR-day) US, 1892–1972

Grooms, Red US, b. 1937 Groover, Jan (GRU-vur, jan) US, b.1943 Gutiérrez, Yolanda (goo-tee-AIR-rez, yo-LAHN-da) Mexico, b.1970

Haas, III, Kenneth B. (hahs, ken-nuth) US, b.1954

Haida culture (hi-deh) British Columbia, Canada

Hammons, David US, b.1943
Harunobu, Suzuki (har-roo-NO-boo, soo-zoo-kee) Japan, 1725–1770
Haydon, Harold US, 1909–1994
Heem, Jan Davidsz de (haym, yahn DAH-vits deh) Holland, 1606–1684
Hepworth, Barbara England, 1903–1975

Hiroshige, Ando (hee-ro-shee-gay, ahndo) Japan, 1797–1858

Hnizdovsky, Jacques (hniz-DOFF-ski, zhak) US, b.1915

Höch, Hannah (hoek, HAHN-nah) Germany, 1889–1978

Hockney, David England, b.1937 Hokusai, Katsushika (ho-koo-sy, kahtsoo-shee-kah) Japan, 1760–1849

Holst, Gustav (holst, GOO-stahf) England, 1874–1934

Hooch, Pieter de (hoak, PEE-tehr duh) Holland, 1629–1684

Hopper, Edward US, 1882–1967 Hunter, Inga (HUN-ter, ING-ga) Africa, b.1938

Ife culture (EE-fay) Nigeria **Ikenobo, Sen'ei** (ee-ken-o-bo, sen-ayee) Japan, b.1933

Iktinus (ICK-tih-nus) Greece, active 450–420 BC

Inca culture (ING-keh) Peru Ingres, Jean-Auguste-Dominique

(aingr, zhahn-oh-goost-doe-mee-neek) France, 1780–1867

Isidorus of Miletus (iz-i-dor-us of mi-LAY-tus) Turkey, died c.540

Izquierdo, Maria (ees-KYER-doe, ma-REE-ah) Mexico, 1902–1955

James, J. Michael US, b.1946 Jefferson, Thomas US, 1743–1826

Kahlo, Frida (KAH-lo, FREE-dah) Mexico, 1907–1954

Kallikrates (ka-LI-cra-tees) Greece, 5th century BC

Kammeraad, Lori US, b. 1955 **Kauffmann, Angelica** (KAWF-mahn, an-GAY-le-kah) Switzerland, 1741–1807 **Kazuo, Hiroshima** (ka-zoo-oh, he-ro-she-ma) Japan, b.1919

Kelly, Ellsworth (KEL-ee, ELZ-wurth) US, b.1923

Kidder, Christine US, b. 1963

Koetsu, **Honami** (ko-way-tzu, ho-nah-mee) Japan, 1558–1637

Kollwitz, Käthe (KOHL-vits, KAY-teh) Germany, 1867–1945

Kongo culture (kahn-go) Congo Republic, Democratic Republic of the Congo, Angola

Krahn culture (krahn) Liberia **Krasner, Lee** (KRAZ-nur, lee) US, 1908–1984

Kropper, Jean US, 21st century **Kruger, Barbara** (KROO-ger, BAHR-buruh) US, b.1945

Kuba culture (koo-bah) Democratic Republic of the Congo

Kwakiutl culture (KWAH-kee-oo-tel) Canada

Lackow, Andy US, b. 1953 Lawrence, Jacob US, b.1917

Leonardo da Vinci (lay-oh-NAR-doh dah VIN-chee) Italy, 1452–1519 Leyster, Judith (LY-stir, YOO-deet)

Holland, 1609–1660

Lichtenstein, Roy (LICK-ten-stine, roy) US, 1923–1997

MacDonald-Wright, Stanton US, 1890–1973

Maori culture (mou-ree) New Zealand Martorell, Antonio (mahr-toh-REL, ahn-TON-yo) Puerto Rico, b.1939 Masaccio (ma-ZAHT-cho) Italy, 1401–c.1428

Matisse, Henri (mah-TEESS, ahn-REE) France, 1869–1954

Maya (my-ah) Mexico

McQuillen, Charles US, b. 1962 Melchior, Johann Peter (mel-kee-or, yohan pay-ter) Germany, 1747–1825

Memkus, Frank US, 1895–1965 Mendez, Leopoldo (MEN-des, lay-o-POL-do) Mexico, 1902–1969

Merian, Maria Sibylla (MAY-ree-ahn, mah-REE-ah SEE-be-lah) Germany, 1647–1717

Metsys, Quentin (met-seese, KWEN-tin) Netherlands, c.1465–1530

Metzelaar, L. (met-ze-lair) Indonesia, 20th century

Michelangelo Buonarroti (mee-kel-AN-jay-loh bwo-na-ROH-tee) Italy, 1475–1564

Mies van der Rohe, Ludwig (mees van der ROAH, LOOD-vig) Germany, 1886–1969 Millet, Jean-François (mee-lay, zhahnfran-swah) France, 1814–1875 Mimbres people (mim-brayz) New Mexico

Mitchell, Joan US, 1926–1992 Moche culture (mo-kay) Peru Monet, Claude (moh-nay, kload) France, 1840–1926

Moran, Thomas (muh-RAN, TOM-us) US, 1837–1926

Morisot, Berthe (mo-ree-zoh, bert) France, 1841–1895

Myron (MY-ron) Greece, 5th century BC **Nabageyo**, **Bruce** (na-ba-ge-yo)

Nahl, Charles Christian US, 1818–1878

Australia, b.1949

Nalo, Joe (na-lo) Papua New Guinea, 21st century

Natzler, Gertrude and Otto (NATZ-lur, ger-trood, ot-toh) Austria–US, 1908–1971 (Gertrude), b.1908 (Otto)

Navajo culture (NAV-ah-ho) Southwestern US

Nevelson, Louise (NEV-ul-sun, loo-EEZ) Russia, 1899–1988

Ninsei, Nonomura (nin-say, no-no-mura) Japan, died 1695

Nok culture (noek) Nigeria Nuu-Chah-Nulth culture (nu-chanuhlth) Canada

Okakoto (oh-ka-ko-toh) Japan, early 19th century

O'Keeffe, Georgia US, 1887–1986 Oldenburg, Claes (OLD-en-burg, klayss) Sweden, b. 1929

Ortakales, Denise (or-ta-KA-less) US, b. 1958

Paracas culture (pah-ROCK-us) Peru Park, Jau Hyun (park, jow-hyun) Korea, b.1960

Patrick, Alice US, 21st century **Peeters, Clara** (PAY-turs, KLAH-rah) Flanders, 1594–1657

Pei, I.M. (pay) China, b.1917 **Peláez, Amelia** (pay-LAH-es, ah-MEH-yah) Cuba, 1897–1968

Picasso, Pablo (pee-KAHS-so, PAHV-lo) France, 1881–1973

Pickering, Mary Carpenter US, 1831–1900

Piero della Francesca (PYAY-roh DEL-lah fran-CHES-kah) Italy, c.1410–1492

Popova, Liubov (puh-PO-vuh, lyu-BOF) Russia, 1889–1924

Praetorius, Michael (pray-TOR-ius, mic-HI-el) Germany, 1571–1621

Puryear, Martin (PUR-yeer, MAHR-tin) US, b.1941

Raphael (RA-fah-ell) Italy, 1483–1520 Rembrandt van Rijn (REM-brant van rhine) Netherlands, 1606–1669

Artist Guid

Renoir, Pierre-Auguste (ren-wahr, pyer oh-goost) France, 1841-1919 Ringgold, Faith US, b.1934 Rivera, Diego (re-VAY-rah, dee-AY-go) Mexico, 1886-1957 Robinson, Rene Australia, b. early 1960s Rossini, Gioacchino (roes-SI-ni, jo-AHK-ki-no) Italy, 1792-1868 Rubins, Nancy US, 20th century Saar, Alison (sahr, AL-e-sun) US, b.1956 Samuels, Jeffrey Australia, 20th century Savage, Augusta US, 1892-1962 Sayvid-Ali, Mir (sai-vid-ali, meer) Persia, active c.1525-1543 Schapiro, Miriam (shuh-PEER-oh, MEER-ee-um) US/ Canada, b.1923 Scharf, Kenny (sharf, KEN-nee) US, b.1958 Schiltz, Rand (shiltz, rand) US, b. 1950 Seurat, Georges (ser-rah, zhorzh) France, 1859-1891 Sewell, Leo (SOO-ull, LEE-oh) US, b.1945 Sheeler, Charles US, 1883-1965 Sikander, Shahzia (see-kan-der, shazia) Pakistan, b. 1969 Smith, Jaune Quick-to-See (smith, zhoan kwik-too-see) US, b.1940 Soami (so-ah-mi) Japan, c.1485-1525 Sonnino, Franca (sohn-NEE-no, frahnka) Italy, 21st century Sotatsu, Tawaraya (so-tat-su, ta-wa-raya) Japan, active 1620s-1640s Stahlecker, Karen US, b. 1954 Stella, Frank US, b.1936 Storm, Howard US, b. 1946 Teokolai, Maria (TAYO-ko-li, mah-reea) New Zealand, 21st century Tjangala, Keith Kaapa (jan-ga-la) Australia, 21st century Tooker, George US, b.1920 Toulouse-Lautrec, Henri de (too-looz low-trek, ahn-ree deh) France, 1864-1901 Turkana culture (tur-KA-na) Kenya Turner, J.M.W. England, 1775-1850 Utamaro, Kitagawa (oo-ta-ma-roh, kih-

Toulouse-Lautrec, Henri de (too-looz low-trek, ahn-ree deh) France, 1864–1901

Turkana culture (tur-KA-na) Kenya Turner, J.M.W. England, 1775–1850

Utamaro, Kitagawa (oo-ta-ma-roh, kihta-ga-wa) Japan, 1753–1806

Van Brekelenkam, Quirijn (fahn BREK-len-kahm, kee-rhine) Netherlands, 1620–1669

Van Bruggen, Coosje (fahn bruhk-ken, coo-sia) Netherlands, b. 1942

Vandenberge, Peter (VAN-den-berg) US, b. 1939

van Gogh, Vincent (vahn GO, VIN-sent) Holland, 1853–1890

Van Vliet, Claire (vahn vleet, clair) US, b.1933 Velázquez, Diego (vay-LAHS-kess, dee-AY-go) Spain, 1590-1660 Vermeer, Jan (ver-MAIR, yahn) Holland, 1632-1675 Vigee-Lebrun, Marie Elizabeth (veezhay leh-brun, mah-ree ay-lee-sah-bet) France, 1755-1842 Voisin, Charles (vwah-ZEN, sharl) France, 1685-1761 von Brusky, Sonia (von BRU-ski) Brazil, 21st century WalkingStick, Kay US, b.1935 Waring, Laura Wheeler US, 1887–1948 Watler, Barbara W. US, b.1932 Weston, Edward US, 1886–1958 Winsor, Jackie Canada, b.1941 Wright, Frank Lloyd US, 1867–1959 Yaure peoples (yaw-ray) Ivory Coast **Yepa, Filepe** (YAY-pah, fee-lee-PAH) Jemez Pueblo, New Mexico, early 20th Yetmgeta, Zerihun (YET-m-geta, ZEHRhun) Ethiopia, b. 1941 Ying, Ch'iu (ying, chee-yoo) China, c.1510-1551 Yoruba culture (YOH-roo-bah) Nigeria Yu'pik (Inuit) culture (YOO-pik) US and Siberia **Zhi, Lu** (she, loo) China, 1496–1576 Zuni (zoo-nee)New Mexico

World Map

The best way to see what the world looks like is to look at a globe. The problem of showing the round earth on a flat surface has challenged mapmakers for centuries. This map is called a Robinson projection. It is designed to show the earth in one piece, while maintaining the shape of the land and size relationships as much as possible. However, any world map has distortions.

This map is also called a *political* map. It shows the names and boundaries of countries as they existed at the time the map was made. Political maps change as new countries develop.

Key to Abbreviations

ALB. Albania AUS. Austria B.-H. Bosnia-Hercegovina BELG. Belgium CRO. Croatia CZ. REP. Czech Republic **EQ. GUINEA Equatorial Guinea** HUNG. Hungary LEB. Lebanon LITH. Lithuania LUX. Luxembourg MAC. Macedonia NETH. **Netherlands** RUS. Russia SLOV. Slovenia SLVK. Slovakia SWITZ. **Switzerland** YUGO. Yugoslavia

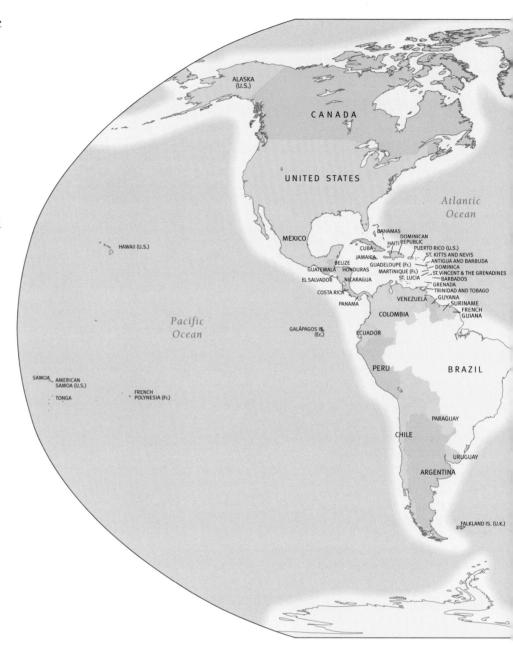

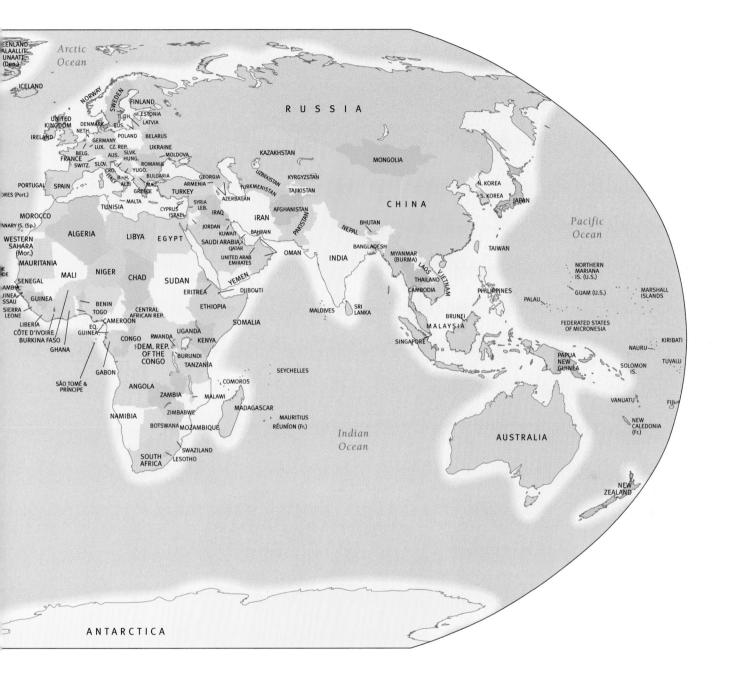

Color Wheel

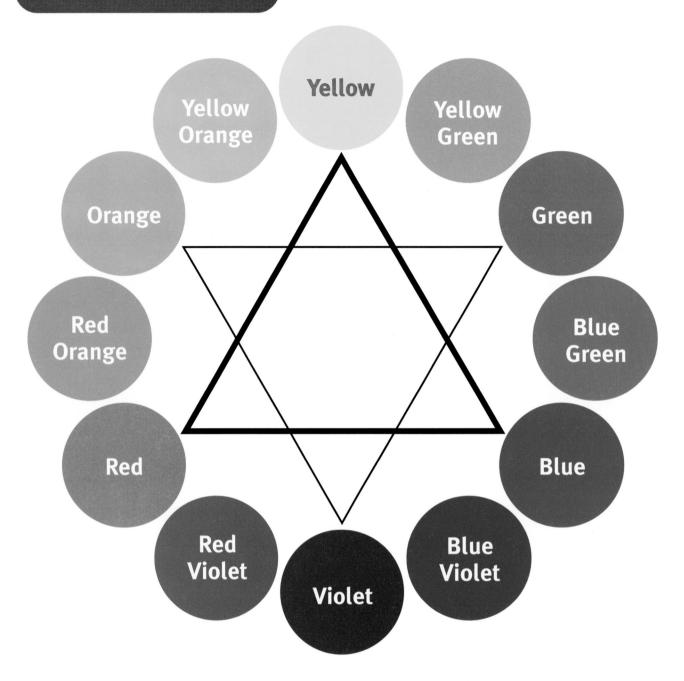

For easy study, the colors of the spectrum are usually arranged in a circle called a **color wheel**. Red, yellow, and blue are the three **primary colors** or hues. All other hues are made by mixing different amounts of these three colors.

If you mix any two primary colors, you will produce one of the three **secondary colors**. From experience, you probably know that red and blue make violet, red and yellow make orange, and blue and yellow make green. These are the three secondary colors.

The color wheel also shows six intermediate colors. You can create these by mixing a primary color with a neighboring secondary color. For example, yellow (a primary color) mixed with orange (a secondary color) creates yellow-orange (an intermediate color). Mixing the primary and secondary colors creates the six intermediate colors shown. Mixing different amounts of these colors produces an unlimited number of hues.

Bibliography

Aesthetics

- Grimshaw, Caroline. *Connections: Art.* Chicago, IL: World Book, 1996.
- Magee, Brian. *The Story of Philosophy.* NY: DK Publishing, 1998.
- Varnedoe, Kirk. A Fine Disregard: What Makes Modern Art Modern. NY: Harry N. Abrams, Inc., 1994.
- Weate, Jeremy. A Young Person's Guide to Philosophy. NY: DK Publishing, 1998.

Art Criticism

- Antoine, Veronique. *Artists Face to Face*. Hauppauge, NY: Barron's, 1996.
- Cumming, Robert. *Annotated Art.* NY: DK Publishing, 1998.
- Franc, Helen M. An Invitation to See: 150 Works from the Museum of Modern Art. NY: Harry N. Abrams, Inc., 1996.
- Greenberg, Jan and Sandra Jordan. *The American Eye.* NY: Delacorte, 1995.
- ——The Painter's Eye. NY: Delacorte, 1991.
- ——The Sculptor's Eye. NY: Delacorte, 1993.
- Richardson, Joy. Looking at Pictures: An Introduction to Art for Young People. NY: Harry N. Abrams, Inc., 1997.
- Rosenfeld, Lucy Davidson. *Reading Pictures: Self-Teaching Activities in Art.* Portland, ME: J. Weston Walch, 1991.
- Roukes, Nicholas. *Humor in Art: A Celebration of Visual Wit.* Worcester, MA: Davis Publications, 1997.
- Welton, Jude. *Looking at Paintings*. NY: DK Publishing, 1994.
- Yenawine, Philip. *How to Look at Modern* Art. NY: Harry N. Abrams, Inc., 1991.

Art History General

- Barron's Art Handbook Series. *How to Recognize Styles*. Hauppauge, NY: Barron's, 1997.
- Belloli, Andrea. Exploring World Art. Los Angeles, CA: The J. Paul Getty Museum, 1999.
- D'Alelio, Jane. *I Know That Building*. Washington, DC: The Preservation Press, 1989.
- Gebhardt, Volker. *The History of Art.* Hauppauge, NY: Barron's, 1998.
- Hauffe, Thomas. *Design*. Hauppauge, NY: Barron's, 1996.
- Janson, H.W. and Anthony F. Janson. History of Art for Young People. NY: Harry N. Abrams, Inc., 1997.
- Remer, Abby. Pioneering Spirits: The Life

- and Times of Remarkable Women Artists in Western History. Worcester, MA: Davis Publications, 1997.
- Stevenson, Neil. Annotated Guides: Architecture. NY: DK Publishing, 1997.
- Thiele, Carmela. *Sculpture*. Hauppauge, NY: Barron's, 1996.
- Wilkinson, Philip and Paolo Donati. *Amazing Buildings*. NY: DK Publishing, 1993.

Ancient World

- Corbishley, Mike. What Do We Know About Prehistoric People. NY: Peter Bedrick Books, 1994.
- Cork, Barbara and Struan Reid. The Usborne Young Scientist: Archaeology. London: Usborne Press, 1991.
- Crosher, Judith. *Ancient Egypt*. NY: Viking, 1993.
- Fleming, Stuart. *The Egyptians*. NY: New Discovery, 1992.
- Giblin, James Cross. The Riddle of the Rosetta Stone. NY: Thomas Y. Crowell, 1990.
- Haslam, Andrew, and Alexandra Parsons. Make It Work: Ancient Egypt. NY: Thomsom Learning, 1995.
- Millard, Anne. *Pyramids*. NY: Kingfisher, 1996.
- Morley, Jacqueline, Mark Bergin, and John Hames. *An Egyptian Pyramid*. NY: Peter Bedrick Books, 1991.
- Powell, Jilliam. *Ancient Art*. NY: Thomsom Learning, 1994.

Classical World

- Avi-Yonah, Michael. Piece by Piece! Mosaics of the Ancient World. Minneapolis, MN: Runestone Press, 1993.
- Bardi, Piero. *The Atlas of the Classical* World. NY: Peter Bedrick Books, 1997.
- Bruce-Mitford, Miranda. Illustrated Book of Signs & Symbols. NY: DK Publishing, 1996.
- Chelepi, Chris. *Growing Up in Ancient Greece*. NY: Troll Associates, 1994.
- Cohen, Daniel. *Ancient Greece*. NY: Doubleday, 1990.
- Corbishley, Mike. *Ancient Rome*. NY: Facts on File, 1989.
- Corbishley, Mike. *Growing Up in Ancient Rome*. NY: Troll Associates, 1993.
- Hicks, Peter. *The Romans*. NY: Thomson Learning. 1993.
- Loverance, Rowena and Wood. *Ancient Greece*. NY: Viking, 1993.
- MacDonald, Fiona. A Greek Temple. NY:

- Peter Bedrick Books, 1992. McCaughrean, G. *Greek Myths*. NY:
- Margaret McElderry Books, 1992. Roberts, Morgan J. *Classical Deities and Heroes*. NY: Friedman Group, 1994.
- Wilkinson, Philip. *Illustrated Dictionary* of Mythology. NY: DK Publishing, 1998
- Williams, Susan. *The Greeks*. NY: Thomson Learning, 1993.

The Middle Ages

- Cairns, Trevor. *The Middle Ages*. NY: Cambridge University Press, 1989.
- Caselli, Giovanni. *The Middle Ages*. NY: Peter Bedrick Books, 1993.
- Chrisp, Peter. Look Into the Past: The Normans. NY: Thomson Learning. 1995.
- Corrain, Lucia. *Giotto and Medieval Art.* NY: Peter Bedrick Books, 1995.
- Howarth, Sarah. What Do We Know About the Middle Ages. NY: Peter Bedrick Books, 1995.
- MacDonald, Fiona. *A Medieval Cathedral*. NY: Peter Bedrick Books, 1994.
- Mason, Antony. If You Were There in Medieval Times. NY: Simon & Schuster, 1996.
- Robertson, Bruce. *Marguerite Makes a Book*. Los Angeles, CA: The J. Paul Getty Museum, 1999.

Renaissance

- Corrain, Lucia. *Masters of Art: The Art of the Renaissance*. NY: Peter Bedrick Books, 1997.
- Di Cagno, Gabriella et al. *Michelangelo*. NY: Peter Bedrick Books, 1996.
- Dufour, Alessia Devitini. *Bosch*. ArtBook Series. NY: DK Publishing, 1999.
- Fritz, Jean, Katherine Paterson, et. al. The World in 1492. NY: Henry Holt & Co., 1992.
- Giorgi, Rosa. *Caravagio*. ArtBook Series. NY: DK Publishing, 1999.
- Harris, Nathaniel. *Renaissance Art.* NY: Thomson Learning, 1994.
- Herbert, Janis. *Leonardo da Vinci for Kids*. Chicago: Chicago Review Press, 1998.
- Howarth, Sarah. *Renaissance People*. Brookfield, CT: Millbrook Press, 1992.
- ——Renaissance Places. Brookfield, CT: Millbrook Press, 1992.
- Leonardo da Vinci. ArtBook Series. NY: DK Publishing, 1999.
- McLanathan, Richard. First Impressions: Leonardo da Vinci. NY: Harry N. Abrams, Inc., 1990.
- ——First Impressions: Michelangelo. NY: Harry N. Abrams, Inc., 1993.
- Medo, Claudio. Three Masters of the Renaissance: Leonardo, Michelangelo, Raphael. Hauppauge, NY: Barron's, 1999.

- Milande, Veronique. *Michelangelo and His Times*. NY: Henry Holt & Co.,
 1995
- Muhlberger, Richard. What Makes a Leonardo a Leonardo? NY: Viking, 1994.

What Makes a Raphael a Raphael? NY: Viking, 1993.

- Murray, Peter and Linda. *The Art of the Renaissance*. NY: Thames and Hudson, 1985.
- *Piero della Francesca*. ArtBook Series. NY: DK Publishing, 1999.
- Richmond, Robin. *Introducing Michelangelo*. Boston, MA: Little,
 Brown, 1992.
- Romei, Francesca. *Leonardo da Vinci*. NY: Peter Bedrick Books, 1994.
- Spence, David. Michelangelo and the Renaissance. Hauppauge, NY: Barron's, 1998.
- Stanley, Diane. *Leonardo da Vinci*. NY: William Morrow, 1996.
- Wood, Tim. *The Renaissance*. NY: Viking, 1993.
- Wright, Susan. *The Renaissance*. NY: Tiger Books International, 1997.
- Zuffi, Stefano. *Dürer.* ArtBook Series. NY: DK Publishing, 1999.
- Zuffi, Stefano and Sylvia Tombesi-Walton. *Titian*. ArtBook Series. NY: DK Publishing, 1999.

Baroque and Rococo

- Barron's Art Handbooks. *Baroque Painting.* Hauppague, NY: Barron's,
 1998.
- Bonafoux, Pascal. A Weekend with Rembrandt. NY: Rizzoli, 1991.
- Jacobsen, Karen. *The Netherlands*. Chicago, IL: Children's Press, 1992.
- Muhlberger, Richard. What Makes a Goya a Goya? NY: Viking, 1994.
- ———What Makes a Rembrandt a Rembrandt? NY: Viking, 1993.
- Pescio, Claudio. Rembrandt and Seventeenth-Century Holland. NY: Peter Bedrick Books, 1996.
- Rodari, Florian. A Weekend with Velázquez. NY: Rizzoli, 1993.
- Schwartz, Gary. First Impressions: Rembrandt. NY: Harry N. Abrams, Inc., 1992.
- Spence, David. Rembrandt and Dutch Portraiture. Hauppauge, NY: Barron's, 1998.
- Velázquez. ArtBook Series. NY: DK Publishing, 1999.
- Vermeer. ArtBook Series. NY: DK Publishing, 1999.
- Wright, Patricia. *Goya*. NY: DK Publishing, 1993.
- Zuffi, Stefano. *Rembrandt*. ArtBook Series. NY: DK Publishing, 1999.

Neoclassicism, Romanticism, Realism *Friedrich.* ArtBook Series. NY: DK

Publishing, 1999.

- Goya. Eyewitness Books. NY: DK Publishing, 1999.
- Rapelli, Paola. *Goya*. ArtBook Series. NY: DK Publishing, 1999.

Impressionism & Post-Impressionism

- Barron's Art Handbooks. *Impressionism*. Hauppauge, NY: Barron's, 1997.
- Bernard, Bruce. Van Gogh. Eyewitness Books. NY: DK Publishing, 1999.
- Borghesi, Silvia. *Cézanne*. ArtBook Series. NY: DK Publishing, 1999.
- Crepaldi, Gabriele. *Gauguin*. ArtBook Series. NY: DK Publishing, 1999.
- ——Matisse. ArtBook Series. NY: DK Publishing, 1999.
- Kandinsky. ArtBook Series. NY: DK Publishing, 1999.
- Monet. Eyewitness Books. NY: DK Publishing, 1999.
- Muhlberger, Richard. What Makes a Cassatt a Cassatt? NY: Viking, 1994.
- ——What Makes a Degas a Degas? NY: Viking, 1993.
- What Makes a Monet a Monet? NY: Viking, 1993.
- ——What Makes a van Gogh a van Gogh? NY: Viking, 1993.
- Pescio, Claudio. *Masters of Art: Van Gogh*. NY: Peter Bedrick Books, 1996.
- Rapelli, Paola. *Monet*. ArtBook Series. NY: DK Publishing, 1999.
- Sagner-Duchting, Karin. *Monet at Giverny*. NY: Neueis Publishing, 1994.
- Skira-Venturi, Rosabianca. A Weekend with Degas. NY: Rizzoli, 1991.
- ———A Weekend with van Gogh. NY: Rizzoli, 1994.
- Spence, David. *Cézanne*. Hauppague, NY: Barron's, 1998.
- ———Degas. Hauppague, NY: Barron's, 1998.
- ——Gauguin. Hauppague, NY: Barron's, 1998.
- ———Manet: A New Realism. Hauppague, NY: Barron's, 1998.
- ——Monet and Impressionism. Hauppague, NY: Barron's, 1998.
- ——Renoir. Hauppague, NY: Barron's, 1998.
- ——Van Gogh: Art and Emotions. Hauppague, NY: Barron's, 1998.
- Torterolo, Anna. *Van Gogh.* ArtBook Series. NY: Dk Publishing, 1999.
- Turner, Robyn Montana. Mary Cassatt. Boston, MA: Little, Brown, 1992.
- Waldron, Ann. *Claude Monet*. NY: Harry N. Abrams, Inc., 1991.
- Welton, Jude. *Impressionism*. NY: DK Publishing, 1993.
- Wright, Patricia. *Manet*. Eyewitness Books. NY: DK Publishing, 1999.

20th Century

Antoine, Veronique. Picasso: A Day in

- His Studio. NY: Chelsea House, 1993. Beardsley, John. First Impressions: Pablo Picasso. NY: Harry N. Abrams, Inc., 1991.
- Cain, Michael. *Louise Nevelson*. NY: Chelsea House, 1990.
- Children's History of the 20th Century. NY: DK Publishing, 1999.
- Faerna, Jose Maria, ed. *Great Modern Masters: Matisse*. NY: Harry N. Abrams, Inc., 1994.
- Faerna, Jose Maria, ed. *Great Modern Masters: Picasso*. NY: Harry N.
 Abrams, Inc., 1994.
- Gherman, Beverly. Georgia O'Keeffe: The Wideness and Wonder of Her World. NY: Simon & Schuster, 1994.
- Greenberg, Jan and Sandra Jordan. Chuck Close Up Close. NY: DK Publishing, 1998.
- Heslewood, Juliet. *Introducing Picasso*. Boston, MA: Little, Brown, 1993.
- Paxman, Jeremy. 20th Century Day by Day. NY: DK Publishing, 1991.
- Ridley, Pauline. *Modern Art.* NY: Thomson Learning, 1995.
- Rodari, Florian. A Weekend with Matisse. NY: Rizolli, 1992. A Weekend with Picasso. NY: Rizolli, 1991.
- Spence, David. Picasso: Breaking the Rules of Art. Hauppauge, NY: Barron's, 1998.
- Tambini, Michael. *The Look of the Century*. NY: DK Publishing, 1996.
- Turner, Robyn Montana. *Georgia*O'Keeffe. Boston, MA: Little, Brown,
 1991.
- Woolf, Felicity. Picture This Century: An Introduction to Twentieth-Century Art. NY: Doubleday, 1993.

United States

- Howard, Nancy Shroyer. *Jacob Lawrence:* American Scenes, American Struggles. Worcester, MA: Davis Publications, 1996.
- ——William Sidney Mount: Painter of Rural America. Worcester, MA: Davis Publications, 1994.
- Panese, Edith. American Highlights: United States History in Notable Works of Art. NY: Harry N. Abrams, Inc., 1993.
- Sullivan, Charles, ed. African-American Literature and Art for Young People. NY: Harry N. Abrams, Inc., 1991.
- ——Here Is My Kingdom: Hispanic-American Literature and Art for Young People. NY: Harry N. Abrams, Inc., 1994.
- ———Imaginary Gardens: American Poetry and Art for Young People. NY: Harry N. Abrams, Inc., 1989.

Native American

Burby, Liza N. The Pueblo Indians. NY:

- Chelsea House, 1994.
- D'Alleva, Anne. *Native American Arts* and *Culture*. Worcester, MA: Davis Publications, 1993.
- Dewey, Jennifer Owings. *Stories on Stone*. Boston, MA: Little, Brown, 1996.
- Garborino, Merwyn S. *The Seminole*. NY: Chelsea House, 1989.
- Gibson, Robert O. *The Chumash*. NY: Chelsea House, 1991.
- Graymont, Barbara, *The Iroquois*. NY: Chelsea House, 1988.
- Griffin-Pierce, Trudy. *The Encyclopedia of Native America*. NY: Viking, 1995.
- Hakim, Joy. *The First Americans*. NY: Oxford University Press, 1993.
- Howard, Nancy Shroyer. Helen Cordero and the Storytellers of Cochiti Pueblo. Worcester, MA: Davis Publications, 1995.
- Jensen, Vicki. *Carving a Totem Pole*. NY: Henry Holt & Co., 1996.
- Littlechild, George. This Land is My Land. Emeryville, CA: Children's Book Press, 1993.
- Moore, Reavis. *Native Artists of North America*. Santa Fe, NM: John Muir Publications, 1993.
- Perdue, Theda. *The Cherokee*. NY: Chelsea House, 1989.
- Remer, Abby. Discovering Native
 American Art. Worcester, MA: Davis
 Publications, 1996.
- Sneve, Virginia Driving Hawk. *The Cherokees*. NY: Holiday House, 1996.

Art of Global Cultures General

- Bowker, John. World Religions. NY: DK Publishing, 1997.
- Eyewitness World Atlas. DK Publishing (CD ROM)
- Wilkinson, Philip. Illustrated Dictionary of Religions. NY: DK Publishing, 1999.
- World Reference Atlas. NY: DK Publishing, 1998.

Africa

- Ayo, Yvonne. *Africa*. NY: Alfred A. Knopf, 1995.
- Bohannan, Paul and Philip Curtin. *Africa and Africans*. Prospect Heights, IL: Waveland Press, 1995.
- Chanda, Jacqueline. *African Arts and Culture*. Worcester, MA: Davis Publications, 1993.
- ——Discovering African Art.Worcester, MA: Davis Publications, 1996.
- Gelber, Carol. *Masks Tell Stories*. Brookfield, CT: Millbrook Press, 1992
- La Duke, Betty. Africa: Women's Art. Women's Lives. Trenton, NJ: Africa World Press, 1997. Africa Through the Eyes of Women

- Artists. Trenton, NJ: Africa World Press, 1996.
- McKissack, Patricia and Fredrick McKissack. *The Royal Kingdoms of Ghana, Mali, and Songhay.* NY: Henry Holt & Co., 1994.

Mexico, Mesoamerica, Latin America

- Baquedano, Elizabeth, *Eyewitness Books: Aztec, Inca, and Maya.* NY: Alfred A. Knopf, 1993.
- Berdan, Frances F. *The Aztecs*. NY: Chelsea House, 1989.
- Braun, Barbara. A Weekend with Diego Rivera. NY: Rizzoli, 1994.
- Cockcroft, James. *Diego Rivera*. NY: Chelsea House, 1991.
- Goldstein, Ernest. The Journey of Diego Rivera. Minneapolis, MN: Lerner, 1996.
- Greene, Jacqueline D. *The Maya*. NY: Franklin Watts, 1992.
- Neimark, Anne E. *Diego Rivera: Artist of the People*. NY: Harper Collins, 1992.
- Platt, Richard. Aztecs: The Fall of the Aztec Capital. NY: DK Publishing, 1999.
- Sherrow, Victoria. *The Maya Indians*. NY: Chelsea House, 1994.
- Turner, Robyn Montana. *Frida Kahlo*. Boston, MA: Little, Brown, 1993.
- Winter, Jonah. *Diego*. NY: Alfred A. Knopf, 1991.

Asia

- Doherty, Charles. *International* Encyclopedia of Art: Far Eastern Art. NY: Facts on File, 1997.
- Doran, Clare. *The Japanese*. NY: Thomson Learning, 1995.
- Ganeri, Anita. What Do We Know About Buddhism. NY: Peter Bedrick Books, 1997.
- ——What Do We Know About Hinduism. NY: Peter Bedrick Books, 1996.
- Lazo, Caroline. The Terra Cotta Army of Emperor Qin. NY: Macmillan, 1993.
- MacDonald, Fiona, David Antram and John James. *A Samurai Castle*. NY: Peter Bedrick Books, 1996.
- Major, John S. *The Silk Route*. NY: Harper Collins, 1995.
- Martell, Mary Hazel. *The Ancient Chinese*. NY: Simon & Schuster, 1993.

Pacific

- D'Alleva, Anne. Arts of the Pacific Islands. NY: Harry N. Abrams, 1998.
- Haruch, Tony. Discovering Oceanic Art. Worcester, MA: Davis Publications, 1996.
- Niech, Rodger and Mick Pendergast.

 Traditional Tapa Textiles of the Pacific.

 NY: Thames and Hudson, 1998.
- Thomas, Nicholas. *Oceanic Art.* NY: Thames and Hudson, 1995.

Studio

- Drawing Basic Subjects. Hauppauge, NY: Barron's, 1995.
- Ganderton, Lucinda. *Stitch Sampler*. NY: DK Publishing, 1999.
- Grummer, Arnold. *Complete Guide to Easy Papermaking*. Iola, WI: Krause Publications, 1999.
- Harris, David. *The Art of Calligraphy*. NY: DK Publishing, 1995.
- Horton, James. *An Introduction to Drawing*. NY: DK Publishing, 1994.
- Learning to Paint: Acrylics. Hauppauge, NY: Barron's, 1998.
- Learning to Paint: Drawing. Hauppauge, NY: Barron's, 1998.
- Learning to Paint: Mixing Watercolors. Hauppauge, NY: Barron's, 1998.
- Learning to Paint in Oil. Hauppauge, NY: Barron's, 1997.
- Learning to Paint in Pastel. Hauppauge, NY: Barron's, 1997.
- Learning to Paint in Watercolor. Hauppauge, NY: Barron's, 1997.
- Lloyd, Elizabeth. *Watercolor Still Life*. NY: DK Publishing, 1994.
- Slafer, Anna and Kevin Cahill. Why Design? Chicago, IL: Chicago Review Press, 1995.
- Smith, Ray. *An Introduction to Acrylics*. NY: DK Publishing, 1993.
- ———An Introduction to Oil Painting. NY: DK Publishing, 1993.
- ———An Introduction to Watercolor. NY: DK Publishing, 1993.
- ——Drawing Figures. Hauppauge, NY: Barron's, 1994.
- ——Oil Painting Portraits. NY: DK Publishing, 1994.
- ——Watercolor Color. NY: DK Publishing, 1993.
- Wright, Michael. An Introduction to Pastels. NY: DK Publishing, 1993.
- Wright, Michael and Ray Smith. *An Introduction to Mixed Media*. NY: DK
 Publishing, 1995.
- ———An Introduction to Perspective. NY: DK Publishing, 1995.
- *Perspective Pack.* NY: DK Publishing, 1998.

Glossary

Abstract art Art that is based on a subject you can recognize, but the artist simplifies, leaves out, or rearranges some elements so that you may not recognize them. (arte abstracto)

additive process Sculptural process in which material (clay, for example) is added to create form. In a subtractive process, material is carved away. (*proceso aditivo*)

aesthetician (*es-tha-TISH-un*) One who wonders about art or beauty. A person who asks questions about why art was made and how it fits into society. (*estético*)

allover pattern A design or pattern that covers an entire surface. (*dibujo entero*)

analogous colors (*an-AL-oh-gus*) Colors that are closely related because they have one hue in common. For example, blue, blue-violet, and violet all contain the color blue. Analogous colors appear next to one another on the color wheel. (*colores análogos*)

appliqué (ah-plee-KAY) A process of stitching and/or gluing cloth to a background, similar to collage. (aplicación) **architectural floor plan** A diagram of an architectural complex (a building or group of buildings) seen from above. (diagrama de planta arquitectónica)

art critic One who expresses a reasoned opinion on any matter concerning art. (*critico de arte*)

art form A category or kind of art such as painting, sculpture or photography. (*forma artística*)

art historian A person who studies art—its history and contributions to cultures and societies. (historiador de arte)

art media The material or technical means for artistic expression. (*medios artísticos*)

artist A person who makes art. (*artista*) **assemblage** (*ah-SEM-blij*) A three-dimensional work of art consisting of many pieces joined together. A sculpture made by joining many objects together. (*ensamblaje*)

asymmetrical (*a*-si*m*-*MET*-*tri*-*kal*) A type of visual balance in which the two sides of the composition are different yet balanced; visually equal without being identical. Also called informal balance. (*asimétrico*)

atmospheric color (*at-mos-FER-ik*) Colors in nature that seem to change as natural light changes. (*color atmosférico*) **atmospheric perspective** (at-mos-FER-ik per-SPEK-tiv) A way to create the illusion of space in an artwork, based on the observation that objects look more muted and less clear the farther they are from the viewer. (perspectiva atmosférica)

background Parts of artwork that appear to be in the distance or behind the objects in the foreground or front. (*fondo*)

balance A principle of design that describes how parts of an artwork are arranged to create a sense of equal weight or interest. An artwork that is balanced seems to have equal visual weight or interest in all areas. Types of balance are symmetrical, asymmetrical, and radial. (equilibrio)

Baroque (bah-ROKE) 1600–1700. An art history term for a style marked by swirling curves, many ornate elements, and dramatic contrasts of light and shade. Artists used these effects to express energy and strong emotions. (barroco)

bas-relief (bah ree-LEEF) Also called low relief. A form of sculpture in which portions of the design stand out slightly from a flat background. (bajorrelieve) batik (bah-TEEK) A method of dyeing cloth that uses wax to resist dye. Wax is used where the color of the dye is not wanted. (batik)

caricature (*cah-ri-CAH-chur*) A picture in which a person's or an animal's features, such as nose, ears or mouth, are different, bigger or smaller than they really are. Caricatures can be funny or critical and are often used in political cartoons. (*caricatura*)

center of interest The part of an artwork which attracts the viewer's eye. Usually the most important part of a work of art. (foco de atención)

ceramics (*sir-AM-miks*) The art of making objects from clay, glass, or other minerals by baking or firing them at high temperatures in an oven known as a kiln. Ceramics are also the products made in this way. (*cerámica*)

color Color is another word for hue, which is the common name of a color in or related to the spectrum, such as yellow, yellow-orange, blue-violet, green. (color)

color scheme A plan for selecting or organizing colors. Common color schemes include: warm, cool, neutral, monochromatic, analogous, complementary, split-complementary and triad. (combinación de colores)

complementary (com-ple-MEN-tah-ree) Colors that are directly opposite each other on the color wheel, such as red and green, blue and orange, and violet and yellow. When complements are

mixed together, they make a neutral brown or gray. When they are used next to each other in a work of art, they create strong contrasts. (complementarios) concertina (con-ser-TEE-nah) A type of book made from a long strip of paper that is folded accordion-style to form the pages. (concertina)

continuity (con-tin-OO-ih-tee) To carry on, as a tradition or a custom. (continuidad)

contour A line which shows or describes the edges, ridges, or outline of a shape or form. (*contorno*)

contrast A principle of design that refers to differences in elements such as color, texture, value, and shape. Contrasts usually add excitement, drama, and interest to artworks. (*contraste*)

cool colors Colors often connected with cool places, things, or feelings. The family of colors ranging from the greens through the blues and violets. (*colores frescos*)

crest In many North American communities, a grouping of totems used to show the identity of a tribe or family group. (*poste totémico*)

Cubism 1907–1914. An art history term for a style developed by the artists Pablo Picasso and Georges Braque. In Cubism, the subject matter is broken up into geometric shapes and forms. The forms are analyzed and then put back together into an abstract composition. Often, three-dimensional objects seem to be shown from many different points of view at the same time. (*cubismo*)

cultural meaning Meaning that only the members of a specific culture or cultural group can understand. (significado cultural)

cuneiform (*kew-NAY-i-form*) Early form of writing developed in Mesopotamia as early as 3000 BC. Made up of wedge-shaped symbols that were pressed into clay. (*cuneiforme*)

document (DOK-you-ment) To make or keep a record of. (documentar)

earthwork Any work of art in which land and earth are important media. Often, large formations of moved earth, excavated by artists in the surface of the earth, and best viewed from a high vantage point. (obras de tierra)

elevation drawing A drawing that shows the external faces of a building. It can also be a side or front view of a structure, painted or drawn to reveal each story with equal detail. (*plano de alzado*)

emboss To create a mark or indentation by pressing objects into a soft surface, such as clay. (*grabar o tallar en relieve*)

emphasis Area in a work of art that catches and holds the viewer's attention. This area usually has contrasting sizes, shapes, colors or other distinctive features. (*acentuación*)

Expressionism 1890–1920. A style of art which began mostly in Germany but spread to other parts of Europe. The main idea in expressionist artworks is to show strong mood or feeling. (*expressionismo*)

fan A type of book whose pages—usually strips of paper—are loosely bound at one end.(*abanico*)

Fauves (*fohvz*) 1905–1907. A group of painters who used brilliant colors and bold exaggerations in a surprising way. (*fauvistas*)

fiber artists Artists who use long, thin, thread-like materials to create artwork. (*artistas de fibra*)

foreground In a scene or artwork, the part that seems closest to you. (*primer plano*)

form An element of design; any threedimensional object such as a cube, sphere, pyramid, or cylinder. A form can be measured from top to bottom (height), side to side (width) and front to back (depth). Form is also a general term that means the structure or design of a work. (forma)

fresco (*FRES-coh*) A technique of painting in which pigments are applied to a thin layer of wet plaster. The plaster absorbs the pigments and the painting becomes part of the wall. (*fresco*)

genre (*ZHAHN-rah*) Subjects and scenes from everyday life. (*género*)

geometric Mechanical-looking shapes or forms. Something that is geometric may also be described using mathematical formulas. (*geométricas*)

geometric shapes Shapes that are regular in outline. Geometric shapes include circles, squares, rectangles, triangles and ellipses. Geometric forms include cones, cubes, cylinders, slabs, pyramids and spheres. (figuras geométricas)

Gothic art 1100–1400. A style of art in Europe of the twelfth-fifteenth centuries, emphasizing religious architecture and typified by pointed arches, spires, and verticality. (arte gótico)

handscroll A long, horizontal painting. (makemono)

hanging scroll A long, vertical painting. (*kakemono*)

horizon line A level line where water or land seem to end and the sky begins. It is usually on the eye level of the observer. If the horizon cannot be seen, its location must be imagined. (*línea de horizonte*)

ideal A view of what the world and people would be like if they were perfect. (*ideal*)

identity The distinguishing traits or personality of a person or individual. (*identidad*)

illuminated manuscript A decorated or illustrated manuscript popular during the medieval period in which the pages are often painted with silver, gold and other rich colors. (manuscrito iluminado) **illuminators** (il-LOO-min-ay-torz) Artists who illustrate certain parts of a book. (iluminadores)

implied line The way objects are set up so as to produce the effect of seeing lines in a work, but where lines are not actually present. (*linea implicita*) **implied texture** The way a surface

appears to look, such as rough or smooth. (textura implicita)

Impressionism 1875–1900. A style of painting that began in France. It emphasized views of subjects at a particular moment and the effects of sunlight on color. (*impresionismo*)

installation art Art that is created for a particular site. (arte de instalación) **intermediate color** A color made by mixing a secondary color with a primary color. Blue-green, yellow-green, yellow-orange, red-orange, red-violet and blue-violet are intermediate colors. (color intermedio)

kinetic art (*kih-NET-ick*) A general term for all artistic constructions that include moving elements, whether actuated by motor, by hand crank, or by natural forces as in mobiles. (*arte cinético*)

line A mark with length and direction, created by a point that moves across a surface. A line can vary in length, width, direction, curvature and color. Line can be two-dimensional (a pencil line on paper), three-dimensional (wire), or implied. (*línea*)

linear perspective (lin-EE-er per-SPEK-tiv) A technique used to show three-dimensional space on a two-dimensional surface. (perspectiva lineal)

maquette (*mah-KET*) A small model of a larger sculpture. (*maqueta*)

mezuzah (*muh-ZOO-sah*) A piece of inscribed parchment, rolled up in a scroll, and placed in a small wooden, metal or glass case or tube. It is then hung to the doorpost of some Jewish homes as a symbol and a reminder of faith in God. (*mezuzá*)

middle ground Parts of an artwork that appear to be between objects in the foreground and the background. (*segundo plano*)

mobile (*MOH-beel*) A hanging balanced sculpture with parts that can be moved, especially by the flow of air. Invented by Alexander Calder in 1932. (*móvil*) **model** To shape clay by pinching and pulling. (*modelar*)

monochromatic (mah-no-crow-MAT-ik) Made of only a single color or hue and its tints and shades. (monocromático) montage (mahn-TAHZH) A special kind of collage, made from pieces of photographs or other pictures. (montaje) mosaic (mo-ZAY-ik) Artwork made by fitting together tiny pieces of colored glass or tiles, stones, paper or other materials. These small materials are called tesserae. (mosaico)

motif (*moh-TEEF*) A single or repeated design or part of a design or decoration that appears over and over again. (*motivo*)

movement A way of combining visual elements to produce a sense of action. This combination of elements helps the viewer's eye to sweep over the work in a definite manner. (movimiento)

mudra (muh-DRA) Symbolic hand gestures. Most often associated with Buddha in the Buddhist religion. (mudra)

mural (*MYOR-ul*) A large painting or artwork, usually designed for and created on the wall or ceiling of a public building. (*mural*)

narrative (*NAR-ah-tiv*) Depicting a story or idea. (*narrativa*)

negative shape/space The empty space surrounding shapes or solid forms in a work of art. (forma o espacio negativo) **Neo-Classicism** 1750–1875. A style of art based on interest in the ideals of ancient Greek and Roman art. These ideals were used to express ideas about beauty, courage, sacrifice and love of country. (neoclasicismo)

neutral color A color not associated with a hue—such as black, white, or a gray. Architects and designers call slight changes in black, white, brown and gray neutral because many other hues can be combined with them in pleasing color schemes. (color neutro)

nonobjective art 1917–1932. A style of art that does not have a recognizable subject matter; the subject is the composition of the artwork. Nonobjective is often used as a general term for art that contains no recognizable subjects. Also known as non-representational art. (arte no figurativo)

organic shapes Shapes that are irregular in outline, such as things in nature. (*formas orgánicas*)

patron (*PAY-trun*) A wealthy or influential person or group that supports artists. (*mecenas*)

pattern A choice of lines, colors or shapes, repeated over and over in a planned way. A pattern is also a model or guide for making something. (*patrón*)

for creating a look of depth on a twodimensional surface. (perspectiva) planned pattern Patterns thought out and created in a systematic and organized way. Whether manufactured or natural, they are precise, measurable and consistent. (patrón planificado) Pop Art 1940 to the present. A style of art whose subject matter comes from popular culture (mass media, advertising, comic strips, and so on). (arte pop) porcelain (POR-suh-len) Fine white clay, made primarily of kaolin; also an object made of such clay. Porcelain may be decorated with mineral colorants under the glaze or with overglaze enamels. (porcelana)

perspective (per-SPEK-tiv) Techniques

positive space/shape The objects in a work of art, not the background or the space around them. (*espacio o forma positiva*)

Post-Impressionism 1880–1900. An art history term for a period of painting immediately following Impressionism in France. Various styles were explored, especially by Cézanne (basic structures), van Gogh (emotionally strong brushwork), and Gauguin (intense color and unusual themes). (postimpresionismo)

pre-Columbian art 7000 BC to about 1500 AD. An art history term for art created in North and South America before the time of the Spanish conquests. (arte precolombino)

primary color One of three basic colors (red, yellow and blue) that cannot be made by mixing colors. Primary colors are used for mixing other colors. (*color primario*)

proportion The relation of one object to another in size, amount, number or degree. (*proporción*)

radial A kind of balance in which lines or shapes spread out from a center point. (*radial*)

random pattern Patterns caused by accidental arrangement or produced without consistent design. Random patterns are usually asymmetrical, nonuniform and irregular. (patrón aleatorio) Realism 1850–1900. A style of art that shows places, events, people, or objects as the eye sees them. It was developed in the mid-nineteenth century by artists who did not use the formulas of Neoclassicism and the drama of Romanticism. (realismo)

relief print A print created using a printing process in which ink is placed on the raised portions of the block or plate. (*impresión en relieve*)

relief sculpture A three-dimensional form designed to be viewed from one side, in which surfaces project from a background. (escultura en relieve)

representational Similar to the way an object or scene looks. (realista) rhythm A type of visual or actual movement in an artwork. Rhythm is a principle of design. It is created by repeating visual elements. Rhythms are often described as regular, alternating, flowing, progressive or jazzy. (ritmo) Rococo (roh-COH-coh) 1700–1800. A style of eighteenth-century art that began in the luxurious homes of the French nobility and spread to the rest of Europe. It included delicate colors, delicate lines, and graceful movement.

Romanesque (ROH-man-esk)

(rococó)

the carefree life of the aristocracy.

1000–1200. A style of architecture and sculpture influenced by Roman art, that developed in western Europe during the Middle Ages. Cathedrals had heavy walls, rounded arches, and sculptural decorations. (románico)

Romanticism (ro-MAN-ti-sizm)
1815–1875. A style of art that developed as a reaction against
Neoclassicism. Themes focused on dramatic action, exotic settings, adventures, imaginary events, faraway places and strong feelings. (romanticismo)
scale The size relationship between two sets of dimensions. For example, if a picture is drawn to scale, all its parts are equally smaller or larger than the parts in the original. (escala)

scroll A decorative motif consisting of any of several spiral or convoluted forms, resembling the cross-section of a loosely rolled strip of paper; also, a curved ornamental molding common in medieval work. (*voluta*)

secondary color A color made by mixing equal amounts of two primary colors. Green, orange and violet are the secondary colors. Green is made by mixing blue and yellow. Orange is made by mixing red and yellow. Violet is made by mixing red and blue. (color secundario)

self-portrait Any work of art in which an artist shows himself or herself. (*autorretrato*)

shade Any dark value of a color, usually made by adding black. (*sombra*) **shading** A gradual change from light to dark. Shading is a way of making a picture appear peak in the properties and three

ture appear more realistic and threedimensional. (sombreado) **shape** A flat figure created when actual

or implied lines meet to surround a space. A change in color or shading can define a shape. Shapes can be divided into several types: geometric (square, triangle, circle) and organic (irregular in outline). (forma)

simplify To create less detail in certain objects or areas of an artwork in order to highlight other areas. To reduce the complex to its most basic elements. (*simplificar*)

space The empty or open area between, around, above, below or within objects. Space is an element of art. Shapes and forms are made by the space around and within them. Space is often called three-dimensional or two-dimensional. Positive space is filled by a shape or form. Negative space surrounds a shape or form. (*espacio*)

split complement A color scheme based on one hue and the hues on each side of its complement on the color wheel. Orange, blue-violet, and bluegreen are split complementary colors. (complemento fraccionario)

stele (*steel*) An upright slab, bearing sculptured or painted designs or inscriptions. From the Greek for "standing block." (*estela*)

still life Art based on an arrangement of objects that are not alive and cannot move, such as fruit, flowers, or bottles. The items are often symbols for abstract ideas. A book, for example, may be a symbol for knowledge. A still life is usually shown in an indoor setting. (naturaleza muerta)

stupa (*STEW-pah*) A hemispherical or cylindrical mound or tower artificially constructed of earth, brick or stone, surmounted by a spire or umprella, and containing a relic chamber. (*estupa*) **style** The result of an artist's means of expression—the use of materials, design qualities, methods of work, and choice of subject matter. In most cases, these choices show the unique qualities of an individual, culture or time period. The style of an artwork helps you to know how it is different from other artworks. (*estilo*)

subject A topic or idea shown in an artwork, especially anything recognizable such as a landscape or animals. (*tema*) **Surrealism** 1924–1940. A style of art in which dreams, fantasy and the human mind were sources of ideas for artists. Surrealist works can be representational or abstract.

symbol Something that stands for something else; especially a letter, figure or sign that represents a real object or idea. A red heart shape is a common symbol for love. (símbolo)

symmetrical (*sim-MET-ri-kal*) A type of balance in which both sides of a center line are exactly or nearly the same, like a mirror image. For example, the wings of a butterfly are symmetrical. Also known as formal balance. (*simétrico*) **tesserae** (*TESS-er-ah*) Small pieces of

glass, tile, stone, paper or other materials used to make a mosaic. (teselas) texture The way a surface feels (actual texture) or how it may look (implied texture). Texture can be sensed by touch and sight. Textures are described by words such as rough, silky, pebbly. (textura)

theme The subject or topic of a work of art. For example, a landscape can have a theme of the desire to save nature, or to destroy nature. A theme such as love, power, or respect can be shown through a variety of subjects. The phrase "theme and variations" usually means several ways of showing one idea. (*idea central*) tint A light value of a pure color, usually made by adding white. For example, pink is a tint of red. (*matiz claro*) totem (*TOH-tem*) An object that serves as a symbol of a family, person, idea, or legend. (*tótem*)

triad (*TRY-ad*) Three colors spaced equally apart on the color wheel, such as orange, green, and violet. (*triada*) **triptych** (*TRIP-tick*) An altarpiece consisting of three panels joined together. Often, the two outer panels are hinged to close over the central panel. (*triptico*) **tympanum** (*TIM-pah-num*) The arched space above a church doorway. (*timpano*)

unity A feeling that all parts of a design are working together as a team.

(unidad)

value An element of art that means the darkness or lightness of a surface. Value depends on how much light a surface reflects. Tints are light values of pure colors. Shades are dark values of pure colors. Value can also be an important element in works of art in which there is little or no color (drawings, prints, photographs, most sculpture and architecture). (*valor*)

vanishing point In a perspective drawing, one or more points on the horizon where parallel lines that go back in space seem to meet. (punto de fuga) variety The use of different lines, shapes, textures, colors, and other elements of design to create interest in a work of art. (variedad)

warm colors Warm colors are so-called because they often are associated with fire and the sun and remind people of warm places, things, and feelings. Warm colors range from the reds through the oranges and yellows. (colores cálidos)

Spanish Glossary

abanico Tipo de libro cuyas páginas (por lo general, tiras de papel) se encuentran ligeramente encuadernadas en un extremo. (fan)

acentuación Parte de una obra artística que captura y retiene la atención del espectador. Por lo general, esta área exhibe contrastes en tamaño, forma, color u otros rasgos distintivos. (*emphasis*)

aplicación Proceso parecido al collage en el cual trozos de tela se cosen y/o se pegan a un fondo. (appliqué) arte abstracto Arte que se basa en un tema reconocible pero en el que el artista ha simplificado, excluido o reordenado algunos elementos de modo que no podamos reconocerlos. (Abstract art) arte cinético Término general que se usa para describir cualquier construcción artística que incluya elementos móviles, ya sea mediante un motor, una manivela o fuerzas naturales, como en el caso de los móviles. (kinetic art)

arte de instalación Arte que se crea especialmente para un lugar en particular. (installation art)

arte gótico 1100-1400. Estilo de arte europeo que se desarrolló del siglo XII al XV. Ponía énfasis en la arquitectura religiosa y se caracterizaba por arcos ojivales, capiteles y verticalidad. (*Gothic art*)

arte no figurativo 1917-1932. Estilo de arte que no posee un tema reconocible; el tema es la composición de la obra artística. A menudo, se usa como un término general para el arte que contiene temas irreconocibles. También se le conoce como arte abstracto. (*nonobjective art*)

arte pop De 1940 hasta el presente. Tendencia artística cuyos temas provienen de la cultura popular (medios de comunicación, publicidad y tiras cómicas, entre otros). (*Pop Art*)

arte precolombino 7000 a.C. hasta aproximadamente el siglo XVI d.C. Término que se utiliza para referirse al arte creado en Norteamérica y Sudamérica antes de la llegada de los conquistadores españoles. (pre-Columbian art)

artista Persona que hace arte. (artist) artistas de fibra Artistas que utilizan materiales largos y filamentosos en la creación de sus obras de arte. (fiber artist)

asimétrico Tipo de equilibrio visual en el cual los dos lados de una composi-

ción son diferentes pero están equilibrados; son iguales visualmente pero no idénticos. También se denomina equilibrio irregular. (asymmetrical)

autorretrato Cualquier obra artística en la cual el artista se muestra a sí mismo. (*self-portrait*)

bajorrelieve Forma de escultura en la cual las partes de un diseño resaltan poco del plano. (*bas-relief*)

barroco 1600-1700. El barroco es un término de arte relativo a un estilo que se caracterizó por curvas turbulentas, por estar excesivamente ornamentado y por presentar dramáticos contrastes de luz y sombra. Mediante estos efectos los artistas expresaban energía y emociones exaltadas. (*Baroque*)

batik Procedimiento de teñido de un tejido que usa cera para impedir el tinte. La cera se aplica en las partes donde no se desea teñir. (batik) caricatura Ilustración en la cual los rasgos de una persona o de un animal, como por ejemplo, la nariz, las orejas o la boca, son diferentes, más grandes o más pequeñas de lo que son en realidad. Las caricaturas pueden ser divertidas o críticas y se usan, a menudo, en las tiras cómicas políticas. (caricature)

cerámica Arte de fabricar objetos de barro, vidrio u otros minerales cociéndolos o quemándolos a altas temperaturas en un horno de secar. La palabra también se refiere a los productos que se forman de esta manera. (ceramics) color Otro término para denominar el matiz, que es el nombre común de un color que está en el espectro o que está relacionado con él, por ejemplo, amarillo, amarillo anaranjado, azul violeta y verde. (color)

color atmosférico Colores de la naturaleza que parecen cambiar según cambia la luz natural. (atmospheric color) **color intermedio** Color que se produce al mezclar un color secundario con un color primario. El azul-verde, el verdeamarillo, el amarillo-anaranjado, el rojo-anaranjado, el rojo-violeta y el azul-violeta son colores intermedios. (intermediate color)

color neutro Color que no se asocia con un matiz, como por ejemplo, el negro, el blanco o el gris. Los arquitectos y los diseñadores llaman neutros a los leves cambios en negro, blanco y gris debido a que pueden combinarse con diferentes matices para crear combinaciones atractivas de colores. (*neutral color*)

color primario Uno de los tres colores básicos (amarillo, rojo y azul) que no se puede producir mezclando colores. Los colores primarios se usan para formar otros colores. (*primary color*)

color secundario Color que se produce al mezclar dos colores primarios en cantidades iguales. El verde, el anaranjado y el violeta son colores secundarios. El verde es la combinación de azul con amarillo. El anaranjado se obtiene al mezclar el rojo y el amarillo. El color violeta se produce al mezclar el rojo con el azul. (*secondary color*)

colores análogos Colores estrechamente relacionados debido a un matiz que comparten en común. Por ejemplo, el azul, el azul-violeta y el violeta contienen el color azul. En la rueda de colores, los colores análogos se

encuentran uno al lado del otro. (analogous colors)

colores cálidos Reciben este nombre porque a menudo se les asocia con el fuego y el Sol. Asimismo, nos recuerdan lugares, cosas y sensaciones cálidas. Los colores cálidos van desde distintas tonalidades de rojo hasta el anaranjado y amarillo. (warm colors)

colores frescos Colores que se relacionan, a menudo, con lugares, cosas o sentimientos que proyectan frescura. Familia de colores que va del verde al azul y violeta. (cool colors)

combinación de colores Plan para seleccionar u organizar los colores. Entre las combinaciones de colores comunes se encuentran las siguientes: cálido, fresco, neutro, monocromático, análogo, complementario, complementario fraccionado y tríada. (color scheme)

complementarios Colores directamente opuestos entre sí en la rueda de colores. Por ejemplo, el rojo y el verde, el azul y el anaranjado, el violeta y el amarillo. Cuando los colores complementarios se mezclan, el resultado es un color marrón o gris neutro. Cuando se usan uno al lado del otro en una obra artística, producen contrastes intensos. (complementary)

complemento fraccionario

Combinación de colores que se basa en un matiz y en los matices de cada lado de su complemento en la rueda de colores. El anaranjado, el azul-violeta y el azul-verde son colores complementarios fraccionados. (split complement)

concertina Tipo de libro hecho de una tira larga de papel que se dobla como un acordeón para formar las páginas. (concertina)

continuidad Condición de continuar, seguir o persistir. Por ejemplo, la continuidad de una tradición o una costumbre. (continuity)

contorno Línea que muestra o describe los extremos, las salientes o el perfil de una figura o forma. (contour)

contraste Principio de diseño que se refiere a las diferencias en elementos como el color, la textura, el valor y la forma. Por lo general, los contrastes añaden vivacidad, drama e interés a las obras de arte. (*contrast*)

crítico de arte Persona que expresa una opinión razonada acerca de cualquier asunto relacionado con el arte. (art critic)

cubismo 1907-1914. Término de arte que denota un estilo desarrollado por Pablo Picasso y Georges Braque. En el cubismo, el tema se descompone en formas y figuras geométricas. Éstas se analizan y luego se vuelven a juntar en una composición abstracta. A menudo, da la impresión de que los objetos tridimensionales se están mostrando desde muchos puntos de vista diferentes al mismo tiempo. (*Cubism*)

cuerpo geométrico Cualquier objeto tridimensional, como un cubo, una esfera, una pirámide o un cilindro. Éstos pueden medirse desde arriba hacia abajo (altura), de lado a lado (ancho) y de adelante hacia atrás (profundidad). (*geometric form*)

cuneiforme Sistema antiguo de escritura que se desarrolló en Mesopotamia alrededor del año 3000 a.C. Este tipo de escritura consistía en símbolos en forma de cuña que se presionaban sobre arcilla. (*cuneiform*)

diagrama de planta arquitectónica Esquema de un complejo arquitectónico (un edificio o un grupo de edificios) visto desde arriba. (architectural floor plan)

dibujo entero Diseño o modelo que cubre una superficie completa. (allover pattern)

documentar Llevar un registro de algo. (document)

ensamblaje Obra artística tridimensional que consiste en muchas piezas unidas. Escultura realizada reuniendo diversos objetos. (assemblage)

equilibrio Principio de diseño que describe la manera en que se encuentran ordenadas las partes de una obra artística con el fin de crear la sensación de igual peso o interés. Una obra artística equilibrada ofrece un peso visual o un interés igual en todas sus áreas. Los tipos de equilibrio son simétrico, asimétrico y radial. (balance)

escala La relación de tamaño entre dos conjuntos de dimensiones. Por ejemplo, si se hace un dibujo a escala, todas sus partes son igualmente más pequeñas o más grandes que las partes del original. (scale)

escultura en relieve Forma tridimensional diseñada para observarse desde un lado, en el cual las superficies se

proyectan desde el fondo. (relief sculpture)

espacio La extensión vacía o abierta que se encuentra entre objetos, alrededor de ellos, encima de ellos, debajo de ellos o dentro de los mismos. El espacio es un elemento artístico. Las figuras y las formas se producen debido al espacio que existe a su derredor y dentro de ellas. A menudo nos referimos al espacio como tridimensional o bidimensional. Una figura o una forma llenan el espacio positivo mientras que el espacio negativo rodea una figura o una forma. (space)

espacio o forma positiva Los objetos de una obra artística que no constituyen ni el fondo ni el espacio que se halla a su alrededor. (positive space/shape) estela Losa o monumento que se dispone en forma vertical y que lleva diseños esculpidos o pintados o inscripciones. Viene del latín stelam, y éste del griego, que significa "bloque de pie". (stele)

estético Persona que se dedica al estudio del arte o la belleza. Persona que cuestiona cómo se produce el arte y el papel que juega en la sociedad. (aesthetician)

estilo Resultado de los medios de expresión de un artista: el uso de materiales, la calidad del diseño, los métodos de trabajo y la selección del tema. En la mayoría de los casos, estas selecciones muestran las cualidades singulares de un individuo, una cultura o un período de tiempo. El estilo de una obra artística nos ayuda a distinguirla de otras obras de arte. (style)

estupa Montículo o torre hemisférica o cilíndrica que se construye artificialmente usando tierra, ladrillos o piedras coronada con un capitel o sombrilla y que contiene reliquias. (*stupa*)

expresionismo 1890-1920. Estilo artístico que originalmente se desarrolló en Alemania pero que más tarde se propagó a otras partes de Europa. La idea principal de las obras expresionistas es mostrar estados de ánimo o sensaciones intensas. (Expressionism)

fauvistas 1905-1907. Grupo de pintores que hacían uso de colores brillantes y exageraciones audaces de una manera sorprendente. (*Fauves*)

figuras geométricas Formas de perfil regular. Entre las figuras geométricas se encuentran los círculos, los cuadrados, los rectángulos, los triángulos y las elipses. Entre los cuerpos geométricos se incluyen los conos, los cubos, los cilindros, las losas, las pirámides y las esferas. (*geometric shapes*)

foco de atención Parte de una obra de arte, atractiva a la vista del espectador. Por lo general, constituye la parte más

importante de una obra artística. (center of interest)

fondo Parte de una obra artística que parece estar a la distancia o detrás de los objetos que se encuentran en primer plano. (background)

forma Elemento de diseño. Término general que se usa para referirse a la estructura o diseño de una obra. También se define como una figura plana que se produce al juntarse líneas reales o implícitas alrededor de un espacio. Se puede definir una forma mediante un cambio en color o sombreado. Las formas se pueden dividir en varios tipos: geométricas (cuadrado, triángulo, círculo) y orgánicas (de perfil irregular). (shape)

forma artística Técnica o método utilizado en la creación de una obra artística, como una pintura, una fotografía o un collage. (art form)

forma o espacio negativo El espacio vacío que rodea las formas o los cuerpos geométricos en una obra artística. (*negative shape/space*)

formas orgánicas Formas cuyos perfiles son irregulares, como por ejemplo, los objetos que se hallan en la naturaleza. (*organic shapes*)

fresco Técnica de pintura mural que consiste en aplicar pigmentos a una capa delgada de yeso húmedo. El yeso absorbe los pigmentos y la pintura se convierte en parte de la pared. (*fresco*) **género** Temas y escenas de la vida cotidiana. (*genre*)

geométricas Figuras o formas que parecen mecánicas. También se pueden usar fórmulas matemáticas para describir algo que es geométrico. (*geometric*) **grabar o tallar en relieve** Crear una

grabar o tallar en relieve Crear una marca o depresión al presionar objetos en una superficie suave, como por ejemplo, la arcilla. (*emboss*)

historiador de arte Persona que estudia el arte: su historia y aportaciones a las culturas y sociedades. (art historian) idea central Tema o tópico de una obra artística. Por ejemplo, un paisaje puede tener como idea central el deseo de salvar la naturaleza o de destruirla. Una idea central como el amor, el poder o el respeto se pueden mostrar a través de una variedad de temas. Por lo general, la frase "idea central y variaciones" se usa para expresar varias maneras de mostrar una idea. (theme)

ideal Opinión de cómo sería el mundo y sus habitantes si éstos fueran perfectos. (*ideal*)

identidad La personalidad o los caracteres distintivos de una persona o individuo. (*identity*)

iluminadores Artistas que decoran e ilustran ciertas partes de un libro. (*illuminators*)

impresión en relieve Impresión que se crea al usar un proceso de imprimir en el cual se coloca tinta en las partes elevadas del clisé topográfico. (relief print) impresionismo 1875-1900. Estilo de pintura que surgió en Francia. Ponía énfasis en la visión del individuo en un momento en particular y en los efectos de la luz solar sobre los colores. (Impressionism)

kakemono Pintura realizada en un rollo largo y vertical. (hanging scroll) línea Trazo que muestra longitud y dirección, creado por un punto que se mueve por una superficie. Una línea puede variar en longitud, ancho, dirección, curvatura y color. Puede ser bidimensional (una línea hecha con un lápiz sobre papel), tridimensional (alambre) o puede estar implícita. (line) línea de horizonte Línea de nivel donde parece que el agua o la tierra terminan y comienza el cielo. Por lo general, se encuentra al nivel de los ojos del espectador. Si el horizonte no se puede ver, entonces se debe imaginar su ubicación. (horizon line)

línea implícita Manera en que se arreglan los objetos con el fin de producir el efecto de que se vean líneas en una obra, aunque estas líneas en realidad no están presentes. (implied line) makemono Pintura realizada en un rollo largo y horizontal. (handscroll) manuscrito iluminado Tipo de manuscrito decorado o ilustrado que fue popular en la Edad Media. A menudo, sus páginas se pintaban con plata, oro y otros colores intensos. (illuminated manuscript)

maqueta Modelo, a escala reducida, de una escultura. (*maquette*)

matiz claro Valor leve de un color puro, que se produce generalmente al añadir blanco. Por ejemplo, el rosado es un matiz claro del rojo. *(tint)*

mecenas Persona o grupo adinerado o influyente, protector de las letras y las artes. (*patrons*)

medios artísticos Material o medios técnicos para realizar una expresión artística. (*art media*)

mezuzá Trozo enrollado de pergamino grabado que se coloca en un estuche o en un tubo de madera, metal o vidrio. Luego se cuelga en el marco de la puerta de algunas casas judías como símbolo y recordatorio de la fe en Dios. (*mezuzah*)

modelar Apretar y tirar de una sustancia como la arcilla para darle forma artística. (*model*)

monocromático Hecho de un solo color o matiz y sus tintes y tonos. (*monochromatic*)

montaje Tipo especial de collage, hecho con trozos de fotografías u otro tipo de ilustraciones. (*montage*)

mosaico Obra artística compuesta de pequeños trozos de vidrio o azulejos, piedras, papel u otros materiales, de diversos colores. Estos materiales reciben el nombre de teselas. (mosaic) motivo Diseño individual o repetido o parte de un diseño o decoración que se presenta constantemente. (motif) móvil Escultura equilibrada en suspensión que tiene partes que pueden entrar en movimiento, especialmente por la acción del viento. Ideada por Alexander Calder en 1932. (mobile)

movimiento Manera de combinar elementos visuales con el fin de producir una sensación de acción. Gracias a esta combinación de elementos, los ojos del espectador recorren la obra de arte de una manera definida. (movement) mudra Gesto simbólico efectuado con las manos y los dedos. Relacionado a menudo con Buda, el predicador de la doctrina budista. (mudra)

mural Pintura u obra artística que, por lo general, se realiza o se aplica a un muro o al cielorraso de un edificio público. (*mural*)

narrativa Que describe un cuento o una idea. Este término se puede utilizar como un sinónimo no despectivo de literario. (narrative)

naturaleza muerta Arte que se basa en un arreglo de objetos inertes e inmóviles, como por ejemplo, frutos, flores o botellas. Estos objetos expresan, a menudo, ideas abstractas. Por ejemplo, un libro puede representar un símbolo para el conocimiento. Por lo general, una naturaleza muerta se muestra en un ambiente interior. (still life)

neoclasicismo 1750-1875. Estilo de arte que se basaba en un interés por los ideales del arte de la Grecia y Roma antiguas. Estos ideales se utilizaban para expresar ideas sobre la belleza, la valentía, el sacrificio y el amor a la patria. (*Neo-Classicism*)

obras de tierra Cualquier obra artística en la cual el terreno y la Tierra son medios importantes. A menudo, el término se refiere a extensas formaciones de tierra removida, excavadas por artistas en la superficie de la Tierra, y que se pueden observar mucho mejor desde una posición ventajosa de altitud. (earthwork)

patrón Selección de líneas, colores o formas, que se repiten constantemente de manera planificada. Un patrón es también un modelo o guía para realizar algo. (*pattern*)

patrón aleatorio Patrones originados por arreglos accidentales o que se reproducen sin un diseño consistente. Por lo general, los patrones aleatorios son asimétricos, irregulares y no uniformes. (*random pattern*)

patrón planificado Patrón desarrollado y creado de manera sistemática y organizada. Ya sean manufacturados o naturales, estos patrones son precisos, mensurables y consistentes. (*planned pattern*)

perspectiva Técnica para crear una sensación de profundidad sobre un plano bidimensional. (*perspective*)

perspectiva atmosférica En las artes gráficas, el efecto emocional que se produce o el estado de ánimo que se crea. Indica también el espacio tridimensional en una composición, en particular cuando se produce mediante una perspectiva aérea. (atmospheric perspective) perspectiva lineal Técnica que se utiliza para mostrar un espacio tridimensional sobre una superficie bidimensional. (linear perspective)

plano de alzado Dibujo que muestra las caras externas de una edificación. También puede ser un costado o la vista frontal de una estructura, pintada o dibujada para revelar cada piso con detalles iguales. (elevation drawing) porcelana Arcilla blanca y de poco espesor, hecha principalmente de caolín; objeto hecho de este material. La porcelana se puede decorar con colorantes minerales antes de vidriar o con un esmaltado. (porcelain)

poste totémico Conjunto de tótems que se usa para identificar una tribu o un grupo familiar en diversas comunidades de Norteamérica. (*crest*)

postimpresionismo 1880-1900. Término que designa un período de la pintura que siguió inmediatamente al impresionismo en Francia. Se exploraron diversos estilos, en especial Cézanne (estructuras básicas), van Gogh (intenso manejo emocional del pincel) y Gauguin (colores intensos y temas insólitos). (Post-Impressionism) primer plano En una escena o en una obra artística, es la parte que parece estar más cerca del espectador. (foreground)

proceso aditivo Sustancia que se añade a otra en cantidades relativamente pequeñas con el fin de impartir las propiedades deseadas o de suprimir las propiedades indeseables. (additive process)

proporción Relación de un objeto con otro en cuanto a tamaño, cantidad, número o grado. (proportion) punto de fuga Punto donde parecen converger las rectas paralelas en el dibujo en perspectiva. (vanishing point) radial Especie de equilibrio en el cual las líneas o las formas se extienden a partir de un punto central. (radial) realismo 1850-1900. Estilo de arte que

muestra los lugares, sucesos, personas u objetos tal como son. Desarrollado a mediados del siglo XIX por artistas que no usaban las fórmulas del neoclasicismo o el drama del romanticismo. (*Realism*)

realista Semejante a la manera en que se ve un objeto o una escena. (*representational*)

ritmo Tipo de movimiento visual o real en una obra artística. El ritmo es un principio de diseño. Se crea mediante la repetición de elementos visuales. A menudo, el ritmo se describe como regular, alternativo, fluido, progresivo o animado. (*rhythm*)

rococó 1700-1800. Estilo artístico del siglo XVIII que se inició en las mansiones lujosas de la nobleza francesa y que se propagó al resto de Europa. Incluía colores suaves, líneas delicadas y movimientos elegantes. Entre los temas favoritos de esta tendencia se encontraban las aventuras románticas y el estilo de vida despreocupado de la aristocracia. (*Rococo*)

románico 1000-1200. Estilo arquitectónico y escultural influenciado por el arte romano que se desarrolló en la Europa occidental durante la Edad Media. Las catedrales tenían paredes gruesas, arcos redondeados y decoraciones esculturales. (*Romanesque*) romanticismo 1815-1875. Estilo artísti-

romanticismo 1815-1875. Estilo artistico que surgió como una reacción contra el neoclasicismo. Los temas se concentraban en la acción dramática, ambientes exóticos, aventuras, acontecimientos imaginarios, lugares remotos e intensas emociones. (Romanticism)

segundo plano Partes de una obra artística que parecen hallarse entre los objetos del primer plano y el fondo. (*middle ground*)

significado cultural Significado que sólo comprenden los miembros de una cultura específica o de un cierto grupo cultural. (cultural meaning)

símbolo Algo que representa otra cosa; especialmente una letra, una figura o un signo que representa un objeto o una idea real. Una figura roja en forma de corazón es un símbolo común del amor. (symbol)

simétrico Tipo de equilibrio en el cual los dos lados de una línea central son exactamente o casi iguales, como un reflejo exacto. Por ejemplo, las alas de una mariposa son simétricas. A este tipo de equilibrio también se le denomina equilibrio formal. (symmetrical) simplificar Crear menos detalles en ciertos o áreas de una obra artís-

ciertos objetos o áreas de una obra artística con el fin de destacar otras áreas.
Reducir lo complejo a sus elementos más básicos. (simplify)

sombra Cualquier pigmento oscuro de

un color que, por lo general, se crea al añadir negro. (shade)

sombreado Cambio paulatino de claro a oscuro. El sombreado es una manera de producir un efecto más realista y tridimensional en una ilustración. (*shading*)

tema Tópico o idea que se muestra en una obra artística, en particular cualquier cosa que sea reconocible, como un paisaje o los animales. (subject)

teselas Pequeños trozos de vidrio, azulejo, piedras, papel u otros materiales que se utilizan en la confección de mosaicos. (*tesserae*)

textura Manera en que se siente una superficie (textura real) o cómo se ve (textura implícita). Podemos sentir la textura gracias al tacto y a la vista. Palabras como áspera, sedosa, rugosa se usan para describir la textura. (*texture*) **textura implícita** Manera en que parece verse una superficie: áspera o lisa. (*implied texture*)

tímpano Espacio arqueado sobre el pórtico de una iglesia. (*tympanum*) **tótem** Objeto que sirve como emblema o símbolo de una familia, persona, idea o leyenda. (*totem*)

tríada Tres colores igualmente espaciados entre sí en la rueda de colores, como por ejemplo, el anaranjado, el verde y el violeta. (*triad*)

tríptico Retablo que consiste en tres

paneles unidos. A menudo, los dos paneles exteriores giran sobre un gozne y se cierran sobre el central. (triptych) **unidad** Sensación de que todas las partes de una obra artística funcionan juntas como un conjunto. (unity) valor Elemento artístico que denota el grado de oscuridad o claridad de una superficie. El valor depende de la cantidad de luz que puede reflejar una superficie. Los matices claros son valores leves de los colores puros. Las sombras son valores oscuros de los colores puros. El valor también tiene importancia como elemento en las obras artísticas que muestran una cantidad mínima o inexistente de color (dibujos, grabados, fotografías, la mayor parte de la escultura y la arquitectura). (value) variedad Uso de diferentes líneas, formas, texturas, colores y otros elementos del diseño con el fin de crear interés en la obra artística. (variety)

voluta Motivo decorativo que consiste en alguna forma espiral o enrollada que se asemeja a la sección transversal de una tira de papel ligeramente enrollada; moldura decorativa en forma de curva, común en las obras de arte medievales. (scroll)

A
Aboriginal art, 41, 214–215
abstract art, 260
Abstract Expressionism, 284–285
The Bull (Krasner, Lee; United States), 284
abstraction, 12
additive process, 256–257
adobe design, 221
aesthetics, 14, 60–61
Affandi (Indonesia), Self-portrait, 267
Africa/African kingdoms, 82–85
Benin (Edo peoples; Plaque), 83
Democratic Republic of the Congo (Kongo,
Kuba; Female Mask (Ngady Mwaash)), 83
Ghana (Asante people; Display Cloth), 82
Ivory Coast (Dan culture; African Mask), 3
Ivory Coast (Yaure peoples; Mask), 253
Kenya (Turkana; Doll), 85
Liberia (Kran culture; Mask Dance), 229
Nigeria (Benin; Cock), 40
Nigeria (Nok culture; Terra cotta head from
Rafin Kura), 84
Nigeria (Yoruba people; Magbo Headpiece for
Oro Society), 85
African Mask (Dan culture, Ivory Coast), 3
Ancient Egypt, 78–79
Banquet Scene (Thebes), 74
Garden with Pond (Thebes, XVIIIth dynasty),
148
King Tutankhamen after the Hunt, 80
Lady Taperet before Re-Harakhte; 22nd dynasty
(950-730 BC.), 68
Outer coffin of Henettawy, Chantress of Amun at
Thebes (Thebes, Egypt), 81
Ptahmoses, high ranking official of Memphis
receiving offerings from his children (19th dynasty), 78
Pyramids of Mycerinus, Chefren, and Cheops, The,
78
Ancient Greece, 103
Charioteer of Delphi, The, 102
Myron of Athens, 94
West Facade of the Parthenon Temple, 103
Ancient Near East, 77
Ashurbanipal in battle, 87
L . ************************************

Head of Man with Beard (Neo-Assyrian), 75 Standard of Ur: Peace (Sumerian), 77 Tribute Beaver (Persepolis), 87 Ancient Rome, 104 Arch of Constantine, 117 Augustus of Prima Porta, 104, 104 Colosseum, The, 103 Roman Gentleman, The, 104 Angkor Wat (Cambodia), 264 Anguissola, Sofonisba (Italy), Three Sisters Playing Chess, 159 Anna and David (Schapiro, Miriam; United States), Anna Washington Derry (Waring, Laura Wheeler), 39 appliqué, 216 Archangel Michael with sword, The (Byzantium), 105 architectural floor plan, 112 architecture, 24 Buddhist, 134-135 classical Greek, 103 studio lesson Creating your elevation drawing, 114–115 Arch of Constantine, 117 Armchair (Mies van der Rohe, Ludwig), 27 art global possibilities of, 290–293 as a source of information, 124–127 art criticism, 56-57 art history, 54-55 art production, 58-59 Ashurbanipal in battle (Assyrian), 87 assemblage, 256-257 asymmetrical balance, 133 Atget, Eugène (France), Cours d'Amoy 12, Place de la Bastille, 261 atmospheric color, 236 atmospheric perspective, 155 audience, art, 280 Audience of the Chinese Emperor, The (Melchior, Johann Peter), 191 Augustus of Prima Porta (Ancient Rome), 104 Austria, art forms, 158 Autohenge (Lishman, William; United States), 91

background, 147 balance, 42, 133 Balla, Giacomo, *Dynamism of a Dog on a Leash*, 47 Bancroft, Bronwyn (Australia), *Cycle of Life* Cape, 293 Banquet Scene (Thebes), 74 Bustan, (Garden of Perfume): Darius and the Baroque, 180. See also de Hooch, Pieter (Holland); Herdsmen (Sa'di), 72 Rembrandt Harmensz van Rijn (Holland); Byzantium, 105 Velásquez, Diego (Spain) The Archangel Michael with Sword, 105 Bartlett, Jennifer (United States), Sea Wall, 278 The Court of Justinian, 107 bas-relief, 86 Reliquary Cross of Justinian, 99 batik, 266 Baumbach, Amy, Who's At My Door, 294 \mathbf{C} Bayer, Herbert (United States), Metamorphosis, Cabinet Maker (Lawrence, Jacob; United States), 263 Bayeux Tapestry, 124 Caged (Brooks, Philip; United States), 55 Calendar disk (Pre-Columbian; Maya), 195 Bearden, Romare (African American), Eastern Barn, calendars, 195 Bedroom, The (Hooch, Pieter de; Holland), 54, 65 Cambodia Bernini, Gianlorenzo, 220 Angkor Wat, 264 Besler, Basil, Crocus Sativa, Bulbosa Flora Luteo, art forms, 265 Lilium Bizantinum Serot, 246 Canale, Giovanni Antonio, called Canaletto Birds of Paradise (Chespak, Ron), 242 (Italy), The Clock Tower in the Piazza San Birth of a New Technology (Lackow, Andy; United Marco, 202 States), 23 careers Blanca Snow in Puerto Rico (Martorell, Antonio; aesthetician, 14, 60 Caribbean island), 280 animation artist, 272 Boffrand, Germain (France), Salon de la Princesse archaeologist, 91 (Hôtel de Soubise, Paris), 181 architect, 117 Bonheur, Rosa (France), Sheep by the Sea, 198 art critic, 56, 63 book, 294-297 art historian, 54 Borie, Trumbauer, and Zantzinger, Philadelphia artist, 58 Museum of Art, 113 graphic design, 168 museum curator, 299 Bowl (Natzler, Gertrude and Otto), 26 Bowl (New Mexico, Mimbres people), 3 painter, 28 photography, 48 Bowl with design of maple and cherry blossoms product designer, 194 (Dohachi, Nin'ami; Japan, Edo period), 241 Brancusi, Constantin (Romania), Mlle Pogany (III), public artist, 220 254 science illustrator, 246 Bravo, Claudio, Still Life, 36 stained-glass designer, 142 Brayer, 230 Cassatt, Mary (United States), Feeding the Ducks, Brazil, Brusky, Sonia von, 29 232 Brekelenkam, Quiringh Gerritsz van (Holland), Cavern Gardens (Watler, Barbara W.), 216 The Tailor's Workshop, 177 center of interest, 211 Brooks, Philip (United States), Caged, 55 ceramics, 26 Brueghel, Pieter (Austria), Children's Games, 158 Cézanne, Paul (France), Mont Sainte-Victoire, 235 Brunelleschi, Filippo, 164 Chagall, Marc, The Green Violinist, 13 Brusky, Sonia von (Brazil), Fractalization of a Chand, Nek, Rock Garden at Chandigarh, 289 Circle, 29 Chardin, Jean-Baptiste Simeon (France), The Buddhist art, 135 Silver Gobelet, 184 Bull, The (Krasner, Lee; United States), 284 Charioteer of Delphi, The (Greece), 102 Burson, Nancy, with Rich Carling and Kremlich Chartres cathedral (United States), First and Second Beauty North Transept Rose and Lancet Windows (Melchizedek & Nebuchadnezzar, David & Saul, Composites, 61 St. Anne, Solomon, Herod, Aaron & Pharaoh), 133 Chase, Second Day, The (Stella, Frank; United States), 282

Chen, Georgette (Singapore), Mosque in Kuala	contrast, 185
Lumpur, 266 Charmala Ban Birda of Banadian 242	corinthian capital, 113
Children's Grant (Property of Pietran Acceptain) 159	Costumes de la ville de Constantinople (Turkey), 63
Children's Games (Brueghel, Pieter; Austria), 158	Counter Culture (Coe, Anne; United States), 56
China	Cours d'Amoy 12, Place de la Bastille (Atget,
art forms, 5, 99, 168, 203, 205	Eugène; France), 261
art of, 160–163	Court of Justinian, The (Byzantium), 107
Chinese Merchant Making Calculator, 273	Courtyard of a House in Delft (de Hooch, Pieter;
Chi-rho Gospel of St. Matthew, Book of Kells, 129	Holland), 182
Christo and Jeanne-Claude (France), Wrapped	crafts, 26
Reichstag, 276	crest, 109
classical artworks, 103	Crocus Sativa, Bulbosa Flora Luteo, Lilium
clay containers, 168	Bizantinum Serot (Besler, Basil), 246
Clock Tower in the Piazza San Marco, The (Canale,	Crossroads (Haas, Kenneth B., III; United States),
Giovanni Antonio, called Canaletto; Italy), 202	73
Coatl (snake) (Escobedo, Helen), 35	Crows over a Cornfield (Van Gogh, Vincent;
Cock (Nigeria, Benin), 40	Holland), 235
Coconut Oil Jar (Thailand), 265	Cuba, art form, 186
Coe, Anne (United States), Counter Culture, 56	Cubism, 152, 260. See also Delaunay, Sonia Terk
The coldest I have ever known in Britain/	(France); Picasso, Pablo (Spain)
(Goldsworthy, Andy), 281	cultural artifact, 117
collage, 20, 268	cultural meaning, of art, 82
studio lesson	cuneiform, 77
Creating a montage, 268–269	Cycle of Life Cape (Bancroft, Bronwyn; Australia),
Creating your montage, 270–271	293
color, 36–39	D
Impressionism and colors of nature, 233	daily life
in nature, 236–237	art and, 174–179, 190–191
Post-Impressionist composition and, 234	computer devices in, 298
color Field, 285	contemplation and, 221
Rock Pond (Frankenthaler, Helen; United	Dutch painting and, 182
States), 285	events as artwork's subject matter, 176–177
color wheel, 36, 49	nature in, 247
Colosseum, The (Ancient Rome), 103	photography and, 273
Colson, Jaime (Dominican Republic), Merengue,	Pre-Columbian art and, 187
177	Dali, Salvador (Spain), The Persistence of Memory,
Colucci, Michael, Digital Tortoise, 247	259
Comenius, John Amos (Germany), Typographers	dance, 63
(Die Buchdruckerey), 169	D.A.S.T. (Danae Stratou, Alexandra Stratou, and
complementary color, 237	Stella Constantinides), Desert Breath, 287
composition, Post-Impressionist, 234	Daumier, Honoré (France), The Third Class
computer art, 23	Carriage, 209
Conception Synchronie (Wright, Stanton	David, Jacques Louis (France), Oath of the Horatii,
MacDonald), 36	207
concertina, 294–296	Da Vinci, Leonardo (Italy), Study of a Flying
Constable, John (Great Britain), View on the Stour	Machine, 155
near Dedham, 201	decalcomania, 261
contour lines, 74	Decorated lamp (Lascaux, France), 174
	Degas, Edgar (France), Horse Rearing, 233
	De Heem, Jan Davidsz (Holland), A Still Life with Parrots, 178

De Hooch, Pieter (Holland) Bedroom, The, 54, 65 E Courtyard of a House in Delft, 182 earthworks, 281 Delacroix, Eugène (France) The coldest I have ever known in Britain... Horses Coming Out of the Sea, 208 (Goldsworthy, Andy), 281 Paganini, 10 Desert Breath (D.A.S.T. (Danae Stratou, Delaunay, Sonia Terk (France), Electric Prisms, Alexandra Stratou, and Stella Constantinides)), 261 287 Della Francesca, Piero (Italy), The Ideal City, 164 East Building of the National Gallery of Art (Pei, I. depth, illusion of, 148-149 M.; Japan), 24 Derain, André (France), Turning Road, L'Estaque, Eastern Barn (Bearden, Romare; African 258 American), 269 Desert Breath (D.A.S.T. (Danae Stratou, Alexandra Egypt. See Ancient Egypt Stratou, and Stella Constantinides)), 287 Electric Prisms (Delaunay, Sonia Terk; France), design, 15 as an organizational tool, 150-151 elements of design, 32, 34–41. See also color; Detail from mosaic pavement from a synagogue at form; line; shape; space; texture; value Hammat Tiberias, 122 elevation drawing, 112 Deux Chevaux (Toy Car) (South Africa), 175 Elevation drawing of the facade of the rotunda at Dido and Aeneas (Vliet, Claire Van), 294 University of Virginia, 117 Diego y yo (Kahlo, Frida; Mexico), 9 emphasis, 44, 210, 211 Digital Tortoise (Colucci, Michael), 247 Endangered Hawksbill Turtle (Kidder, Christine), Discobolus (Discus Thrower) (Myron of Athens; Greece), 94 Ennis-Brown House (Wright, Frank Lloyd; United Display Cloth (Asante people, Ghana), 82 States), 254 document, 201 environmental design, 24 Dog Wearing a Human Face Mask (Mexico, Ernst, Max (Germany), King Playing with the Colima), 151 Queen, 259 Dohachi, Nin'ami (Japan), Bowl with design of Escobedo, Helen, Coatl (snake), 35 maple and cherry blossoms, 241 Eskofatshi (beaded Bandoliers) (Choctaw, Doll (Kenya (Turkana)), 85 Mississippi), 111 Dome of St. Peter's (Michelangelo Buonarroti; European art, 180–185, 206–209, 232–235, Italy), 154 258-261 Dominican Republic, art forms, 177 Evening Rain on the Karsaki Pine, from the series Doric capital, 113 Eight Views of Omi Province (Hiroshige, Ando; Double Bound Circle (Winsor, Jackie), 33 Japan), 241 Double Spired Temple Model (Fiji Island, Expressionism, 10, 258. See also Atget, Eugène Melanesia), 212 (France) Dragon Robe (China; Quing dynasty), 99 drawing, 20 studio lesson Faces of the World (Kropper, Jean), 295 Fallingwater (Kaufmann House) (Wright, Frank Creating your own message, 74–75 Drawing architectural forms, 112–113 Lloyd; United States), 229 Drawing in perspective, 164–165 fan, 294–296 Drawing your scene, 166–167 fantasy, 13 Dreamtime, Aboriginal, 214 Fauvism, 258. See also Derain, André (France); Dürer, Albrecht (Germany), Knight, Death, and Matisse, Henri (France) Devil, 156 Feeding the Ducks (Cassatt, Mary; United States), Dynamism of a Dog on a Leash (Balla, Giacomo), 47 Female Mask (Ngady Mwaash) (Kongo, Kuba (Zaire)), 83

Ferrata, Ercole, 220	geometric shape, 132
fiber art	Germantown "eye-dazzler" (Navajo), 255
studio lesson	Germany, art form, 70, 120, 156, 210, 259
Stitching an artwork, 216–217	Gershwin, George, 220
Stitching your dream-like place, 218–219	Girl in a Boat with Geese (Morisot, Berthe; France),
film, 23	224
Finster, Howard (United States), The Model of a	Giselbertus (France), The Last Judgment, 130
Super Power Plant, 53	Gleaners, The (Millet, François; France), 209
First and Second Beauty Composites (Burson,	Go Fish (Kropper, Jean), 295
Nancy, with Rich Carling and Kremlich; United	Golden Pavillion (Kinkaku-ji), 238
States), 61	Golden Shrine (Sthlecker, Karen; United States),
Fishtrap Basket (Kazuo, Hiroshima; Japan), 174	126
Flack, Audrey (United States), Parrots Live Forever,	Goldsworthy, Andy, The coldest I have ever known
179	in Britain/, 281
Fogle, Clayton, 48	Gothic art, 128, 131
foreground, 147	Notre Dame Cathedral (exterior), (Paris,
Forget It! Forget Me! (Lichtenstein, Roy; United	France), 128
States), 58	Notre Dame Cathedral (Paris, France), 143
form, 35, 262	Grainstack (Sunset) (Monet, Claude; France), 236
in two dimensions, 263	Grand Canyon (Moran, Thomas; United States),
found materials, 100–101	227
found objects, 88, 192–193, 205–205, 282	Grand Mosque (Cordoba, Spain), 49
Fractalization of a Circle (Brusky, Sonia von; Brazil),	graph paper, 114
29	Graves, Nancy (United States), Zaga, 151
Frade, Ramon (Puerto Rico), Our Daily Bread, 188	Great Britain, art forms, 201, 211
France, art forms, 3, 10, 11, 22, 59, 130, 184, 198,	Great Stupa (Sanchi, India), 134
207, 208, 209, 224, 233, 234, 235, 237, 258,	Green Violinist, The (Chagall, Marc; Russia), 13
261, 262	Grooms, Red, The Woolworth Building from Ruckus
Frankenthaler, Helen (United States), Rock Pond,	Manhattan, 288
285	Groover, Jan, Untitled, 7
fresco, 20	Güell Park Benches (Gaudi, Antonio; Spain), 106
Friedrich, Caspar David (Germany), Periods of	Guernica (Picasso, Pablo; Spain), 124
Life (Lebensstufen), 210	Guitar on a Table (Picasso, Pablo; Spain), 152
Fumio, Kitaoka (Japan), Woodcuts, 230	Guitar (Picasso, Pablo; Spain), 153
functions of art, 4–5	Gutenberg, Johannes, 169
	Gutierrez, Yolanda, Umbral (Threshold), 291
G	
Game of Tric-Trac (Leyster, Judith; Holland), 182	Н
Gamin (Savage, Augusta; United States), 250	Haas, Kenneth B., III (United States), Crossroads,
Garden of the Rue Cortot, The (Renoir, Pierre-	73
Auguste; France), 233	Haida house model (Haida, Canada), 112
Garden with Pond (Thebes, XVIIIth dynasty), 148	haiku, 247
Garza, Carmen Lomas, La Tamalada, 176	Half-Tunic (Inca, Early Colonial Period), 71
Gaudi, Antonio (Spain), Güell Park Benches, 106	Hall of Bulls (Lascaux, France), 76
Gauguin, Paul (France), Haystacks in Brittany,	Haydon, Harold (United States), The Path, 132
237	Haystacks in Brittany (Gauguin, Paul; France), 237
Gazing at a Waterfall (China; Southern Sung	Head of Man with Beard (Neo-Assyrian), 75
Dynasty), 5	Hepworth, Barbara (United States), Two Figures,
geography, maps, 221	262
	Hindu art, 136

Hiroshige, Ando (Japan), Evening Rain on the brave Giant), 265 Karsaki Pine, from the series Eight Views of Omi Java (Woman's Sarong in batik canting Province, 241 technique), 266 Hnizdovsky, Jacques, New York Subway, 40 industrial design, 27 Höch, Hannah, Priestess, 268 Infinite Condors (James, J. Michael; United States), Hockney, David (United States) Merced River, Yosemite Valley Sept. 1982, 148 Ingres, Jean-Auguste-Dominique, Paganini, 11 Stephen Spender, Mas St. Jerome II, 19 installation art, 281 Hokusai, Katsushika (Japan), Kirifuri Waterfall at Blanca Snow in Puerto Rico (Martorell, Antonio; Mt. Kurokami, Shimozuke Province, Series: The Caribbean island), 280 Various Provinces, 231 Wrapped Reichstag (Christo, and Jeanne-Holland, art forms, 6, 54, 177, 178, 181, 182, 185, Claude; France), 276 Ionic capital, 113 Hopper, Edward, Night Shadows, 33 Islamic religious art, 137. See also Ancient Egypt; horizon line, 164 Persia Horse Rearing (Degas, Edgar; France), 233 Italy, art forms, 47, 154, 155, 156–157, 159, 165, Horses Coming Out of the Sea (Delacroix, Eugène; 202 France), 208 It's Hard to be Traditional When you're All Plugged Hostess (Vandenberge, Peter; United States), 100 (Malotte, Jack; Native American), 97 Hunter, Inga, Imperium Scroll, 295 Izquierdo, Maria, 299 I J Ideal City, The (della Francesca, Piero; Italy), 164 James, J. Michael (United States), *Infinite Condors*, ideals, 95 279 of nature, 110 Japan promotion through art, 98-99 art forms, 143 art of, 238-241 identity, 95 art as reflection of, 96-97 Jar (China, Yuan dynasty), 168 ikebana, 240 Jefferson, Thomas, 117 Ikenobo, Sen'ei (Japan), Rikka style Ikebana Jizo Bosatsu (Japan), 143 arrangement, 240 illuminated manuscript, 121, 129 Chi-rho Gospel of St. Matthew, Book of Kells, 129 Kahlo, Frida (Mexico), Diego y yo, 9 St. Matthew (German), 120 Kailasanatha Temple (India, Kanchipuram), 136 Kammeraad, Lori (United States), Llama, 43 Imperium Scroll (Hunter, Inga), 295 Katsina Doll (Zuni, New Mexico), 4 implied space, 210 Impressionism, 232, 233. See also Cassatt, Mary Kauffman, Angelica, Pliny the Younger and His Mother at Misenum, 206 (United States); Degas, Edgar (France); Monet, Claude (France); Morisot, Berthe (France); Kazuo, Hiroshima (Japan), Fishtrap Basket, 174 Renoir, Pierre-Auguste (France) Kelly, Ellsworth (United States), Sweet Pea, 34 Ina and the Shark (Teokolai, Maria, and others; Kennedy, Clare, Sunset Sailing, 33 Cook Islands), 217 Kidder, Christine, Endangered Hawksbill Turtle, 44 King Playing with the Queen (Ernst, Max; India, 25, 134–136, 137 Indonesia Germany), 259 King Prasenajit Visits the Buddha (Bharhut Stupa), Affandi, 267 art forms, 265-266 Bali (Wahana (miniature vehicle for a votive King Tutankhamun after the Hunt, 80 Kirifuri Waterfall at Mt. Kurokami, Shimozuke figure)), 252 Province, Series: The Various Provinces (Hokusai, Java (Wajang purwa shadow puppet: Bima, the Katsushika; Japan), 231 Knight, Death, and Devil (Dürer, Albrecht; Germany), 156

Kollwitz, Käthe (Germany), Seed for sowing shall Not Be Ground, 70	Little Big Painting, 285 line, 34, 74, 80
	linear perspective, 148, 155
Korea, art of, 160–163	linoleum block, 230
Krasner, Lee (United States), The Bull, 284	Lishman, William (United States), Autohenge, 91
Kropper, Jean	Little Big Painting (Lichtenstein, Roy; United
Faces of the World, 295	
Go Fish, 295	States), 285
Kruger, Barbara, <i>Untitled</i> (A Picture is Worth	Llama (Kammeraad, Lori), 43
More than a Thousand Words), 3	Lu Zhi (China), Pulling Oars Under Clearing
Kuang Ceremonial Vessel (China, Shang Dynasty),	Autumn skies ("Distant Mountains"), 162
160	
Kwakiutl Painted House, 109	M
•	M
L	Magbo Headpiece for Oro Society (Yoruba people,
Lackow, Andy (United States), Birth of a New	Nigeria), 85
Technology, 23	Mali, art forms, 200
Ladybug (Mitchell, Joan; United States), 53	Malotte, Jack (Native American), It's Hard to be
Lady Taperet before Re-Harakhte (Lower Egypt	Traditional When you're All Plugged, 97
(Lybia) 22nd dynasty), 68	Man with Violin (Picasso, Pablo; Spain), 12
landscape, 6	maps, 221
east Asian painting, 162–163	Marriage of the Virgin (Raphael; Italy), 146
language Arts, 62	Martorell, Antonio (Caribbean island), Blanca
books in electronic form, 299	Snow in Puerto Rico, 280
haiku, 247	Masaccio (Italy), The Tribute Money, 155
invention of the printing press, 169	Mask Dance (Kran culture, Liberia), 229
La Revue Blanche Poster (Toulouse-Lautrec, Henri	Mask of Born-to-Be-Head-of-the-World (Hopetown)
de; France), 22	96
Las Meninas (The Maids of Honor) (Velásquez,	Mask of diving loon (Yup'ik), 110
Diego; Spain), 180	Mask (Yaure peoples, Ivory Coast), 253
Last Judgment, The (Giselbertus, France), 130	mathematics, 29, 49, 117
La Tamalada (Garza, Carmen Lomas), 176	accurate proportions, 91
Latin American art, 186–189. See also Mexico;	calculations, 272
Peru; Pre-Columbian art	calendars, 195
modern art, 188–189	radial symmetry, 143
Lawrence, Jacob (United States)	symmetrical balance, 247
Cabinet Maker, 53	Matisse, Henri (France), Sorrows of the King, 262
Tombstones, 72	Matsys, Quentin, The Moneylender and His Wife,
Le Bec du Hoc at Grand Champ (Seurat, George;	156
France), 234	Mattresses and Cakes (Rubins, Nancy; United
Legend of Leip Island, The (Nalo, Joe; New	States), 279
Guinea), 203	Mayan culture, A Ruler Dressed as Chac-Xib-Chac
lessons	and the Holmul Dancer, 97
from artwork, 122–126	Mayan Model of a Ball Game, 187
in light, 131	McQuillen, Charles (United States), Ritual III, 60
in stone, 130	media, art, 18
Leyster, Judith (Holland), Game of Tric-Trac, 182	Medicine Man (Saar, Alison; United States), 101
Lichtenstein, Roy (United States)	medieval art, 128–131
Forget It! Forget Me!, 58	early, 129
	Meeting house of Hotunui (Maori, New Zealand),
	213

Mei P'ing vase (China, Ming Dynasty), 161 Mont Ste Victoire (Cézanne, Paul; France), 235 Meiping Vase with crane and Cloud design (Korea, Moran, Thomas (United States), Grand Canyon, Koryo dynasty), 161 Melanesia, Malanggan people, New Ireland Morisot, Berthe (France), Girl in a Boat with Geese, (Memorial Pole), 200 224 Melchior, Johann Peter, The Audience of the mosaic, 26, 106–107 Chinese Emperor, 191 Mosque in Kuala Lumpur (Chen, Georgette; Memkus, Frank (United States), Whirling entitled Singapore), 266 "America," 98 motifs, 215 Memorial Pole (Malanggan people, New Ireland, Mountain, New Mexico, The (O'Keeffe, Georgia), Melanesia), 200 39 Méndez, Leopoldo, Arando, 8 Mountain Landscape (China, Qing dynasty, Merced River, Yosemite Valley Sept. 1982 (Hockney, Qianlong period), 203 David; United States), 148 movement, 47 Merengue (Colson, Jaime; Dominican Republic), mural, 125 177 music, 48, 63, 90, 169 Merian, Maria Sibylla, Plate 2 from Dissertation in continuity and change in, 272 Insect Generations and Metamorphosis in musical picture, 220 Surinam, 226 representation of animals or natural events, 246 messages in art, 70–75 Myron of Athens (Greece), Discobolus (Discus Metamorphosis (Bayer, Herbert; United States), Thrower), 94 263 Metzelaar, L. (Indonesia), Woman's Sarong in batik canting technique, 266 Mexico. See also Pre-Columbian art Nabageyo, Bruce (Australia), The Rainbow Serpent art forms, 9, 35, 151, 189 at Gabari, 215 Mezuzah (Galicia), 139 Nahl, Charles Christian, Saturday Night at the Michelangelo Buonarroti (Italy) Mines, 273 Dome of St. Peter's, 154 Nalo, Joe (New Guinea), The Legend of Leip Island, Pieta, 157 middle ground, 147 Narasimha: Lion Incarnation of Vishnu (India, late Mies van der Rohe, Ludwig, Armchair, 27 Chola period), 134 Mihrab of the Meders Imami, Isfahan, 123 narrative artwork, 62, 72 Millet, François (France), The Gleaners, 209 Native American miniature, 137 art forms, 19, 97, 110 Mitchell, Joan, Ladybug, 53 Native North American art, 108-109 mixed media Anasazi people (New Mexico; Seed Jar), 109 studio lesson Choctaw (Mississippi; Eskofatshi (beaded Making a painting/sculpture, 282–283 Bandoliers)), 111 Teaching triptychs, 126 Haida (Canada; Haida house model), 112 Mlle Pogany (III) (Brancusi, Constantin; Romania), ideals of nature, 110 254 Kwakiutl (Canada; Kwakiutl Painted House), mobile, 25 Model of a Super Power Plant, The (Finster, Kwakiutl (Mask of Born-to-Be-Head-of-the-Howard; United States), 53 World), 96 Monet, Claude (France), 233 Mimbres people (New Mexico; Bowl), 3 Grainstack (Sunset), 236 Navajo (Germantown "eye-dazzler"), 255 The Seine at Giverny, Morning Mists, 3 Navajo saddle blanket, 55 Moneylender and His Wife, The (Matsys, Quentin), Nuu-Chah-Nulth people (Canada; Totem), 109 156 montage, 20, 268-271

Yup'ik (Mask of diving loon), 110 Outer coffin of Henettawy, Chantress of Amun at Thebes (Thebes, Egypt), 81 Zuni (New Mexico; Katsina Doll), 4 Zuni Pueblo (New Mexico; Olla (Storage Jar)), P 227 Paganini (Delacroix, Eugène; France), 10 nature Paganini (Ingres, Jean-Auguste-Dominique; as an artwork's subject, 226–227 France), 11 Impressionism and colors of, 233 Painterly Architectonics (Popova, Liubov; Russia), Japanese art and, 238-241 as source of art materials, 228-229, 240-241 Natzler, Gertrude and Otto, Bowl, 26 painting, 20 exploring new techniques in, 278, 282-283 Navajo saddle blanket, 55 studio lesson negative shape, 132 Making a painting/sculpture, 282-283 negative space, 210 Neoclassicism, 206, 207. See also David, Jacques A still-life painting, 178–179 paper, in art, 242-243 Louis (France); Kauffman, Angelica paper-sculpture techniques, 244 netsuke, 241 papier-mâché, 100-101 Nevelson, Louise (United States), Sky Cathedral, Park, Jae Hyun, Toward Unknown Energy, 292 257 Parrots Live Forever (Flack, Audrey; United States), New Guinea, art forms, 203 Newton, Isaac, 62 179 Passing a Summer Day Beneath Banana Palms New York Subway (Hnizdovsky, Jacques), 40 (Ying, Ch'iu; China), 205 Night Shadows (Hopper, Edward), 33 Path, The (Haydon, Harold; United States), 132 Noli me tangere and Crucifixion (detail) (Cathedral patrons, 154 of Chartres, France), 131 nonobjective art, 6 pattern, 45, 49, 74, 80-81, 161. See also motifs Peacock (Ortakales, Dennis), 243 Notre Dame Cathedral (exterior), Paris, 128 Peeters, Clara (Holland), Still Life with Nuts and Notre Dame Cathedral (Paris, France), 143 Fruit, 185 Pei, I. M., East Building of the National Gallery of 0 Oath of the Horatii (David, Jacques Louis; France), Art, Washington, D.C., 24 Pelaez, Amelia (Cuba), Still Life, 186 207 Penguin (Sewell, Leo; United States), 256 Oceanic art, 212-215, 217. See also Aboriginal art Periods of Life (Lebensstufen) (Friedrich, Caspar Okakoto (Japan), Two Quails, 241 David; Germany), 210 O'Keeffe, Georgia (United States) The Mountain, New Mexico, 39 Persia, art forms, 72, 149 Persistence of Memory, The (Dali, Salvador; Spain), Oriental Poppies, 253 Oldenburg, Claes/VanBruggen, Spoonbridge & 259 Cherry, 45 perspective, 40 atmospheric, 155 Old Mole (Puryear, Martin; African American), linear, 148, 155 one point, 164 Olla (Storage Jar) (Zuni Pueblo), 227 On the Edge (WalkingStick, Kay; Native Peru, 187 American), 111 Inca, Early Colonial Period, 71 Mochica culture, 189 Opulado Teeveona (Scharf, Kenny), 286 organic shape, 132 Philadelphia Museum of Art, 113 photographs, used in montage, 270-271 Oriental Poppies (O'Keeffe, Georgia; United States), photography, 23, 261 Ortakales, Dennis, Peacock, 243

Our Daily Bread (Frade, Ramon; Puerto Rico), 188

physical education, Mayan ball game, 195 Puerto Rico, art form, 188 Picasso, Pablo (Spain) Pulling Oars Under Clearing Autumn skies Guernica, 124 ("Distant Mountains") (Lu Zhi; China), 162 Guitar, 153 Puryear, Martin (African American), Old Mole, Guitar on a Table, 152 286 Man with Violin, 12 Pyramids of Mycerinus, Chefren, and Cheops, The Three Musicians, 260 (Giza, Egypt), 78 Pickering, Mary Carpenter (United States), Quilt appliqued with fruit and flowers, 175 Q Pieta (Michelangelo Buonarroti; Italy), 157 quilt, 216-217 places Quilt appliqued with fruit and flowers (Pickering, as artwork's subject, 200–205 Mary Carpenter; United States), 175 in Neoclassicism, 207 in Realism, 209 R in Romanticism, 208 radial balance, 133 Plaque (Edo peoples, Benin), 83 Rainbow Serpent at Gabari, The (Nabageyo, Bruce; Plate 2 from Dissertation in Insect Generations and Australia), 215 Metamorphosis in Surinam (Merian, Maria Raphael (Italy) Sibylla), 226 Marriage of the Virgin, 146 Pliny the Younger and His Mother at Misenum, 206 School of Athens, The, 165 Poem-Card (Shikishi) (Sotatsu, Tamaraya, and Raven, Arlene, 63 Hon'ami Koetsu; Japan), 247 Ready to Leave Series II (Sikander, Shahzia; India), Poncho (Peru), 187 292 Pop Art, 285, 288, 289 Realism, 11, 206, 208–209. See also Daumier, Popova, Liubov, Painterly Architectonics, 7 Honoré (France); Millet, François (France) porcelain, 161 relief print, 230-231 portrait, 9 relief sculpture, 25 positive shape, 132 religious art, 122-123. See also Buddhist art; positive space, 210 Hindu art; Islamic religious art posterboard, 152 Chi-rho Gospel of St. Matthew, Book of Post-Impressionism, 232, 234. See also Cézanne, Kells, 129 Paul (France); Gauguin, Paul (France); Seurat, Detail from mosaic pavement from a George (France); van Gogh, Vincent (Holland) synagogue at Hammat Tiberias, 122 Pre-Columbian art, 187 Mezuzah (Galicia), 139 Maya, 20, 195 Mihrab of the Meders Imami, Isfahan, 123 Pre-historic art, 77 Seated Buddha, Preaching in the First Sermon, Decorated lamp (Lascaux, France), 174 Sarnath (India, Gupta period), 123 Hall of Bulls (Lascaux, France), 76 St. Matthew (German), 120 Saharan rock painting of Jabbaren Showing early Zodiac Mosaic Floor (Synagogue Beth Alpha, herders driving cattle, 71 Israel), 138 Priestess (Höch, Hannah), 268 Reliquary Cross of Justinian (Byzantine), 99 principles of design, 32, 42-47. See also balance; Rembrandt Harmensz van Rijn (Holland) emphasis; movement; pattern; proportion; Side of Beef, 185 rhythm; unity; variety View of Amsterdam, 181 printmaking, 21 Renaissance art, 154-157 studio lesson, Nature in relief, 230-231 in Italy, 154–156. See also Anguissola, proportion, 46, 288 Sofonisba (Italy); da Vinci, Leonardo (Italy); Ptahmoses, high ranking official of Memphis della Francesca, Piero (Italy); Masaccio (Italy); receiving offerings from his children (19th Michelangelo Buonarroti (Italy); Raphael dynasty), 78 in Northern Europe, 156. See also Brueghel, Pieter (Austria); Dürer, Albrecht (Germany); Matsys, Quentin

Schapiro, Miriam (United States), Anna and David, Renoir, Pierre-Auguste (France), The Garden of the Rue Cortot, 233 Renovations, Out with the Old, In with the New Scharf, Kenny, Opulado Teeveona, 286 Schiltz, Rand (United States), Renovations, Out (Schiltz, Rand; United States), 73 with the Old, In with the New, 73 rhythm, 47, 106, 107 Rikka style Ikebana arrangement (Ikenobo, Sen'ei; School of Athens, The (Raphael; Italy), 165 School Scene, A (Syyid-Ali, Mir), 149 Japan), 240 science, 15 Ringgold, Faith (United States), Tar Beach, 203, adobe design, 221 255 Ritual III (McQuillen, Charles; United States), 60 Gothic architecture, 143 Rivera, Diego (Mexico), Woman Grinding Maize, human life span, 299 optics, 49 scientific method, 62 River Bridge at Uji, The (Japan, Momoyama periscroll, 294-296 od), 239 Robinson, Rene, Snake Dreaming, 41 sculpture, 25. See also assemblage Rock Garden at Chandigarh (Chand, Nek), 289 classical Greek, 103 Cubist, 152-153 Rococo art, 180 Audience of the Chinese Emperor, The (Melchior, new approaches to, 278-279, 286-287 Renaissance, 156-157 Johann Peter), 191 in everyday life, 183 studio lesson Creating a folded box of lessons, 138 Salon de la Princesse (Hôtel de Soubise, Paris) Creating a place for thought, 204-205 (Boffrand, Germain; France), 181 Creating your box of lessons, 140–141 Soup Tureen, Cover, and Stand (France), 183 Wall Clock (Voisin, Charles, and Chantilly Decorating a container, 190–191 Decorating your container, 192–193 manufactory; France), 191 Making a bas-relief, 86-88 Romanesque art, 128, 130 Last Judgment, The (Giselbertus, France), 130 Making a book, 294–295 Making an assemblage, 256-257 Romanticism, 206, 208. See also Delacroix, Eugène (France) Making a painting/sculpture, 282–283 Making a paper-relief sculpture, 242-243 round arch, 117 Making your bas-relief, 87-88 Rubins, Nancy (United States), Mattresses and Making your book, 296–297 Cakes, 279 Making your paper-relief sculpture, Ruler Dressed as Chac-Xib-Chac and the Holmul Dancer, A (Mayan), 97 244-245 Russia, visual representations, 7, 13 Organizing a sculpture, 152–153 Sculpting your identity, 100–101 Seated Buddha, Preaching in the First Sermon, S Saar, Alison (United States), Medicine Man, 101 Sarnath (India, Gupta period), 123 Sea Wall (Bartlett, Jennifer; United States), 278 Saharan rock painting of Jabbaren Showing early Seed for sowing shall Not Be Ground (Kollwitz, herders driving cattle, 71 Salon de la Princesse (Hôtel de Soubise, Paris) Käthe; Germany), 70 Seed Jar (Anasazi people, New Mexico), 108 (Boffrand, Germain; France), 181 Sefarim (Sonnino, Franca), 297 Samuels, Jeffrey (Australia), This Changing Seine at Giverny, Morning Mists, The (Monet, Continent of Australia, 214 Claude; France), 3 Sanzio, Raphael. See Raphael (Italy) Saturday Night at the Mines (Nahl, Charles self-portrait, 9, 100 Self-portrait (Affandi; Indonesia), 267 Christian), 273 Savage, Augusta (United States), Gamin, 250 Self-Portrait of Marie Louise Elisabeth Vigée-Lebrun scale, 289 Scale of Civilization (Yetmgeta, Zerihun;

Ethiopia), 290

59 Standard of Ur: Peace (Sumerian), 77 Seurat, George (France), Le Bec du Hoc at Grand Standing Buddha (India, Gandhara), 135 Champ, 234 Starr, Julia May, 28 Seven Jewelled Peaks (ch'ibosan) (Korea, Choson Starry Night (van Gogh, Vincent; Holland), 6 period), 163 Stavelot Triptych, The (Mosan), 127 Sewell, Leo (United States), Penguin, 256 stele of Naram-Sin, The (Akkadian), 86 shape, 35, 132, 262 Stella, Frank (United States), The Chase, Second simplified natural, 226 Day, 282 Sheeler, Life, Still Life (Suspended Forms), 42 Stephen Spender, Mas St. Jerome II (Hockney, Sheep by the Sea (Bonheur, Rosa; France), 198 David; United States), 19 Shinto shrines, 238 Sthlecker, Karen (United States), Golden Shrine, Shipwreck, The (Turner, Joseph Mallord William; 126 Great Britain), 211 stitches, types of, 218 Stick Chart (Marshall Islands, Micronesia), 212 Side of Beef (Rembrandt Harmensz van Rijn; Holland), 185 Still Life (Bravo, Claudio), 36 Sikander, Shahzia (India), Ready to Leave Series II, still-life painting, 7, 178–179 Still Life (Pelaez, Amelia; Cuba), 186 Silver Gobelet, The (Chardin, Jean-Baptiste Still Life (Suspended Forms) (Sheeler, Life), 42 Simeon; France), 184 Still Life with Nuts and Fruit (Peeters, Clara; Sita in the Garden of Lanka from the Ramayana Epic Holland), 185 of Valmaki, 137 Still Life with Parrots, A (de Heem, Jan Davidsz; sites, artwork and, 281 Holland), 178 Siva, King of the Dancers, Performing the Nataraja Storm, Howard, Winter House, 39 (India, Tamil Nadu), 136 Study of a Flying Machine (da Vinci, Leonardo; Sky Cathedral (Nevelson, Louise; United States), Italy), 155 257 stupa, 134–135 Smith, Jaune Quick-to-See, Tree of Life, 291 style, of artwork, 10 Snake Dreaming (Robinson, Rene), 41 subject, artwork, 6 Soami (Japan), Zen Stone Garden, 228 Subway, The (Tooker, George; United States), 150 social studies, 15, 29, 91, 117 Sully, Maurice de, Notre Dame Cathedral (exteritechnological advances, 273 or), Paris, 128 women in art, 169 Sung, Melissa (United States), Untitled, 59 Sunset Sailing (Kennedy, Clare), 33 Sonnino, Franca, Sefarim, 297 Sophocles, 116 Surrealism, 259. See also Dali, Salvador (Spain); Sorrows of the King (Matisse, Henri; France), 262 Ernst, Max (Germany) Sotatsu, Tamaraya, and Hon'ami Koetsu (Japan), Sweet Pea (Kelly, Ellsworth), 34 Poem-Card (Shikishi), 247 symbol, 70, 122 Soup Tureen, Cover, and Stand (France), 183 in religious art, 138 Southeast Asia, Art of, 264-267. See also symmetrical balance, 133 Cambodia; Indonesia; Thailand Syyid-Ali, Mir, A School Scene, 149 space, 40, 210 organizing a picture's, 164 Spain, art forms, 12, 49, 106, 124, 152, 153, 180, Tailor's Workshop, The (Brekelenkam, Quiringh 259, 260 Gerritsz van; Holland), 177 Spoonbridge & Cherry (Oldenburg, Tar Beach (Ringgold, Faith; United States), 203, Claes/VanBruggen), 45 St. Matthew (German), 120 tempera paint, 178-179, 205-205 Stained Glass Window (Wright, Frank Lloyd; Temple of Frescoes (Pre-Columbian; Mexico), 20 Teokolai, Maria, and others (Cook Islands), Ina

United States), 4

and the Shark, 217

(Vigée-Lebrun, Marie Louise Elisabeth; France),

Terra cotta head from Rafin Kura (Nok culture,	tympanum, 130
Nigeria), 83	Typographers (Die Buchdruckerey) (Comenius,
tesserae, 106	John Amos; Germany), 169
texture, 41, 106	
Thailand, Coconut Oil Jar, 265	U
theater, 14, 28, 116	Umbral (Threshold) (Gutierrez, Yolanda), 291
dramatic dialogue, 194	Unfinished Basket (Yepa, Filepe), 19
exploring "What if?" question, 298	unity, 43, 156
morality play, 142	Untitled (A Picture is Worth More than a
theme, artwork, 8	Thousand Words) (Kruger, Barbara; United
Third Class Carriage, The (Daumier, Honoré;	States), 3
France), 209	Untitled (Groover, Jan), 7
This Changing Continent of Australia (Samuels,	Untitled (Sung, Melissa; United States), 59
Jeffrey; Australia), 214	Unwrapped Reichstag (Parliament) (Wallot, Paul),
three-dimensional (3-D) art forms, 24–27	276
Three Musicians (Picasso, Pablo; Spain), 260	
Three Sisters Playing Chess (Anguissola,	V
Sofonisba; Italy), 159	value, 36–37
Tjangala, Keith Kaapa (Australia), Wichetty drub	light, 184
dreaming, 214	Vandenberge, Peter (United States), Hostess, 100
Tombstones (Lawrence, Jacob; United States), 72	van Gogh, Vincent (Holland), Crows in the
Tooker, George (United States), The Subway, 150	Wheatfields, 235
totem, 109	Van Gogh, Vincent (Holland), Starry Night, 6
Totem (Nuu-Chah-Nulth people), 109	vanishing point, 149
Toulouse-Lautrec, Henri de, La Revue Blanche	variety, 43, 159
Poster, 22	Velásquez, Diego (Spain), Las Meñinas (The Maids
Toward Unknown Energy (Park, Jae Hyun), 292	of Honor), 180
traditions	Vermeer, Johannes (Holland), The Milkmaid, 172
art and, 252	Vessel representing seated ruler with pampas cat
breaking, borrowing, and building on, 254–255	(Peru; Mochica culture), 189
expressionism and, 258	View of Amsterdam (Rembrandt Harmensz van
surrealism and, 259	Rijn; Holland), 181
Traoré, Ismaila (Mali), The weekly market at the	View on the Stour near Dedham (Constable, John;
Great Mosque of Djénné, 200	Great Britain), 201
Tree of Life (Smith, Jaune Quick-to-See), 291	Vigée-Lebrun, Marie Louise Elisabeth (France),
Tribute Beaver (Persia, Persepolis), 87	Self-Portrait of Marie Louise Elisabeth Vigée-
Tribute Money, The (Masaccio; Italy), 155	Lebrun, 59
triptych, 126	visual record of events, art as, 142
trompe l'œil, 28	Vliet, Claire Van, Dido and Aeneas, 294
Turkey, Costumes de la ville de Constantinople, 63	
Turner, Joseph Mallord William (Great Britain),	\mathbf{W}
The Shipwreck, 211	Wahana (miniature vehicle for a votive figure)
Turning Road, L'Estaque (Derain, André; France),	(Bali), 252
258	Wajang purwa shadow puppet: Bima, the brave
two-dimensional (2-D) art forms, 20–23, 40	Giant (Java, Indonesia), 265
Two Figures (Hepworth, Barbara; United States),	WalkingStick, Kay (Native American), On the
262	Edge, 111
Two Quails (Okakoto; Japan), 241	Wall Clock (Voisin, Charles, and Chantilly manu-
Two Shells (Weston, Edward; United States), 57	factory; France), 191
	Wallot, Paul, Unwrapped Reichstag (Parliament),

Waring, Laura Wheeler, Anna Washington Derry,

Watler, Barbara W., Cavern Gardens, 216 weekly market at the Great Mosque of Djénné, The (Traoré, Ismaila; Mali), 200

West Facade of the Parthenon Temple (Greece), 103 Weston, Edward (United States), Two Shells, 57 wheat paste, 192–193

Whirling entitled "America" (Memkus, Frank; United States), 98

Who's At My Door (Baumbach, Amy), 294 Wichetty drub dreaming (Tjangala, Keith Kaapa;

Australia), 214

William and Mary Gardens (Hampton Court, England), 221

Williams, Tennessee, 194

Winsor, Jackie, Double Bound Circle, 33

Winter House (Storm, Howard), 39

Woman Grinding Maize (Rivera, Diego; Mexico),

Woman's Sarong in batik canting technique (Metzelaar, L.; Indonesia), 266 woodcut, 230-231 Woodcuts (Fumio, Kitaoka; Japan), 230 Woolworth Building from Ruckus Manhattan, The

(Grooms, Red), 288

Wrapped Reichstag (Christo, and Jeanne-Claude; France), 276

Wright, Frank Lloyd (United States) American Stained Glass Window, 4 Ennis-Brown House, 254 Fallingwater (Kaufmann House), 229 Wright, Stanton MacDonald, Conception Synchronie, 36

Y

Yepa, Filepe, Unfinished Basket, 19 Yetmgeta, Zerihun (Ethiopia), Scale of Civilization, 290 Ying, Ch'iu (China), Passing a Summer Day Beneath Banana Palms, 205

Z

Zaga (Graves, Nancy; United States), 151 Zen Stone Garden (Soami; Japan), 228 Zodiac Mosaic Floor (Synagogue Beth Alpha, Israel), 138

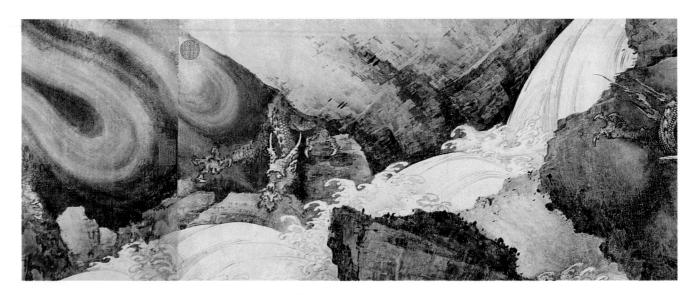

Anonymous, *Dragons*, China, Southern Sung dynasty, mid-13th century. Handscroll, ink, and a touch of color on paper, $17^{5}/8$ " x $100^{5}/16$ " (44.8 x 254.8 cm). Chinese and Japanese Special Fund, 14.423. Courtesy Museum of Fine Arts, Boston.